THE COMPLETE
BEGINNER'S GUIDE TO
DRAWING

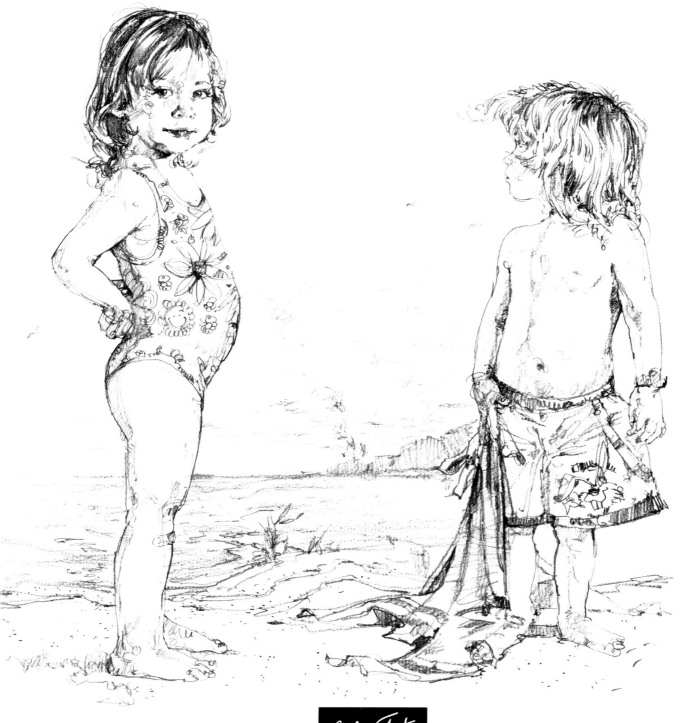

Walter Foster

CONTENTS

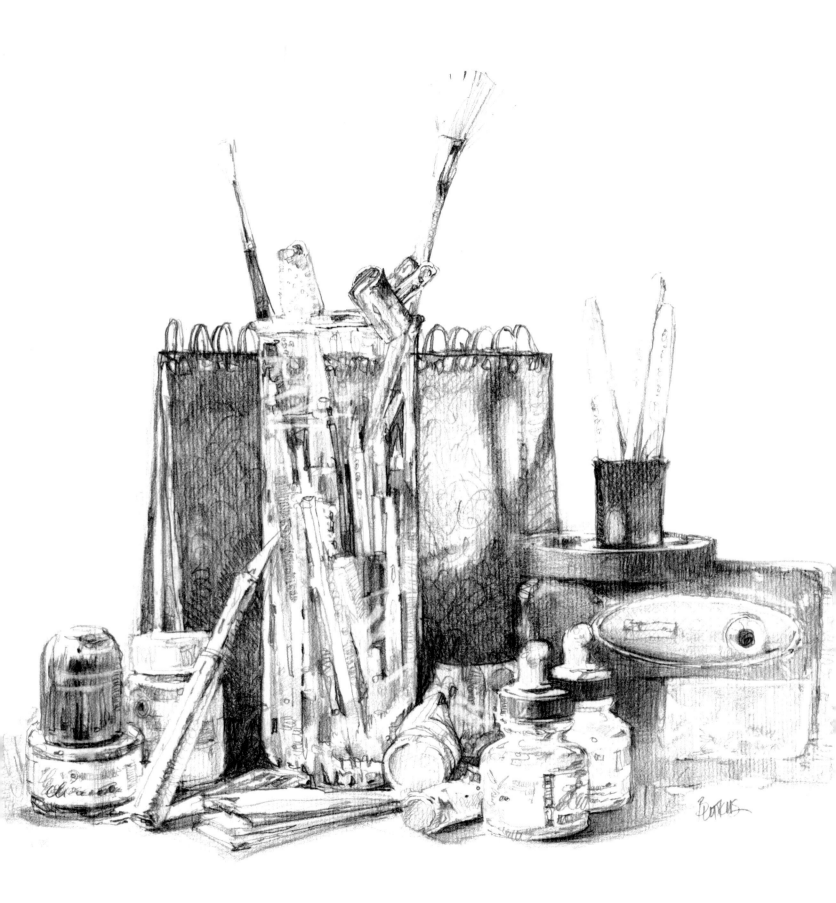

BASICS

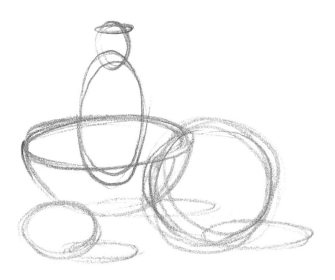

TOOLS & MATERIALS

Drawing is not only fun, it is also an important art form in itself. Even when you write or print your name, you are drawing! If you organize the lines, you can make shapes, and when you carry that a bit further and add dark and light shading, your drawings begin to take on a three-dimensional form and look more realistic. One of the great things about drawing is you can do it anywhere—and the materials are very inexpensive. You get what you pay for though, so purchase the best you can afford at the time, and upgrade your supplies whenever possible. Although anything that makes a mark can be used for some type of drawing, you'll want to make certain your magnificent efforts will not fade over time. Here are some of the materials that will get you off to a good start.

Sketch Pads Conveniently bound drawing pads come in a wide variety of sizes, textures, weights, and bindings. They are particularly handy for making quick sketches and when drawing outdoors. You can use a large sketchbook in the studio for laying out a painting or take a small one with you for recording quick impressions when you travel. Smooth- to medium-grain paper texture (which is called the "tooth") is often an ideal choice.

Work Station It is a good idea to set up a work area that has bright lighting and enough room for you to work and lay out your tools. Of course, an entire room with track lighting, an easel, and a drawing table is ideal. But all you really need is a place by a window for natural lighting. When drawing at night, use a soft white light bulb and a cool white fluorescent light so you have both warm (yellowish) and cool (bluish) light.

Charcoal Papers Charcoal paper and tablets are available in a variety of textures. Some of the surface finishes are quite pronounced and can be used to enhance the texture in your drawings. These papers also come in a variety of colors, which can add depth and visual interest to your drawings.

Drawing Papers For finished works of art, using single sheets of drawing paper is best. They are available in a range of surface textures: smooth grain (plate and hot pressed), medium grain (cold pressed), and rough to very rough. The cold-pressed surface is the most versatile. It is of medium texture but not totally smooth, so it makes a good surface for a variety of drawing techniques.

GATHERING THE BASICS

You don't need a lot of supplies to start; you can begin enjoying drawing with just a No. 2 or an HB pencil, a sharpener, a vinyl eraser, and any piece of paper. You can always add more pencils, charcoal, tortillons, and such later on. When shopping for pencils, notice that they are labeled with letters and numbers; these indicate the degree of lead softness. Pencils with B leads are softer than ones with H leads and make darker strokes. An HB is in between, which makes it very versatile and a good beginner's tool. The chart on the right shows a variety of drawing tools and the kinds of strokes that are achieved with each one. As you expand your pencil supply, practice shaping different points and creating different effects with each pencil by varying the pressure you put on it. The more comfortable you are with your tools, the better your drawings will be!

GATHERING OTHER DRAWING TOOLS

I start my drawings with graphite pencils, but I also like to use other tools as my pieces progress. For example, Conté crayons and charcoal produce chalky, smudged lines that soften the look of a subject. Outlining a drawing with black ink really makes a subject "pop" (see page 30), and thin washes of ink (or black watercolor) applied with a paintbrush produce smooth shadings.

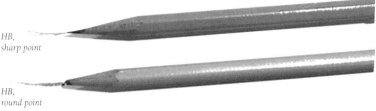

HB, sharp point

HB, round point

HB An HB with a sharp point produces crisp lines and offers good control. With a round point, you can make slightly thicker lines and shade small areas.

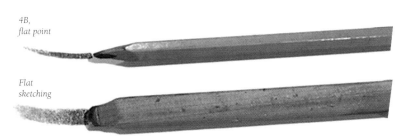

4B, flat point

Flat sketching

Flat For wider strokes, use the sharp point of a flat 4B. A large, flat sketch pencil is great for shading large areas, but the sharp, chiseled edge can also be used to make thinner lines.

Artist's Erasers

A kneaded eraser is a must. It can be formed into small wedges and points to remove marks in very tiny areas. Vinyl erasers are good for larger areas; they remove pencil marks completely. Neither eraser will damage the paper surface unless it is scrubbed too hard.

Tortillons These paper "stumps" can be used to blend and soften small areas where your finger or a cloth is too large. You can also use the sides to quickly blend large areas. Once the tortillons become dirty, simply rub them on a cloth and they're ready to go again.

Utility Knives Utility knives (also called "craft" knives) are great for cleanly cutting drawing papers and matboard; you can also use them for sharpening pencils. (See the box on the right.) Blades come in a variety of shapes and sizes and are easily interchanged. But be careful; the blades are as sharp as scalpels!

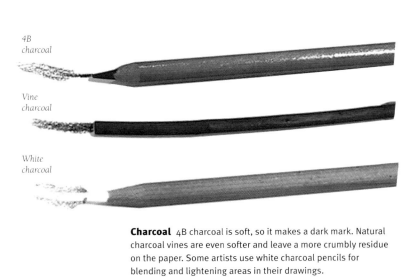

4B charcoal

Vine charcoal

White charcoal

Charcoal 4B charcoal is soft, so it makes a dark mark. Natural charcoal vines are even softer and leave a more crumbly residue on the paper. Some artists use white charcoal pencils for blending and lightening areas in their drawings.

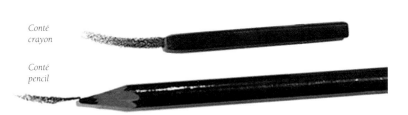

Conté crayon

Conté pencil

Conté Crayon or Pencil Conté crayon is made from very fine Kaolin clay. It used to come only in black, white, red, and sanguine sticks, but now it's also available in a wide range of colored pencils. Because it's water soluble, it can be blended with a wet brush or cloth.

SHARPENING YOUR DRAWING IMPLEMENTS

Utility Knife A knife can be used to form different points (chiseled, blunt, or flat) than those which are possible with an ordinary pencil sharpener. Hold the knife at a slight angle to the pencil shaft, and always sharpen away from you by taking off only a little wood and graphite at a time.

Sandpaper Block Sandpaper will quickly hone the lead into any shape you wish. It will also sand down some of the wood. The finer the grit of the paper, the more controllable the resulting point. Roll the pencil in your fingers when sharpening to keep the shape even.

Rough Paper Rough paper is wonderful for smoothing the pencil point after tapering it with sandpaper. This is a great way to create a very fine point for small details. It is also important to gently roll the pencil while honing to sharpen the lead evenly.

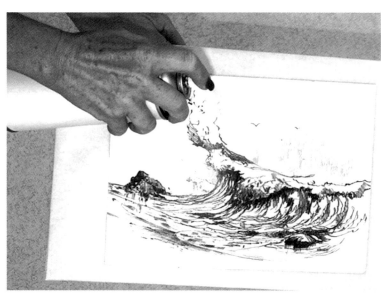

ADDING ON

Unless you already have a drawing table, you will probably want to purchase a drawing board. It doesn't have to be expensive; just get one large enough to accommodate individual sheets of drawing paper. Consider getting a drawing board with a cut-out handle, especially if you want to draw outdoors, so you can easily carry it with you.

Spray Fix A fixative "sets" a drawing and protects it from smearing. Some artists avoid using fixative on pencil drawings because it tends to deepen the light shadings and eliminate some delicate values. However, fixative works well for charcoal drawings. Fixative is available in spray cans or in bottles, but you need a mouth atomizer to use bottled fixative. Spray cans are more convenient, giving a finer spray and more even coverage.

HOLDING YOUR DRAWING PENCIL

Basic Underhand The basic underhand position allows your arm and wrist to move freely, which results in fresh and lively sketches. Drawing in this position makes it easy to use both the point and the side of the lead by simply changing your hand and arm angle.

Underhand Variation Holding the pencil at its end lets you make very light strokes, both long and short. It also gives you a delicate control of lights, darks, and textures. Place a protective "slip sheet" under your hand when using this position so you don't smudge your drawing.

Writing The writing position is the most common, and it gives you the most control for fine details and precise lines. Be careful not to press too hard on the point, or you'll make indentations in the paper. Also remember not to grip the pencil too tightly, as your hand may cramp.

GETTING STARTED

Before you begin sketching, you'll want to get accustomed to using your whole arm, not just your wrist and hand, to draw. (If you use only your wrist and hand, your sketches may appear stiff or forced.) Practice drawing freely by moving your shoulder and arm to make loose, random strokes on a piece of scrap paper. Try to relax, and hold your pencil lightly. You don't need to focus on a particular subject as you warm up; just get used to the feel of a pencil in your hand and the kinds of strokes you can achieve.

LEARNING CONTROL

Once your arm is warmed up, try the strokes and techniques shown here. Although making circles, dots, scribbles, and lines may seem like senseless doodling, creating these marks is actually a great way to learn control and precision—two traits essential to pencil drawing. You should also experiment with different pencil grips to see how they affect the lines you draw. The more you practice with different strokes, sketching styles, and grips, the quicker and more skilled your hand will become!

Practicing Loose Strokes Although drawing requires a certain amount of precision, loose strokes are also essential to art. Free, circular strokes are great for warming up or quickly recording subjects, such as the rough shape of a pot-bellied pig.

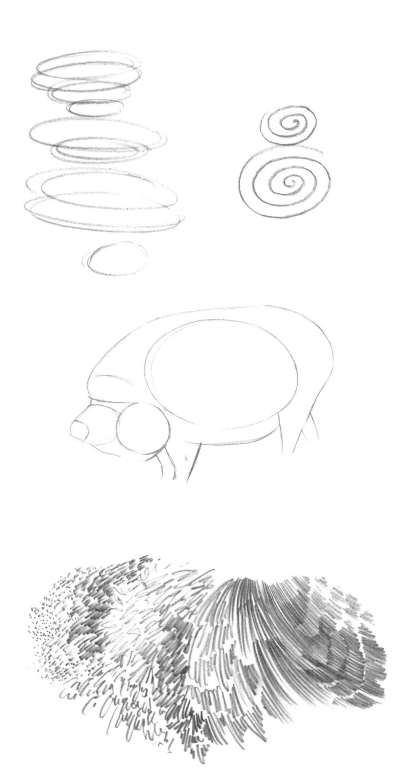

Varying Edges Making small adjustments in your drawings to suit your subject is important. For example, pencil strokes that follow along a straight edge are ideal for creating striped fur. But free edges are more appropriate for creating a natural-looking coat, as straight edges can make the hair seem too stiff and structured. Edges created with an eraser also have their place—these lines can be used to provide a smooth transition between textures or values.

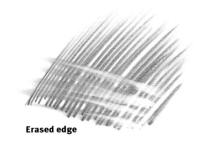

Erased edge

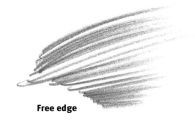

Free edge

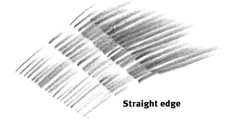

Straight edge

Modifying Strokes You can capture the length, thickness, and texture of an animal's hair by varying the length and curve of your strokes. Small dots are perfect for short, bristly fur; scribbles are appropriate when hair is thick and frizzy; and long, sweeping strokes imply smoothness. Try varying the pressure of your pencil and the length and curve of your strokes to see what other textures you can produce.

EXPERIMENTING WITH STROKES

Learning to draw requires a certain amount of control and precision, so get used to the feel of a pencil in your hand and the kinds of strokes you can achieve. Before you begin sketching, experiment with different pencil grips to see how they affect the lines you produce. Fine, detailed work is more easily accomplished with a sharp pencil held as though you are writing, whereas broad shading is best done with the side of your pencil as you hold it in an underhand position. Practice holding the pencil underhand, overhand, and in a writing position to see the different lines you can create.

You can also vary your strokes by experimenting with the sharpness or dullness of your pencil points. A sharp point is good for keeping your drawings detailed and refined; the harder the lead, the longer your pencil point remains sharp and clean. A flat point or chisel point is helpful for creating a wider stroke, which can quickly fill larger areas. Create a flat or chisel point by rubbing the sides of a pencil on a sandpaper block or even on a separate sheet of paper.

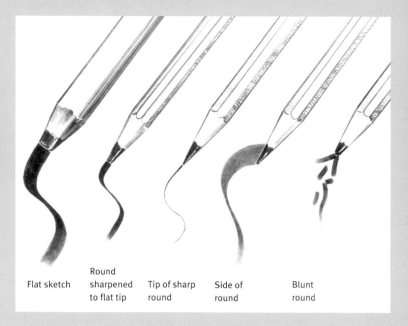

Flat sketch | Round sharpened to flat tip | Tip of sharp round | Side of round | Blunt round

BASIC TECHNIQUES

Practicing basic techniques will help you understand how to manipulate the pencil to achieve a variety of effects. Pencil can be used to recreate everything from the scaly skin of a snake to the soft, fluffy fur of a bunny. But before you attempt to render animal textures (see page 9), it's a good idea to get to know your tools and the variety of strokes you can make. On this page, you'll learn a number of shading techniques as well as how to make a two-dimensional drawing appear three-dimensional.

Hatching

A basic method of shading is to fill an area with hatching, which is a series of parallel strokes.

Crosshatching

For darker shading, go over your hatching with a perpendicular set of hatch marks.

Shading Darkly

By applying heavy pressure to the pencil, you can create dark, linear areas of shading.

Blending

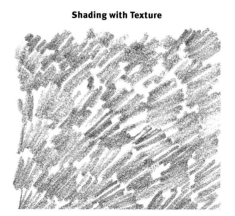

For smoother shading, rub a blending stump over heavily shaded areas to blend the strokes.

Shading with Texture

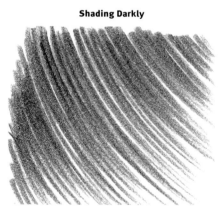

To fill in any area with mottled texture, use the side of the pencil tip and apply small, uneven strokes.

Gradating

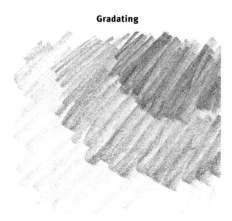

Create a gradation of dark to light by stroking from heavy to light pressure with the side of the pencil.

BUILDING UP FORMS

Values tell us even more about a form than its outline. *Value* is the basic term used to describe the relative lightness or darkness of a color. In pencil drawing, the values range from white to grays to black, and it's the variation among lights and darks (made with shading) and the range of values in shadows and highlights that give a three-dimensional look to a two-dimensional drawing. Once you've established the general shape and form of the subject using basic shapes, refine your drawing by applying lights and darks. Adding values through shading allows you to further develop form and give depth to your subject, making it really seem to come to life on paper!

Shape

Form

Shading enables you to transform mere lines and shapes in your drawing into three-dimensional objects. As you read this book, note how the words shape and form are used. Shape refers to the actual outline of an object, while form refers to its three-dimensional appearance. In the examples above, notice how shading builds up the object, creating the illusion of depth.

SEEING VALUES

This value scale shows the gradation from black, the darkest value, through various shades of gray, ending with white—the lightest value.

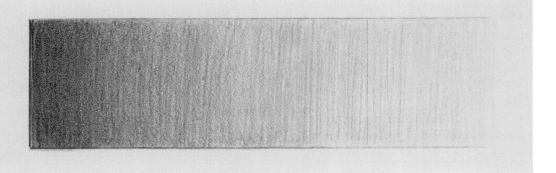

OTHER HELPFUL MATERIALS

You should have a paper stump (also known as a tortillon) for creating textures and blends. The paper stump enhances certain effects and, once covered with lead, can be used to draw smeared lines. To conserve lead, purchase a sandpaper pad to sharpen the point without wearing down the pencil. You may also want to buy a regular hand-held pencil sharpener and a metal ruler. Finally, a sturdy drawing board provides a stable surface for your drawings.

FINAL PREPARATIONS

Before beginning to draw, set up a spacious work area that has plenty of natural light. Make sure all the tools and materials are easily accessible from where you're sitting. Because you might be sitting for hours at a time, find a comfortable chair. Tape the corners of the paper to the drawing board or surface to prevent it from moving while you work. Use a ruler to make a light border around the edges of the paper; this will help you use the space on your paper wisely, especially if you want to frame or mat the finished product.

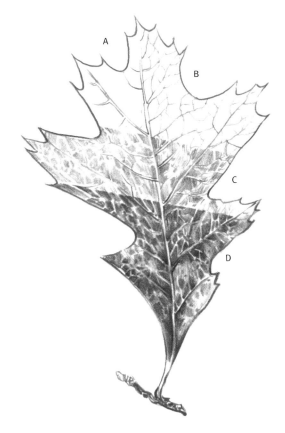

(A) Begin by drawing the basic leaf shape and vein pattern using a pointed HB pencil. (B) Add more vein pattern. (C) Begin middle-value shading using the side of the lead. To create the vein patterns, leave areas clean, or use a kneaded eraser to lift out the highlights. (D) Add darker shading using the point of a 2B pencil. Develop surface textures and detail.

LEARNING TO SEE

M any beginners draw without carefully looking at their subject; instead of drawing what they *actually* see, they draw what they *think* they see. Try drawing something you know well, such as your hand, without looking at it. Chances are your finished drawing won't look as realistic as you expected. That's because you drew what you *think* your hand looks like. Instead, you need to forget about all of your preconceptions and learn to draw only what you really see in front of you (or in a photo). Two great exercises for training your eye to see are contour drawing and gesture drawing.

PENCILING THE CONTOURS

In *contour drawing*, pick a starting point on your subject, and then draw only the contours—or outlines—of the shapes you see. Because you're not looking at your paper, you're training your hand to draw the lines exactly as your eye sees them. Try doing some contour drawings of your own; you might be surprised at how well you're able to capture the subjects.

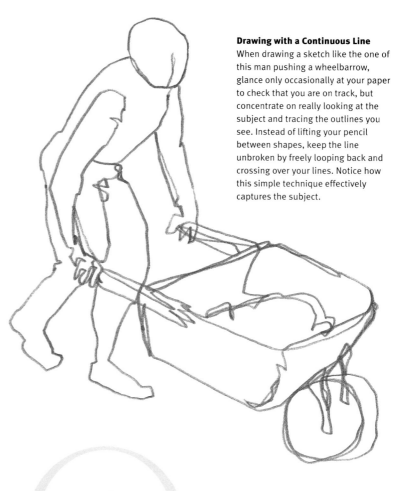

Drawing with a Continuous Line
When drawing a sketch like the one of this man pushing a wheelbarrow, glance only occasionally at your paper to check that you are on track, but concentrate on really looking at the subject and tracing the outlines you see. Instead of lifting your pencil between shapes, keep the line unbroken by freely looping back and crossing over your lines. Notice how this simple technique effectively captures the subject.

Drawing "Blind" The contour drawing above can be made while occasionally looking down at the paper while you draw your hand. The drawing on the right is an example of a blind contour drawing in which you draw without looking at your paper. It will be a little distorted, but it's clearly your hand. Blind contour drawing is one of the best ways to make sure you're truly drawing only what you see.

To test your observation skills, study an object very closely for a few minutes, and then close your eyes and try drawing it from memory, letting your hand follow the mental image.

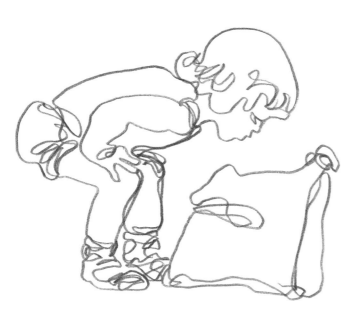

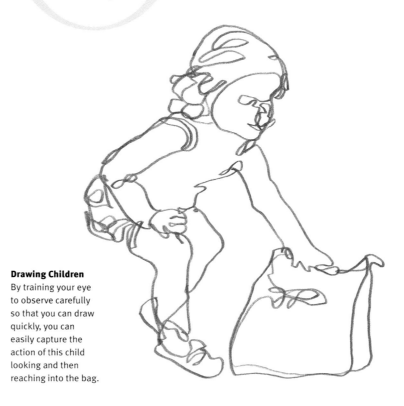

Drawing Children
By training your eye to observe carefully so that you can draw quickly, you can easily capture the action of this child looking and then reaching into the bag.

DRAWING GESTURE AND ACTION

Another way to train your eye to see the essential elements of a subject—and train your hand to record them rapidly—is through *gesture drawing*. Instead of rendering the contours, gesture drawings establish the *movement* of a figure. First determine the main thrust of the movement, from the head, down the spine, and through the legs; this is the *line of action*, or *action line*. Then briefly sketch the general shapes of the figure around this line. These quick sketches are great for practicing drawing figures in action and sharpening your powers of observation. (See pages 174–175 for more on drawing people in action.)

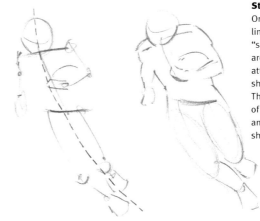

Starting with an Action Line
Once you've established the line of action, try building a "skeleton" stick drawing around it. Pay particular attention to the angles of the shoulders, spine, and pelvis. Then sketch in the placement of the arms, knees, and feet, and roughly fill out the basic shapes of the figure.

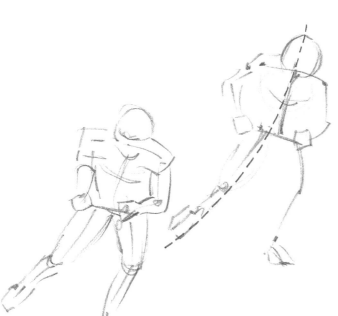

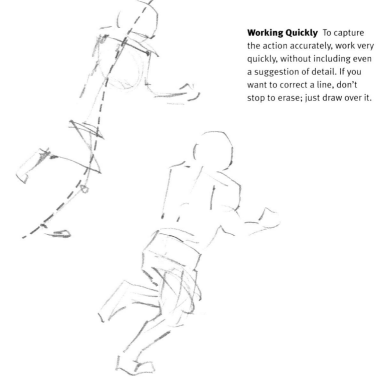

Working Quickly To capture the action accurately, work very quickly, without including even a suggestion of detail. If you want to correct a line, don't stop to erase; just draw over it.

Studying Repeated Action Group sports provide a great opportunity for practicing gesture drawings and learning to see the essentials. Because the players keep repeating the same action, you can observe each movement closely and keep it in your memory long enough to sketch it correctly.

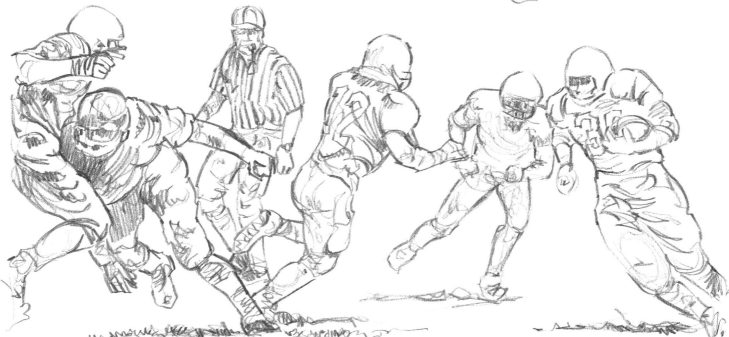

Drawing a Group in Motion Once you compile a series of gesture drawings, you can combine them into a scene of people in action, like the one above.

STARTING WITH SKETCHES

Sketching is a wonderful method for quickly capturing an impression of a subject. Depending on the pencil lead and technique used, you can swiftly record a variety of shapes, textures, moods, and actions. For example, dark, bold strokes can indicate strength and solidity; lighter, more feathered strokes can convey a sense of delicacy; and long, sweeping strokes can suggest movement. (See the examples below for a few common sketching techniques.) Some artists often make careful sketches to use as reference for more polished drawings later on, but loose sketches are also a valuable method of practice and a means of artistic expression, as the examples on these pages show. You might want to experiment with different strokes and sketching styles. With each new exercise, your hand will become quicker and more skilled.

Recording Your Impressions
Here are examples of a few pages that might be found in an artist's sketchbook. Along with sketching interesting things you see, make notes about the mood, colors, light, time of day, and anything that might be helpful when you refer back to them. It's a good idea to carry a pad and pencil with you at all times, because you never know when you will come across an interesting subject you'd like to sketch.

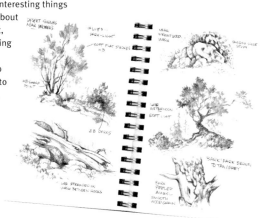

Using Circular Strokes Loose, circular strokes are great for quickly recording simple subjects or for working out a still life arrangement, as shown in this example. Just draw the basic shapes of the objects and indicate the shadows cast by the objects; don't pay attention to rendering details at this point. Notice how much looser these lines are compared to the examples from the sketchbook at right.

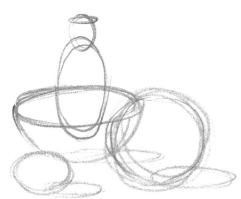

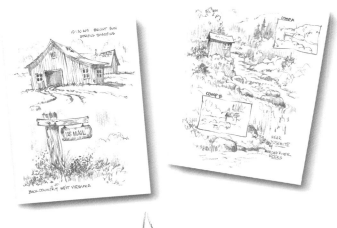

Scribbling Free, scribbled lines can also be used to capture the general shapes of objects such as clouds, treetops, or rocks. Use a soft B lead pencil with a broad tip to sketch the outlines of the clouds; then roughly scribble in a suggestion of shadows, hardly ever lifting your pencil from the drawing paper. Note how this technique effectively conveys the puffy, airy quality of the clouds.

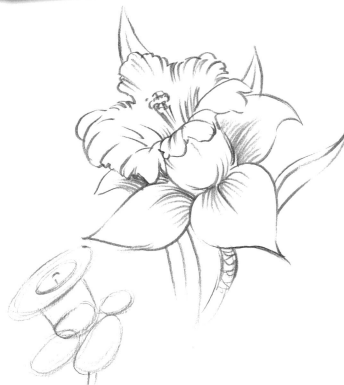

Using Wide, Bold Strokes This method is used for creating rough textures and deep shadows, making it ideal for subjects such as foliage, hair, and fur textures. For this example, use the side of a 2B pencil, varying the pressure on the lead and changing the pencil angle to produce different values (lights and darks) and line widths. This creates the realistic form and rough texture of a sturdy shrub.

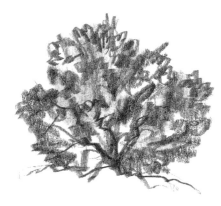

Sketching for Reference Material Here is an example of using a rough sketch as a source of reference for a more detailed drawing. Use loose, circular strokes to record an impression of the flower's general shape, keeping your lines light and soft to reflect the delicate nature of the subject. Then use the sketch as a guide for the more fully rendered flower above.

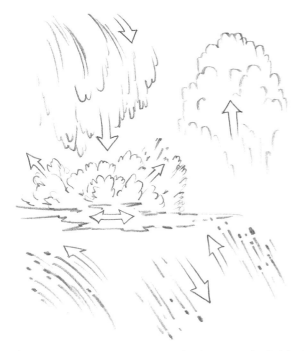

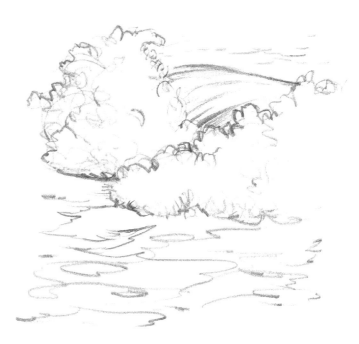

Conveying Movement To show movement in a drawing, you need to fool the viewer's eye and make it appear as if the object is moving up, down, or sideways. In the examples above, the arrows indicate the direction of movement, but your pencil strokes should actually be made in the opposite direction. Press down at the beginning of each stroke to get a strong line, lifting your pencil at the end to taper it off. Note how these lines convey the upward and downward direction of water and the rising and billowing movement of smoke.

Rendering Wave Action Quickly sketch a wave, using long, flowing strokes to indicate the arcing movement of the crest, and make tightly scribbled lines for the more random motions of the water as it breaks and foams. As shown above, your strokes should taper off in the direction opposite the movement of the wave. Also sketch in a few meandering lines in the foreground to depict the slower movement of the pooled water as it flows and recedes.

FOCUSING ON THE NEGATIVE SPACE

Sometimes it's easier to draw the area around an object instead of drawing the object itself. The area around and between objects is called "negative space." (The actual objects are called "positive space.") If an object appears to be too complex or if you are having trouble "seeing" it, try focusing on the negative space instead. At first it will take some effort, but if you squint your eyes, you'll be able to blur the details so you see only the negative and positive spaces. You'll find that when you draw the negative shapes around an object, you're also creating the edges of the object at the same time. The examples below are simple demonstrations of how to draw negative space. Select some objects in your home and place them in a group, or go outside and look at a clump of trees or a group of buildings. Try sketching the negative space, and notice how the objects seem to emerge almost magically from the shadows!

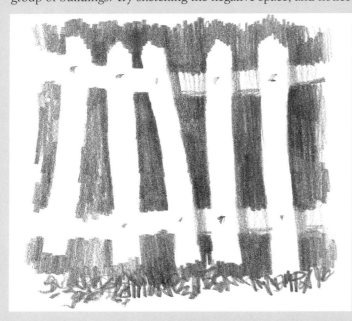

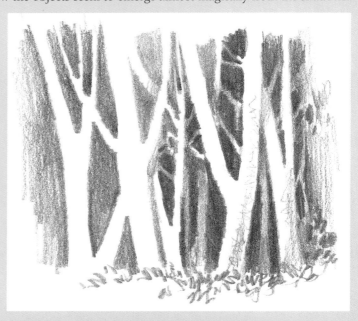

Filling In Create the white picket fence by filling in the negative spaces around the slats. Don't draw the slats. Instead, draw the shapes surrounding them, and then fill in the shapes with the side of a soft lead pencil. Once you establish the shape of the fence, refine the sketch a bit by adding some light shading on the railings.

Silhouetting This stand of trees is a little more complicated than the fence, but having sketched the negative spaces simplified it immensely. The negative shapes between the tree trunks and among the branches are varied and irregular, which adds a great deal of interest to the drawing.

BEGINNING WITH BASIC SHAPES

Anyone can draw just about anything by simply breaking down the subject into the few basic shapes: circles, rectangles, squares, and triangles. By drawing an outline around the basic shapes of your subject, you've drawn its shape. But your subject also has depth and dimension, or *form*. The corresponding forms of the basic shapes are spheres, cylinders, cubes, and cones. For example, a ball and a grapefruit are spheres, a jar and a tree trunk are cylinders, a box and a building are cubes, and a pine tree and a funnel are cones. Sketching the shapes and developing the forms is the first step of every drawing. After that, it's essentially just connecting and refining the lines and adding details.

Creating Forms Here are diagrams showing how to draw the forms of the four basic shapes. The ellipses show the backs of the circle, cylinder, and cone, and the cube is drawn by connecting two squares with parallel lines. (Page 10 shows you how to shade these forms.)

Sphere *Cylinder* *Cube* *Cone*

Combining Shapes Here is an example of beginning a drawing with basic shapes. Start by drawing each line of action (see page 176); then build up the shapes of the dog and the chick with simple ovals, circles, rectangles, and triangles.

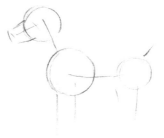

Building Form Once you establish the shapes, it's easy to build up the forms with cylinders, spheres, and cones. Notice that the subjects are now beginning to show some depth and dimension.

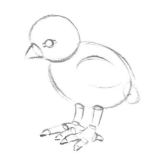
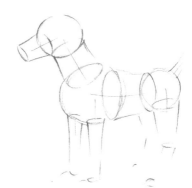

Drawing Through Drawing through means drawing the complete forms, including the lines that will eventually be hidden from sight. When the forms were drawn, the back side of the dog and chick were indicated. Even though you can't see that side in the finished drawing, the subject should appear three-dimensional. To finish the drawing, simply refine the outlines, and add a little fluffy texture to the downy chick.

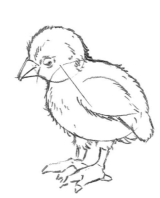
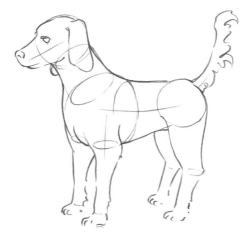

SEEING THE SHAPES AND FORMS

Now train your eye and hand by practicing drawing objects around you. Set up a simple still life—like the one on page 202 or the arrangement below—and look for the basic shapes in each object. Try drawing from photographs, or copy the drawings on this page. Don't be afraid to tackle a complex subject; once you've reduced it to simple shapes, you can draw anything!

Step 1 Begin with squares and a circle, and then add ellipses to the jug and sides to the book. Notice that the whole apple is drawn, not just the part that will be visible. This is another example of drawing through.

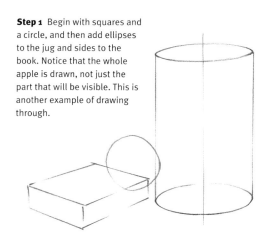

Step 1 Even a complex form such as this '51 Ford is easy to draw if you begin with basic shapes. At this stage, ignore all the details and draw only squares and rectangles. These are only guidelines, which you can erase when your drawing is finished, so draw lightly, and don't worry about making perfectly clean corners.

Step 2 Next add an ellipse for the body of the jug, a cone for the neck, and a cylinder for the spout. Pencil in a few lines on the sides of the book, parallel to the top and bottom, to begin developing its form.

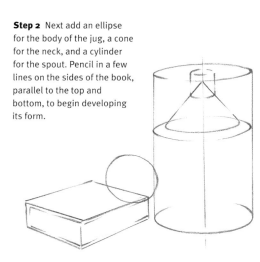

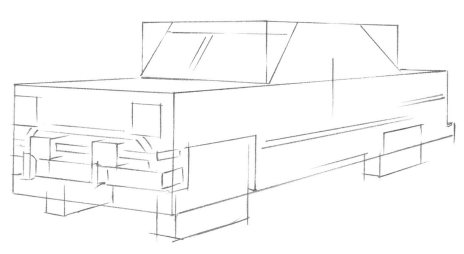

Step 2 Using those basic shapes as a guide, start adding more squares and rectangles for the headlights, bumper, and grille. Start to develop the form of the windshield with angled lines, and then sketch in a few straight lines to place the door handle and the side detail.

Step 3 Finally, refine the outlines of the jug and apple, and then round the book spine and the corners of the pages. Once you're happy with your drawing, erase all of the initial guidelines to complete your drawing.

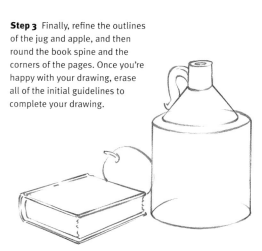

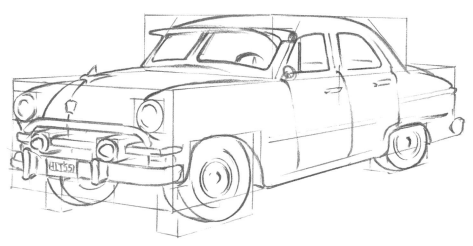

Step 3 Once you have all the major shapes and forms established, begin rounding the lines and refining the details to conform to the car's design. Your guidelines are still in place here, but as a final step, clean up the drawing by erasing the extraneous lines.

WARMING UP

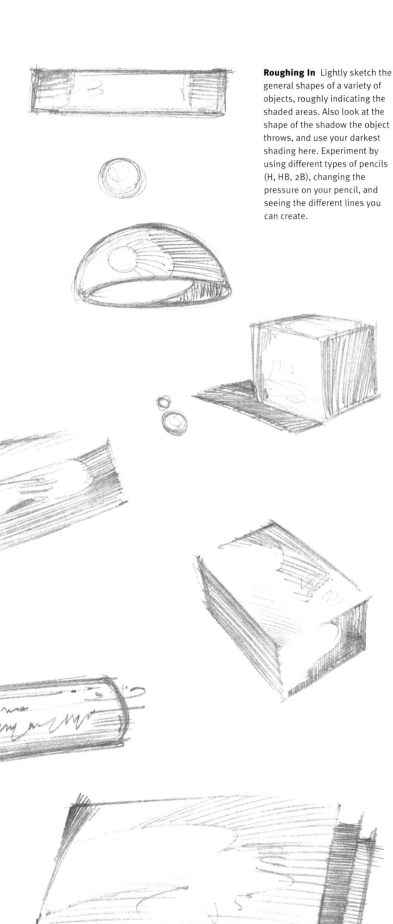

Drawing is about observation. If you can look at your subject and really *see* what is in front of you, you're halfway there; the rest is technique and practice. Warm up by sketching a few basic three-dimensional forms—spheres, cylinders, cones, and cubes. (See page 16 for more on basic shapes and their corresponding forms.) Gather some objects from around your home to use as references, or study the examples here. (By the way, feel free to put a translucent piece of paper over these drawings and trace them. It's not cheating; it's good practice.)

STARTING OUT LOOSELY

Begin by holding the pencil loosely in the underhand position. (See page 8.) Then, using your whole arm, not just your wrist, make a series of loose circular strokes to get the feel of the pencil and to free your arm. (If you use only your wrist and hand, your sketches may appear stiff or forced.) Practice drawing freely by moving your shoulder and arm to make loose, random strokes on a piece of scrap paper. Keep your grip relaxed so your hand does not get tired or cramped, and make your lines bold and smooth. Now start doodling—scribble a bunch of loose shapes without worrying about drawing perfect lines. You can always refine them later.

Roughing In Lightly sketch the general shapes of a variety of objects, roughly indicating the shaded areas. Also look at the shape of the shadow the object throws, and use your darkest shading here. Experiment by using different types of pencils (H, HB, 2B), changing the pressure on your pencil, and seeing the different lines you can create.

APPLYING SHADING

Artists give a three-dimensional look to a two-dimensional drawing by manipulating values. Value refers to the relative lightness or darkness of a color. It is the variation in value that helps define an object's form. Since value tells us even more about a form than its outline, figure artists use a variety of techniques to create a full range of shades and highlights—including the ones demonstrated here. The result is more realistic form and dimension in a drawing.

Flat Shading To shade large areas, create a generalized half-tone by using the underhand position.

Gradation To produce a gradual shift in value, use the underhand position, varying the pressure from heavy to light.

Blending To produce subtle value transitions and soft edges, smudge with your finger or a blending stump.

Eraser Strokes To soften edges and vary the line quality, use a small piece of kneaded eraser. (You can also cut off a sharp piece of vinyl eraser.)

Expressive Lines To draw fluid lines with a dynamic feel, use the mid-hand position; then push, pull, twist, and vary pencil pressure as you draw.

Dotting To create background textures, such as those of a wall or carpet, vary the pressure of your strokes, and use your imagination.

Crosshatching To deepen shadows and enhance form, use crisscrossing strokes. The more strokes that overlap one another, the darker the area becomes.

Linear Hatching To create form with shading, make parallel strokes that follow the shape, curve, or direction of the surface. Change the pressure of your strokes to vary the value.

Squiggles For more contrast in your drawings, include loose, circular strokes and squiggles. When used with hatching, these strokes create many interesting textures.

SIMPLE SHAPES

Study your subject closely, and lightly sketch the simple shapes to which details will later be added. The pear below is made up of two joined circles—one large and one small. Once these basic shapes are drawn, begin shading with strokes that are consistent with the pear's rounded form, as shown in the final drawing.

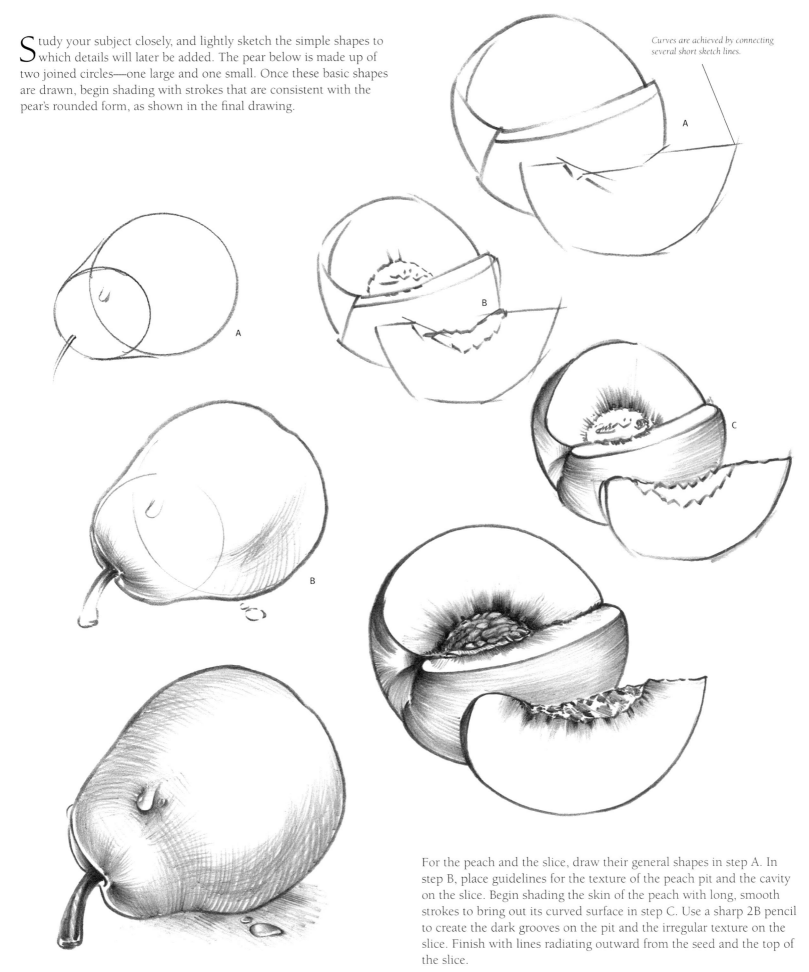

Curves are achieved by connecting several short sketch lines.

For the peach and the slice, draw their general shapes in step A. In step B, place guidelines for the texture of the peach pit and the cavity on the slice. Begin shading the skin of the peach with long, smooth strokes to bring out its curved surface in step C. Use a sharp 2B pencil to create the dark grooves on the pit and the irregular texture on the slice. Finish with lines radiating outward from the seed and the top of the slice.

To draw chestnuts, use a circle and two intersecting lines to make a cone shape in steps A and B below. Then place some guidelines for ridges in step C.

A

Use the arrow directions shown below as a guide for shading the cherry according to its contour. Leave light areas for the water drops, and shade inside them, keeping the values soft.

A

To draw a cherry, lightly block in the round shape and the stem in step A, using a combination of short sketch lines.

B

B

Sketch the outline shape of the pool of water with short strokes, as you did with the cherry. Shade softly, and create highlights with a kneaded eraser.

A

In step B, smooth the sketch lines into curves, and add the indentation for the stem. Then begin light shading in step C.

B

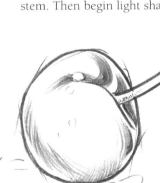

C

C

Continue shading until the cherry appears smooth. Use the tip of a kneaded eraser to remove any shading or smears that might have gotten into the highlights. Then fill in the darker areas using overlapping strokes, changing stroke direction slightly to give the illusion of three-dimensional form to the shiny surface.

Shade the chestnuts using smooth, even strokes that run the length of the objects. These strokes bring out form and glossiness. Finally, add tiny dots on the surface. Make the shadow that is cast by the chestnuts (*the cast shadow*) the darkest part of the drawing. Giving an object a cast shadow adds depth and realism to your drawing.

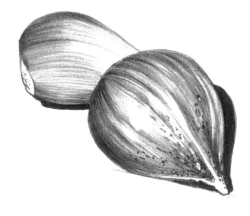

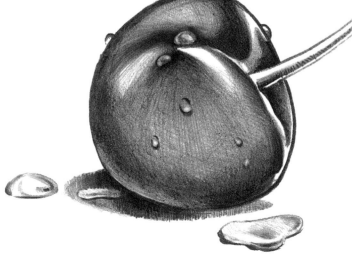

STRAWBERRIES

These strawberries were drawn on plate-finish bristol board using only an HB pencil. Block in the berry's overall shape in steps A and B to the right. Then lightly shade the middle and bottom in step C, and scatter a seed pattern over the berry's surface in step D. Once the seeds are in, shade around them.

A

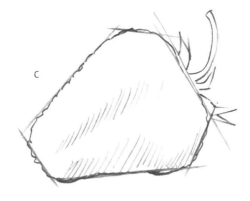

C

A

B

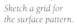

Sketch a grid for the surface pattern.

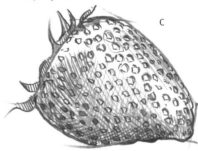

C

B

Draw a grid on the strawberry; it appears to wrap around the berry, helping to establish its seed pattern and three-dimensional form.

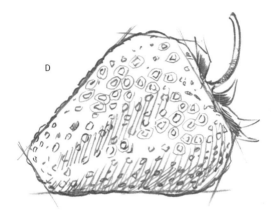

D

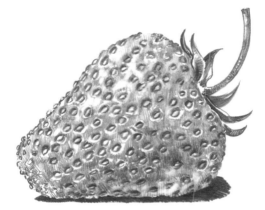

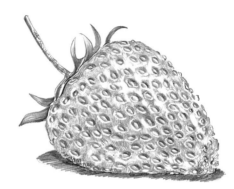

A

It's important to shade properly around the seeds, creating small, circular areas that contain both light and dark. Also develop highlights and shadows on the overall berry to present a realistic, uneven surface.

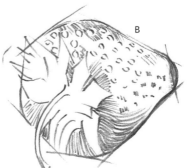

B

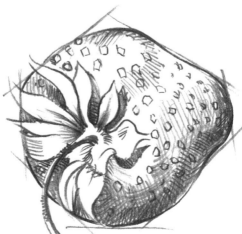

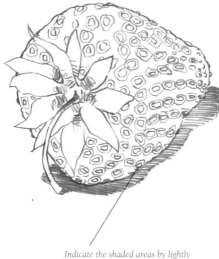

Indicate the shaded areas by lightly drawing circles around the seeds as guides.

PINEAPPLE

Like the strawberry, a prickly pineapple has an involved surface pattern. The pineapple below was done on plate-finish bristol board using an HB pencil for the main layout and light shading as well as a 2B for darker areas.

Practice drawing other fruits and vegetables you have at home, focusing on the varied textures and patterns of their seeds, pulp, and skins.

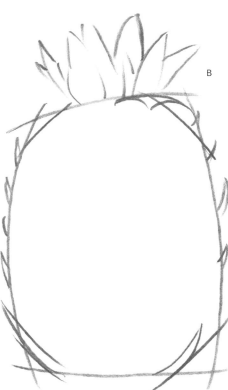

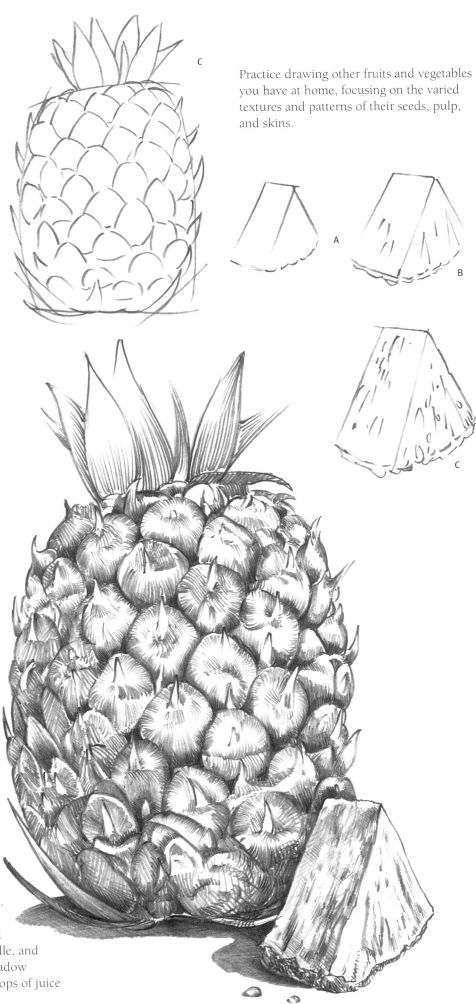

Sketch the primary shape in step A, and add block-in lines for the pineapple's surface pattern in steps B and C. Use a sharp 2B to draw subtle texture lines at various angles on each pineapple "section," using the stroke and lift technique; begin at the edge, stroke toward the middle, and lift the pencil at the end of the stroke. Shade the cast shadow smoother and darker than the fruit surfaces, and add drops of juice for an appealing effect.

DEVELOPING FORM

Values tell us even more about a form than its outline. *Values* are the lights, the darks, and all the shades in between that make up an object. In pencil drawing, the values range from white to grays to black, and it's the range of values in shading and highlighting that gives a three-dimensional look to a two-dimensional drawing. Focus on building dimension in your drawings by modeling forms with lights and darks.

Sketching the Shapes
First lightly sketch the basic shape of this angular wedge of cheese.

Laying in Values Here the light is coming from the left, so the cast shadows fall to the right. Lightly shade in the middle values on the side of the cheese, and place the darkest values in holes where the light doesn't hit.

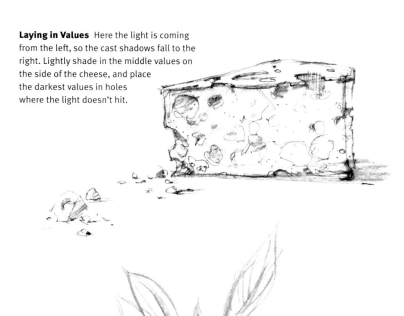

DRAWING CAST SHADOWS

Cast shadows are important in drawing for two reasons. First, they anchor the image, so it doesn't seem to be floating in air. Second, they add visual interest and help link objects together. When drawing a cast shadow, keep in mind that its shape will depend on the light source as well as the shape of the object casting it. For example, as shown below, a sphere casts a round or elliptical shadow on a smooth surface depending on the angle of the light source. The length of the shadow is also affected: the lower the light source, the longer the shadow.

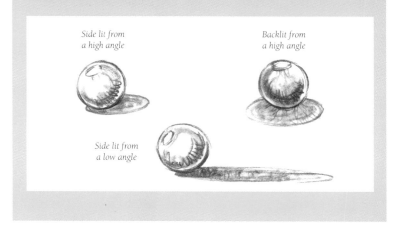

Side lit from a high angle

Backlit from a high angle

Side lit from a low angle

UNDERSTANDING LIGHT AND SHADOWS

To develop a three-dimensional form, you need to know where to place the light, dark, and medium values of your subject. This will all depend on your light source. The angle, distance, and intensity of the light will affect both the shadows on an object (called "form shadows") and the shadows the object throws on other surfaces (called "cast shadows"; see the box above). You might want to practice drawing form and cast shadows on a variety of round and angular objects, lighting them with a bright, direct lamp so the highlights and shadows will be strong and well-defined.

Highlighting
Either "save" the white of your paper for the brightest highlights or "retrieve" them by picking them out with an eraser or painting them on with white gouache.

Adding Shadows Look at a bunch of grapes as a group of spheres. You can place all the shadow areas of the grapes (form shadows) on the sides that are opposite the light source. Then you can also block in the shadows that the grapes throw on one another and on the surrounding surface (*cast shadows*).

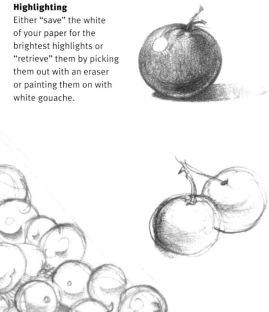

Shading Shade in the middle value of these grapes with a couple of swift strokes using the side of a soft lead pencil. Then increase the pressure on your pencil for the darkest values, and leave the paper white for the lights.

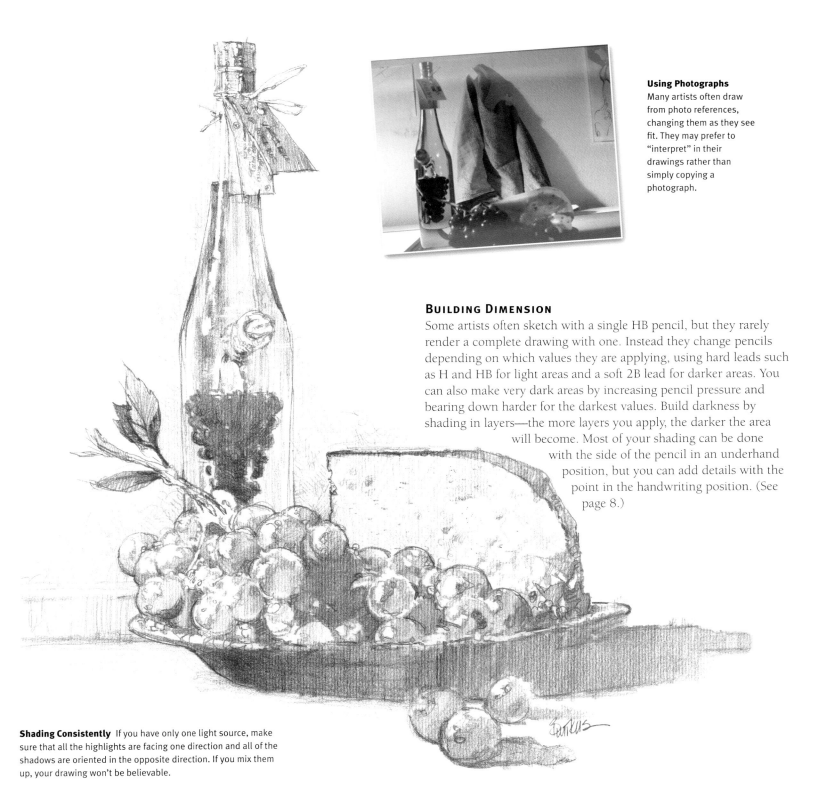

Using Photographs
Many artists often draw from photo references, changing them as they see fit. They may prefer to "interpret" in their drawings rather than simply copying a photograph.

BUILDING DIMENSION

Some artists often sketch with a single HB pencil, but they rarely render a complete drawing with one. Instead they change pencils depending on which values they are applying, using hard leads such as H and HB for light areas and a soft 2B lead for darker areas. You can also make very dark areas by increasing pencil pressure and bearing down harder for the darkest values. Build darkness by shading in layers—the more layers you apply, the darker the area will become. Most of your shading can be done with the side of the pencil in an underhand position, but you can add details with the point in the handwriting position. (See page 8.)

Shading Consistently If you have only one light source, make sure that all the highlights are facing one direction and all of the shadows are oriented in the opposite direction. If you mix them up, your drawing won't be believable.

Getting to Know Your Subject Quick, "thumbnail" sketches are invaluable for developing a drawing. You can use them to play with the positioning, format, and cropping until you find an arrangement you like. These aren't finished drawings by any means, so you can keep them rough. And don't get too attached to them—they're meant to be changed.

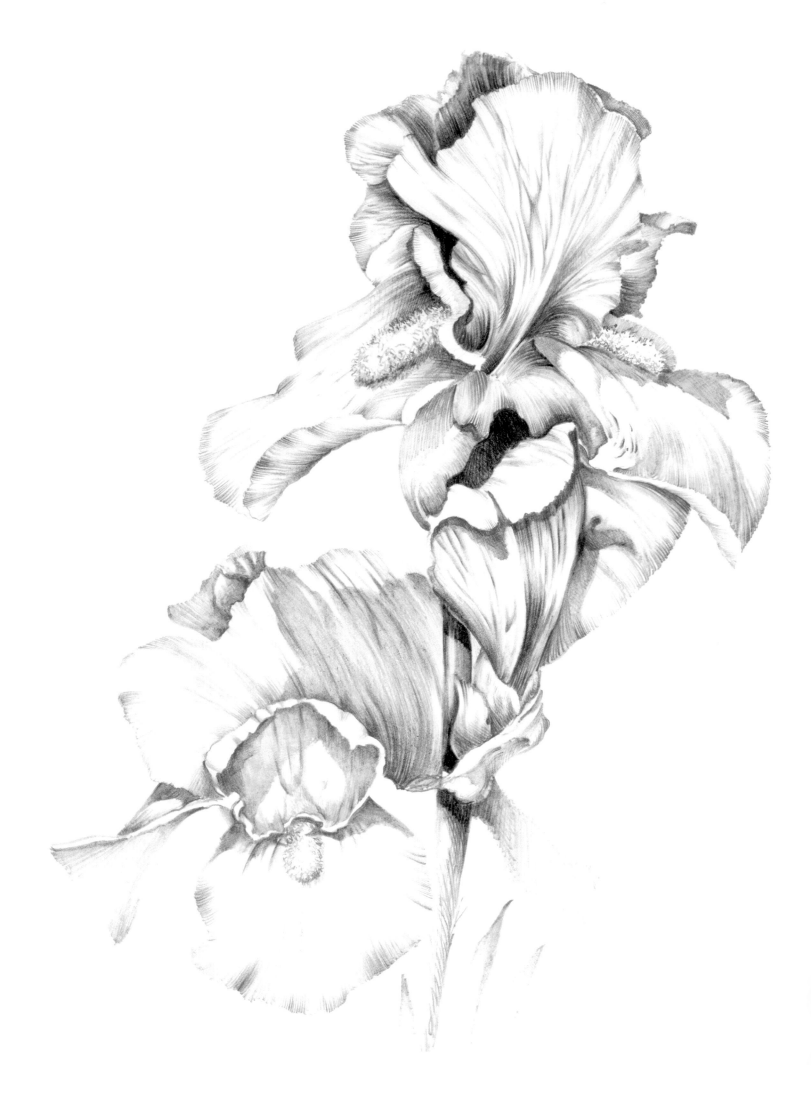

FLOWERS

MASTERING FLOWERS

There is something almost magical about a beautifully drawn flower, particularly one rendered in pencil. The absence of color makes you really look at the delicate forms and lovely nuances of value, just as a black-and-white photo allows you to focus on the subject and ignore extraneous details. When drawing flowers, as with any subject, take it one step at a time: blocking in the overall shape, refining the lines, and then developing the form with shading.

SHADING THE SUBJECT

My favorite technique for shading in flowers and leaves is *hatching*, which is essentially just a series of parallel lines. I draw them close together when I want a dark value and space them farther apart when I want a lighter look. Hatch marks drawn quickly and loosely have a lively effect, while controlled, evenly spaced marks are best for more formal arrangements and flowers with a lot of precise detail.

Producing Soft Shading
To create this softly shaded background, hold your pencil in the underhand position and make light vertical and horizontal strokes. Vary the pressure for soft light and dark areas, and build up the darks by layering. Then shade between the bird of paradise's spiky petals with the side of a sharp-pointed pencil. Finish with broad blending strokes using the side of a stump.

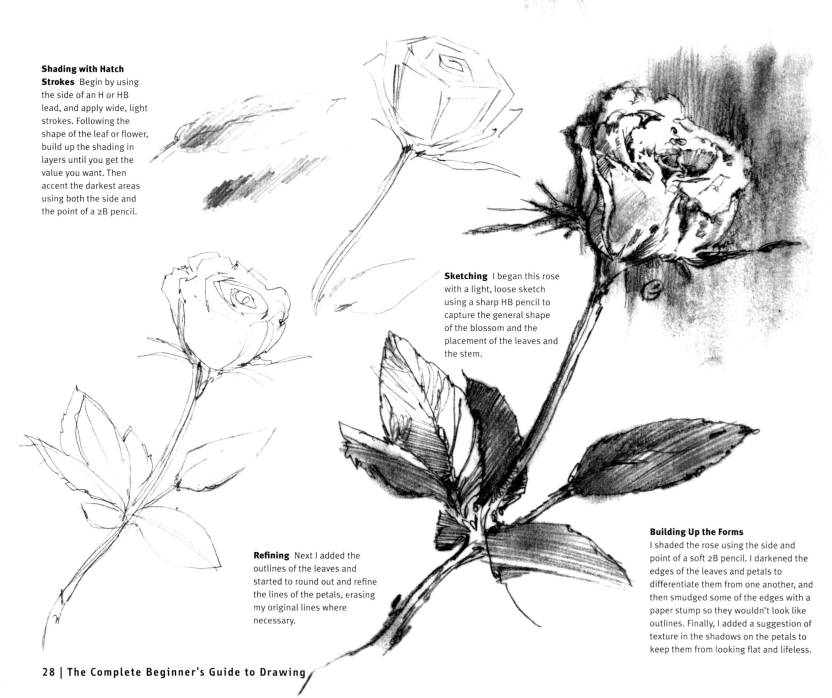

Shading with Hatch Strokes Begin by using the side of an H or HB lead, and apply wide, light strokes. Following the shape of the leaf or flower, build up the shading in layers until you get the value you want. Then accent the darkest areas using both the side and the point of a 2B pencil.

Sketching I began this rose with a light, loose sketch using a sharp HB pencil to capture the general shape of the blossom and the placement of the leaves and the stem.

Refining Next I added the outlines of the leaves and started to round out and refine the lines of the petals, erasing my original lines where necessary.

Building Up the Forms
I shaded the rose using the side and point of a soft 2B pencil. I darkened the edges of the leaves and petals to differentiate them from one another, and then smudged some of the edges with a paper stump so they wouldn't look like outlines. Finally, I added a suggestion of texture in the shadows on the petals to keep them from looking flat and lifeless.

VARYING LINE QUALITY

All edges are not created equal and should not be drawn that way unless you want a coloring-book look. I try to use a variety of lines to avoid giving my flower drawings an overly uniform, mechanical feel. I also either vary the pressure to make some lines thin and others thick, or I switch back and forth between hard and soft leads. Whatever flower subject you choose to draw, decide what feeling you want to convey, and use the pencil techniques to help you express yourself.

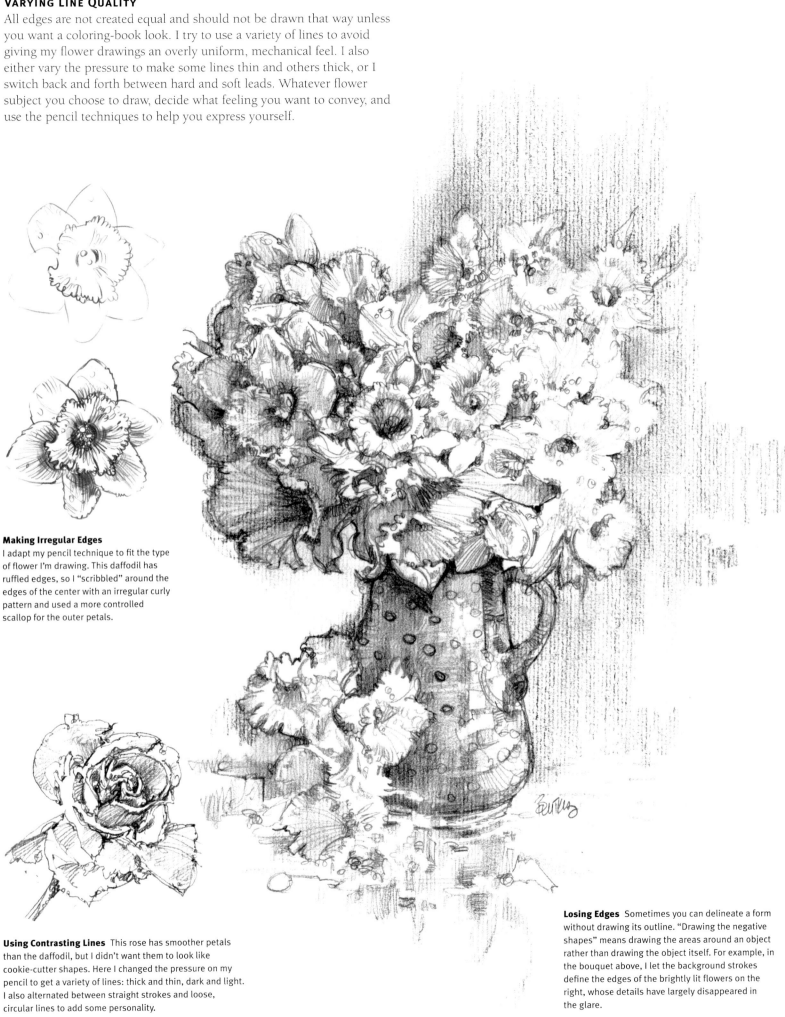

Making Irregular Edges
I adapt my pencil technique to fit the type of flower I'm drawing. This daffodil has ruffled edges, so I "scribbled" around the edges of the center with an irregular curly pattern and used a more controlled scallop for the outer petals.

Using Contrasting Lines This rose has smoother petals than the daffodil, but I didn't want them to look like cookie-cutter shapes. Here I changed the pressure on my pencil to get a variety of lines: thick and thin, dark and light. I also alternated between straight strokes and loose, circular lines to add some personality.

Losing Edges Sometimes you can delineate a form without drawing its outline. "Drawing the negative shapes" means drawing the areas around an object rather than drawing the object itself. For example, in the bouquet above, I let the background strokes define the edges of the brightly lit flowers on the right, whose details have largely disappeared in the glare.

BASIC FLOWER SHAPES

As you can see, even the most complicated flowers can be developed from simple shapes. Select a flower you wish to draw and study it closely, looking for its overall shape. Sketch the outline of this shape, and begin to look for other shapes within the flower. Block in the smaller shapes that make up details, such as petals or leaves. Once you've completed this, smooth out your lines, and begin the shading process.

Front View Angle View Side View

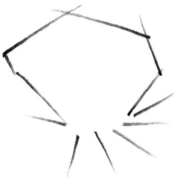

A. Sketch the basic shape.

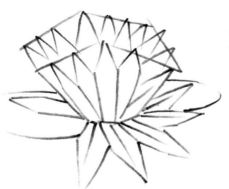

C. Add details.

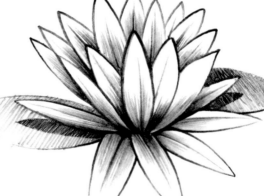

E. Create form by shading.

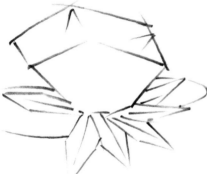

B. Block in smaller shapes.

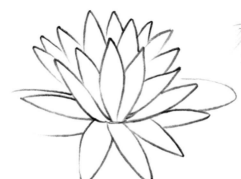

D. Clean up the lines.

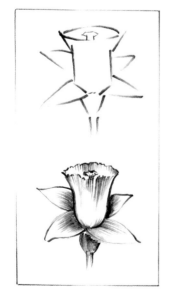

With an HB pencil, sketch the cuplike shape of the flower first; then place the petals and stem, as shown above. Begin developing the form with shading.

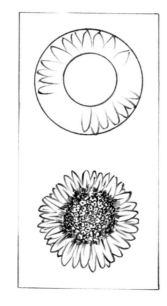

Circles enable you to draw round flowers. Set the size with a large circle, and place a smaller one inside. Using them as a guide, shade the details.

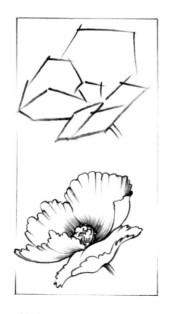

This three-quarter view may seem more difficult to draw, but you can still bring out its basic shapes if you study it carefully. Begin each petal with short lines drawn at the proper angles.

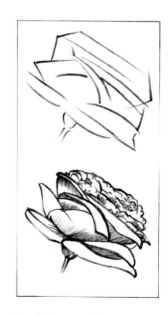

Drawing flowers with many overlapping petals is more involved but, once the basic shapes are sketched in, the details can easily be drawn.

Simple Flowers

This morning glory and gardenia are great flowers for learning a few simple shading techniques called "hatching" and "cross-hatching." Hatch strokes are parallel diagonal lines; place them close together for dark shadows, and space them farther apart for lighter values. Cross-hatch strokes are made by first drawing hatch strokes and then overlapping them with hatch strokes that are angled in the opposite direction. Examples of both strokes are shown in the box at the bottom of the page.

Step 1 Look carefully at the overall shape of a morning glory, and lightly sketch a polygon with the point of an HB pencil. From this three-quarter view, you can see the veins that radiate from the center, so sketch in five curved lines to place them. Then roughly outline the leaves and the flower base.

Morning Glory

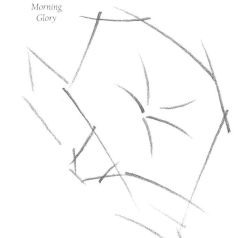

Step 2 Next draw the curved outlines of the flower and leaves, using the guidelines for placement. You can also change the pressure of the pencil on the paper to vary the line width, giving it a little personality. Then add the stamens in the center.

Step 3 Now you are ready to add the shading. With the rounded point and side of an HB pencil, add a series of hatching strokes, following the shape, curve, and direction of the surfaces of the flower and leaves. For the areas more in shadow, make darker strokes placed closer together using the point of a soft 2B pencil.

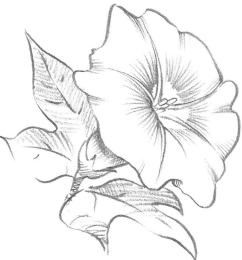

Step 1 The gardenia is a little more complicated to draw than the morning glory, but you can still start the same way. With straight lines, block in an irregular polygon for the overall flower shape, and add partial triangles for leaves. Then determine the basic shape of each petal and begin sketching in each, starting at the center of the gardenia.

Gardenia

Step 2 As you draw each of the petal shapes, pay particular attention to where they overlap and to their proportions, or their size relationships—how big each is compared with the others and compared with the flower as a whole? Accurately reproducing the pattern of the petals is one of the most important elements of drawing a flower. Once all the shapes are laid in, refine their outlines.

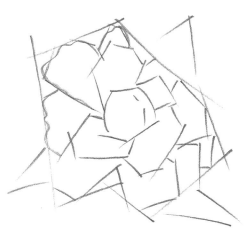

Step 3 Again, using the side and blunt point of an HB pencil, shade the petals and the leaves, making your strokes follow the direction of the curves. Lift the pencil at the end of each petal stroke so the line tapers and lightens, and deepen the shadows with overlapping strokes in the opposite direction (called "crosshatching") with the point of a 2B pencil.

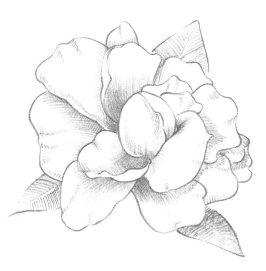

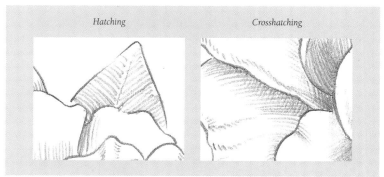

Hatching

Crosshatching

TULIPS

There are several classes of tulips with differently shaped flowers. The one below, known as a parrot tulip, has less of a cup than the tulip to the right and is more complex to draw. Use the layout steps shown here before drawing the details.

Look for the rhythm of line in this next tulip. It begins with the three simple lines in step A, which set its basic direction. Step B demonstrates how to add lines to build the general flower shape. Step C adds more to the shape and begins to show the graceful pose of the flower. Step D shows more detail and leads to shading, which gives the flower its form.

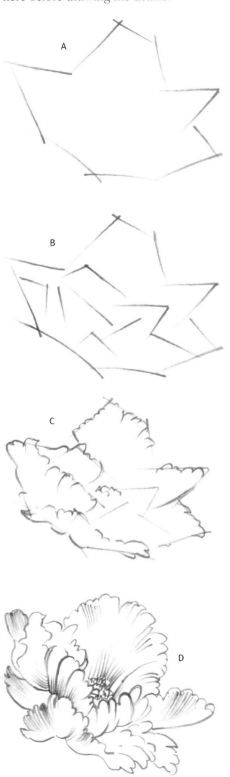

A

B

C

D

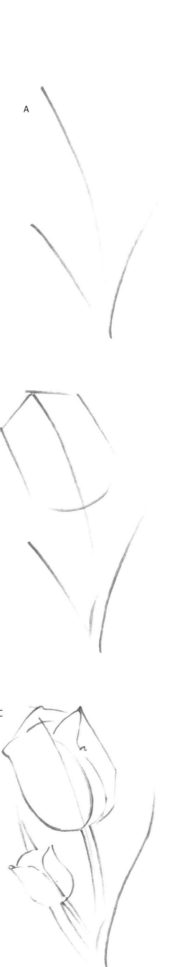

A

B

C

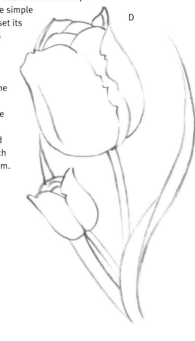

D

Just a few shading strokes here enhance the effect of overlapping petals.

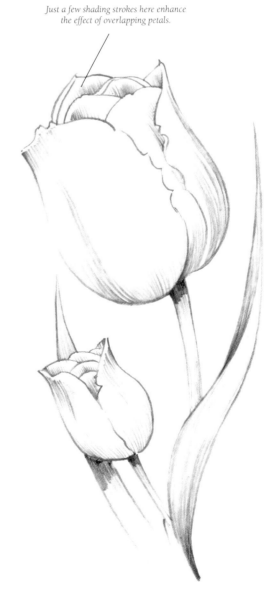

For the tulip above, begin step A using straight lines from point to point to capture the major shape of the flower. Add petal angles in step B. Draw in actual petal shapes in step C, and complete with simple shading in step D.

ROSE & WATER DROPS

Many beginning artists believe a rose is too difficult to draw and therefore shy away from it. But like any other object, a rose can be developed step by step from its most basic shapes.

In step A, use an HB pencil to block in the overall shapes of the rose and petal, using a series of angular lines. Make all guidelines light so you won't have trouble removing or covering them later.

In steps B and C, continue adding guidelines for the flower's interior, following the angles of the petal edges.

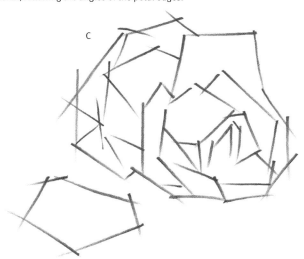

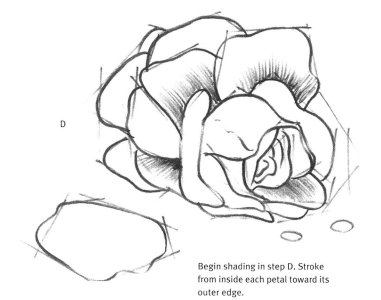

Begin shading in step D. Stroke from inside each petal toward its outer edge.

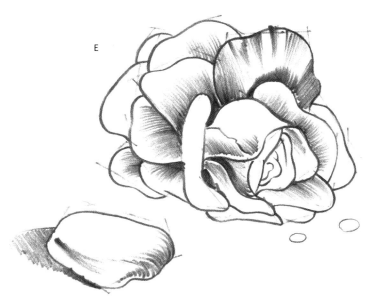

In step E, shade from the outer edge of each petal, meeting the strokes you drew in the opposite direction. Use what is known as a *stroke-and-lift technique*. For this technique, you should draw lines that gently fade at the end. Just press firmly, lifting the pencil as the stroke comes to an end.

Make the cast shadow the darkest area of your drawing.

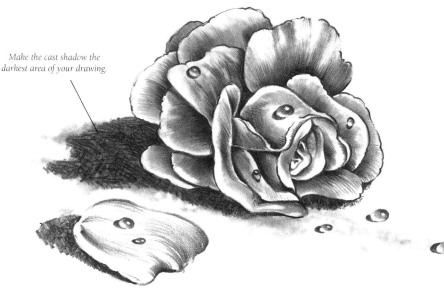

Daffodil

The flower shown here is a trumpet daffodil, of which there are large- and small-cupped varieties. The hornlike opening of this flower enhances its charm. Follow the steps closely in this exercise and you will end up with a perfect drawing. Begin step A by drawing the horn shape.

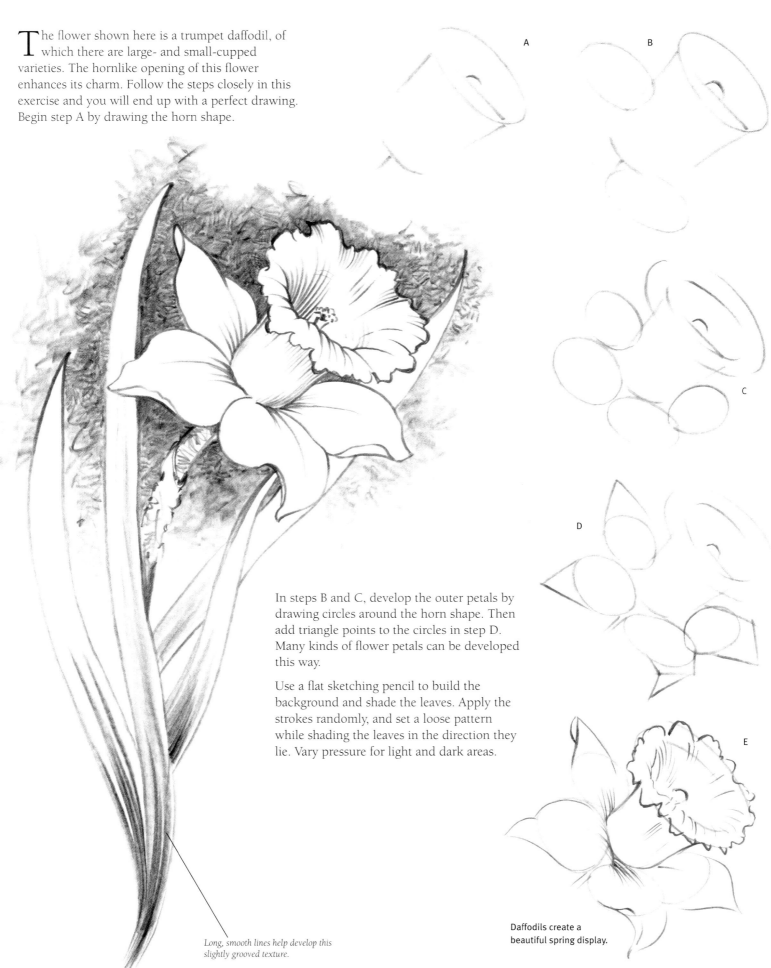

A

B

C

D

E

Long, smooth lines help develop this slightly grooved texture.

In steps B and C, develop the outer petals by drawing circles around the horn shape. Then add triangle points to the circles in step D. Many kinds of flower petals can be developed this way.

Use a flat sketching pencil to build the background and shade the leaves. Apply the strokes randomly, and set a loose pattern while shading the leaves in the direction they lie. Vary pressure for light and dark areas.

Daffodils create a beautiful spring display.

CARNATION

Carnation varieties range from deep red to bicolored to white. They are very showy and easy to grow in most gardens, and they are also fun and challenging to draw because of their many overlaying petals. Shade them solid, variegated, or with a light or dark edge at the end of each petal.

A dark background allows the flower to pop off the page.

Replicating Patterns and Shapes The front view above shows the complex pattern of this type of carnation. Step 1 places the basic shapes seen within the flower. From here, begin drawing the actual curved petal shapes. Once they are in place, shade the flower.

The crinkled petals evolve from drawing irregular edges and shading unevenly in random areas.

Establishing the Basic Shapes Develop the overall shape of the side view, including the stem and sepal. Begin drawing the intricate flower details in step 2, keeping them light and simple.

DENDROBIUM

The dendrobium is an orchid variety native to tropical climates. It has slender stems that can grow up to 2 feet long and 2 ½ to 3 ½ inches across. Colors range from blends of mauve, containing deeper colored veins, to maroon and pale purple.

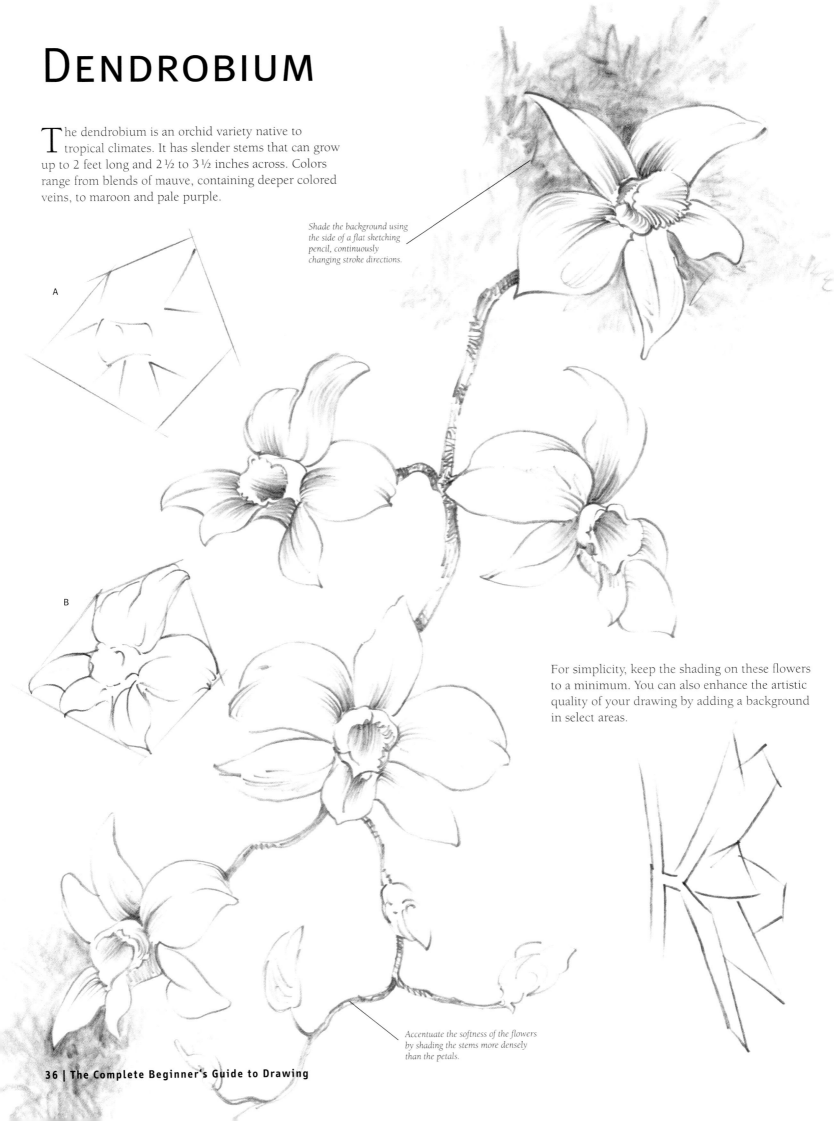

A

B

Shade the background using the side of a flat sketching pencil, continuously changing stroke directions.

For simplicity, keep the shading on these flowers to a minimum. You can also enhance the artistic quality of your drawing by adding a background in select areas.

Accentuate the softness of the flowers by shading the stems more densely than the petals.

FUCHSIA

Fuchsias present a beautiful color variety including greens, reds, and purples. This exercise should be drawn on vellum-finish (rough) bristol board to enhance the irregular texture of the flowers. Use the side of an HB pencil to lightly block in the basic shapes and build the details of the petal pattern.

Start light shading using the tip of an HB pencil, making sure to shade with the surface direction. Develop large shading areas using the side of the lead, and darken creases and lines using a sharpened 2B.

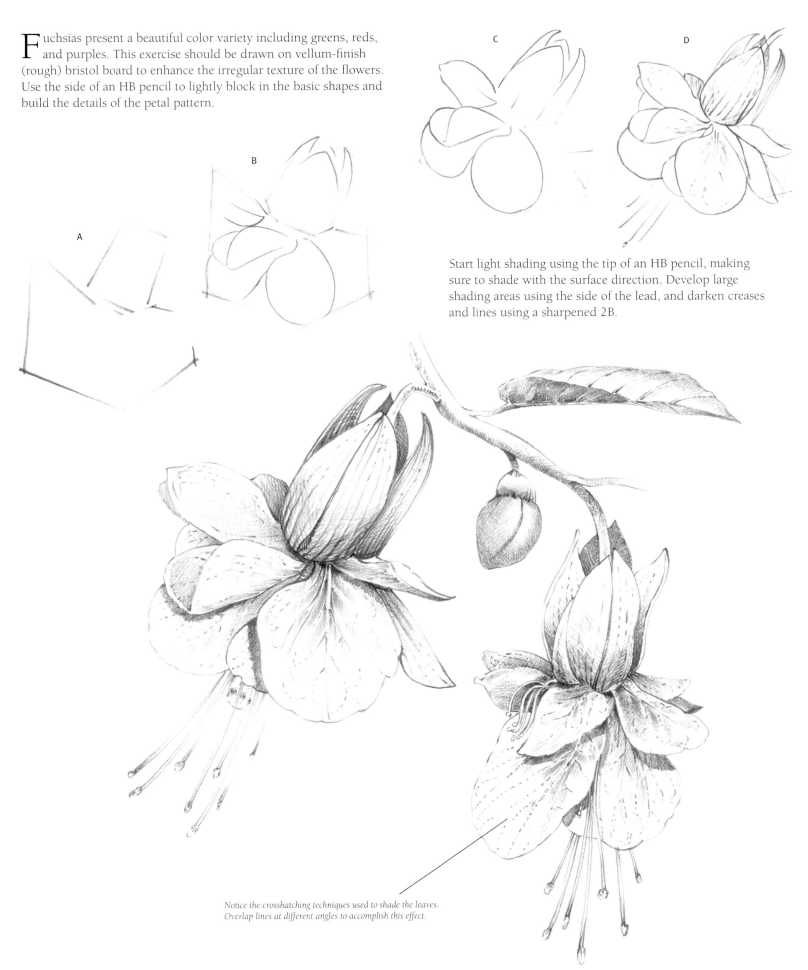

Notice the crosshatching techniques used to shade the leaves. Overlap lines at different angles to accomplish this effect.

PRIMROSE

There are many primrose varieties with a wide range of colors. This exercise demonstrates how to draw a number of flowers and buds together. Take your time when placing them.

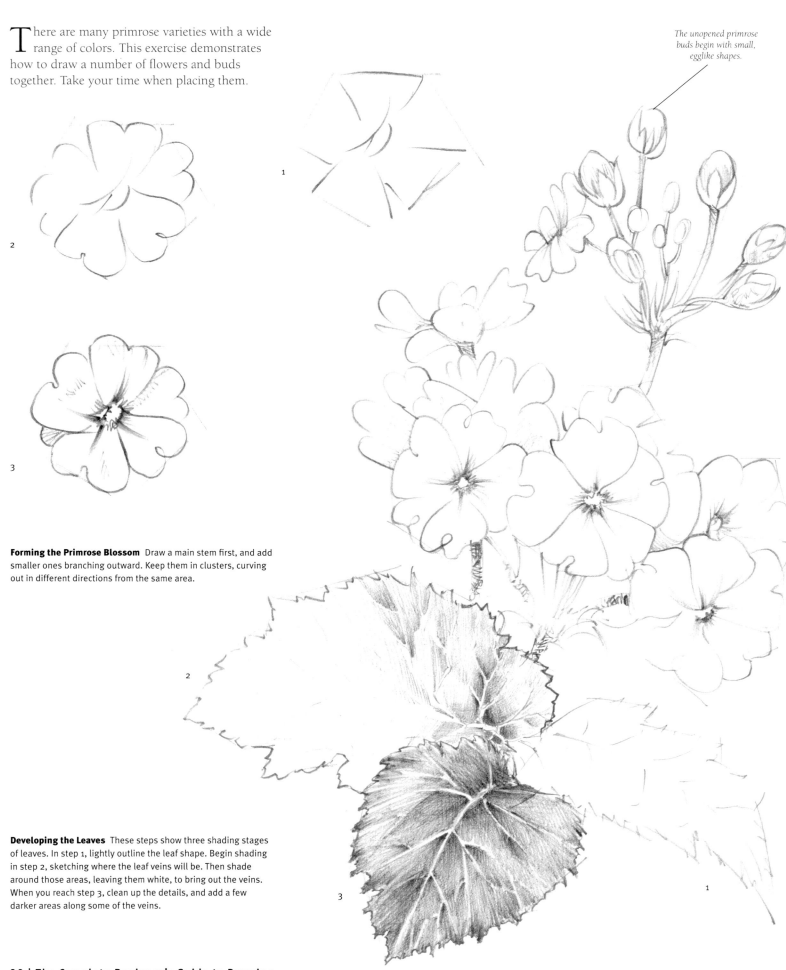

The unopened primrose buds begin with small, egglike shapes.

Forming the Primrose Blossom Draw a main stem first, and add smaller ones branching outward. Keep them in clusters, curving out in different directions from the same area.

Developing the Leaves These steps show three shading stages of leaves. In step 1, lightly outline the leaf shape. Begin shading in step 2, sketching where the leaf veins will be. Then shade around those areas, leaving them white, to bring out the veins. When you reach step 3, clean up the details, and add a few darker areas along some of the veins.

HIBISCUS

Hibiscus grow in single- and double-flowered varieties. Their colors include whites, oranges, pinks, and reds—even blues and purples. Some are multi- or bicolored. The example here is a single-flowered variety.

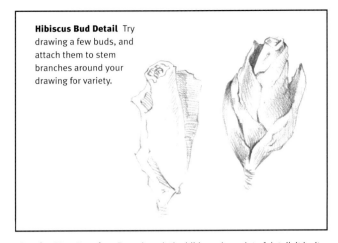

Hibiscus Bud Detail Try drawing a few buds, and attach them to stem branches around your drawing for variety.

Planning Your Drawing Even though the hibiscus has a lot of detail, it isn't difficult to draw. Steps leading up to the finished drawing must be followed closely to get the most out of this exercise. Step 1 shows the overall mass, petal direction, and basic center of the flower. Consider the size of each flower part in relation to the whole before attempting to draw it.

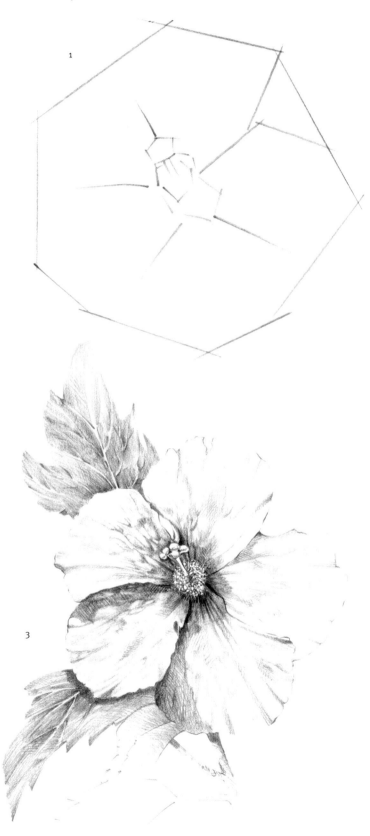

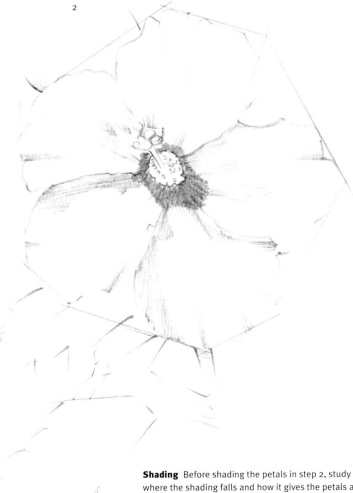

Shading Before shading the petals in step 2, study where the shading falls and how it gives the petals a slightly rippled effect. Add the details of the flower center, and block in the stem and leaves.

HYBRID TEA ROSE

Hybrid tea roses have large blossoms with greatly varying colors. When drawing rose petals, think of each fitting into its own place in the overall shape; this helps position them correctly. Begin lightly with an HB pencil, and use plate-finish Bristol board.

Making Choices The block-in steps are the same no matter how you decide to finish the drawing, whether lightly outlined or completely shaded. For shading, use the side of a 2B pencil and blend with a paper stump.

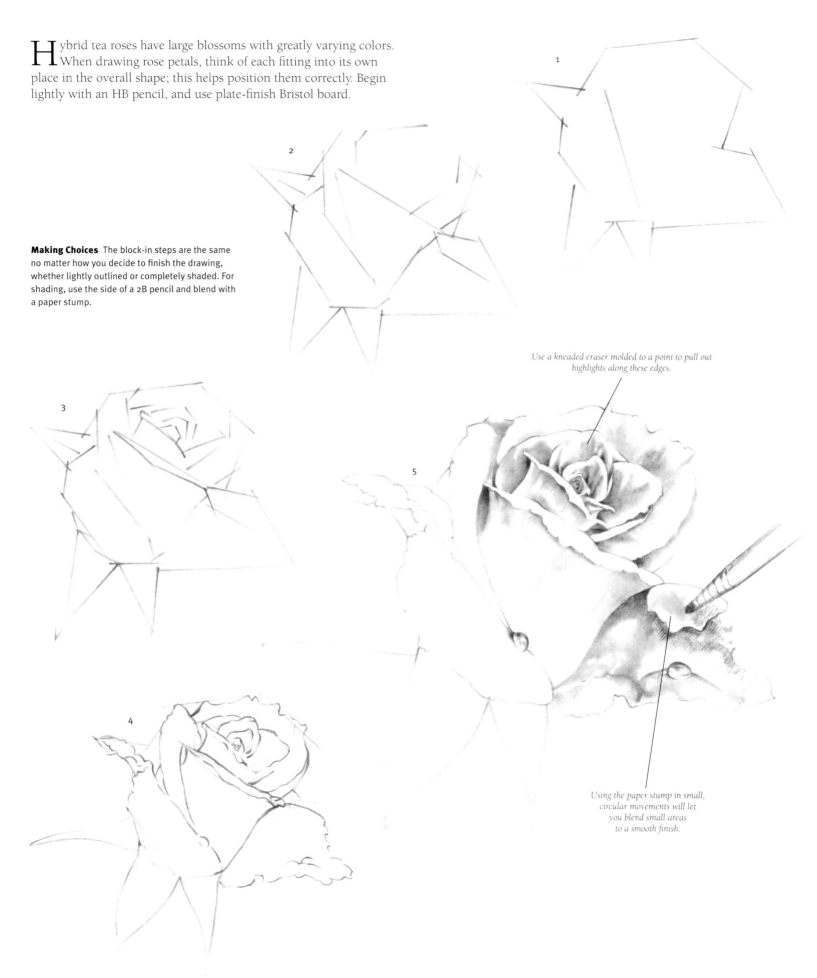

Use a kneaded eraser molded to a point to pull out highlights along these edges.

Using the paper stump in small, circular movements will let you blend small areas to a smooth finish.

FLORIBUNDA ROSE

Floribunda roses usually flower more freely than hybrid tea roses and grow in groups of blossoms. The petal arrangement in these roses is involved; but by studying it closely, you'll see an overlapping, swirling pattern.

Drawing the Rose Use a blunt-pointed HB pencil lightly on plate-finish Bristol board. Outline the overall area of the rose mass in step 1. Once this is done, draw the swirling petal design as shown in steps 2 and 3. Begin fitting the center petals into place in step 4. Use the side of an HB to shade as in step 5, taking care not to cover the water drops. They should be shaded separately.

1

3

4

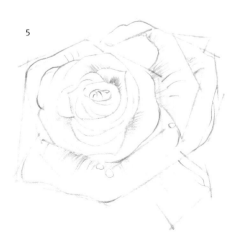
5

2

6
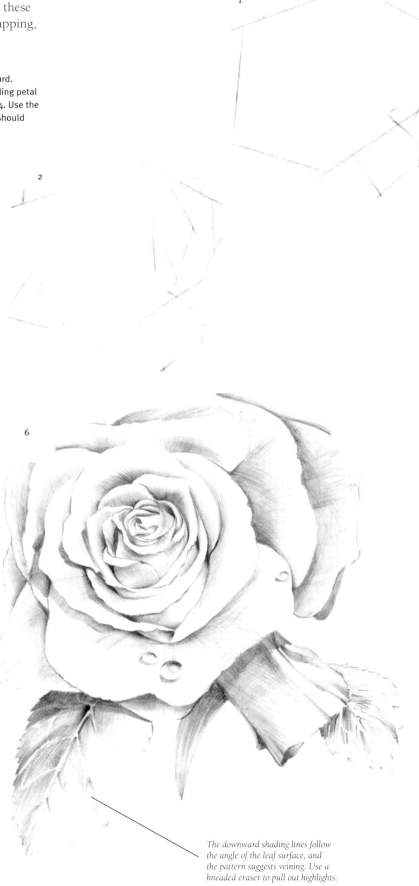

The downward shading lines follow the angle of the leaf surface, and the pattern suggests veining. Use a kneaded eraser to pull out highlights.

BEARDED IRIS

The bearded iris is one of the most beautiful of the iris varieties. Its colors range from deep purples to blues, lavenders, and whites. Some flowers have delicate, lightly colored petals with dark veining. They range in height from less than 1 foot to over 3 feet.

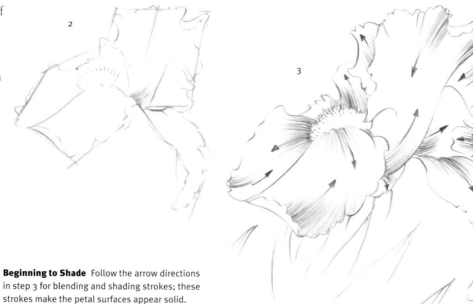

Beginning to Shade Follow the arrow directions in step 3 for blending and shading strokes; these strokes make the petal surfaces appear solid. Darken shadowed areas using the point of a 2B.

Using Guidelines Step 1 (above) shows the block-in lines for a side view of the iris, whereas step 1 (below) shows a frontal view. Whichever you choose to draw, make your initial outline shapes light, and use them as a general guide for drawing the graceful curves of this flower's petals.

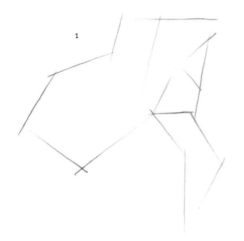

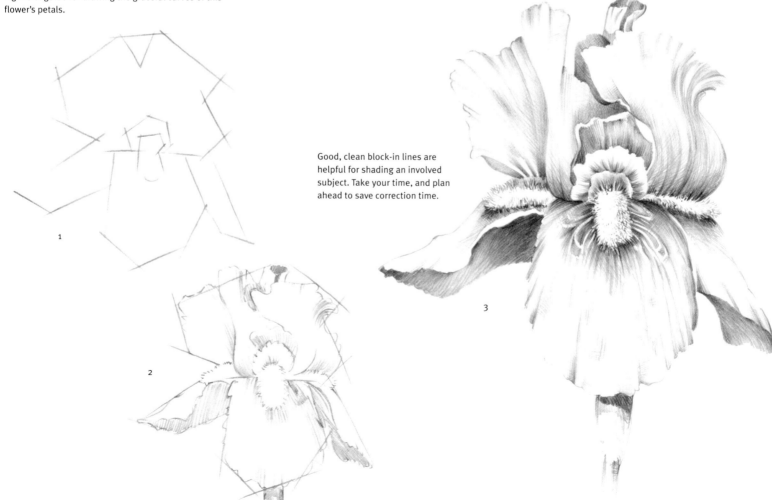

Good, clean block-in lines are helpful for shading an involved subject. Take your time, and plan ahead to save correction time.

Focusing on Details This final drawing is quite involved, but it's no more difficult than the previous drawings; it just has more flowers and shading steps. Once again, we must first draw the overall layout of the flowers before attempting any shading.

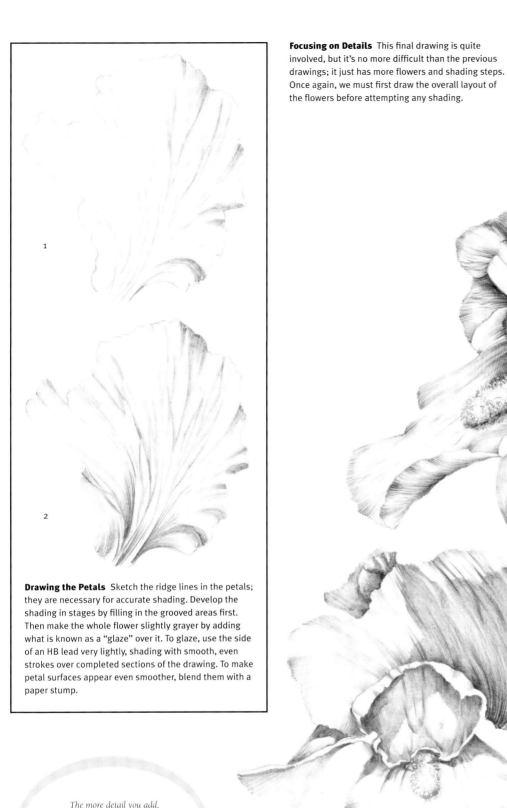

1

2

Drawing the Petals Sketch the ridge lines in the petals; they are necessary for accurate shading. Develop the shading in stages by filling in the grooved areas first. Then make the whole flower slightly grayer by adding what is known as a "glaze" over it. To glaze, use the side of an HB lead very lightly, shading with smooth, even strokes over completed sections of the drawing. To make petal surfaces appear even smoother, blend them with a paper stump.

The more detail you add, the more time a drawing will take. Don't become discouraged. If you get tired, simply put the drawing aside and take a break!

Dark shading under the petals makes them "fold" outward toward you and creates a thin shadow.

Adding Shading and Highlights This drawing was done on a plate-finish Bristol board using HB, 2B, and flat sketching pencils. Create highlights by molding a kneaded eraser into a sharp wedge, "drawing" with it in the same direction as the shading.

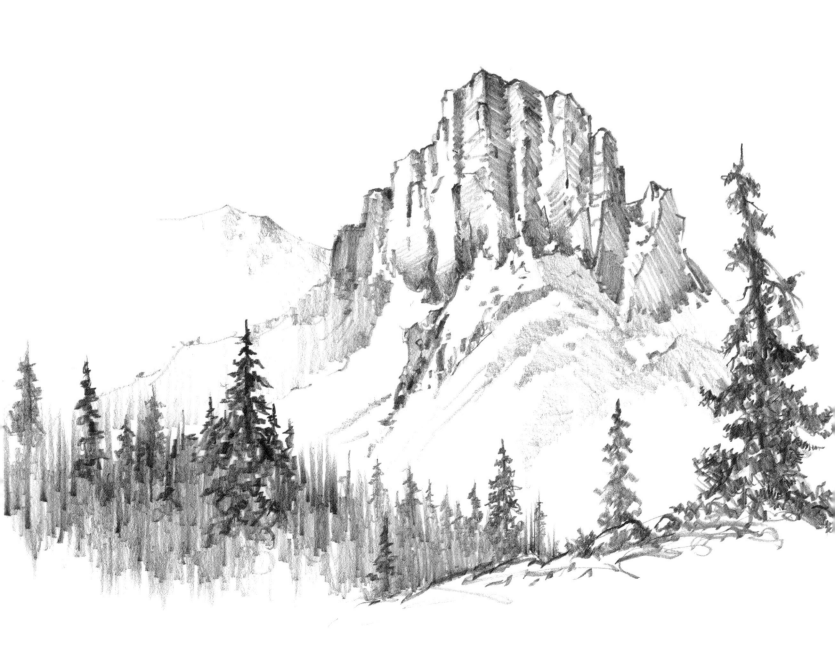

LANDSCAPES

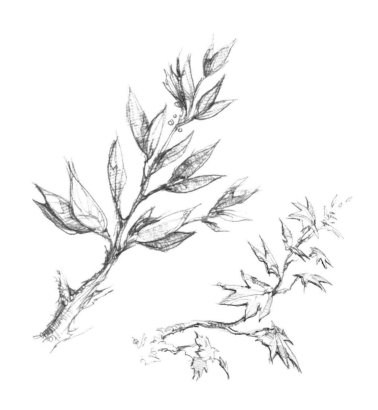

STUDYING TREES

You probably drew your first tree before you were in kindergarten, and if your tree drawings still resemble circles on sticks, there is help. Again, it's all about observation. Study a wide variety of tree species, and look for the characteristics that distinguish one from another. Then apply some of the pencil techniques on these pages to make your drawings come to life.

SIMPLIFYING TREE SHAPES

I wouldn't tackle drawing a tree if I had to do it branch by branch and leaf by leaf. There's a simpler and less frustrating way. Start with a rough, generalized shape that follows the tree's overall outline, and then refine that shape. Look for clumps of branches and bunches of foliage, drawing them as masses. Fill them in with broad strokes with the side of your pencil and doodling patterns. Leave holes for the sky—very few trees are so dense that you can't get a peak at what's behind them!

Changing Pencils This leafless tree made a wonderful study for drawing branches. I used the side of a soft 2B lead for the trunk and large branches, and then switched to an HB and an H for the fine, tapered upper branches and twigs.

Beginning with Branches
Before you attempt to draw an entire tree, I suggest you start out by drawing individual tree branches—they look rather like simplified trees. Here I drew the central branch first, making sure the lower part of all branches were wider than the upper, tapering ends (just like a tree trunk).

Sketching Leaves
I often make quick sketches of branches from different trees to study the various leaf shapes. I concentrate on the outline of the leaves, the pattern of their veins, and the way they attach to the branch.

Artist's Tip
Take a sketchbook out in the field, and sketch as many different trees as you can find. Then you'll have a sourcebook to refer to whenever you need an example to follow.

PENCIL TECHNIQUES FOR TREES

Palm Tree Sketch the overall polygon shape with an HB pencil. Using a 2B with a chisel tip, stroke each frond from the center out, lifting the pencil at the end of each stroke.

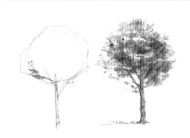

Maple Tree After sketching the circular outline with an HB pencil, use the side of the lead for the mass of foliage, applying more pressure for the dark values. Use the sharp point to add a few details.

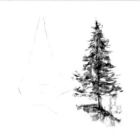

Pine Tree Sketch the triangular outline with an HB. Then use a 2B with a round point to draw the branches with short, horizontal strokes. Go back in with a sharp HB for a few foliage details.

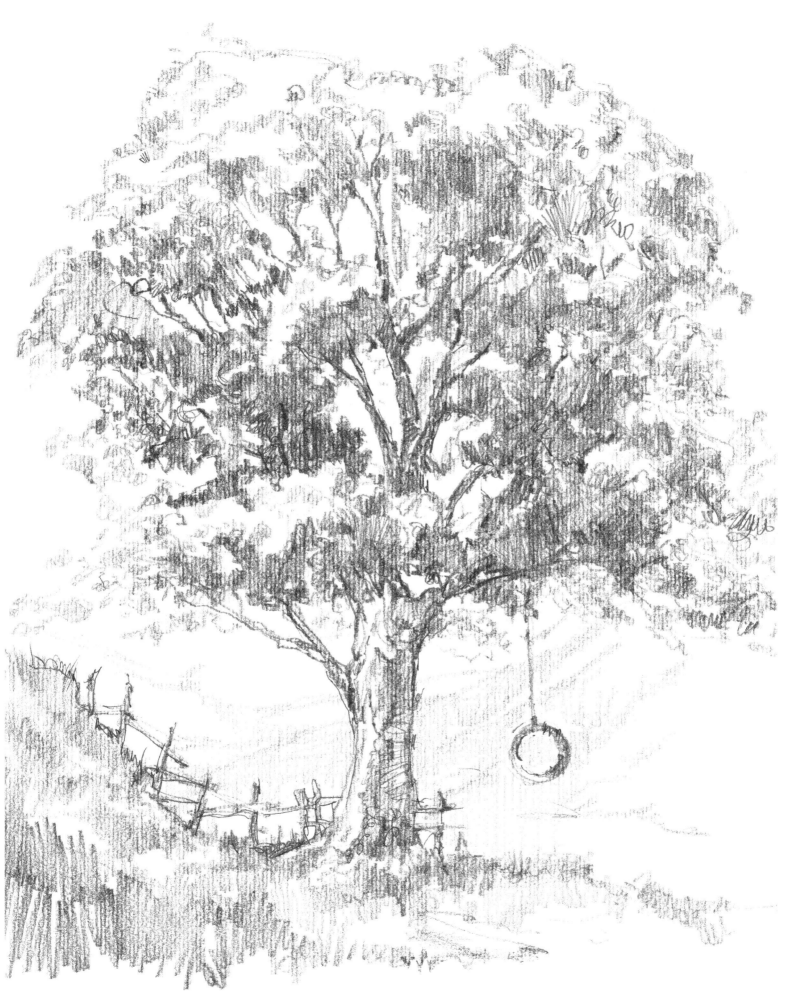

Varying Strokes For this sturdy tree, I chose a fine-ribbed paper and used a soft lead pencil. The grain of the paper adds a lot of interesting texture.

SURFACES & TEXTURES

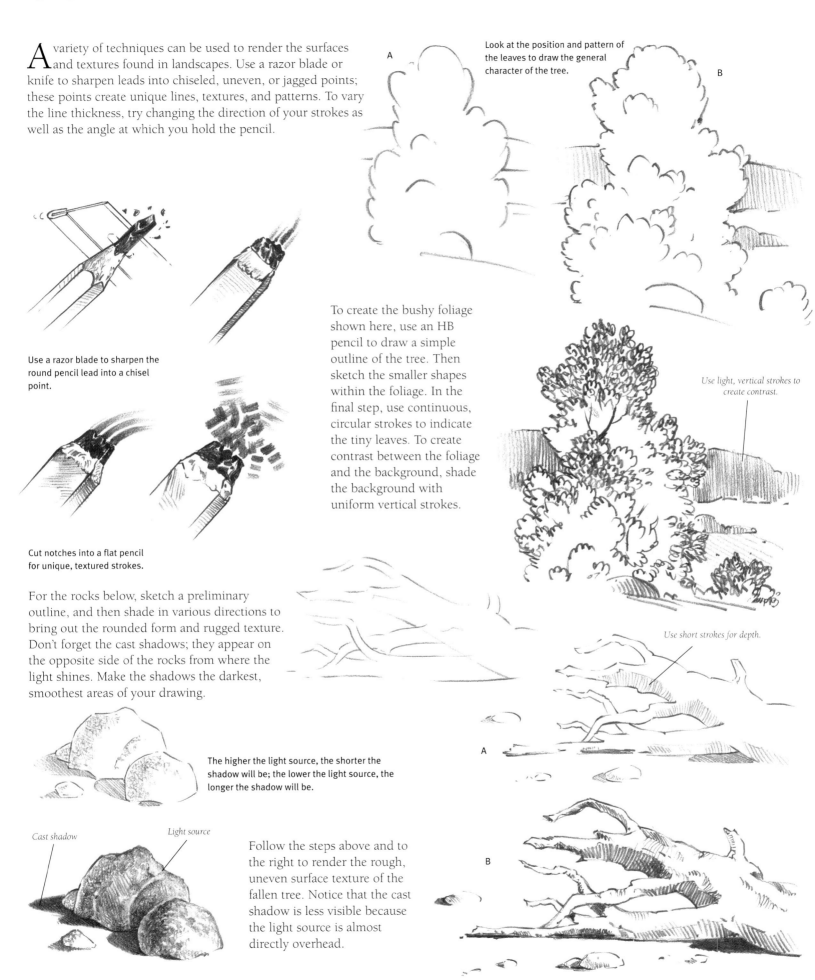

A variety of techniques can be used to render the surfaces and textures found in landscapes. Use a razor blade or knife to sharpen leads into chiseled, uneven, or jagged points; these points create unique lines, textures, and patterns. To vary the line thickness, try changing the direction of your strokes as well as the angle at which you hold the pencil.

A

Look at the position and pattern of the leaves to draw the general character of the tree.

B

Use a razor blade to sharpen the round pencil lead into a chisel point.

To create the bushy foliage shown here, use an HB pencil to draw a simple outline of the tree. Then sketch the smaller shapes within the foliage. In the final step, use continuous, circular strokes to indicate the tiny leaves. To create contrast between the foliage and the background, shade the background with uniform vertical strokes.

Use light, vertical strokes to create contrast.

Cut notches into a flat pencil for unique, textured strokes.

For the rocks below, sketch a preliminary outline, and then shade in various directions to bring out the rounded form and rugged texture. Don't forget the cast shadows; they appear on the opposite side of the rocks from where the light shines. Make the shadows the darkest, smoothest areas of your drawing.

Use short strokes for depth.

A

The higher the light source, the shorter the shadow will be; the lower the light source, the longer the shadow will be.

Cast shadow

Light source

B

Follow the steps above and to the right to render the rough, uneven surface texture of the fallen tree. Notice that the cast shadow is less visible because the light source is almost directly overhead.

TREES IN PERSPECTIVE

The technique used to represent depth or three-dimensional objects on a flat surface is based on the principle of *perspective*. The rules of perspective are guides for keeping objects in proper proportion to one another in a composition. The following exercises demonstrate the principles of one- and two-point perspective. For further information, refer to Walter Foster's *Perspective* (AL13) in the Artist's Library series.

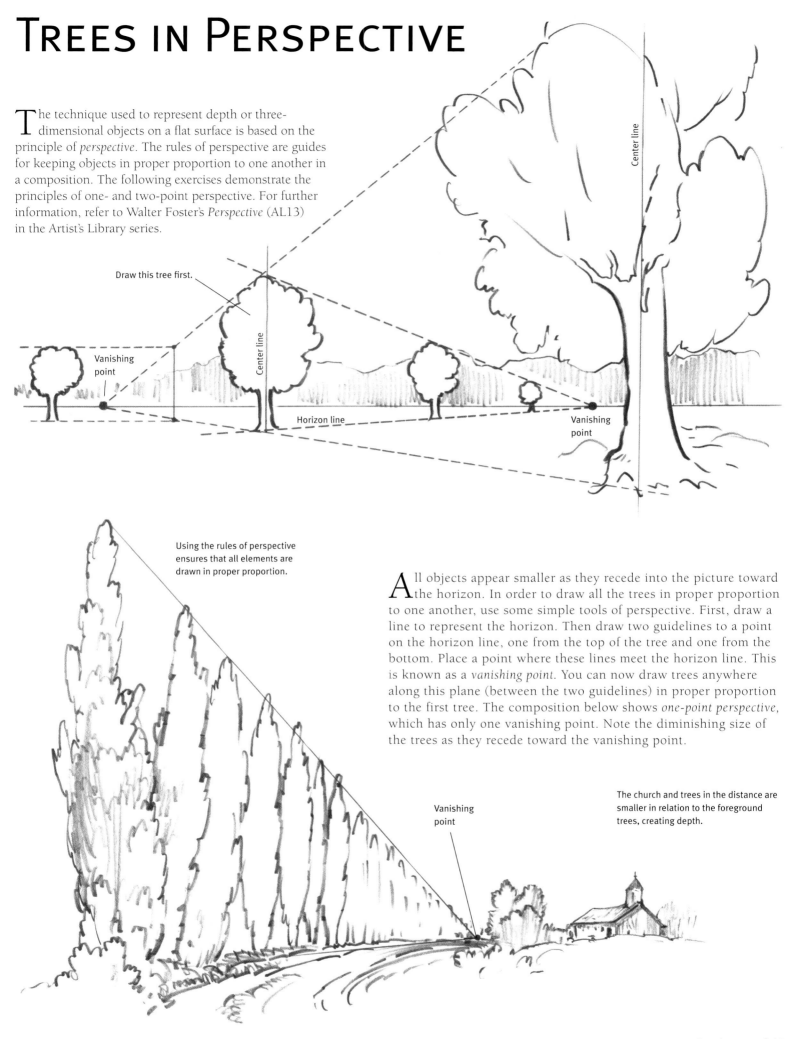

Draw this tree first.

Center line

Vanishing point

Center line

Horizon line

Vanishing point

Using the rules of perspective ensures that all elements are drawn in proper proportion.

All objects appear smaller as they recede into the picture toward the horizon. In order to draw all the trees in proper proportion to one another, use some simple tools of perspective. First, draw a line to represent the horizon. Then draw two guidelines to a point on the horizon line, one from the top of the tree and one from the bottom. Place a point where these lines meet the horizon line. This is known as a *vanishing point*. You can now draw trees anywhere along this plane (between the two guidelines) in proper proportion to the first tree. The composition below shows *one-point perspective*, which has only one vanishing point. Note the diminishing size of the trees as they recede toward the vanishing point.

Vanishing point

The church and trees in the distance are smaller in relation to the foreground trees, creating depth.

BEGIN WITH SIMPLE SHAPES

As you draw trees either from this book or from the outdoors, first work out the basic shapes with simple line drawings. For example, this tree is loosely sketched with straight lines for the trunk and branches and with curved lines for large groups of leaves.

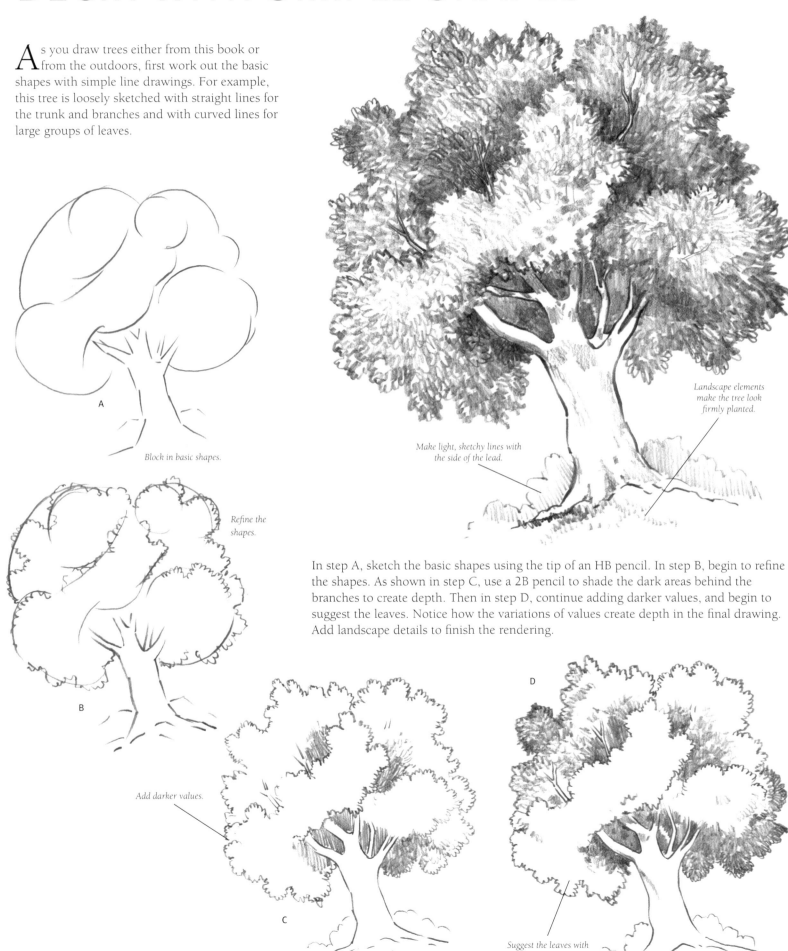

Block in basic shapes.

Refine the shapes.

Make light, sketchy lines with the side of the lead.

Landscape elements make the tree look firmly planted.

In step A, sketch the basic shapes using the tip of an HB pencil. In step B, begin to refine the shapes. As shown in step C, use a 2B pencil to shade the dark areas behind the branches to create depth. Then in step D, continue adding darker values, and begin to suggest the leaves. Notice how the variations of values create depth in the final drawing. Add landscape details to finish the rendering.

Add darker values.

Suggest the leaves with small, curved lines.

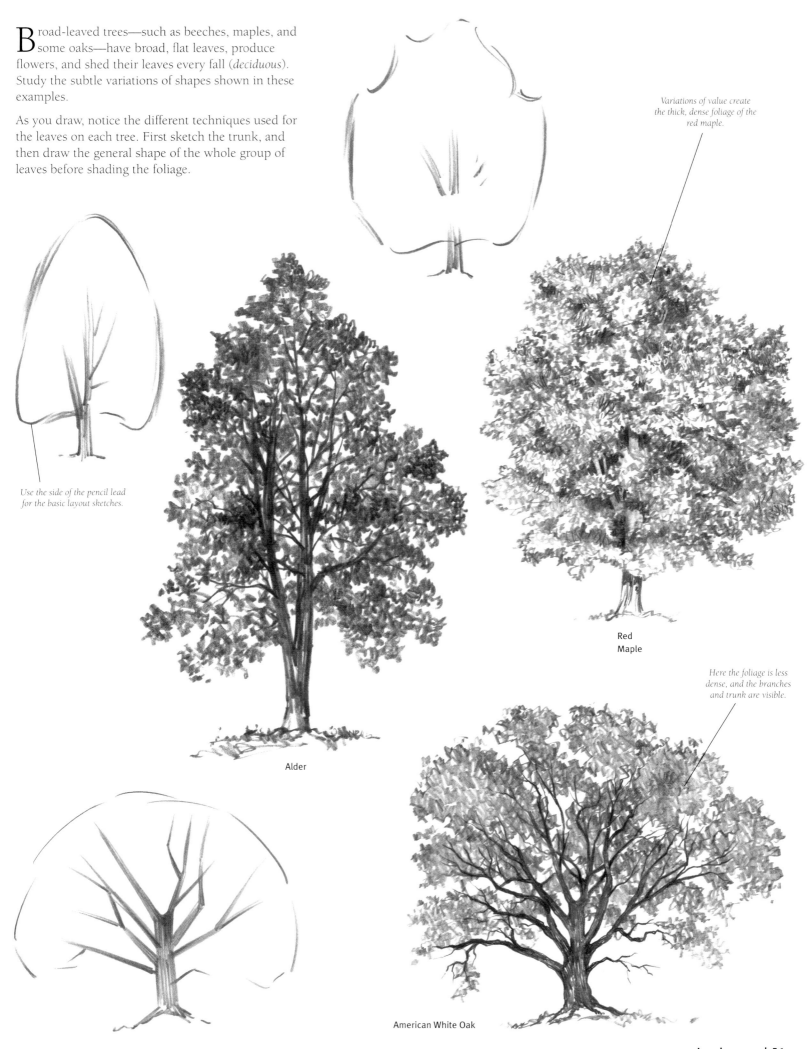

B road-leaved trees—such as beeches, maples, and some oaks—have broad, flat leaves, produce flowers, and shed their leaves every fall (*deciduous*). Study the subtle variations of shapes shown in these examples.

As you draw, notice the different techniques used for the leaves on each tree. First sketch the trunk, and then draw the general shape of the whole group of leaves before shading the foliage.

Variations of value create the thick, dense foliage of the red maple.

Use the side of the pencil lead for the basic layout sketches.

Alder

Red Maple

Here the foliage is less dense, and the branches and trunk are visible.

American White Oak

TREE TRUNKS

A tree trunk is basically a long, cylindrical shape. Likewise, the branches are longer cylinders that extend from the trunk. Draw light elliptical lines around the trunk at strategic points to indicate changes in the trunk's direction.

Use broken elliptical lines as guides for drawing the tree trunk and branches.

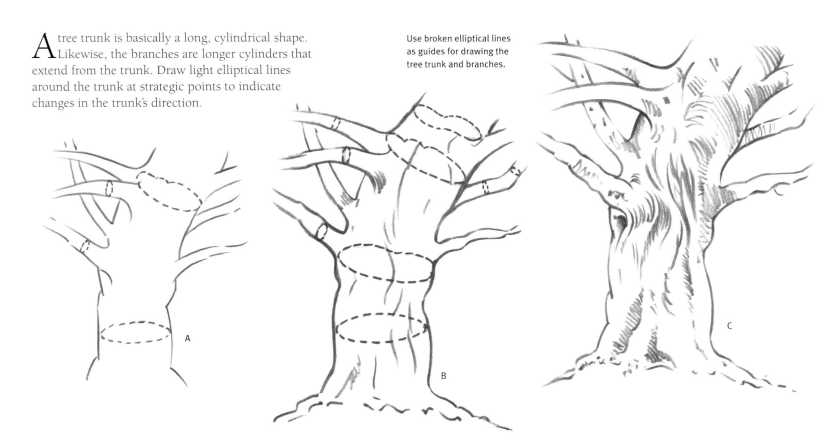

Practice drawing the trunks on this page. In step A, use an HB pencil to lightly draw the basic shape and ellipses. In step B, refine the trunk by adding more ellipses, and then draw some curved lines to indicate the surface changes. In step C, begin shading using the side of an HB pencil. Continue shading to create the grooves and knots. Use the blunt point of a 2B pencil to render the dark areas.

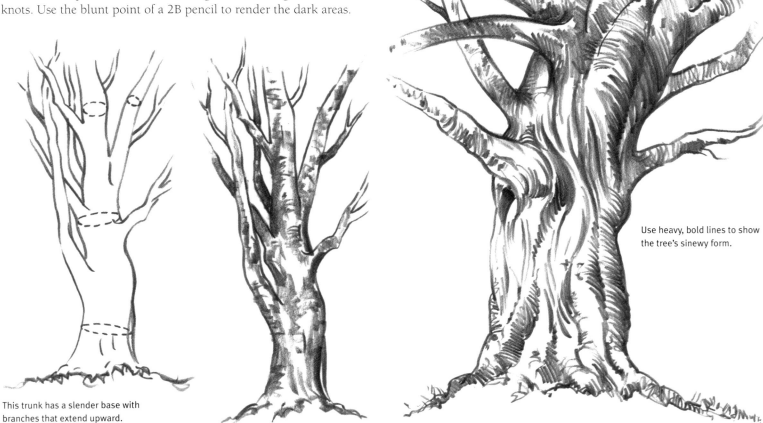

This trunk has a slender base with branches that extend upward.

Use heavy, bold lines to show the tree's sinewy form.

Root Patterns

Tree roots grow down and outward like a crisscrossing net to anchor the tree in the ground. The root patterns have twists and bumps, which make them interesting to draw. Of course, old trees have more intricate shapes than young ones, but all kinds of roots can be drawn from simple block-in lines. Study the root pattern shown, which is found on a mature tree.

Begin by lightly blocking in the shapes with an HB pencil in step A. Refine the shape of the roots in step B, and use small, curved lines to bring out the forms in step C. Vary the depth of the values by pressing hard for dark values and lightly for middle and lighter values. Continue to shade the tree with curved lines going up the root to where it becomes the trunk. Draw curved lines with the side and point of a 2B pencil to show the rounded form of the roots.

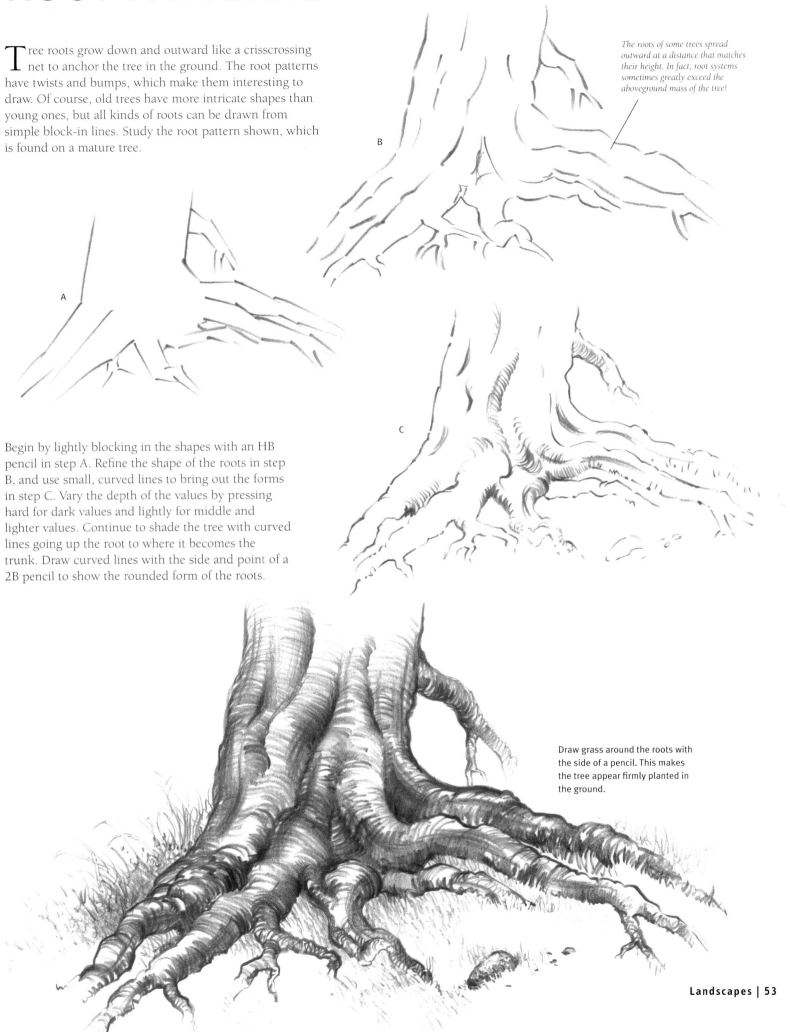

The roots of some trees spread outward at a distance that matches their height. In fact, root systems sometimes greatly exceed the aboveground mass of the tree!

Draw grass around the roots with the side of a pencil. This makes the tree appear firmly planted in the ground.

BRANCHES & BOUGHS

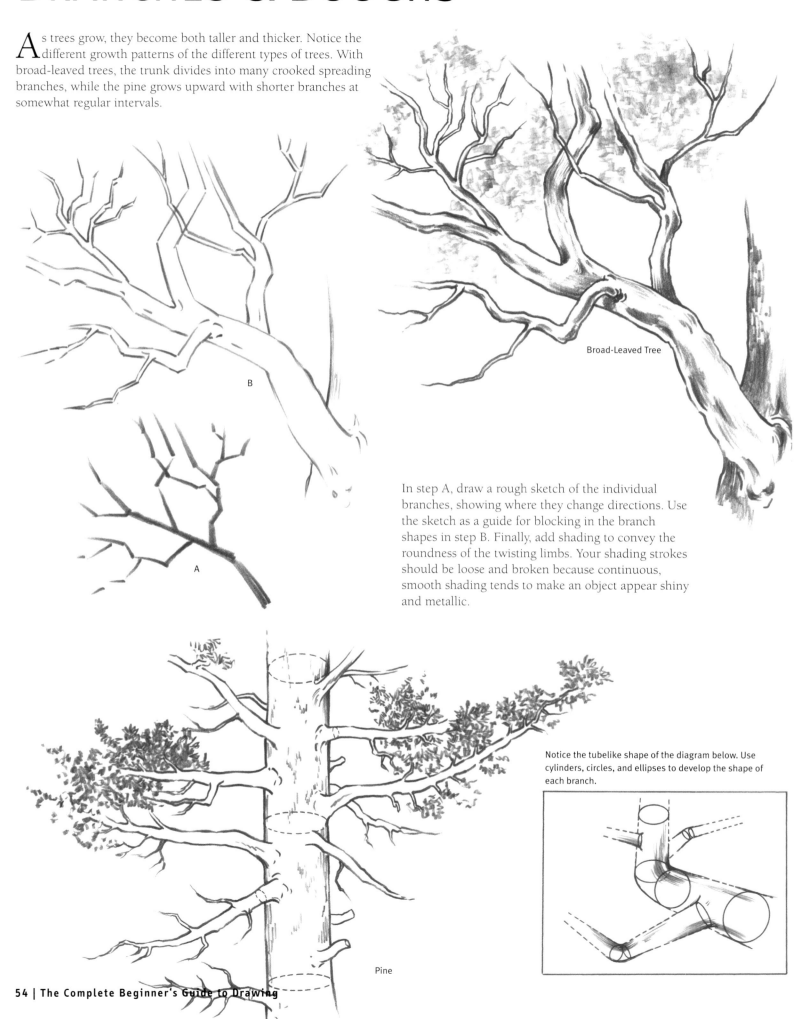

As trees grow, they become both taller and thicker. Notice the different growth patterns of the different types of trees. With broad-leaved trees, the trunk divides into many crooked spreading branches, while the pine grows upward with shorter branches at somewhat regular intervals.

B

A

Broad-Leaved Tree

In step A, draw a rough sketch of the individual branches, showing where they change directions. Use the sketch as a guide for blocking in the branch shapes in step B. Finally, add shading to convey the roundness of the twisting limbs. Your shading strokes should be loose and broken because continuous, smooth shading tends to make an object appear shiny and metallic.

Notice the tubelike shape of the diagram below. Use cylinders, circles, and ellipses to develop the shape of each branch.

Pine

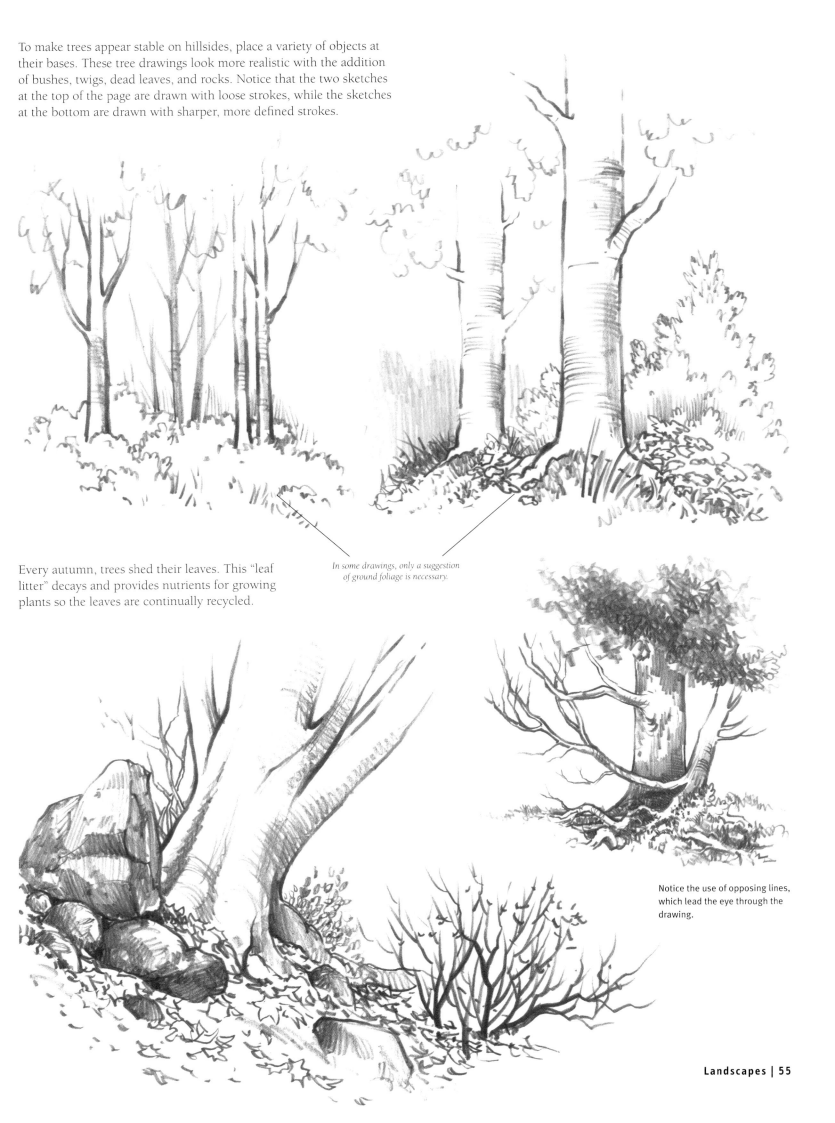

To make trees appear stable on hillsides, place a variety of objects at their bases. These tree drawings look more realistic with the addition of bushes, twigs, dead leaves, and rocks. Notice that the two sketches at the top of the page are drawn with loose strokes, while the sketches at the bottom are drawn with sharper, more defined strokes.

Every autumn, trees shed their leaves. This "leaf litter" decays and provides nutrients for growing plants so the leaves are continually recycled.

In some drawings, only a suggestion of ground foliage is necessary.

Notice the use of opposing lines, which lead the eye through the drawing.

MAJESTIC OAK

Tree drawings provide ample opportunities for practicing cast shadows. When drawing cast shadows, note these few observations: (1) a shadow follows the shape of the ground or area on which it is cast; (2) value changes can occur within the shadow; (3) surface textures and details may be discernible within the shadow; and (4) lighter areas may appear within a shadow cast by tree foliage.

For any accurate drawing, you need to be aware of the light source and render its effects. In this drawing, the sunlight shines through the gaps in the foliage and is projected onto the ground plane.

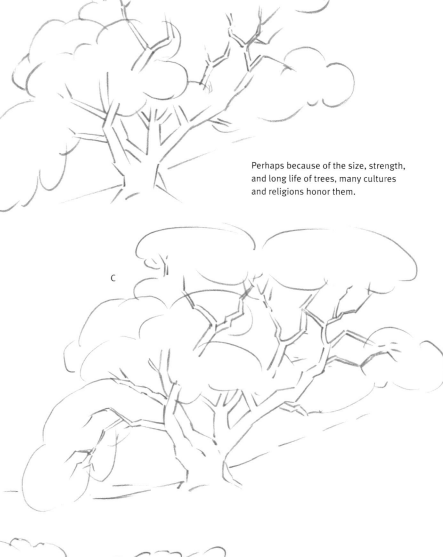

B

Perhaps because of the size, strength, and long life of trees, many cultures and religions honor them.

A

C

Begin by lightly sketching the shape of the tree. Next, shade the trunk using the side of an HB pencil, and add smaller branches with the point of the pencil. Remember to leave a few light areas in the foliage for depth. Also indicate the shadow cast on the grassy hillside, taking into account that the pattern reflects the shape of the tree.

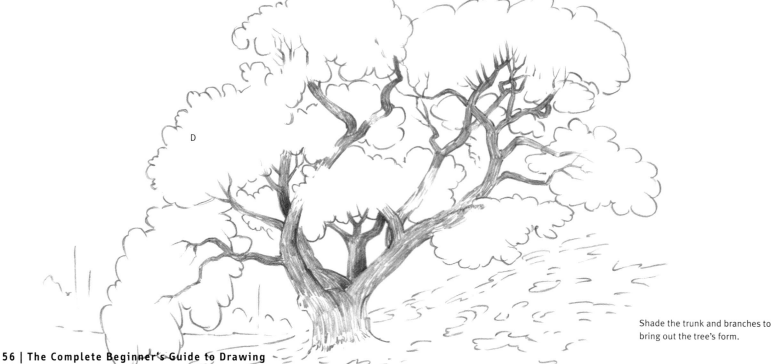

D

Shade the trunk and branches to bring out the tree's form.

Lightly sketch the distant trees with an HB pencil. Next, add shading to the trunk to bring out the form. Don't try to draw each leaf; instead, use small, elliptical, continuous strokes to suggest the foliage.

For the cast shadows in the final step, use the fine point of an HB pencil. Make short, vertical strokes to indicate the texture of the grass. The cast shadow should be darkest in the center and lighter near the outer edges. Place a few short, slightly opposing lines to indicate fallen leaves and debris. Then add the final dark areas using the sharp point of a 2B.

E

Indicate patches of sunlight in the shadow.

The light source is coming from the top left. The tree blocks the light rays, casting a shadow on the ground.

Suggest fallen leaves with short, random strokes.

Sycamore Lane

A good sketch will go a long way toward capturing the mood of a scene. In this drawing, the tree is obviously old and majestic. The trunk leans dramatically from its base to the middle of the drawing at the top. The winding road serves two purposes: It leads the eye into the drawing and creates contrast, which balances out the nearly straight line of the trunk.

To begin this scene, place the basic shapes, refine them, and then add values. Apply light and middle values to establish a backdrop for more intense shading.

Use an HB pencil to block in the mass shapes.

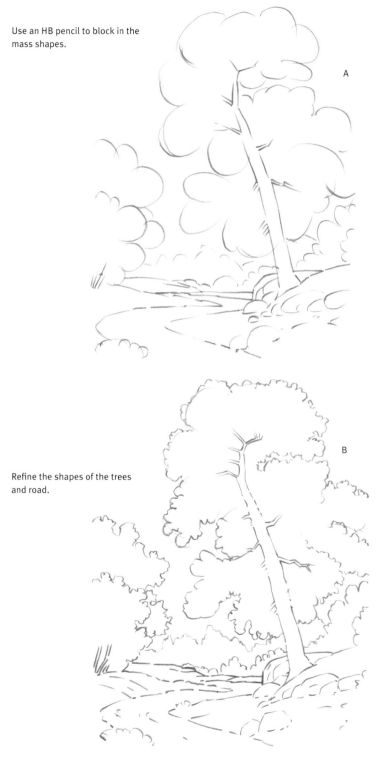

A

Refine the shapes of the trees and road.

B

Continue adding values, and work your way to the foreground.

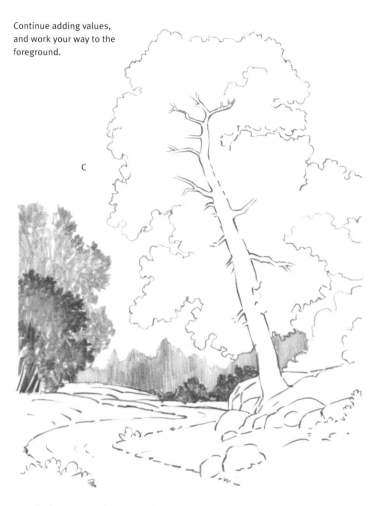

C

Use light, vertical strokes for the trees in the background. Continue to add values and details as you work toward the foreground.

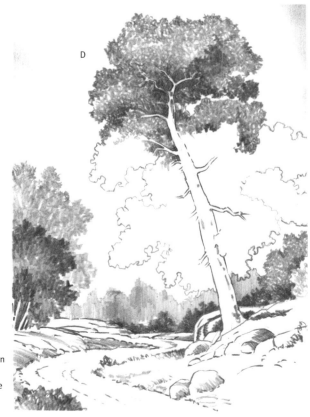

D

Use the side of an HB for the wide strokes of foliage and shaded areas.

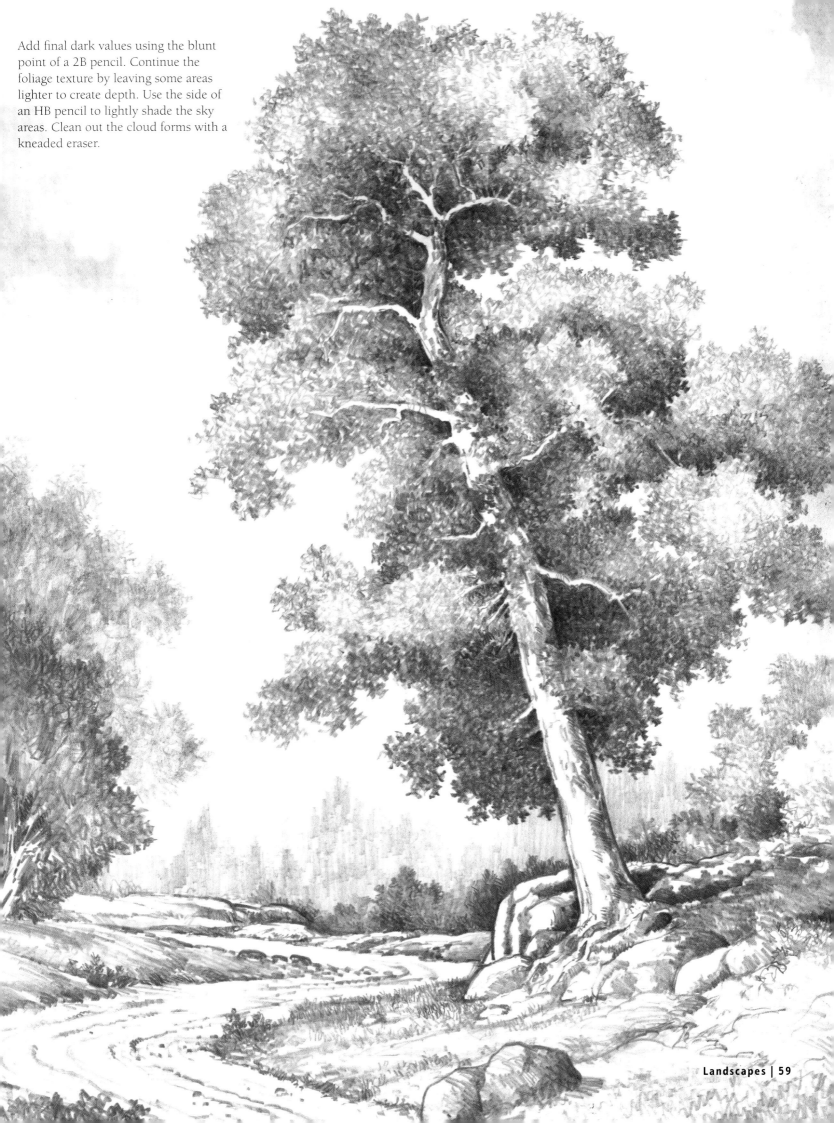

Add final dark values using the blunt point of a 2B pencil. Continue the foliage texture by leaving some areas lighter to create depth. Use the side of an HB pencil to lightly shade the sky areas. Clean out the cloud forms with a kneaded eraser.

LANDSCAPE COMPOSITION

Most landscapes have a background, middleground, and foreground. The background represents areas that are farthest in distance; it leads to the foreground, the areas that appear closest in distance. The background, middleground, and foreground do not have to take up equal space in a composition. Below, the middleground and foreground are placed low, so the elements in the background become the area of interest. Overlapping subjects, such as trees, help create a feeling of depth in a composition. Notice how the bank in the background and the middleground trees enhance the perception of depth and distance.

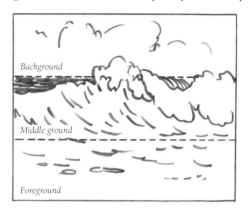

Background

Middle ground

Foreground

Choosing a Viewpoint The wide, horizontal landscape above illustrates a panoramic view. The tree shapes on the left and right lean slightly toward the center, drawing the eye into the middle of the composition. In the example to the right, notice how the elements direct the eye to the center by subtly "framing" that area. Below, the road in the foreground leads back to the small structure, which is the focus of the drawing.

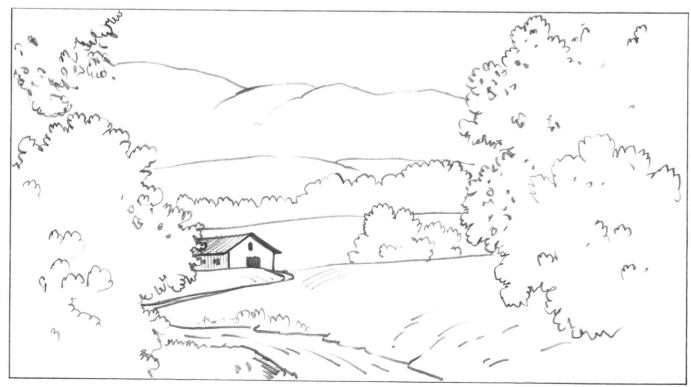

PERSPECTIVE TIPS

To create a realistic landscape, you should be familiar with some basic principles of perspective. In the line drawing below, the horizontal edges of the planes move closer together as they recede to the left and right, eventually merging at vanishing points outside the picture area. Sketch some simple boxes for practice, moving on to more involved subjects, such as buildings.

Once you've correctly drawn the building with straight lines, you can add details that make the structure appear aged, such as the sagging roof and holes in the walls.

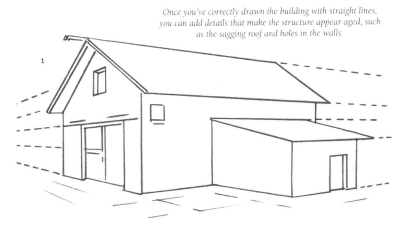

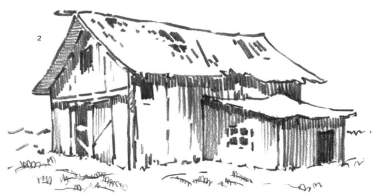

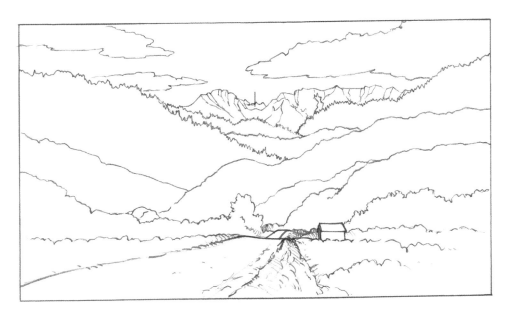

Showing Depth and Distance The illusion of depth is obvious in the line drawing to the left; the road narrows as it travels back into the distance, and the hills overlap each other. To offset the slanting curves of the hills and foliage, a structure was placed just to the right of center.

Practice creating the illusion of depth by sketching some overlapping elements similar to the ones in this landscape. Vary the lines for the areas representing foliage and trees; make them appear bumpy and bushy. For the road, draw two relatively straight lines that move closer together as they recede.

Applying Atmospheric Perspective As objects recede into the distance, they appear smaller and less detailed. Notice that the trees and bushes that surround the little church make it appear far away. Study the arrow directions in the foreground; they help illustrate the correct perspective lines along the ground plane.

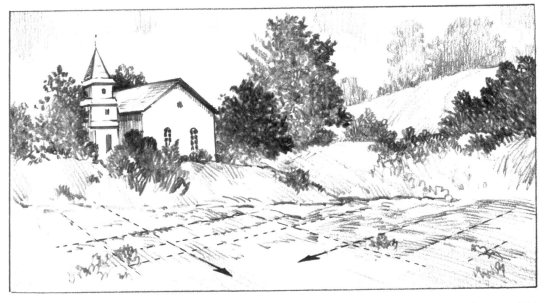

Clouds

Clouds are great elements to include in a landscape because they can set the mood of the drawing. Some clouds create a dramatic mood, while others evoke a calm feeling.

Rendering Cloud Shapes Use a soft pencil, such as a 2B, to lightly outline the basic cloud shapes. Then use the side of the pencil lead to shade the sky in the background. Your shading will give the clouds fullness and form.

Study the various cloud types on this page, and practice drawing them on your own. Try to create puffy, cottonlike clouds and thin, smoky ones. Observe clouds you see in the sky, and sketch those as well.

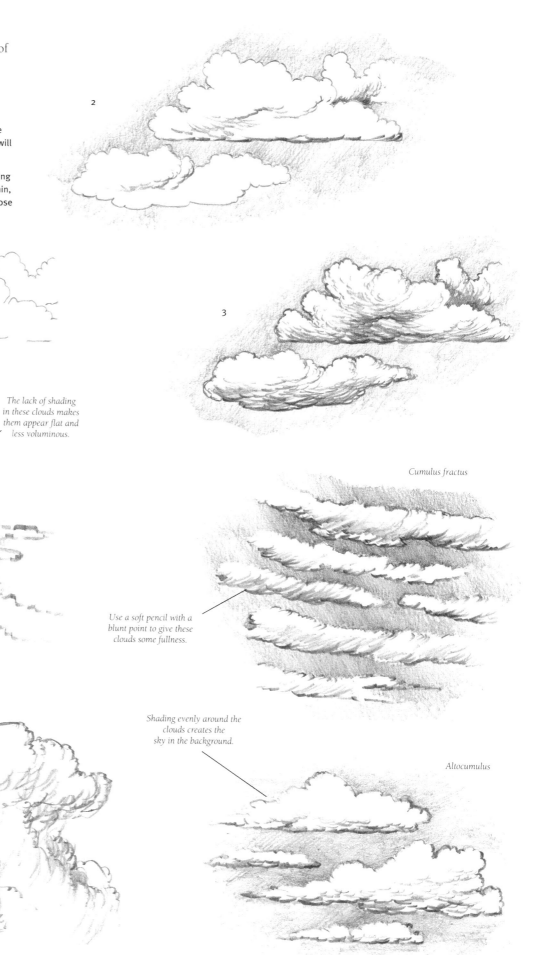

The lack of shading in these clouds makes them appear flat and less voluminous.

Cirrus fibratus

Cumulus fractus

Use a soft pencil with a blunt point to give these clouds some fullness.

Cumulonimbus

Use a paper stump to smooth out this area.

Shading evenly around the clouds creates the sky in the background.

Altocumulus

Applying Shading Techniques The various shading techniques used for the clouds on this page produce distinct feelings. The strong, upsweeping strokes in the drawing to the right evoke power and energy, while the bubbly, puffy texture of the clouds below have a calmer effect.

Use different pencils sharpened to a variety of tips to create the special effects shown. Use your finger or the side of a paper stump to blend the broader areas and the point of the stump for smaller, more intricate details.

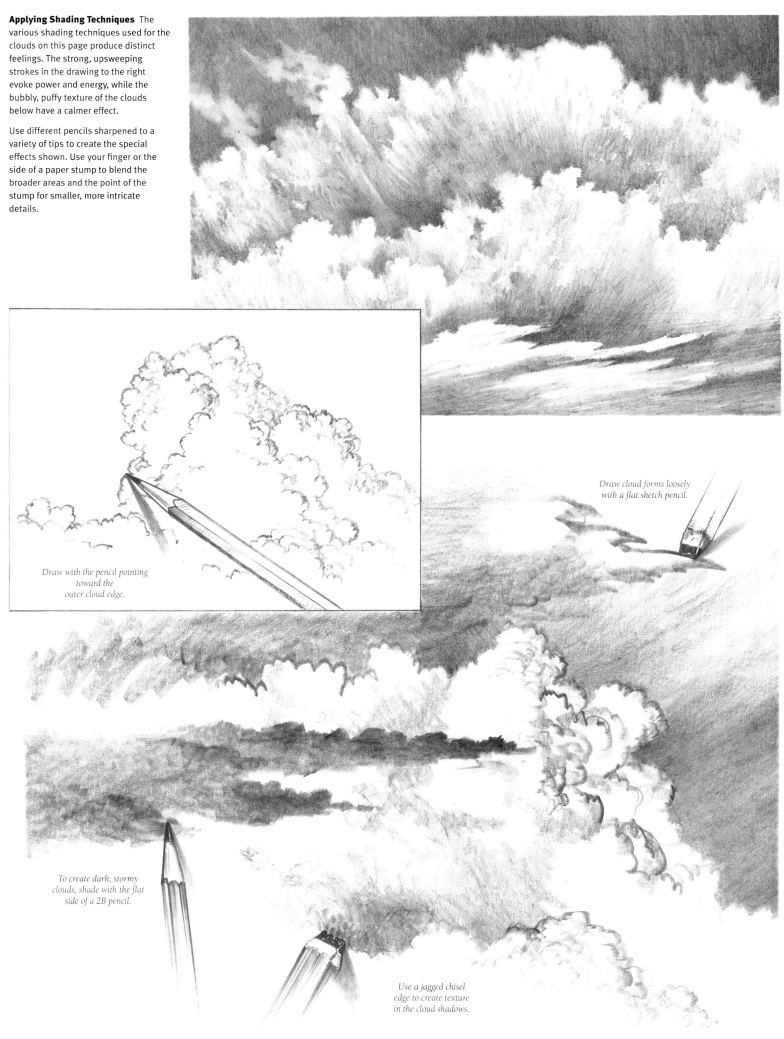

Draw with the pencil pointing toward the outer cloud edge.

Draw cloud forms loosely with a flat sketch pencil.

To create dark, stormy clouds, shade with the flat side of a 2B pencil.

Use a jagged chisel edge to create texture in the cloud shadows.

Rocks

Because rocks come in many different shapes, the best approach is to closely observe the ones you're drawing. To begin, lightly block in the basic shapes in step 1 to establish the different planes.

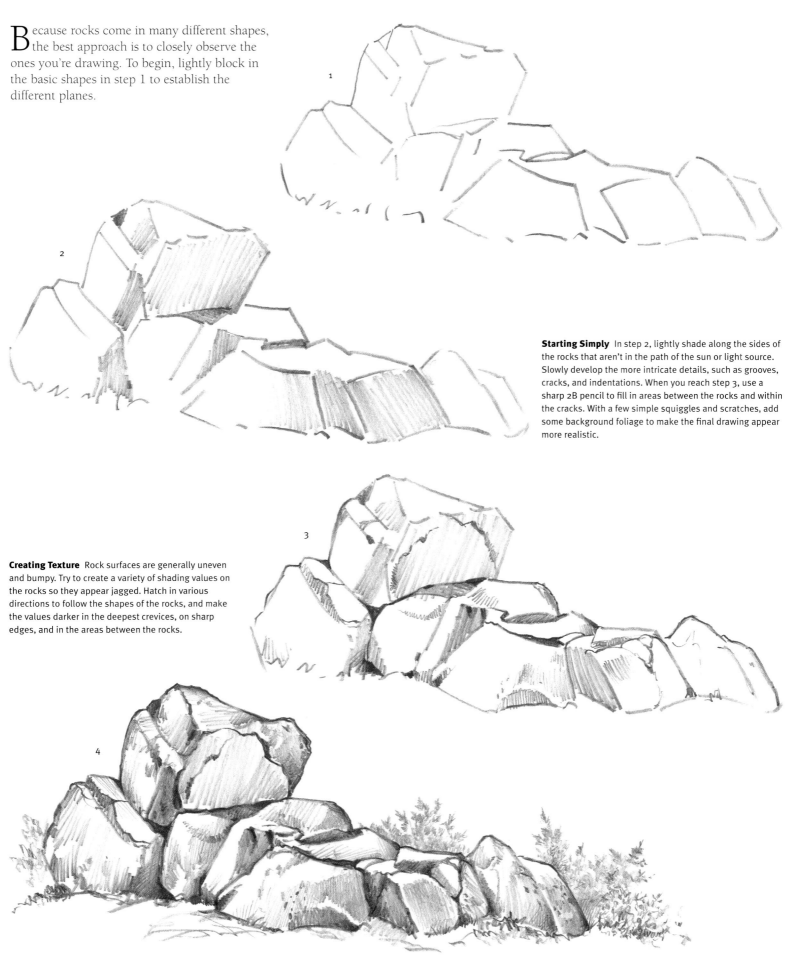

Starting Simply In step 2, lightly shade along the sides of the rocks that aren't in the path of the sun or light source. Slowly develop the more intricate details, such as grooves, cracks, and indentations. When you reach step 3, use a sharp 2B pencil to fill in areas between the rocks and within the cracks. With a few simple squiggles and scratches, add some background foliage to make the final drawing appear more realistic.

Creating Texture Rock surfaces are generally uneven and bumpy. Try to create a variety of shading values on the rocks so they appear jagged. Hatch in various directions to follow the shapes of the rocks, and make the values darker in the deepest crevices, on sharp edges, and in the areas between the rocks.

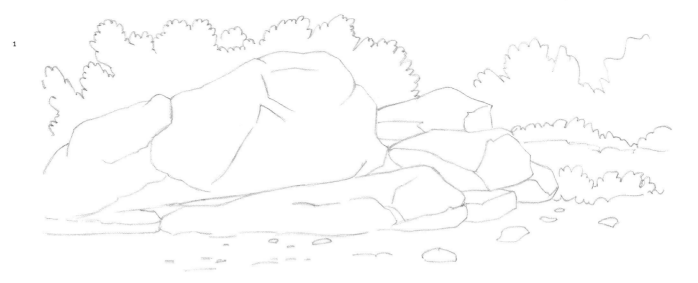

1

Rendering Sunlit Rocks Use the same steps for the rocks on this page, but apply more shading to their entire surfaces. To make the rocks appear as though sunlight is shining on them, use a kneaded eraser to eliminate shading in the appropriate areas, or leave areas of the paper white.

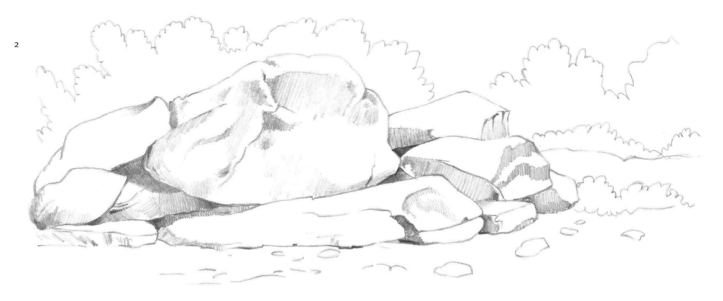

2

Apply heavier shading to the areas of the rocks indenting into the surface.

Adding Greenery Foliage provides an effective, natural background for rocks, because the foliage texture contrasts with the smoothness of the rocks. Block in the general outline for the bushes as you sketch the rocks. Push and pull your pencil in various directions, making some areas darker to create depth.

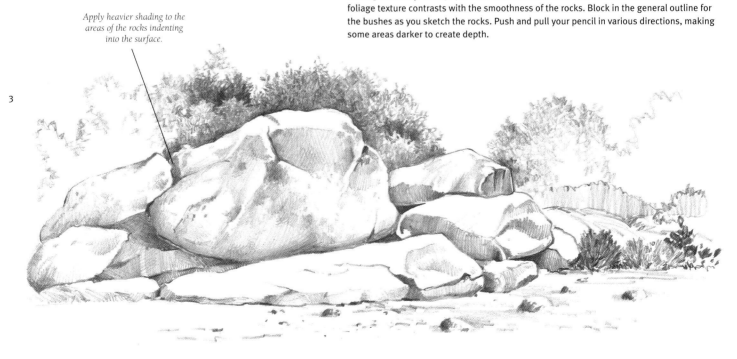

3

CREEK WITH ROCKS

Drawing landscapes containing creeks and rocks is a great way to improve artistic skills because of the variety of surface textures. It's imperative that your preliminary drawing accurately shows depth by overlapping elements, uses proper perspective, and maintains a pleasing balance of elements. This eliminates the need to make corrections later.

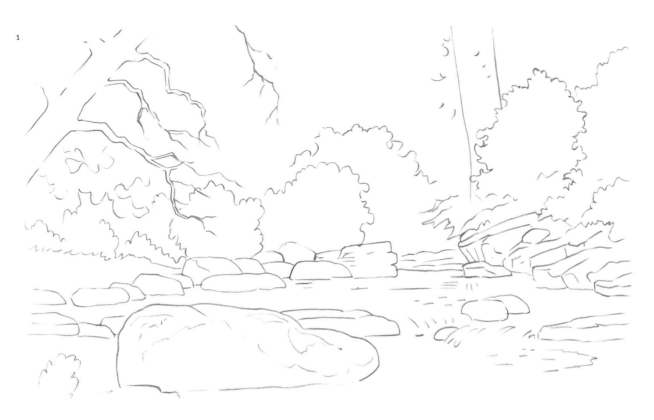

Starting with a Basic Sketch Begin shading the trees in the distance; then work your way to the middle ground and foreground. Remember: Don't completely shade each object before moving to the next one. Work on the entire drawing so it maintains a sense of unity. You don't want one area to unbalance the landscape or appear as though you spent more time on it. Even though there are many light and dark areas throughout the drawing, the degree of shading should remain relatively consistent.

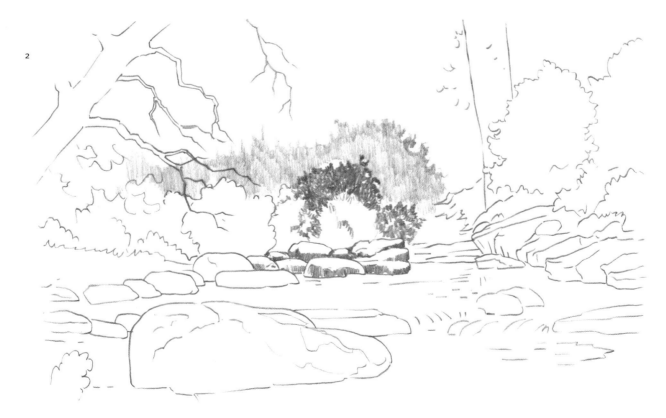

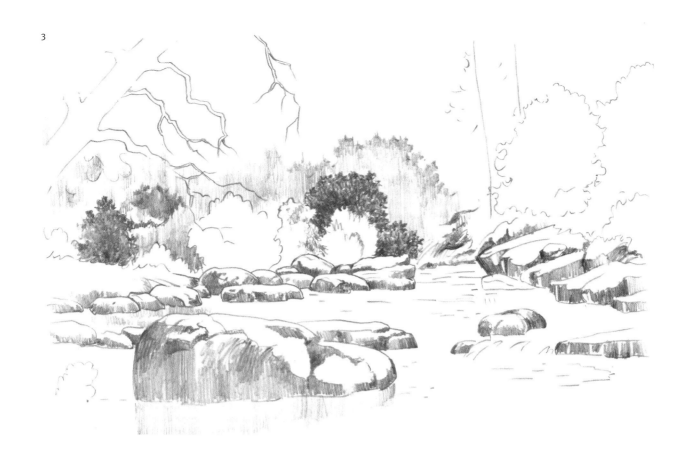

3

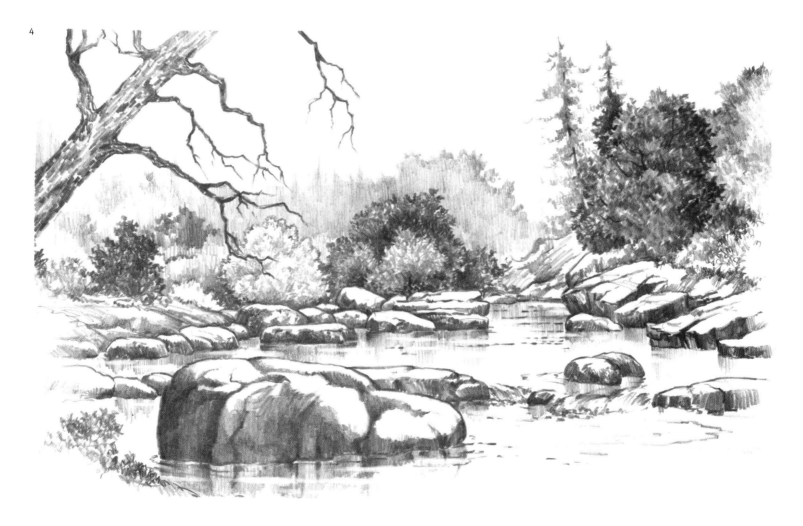

4

Rendering Texture Use the side of an HB pencil, shading in even strokes to create reflections in the water. Keep in mind that an object's reflection is somewhat distorted in moving water and mirrored in still water. For example, the reflection of the sharp rock edges here appears blurred and uneven. Closely study your landscape so you don't miss any of the details. Apply strokes in directions that correspond with the rocks' rugged, uneven texture, and fill in the areas between the cracks with a sharp 2B or 4B pencil.

MOUNTAINS

A mountain landscape can be blocked in with a few straight lines as shown in step 1. Refine the shapes into the rugged mountains in step 2, keeping in mind that it isn't necessary to include every indentation and curvature you see. Just include the major ones to capture the essence of the subject. As you shade in steps 3 and 4, remember that areas indenting deepest into the mountain should be shaded darker to bring out the rocky texture.

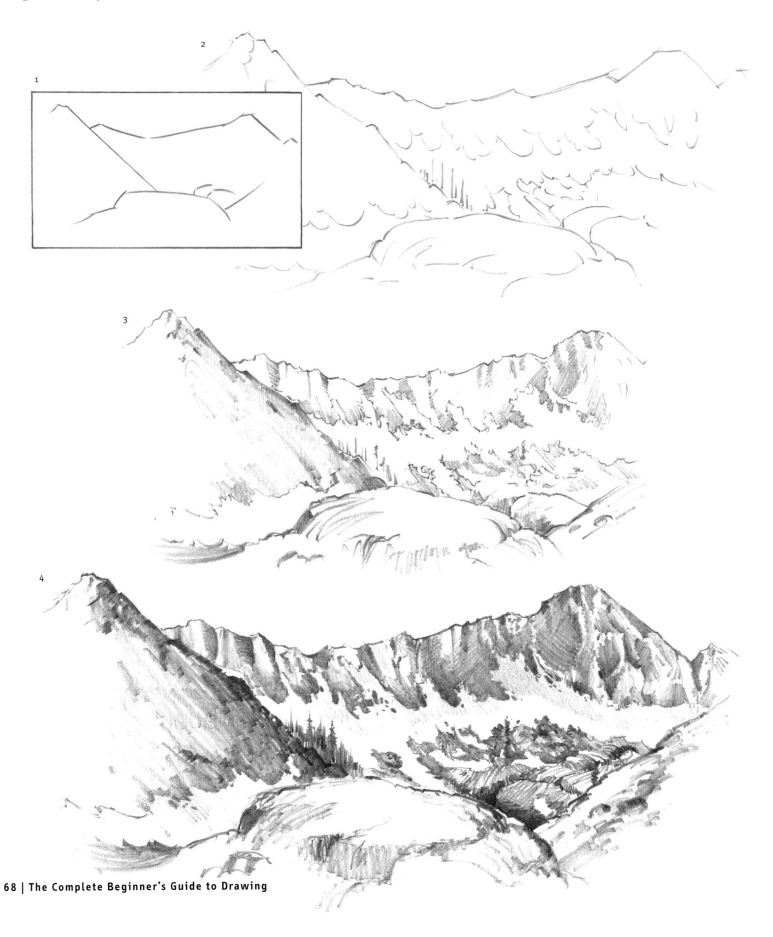

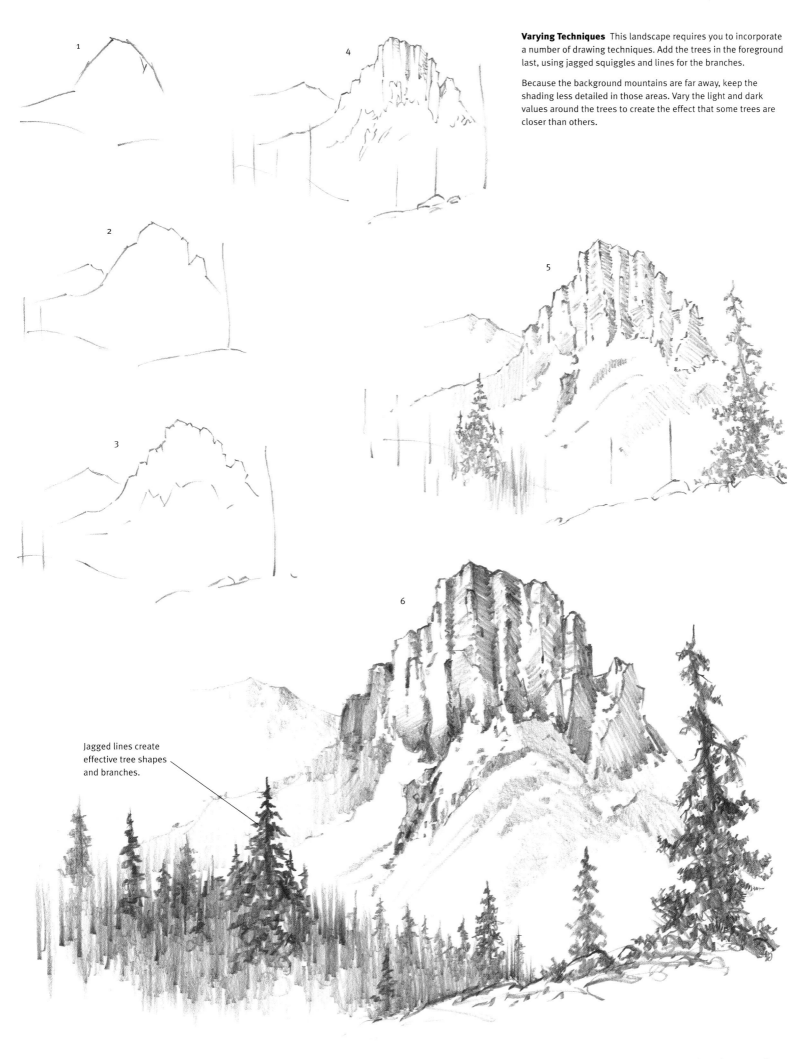

1

4

2

3

5

6

Varying Techniques This landscape requires you to incorporate a number of drawing techniques. Add the trees in the foreground last, using jagged squiggles and lines for the branches.

Because the background mountains are far away, keep the shading less detailed in those areas. Vary the light and dark values around the trees to create the effect that some trees are closer than others.

Jagged lines create effective tree shapes and branches.

RENDERING A GRAND LANDSCAPE

Landscapes are fascinating subjects to draw or paint, and I often sketch them in preparation for painting in my studio. When I make a fully rendered drawing of a landscape as a final work of art and not just as a study sketch, I focus on one part of the panorama, simplify it if needed, and then break it down into steps. That way, I'm not distracted by the sheer expanse of nature! Landscapes offer me the chance to use some special drawing techniques that add to the realism and illusion of distance—a method referred to as "atmospheric" or "aerial perspective."

DEPICTING AERIAL PERSPECTIVE

Aerial perspective refers to creating the illusion of depth and atmospheric distance through a subtle change of value and detail. When landscape elements such as trees or mountains recede into the distance, the particles in the atmosphere cause the elements to appear lighter in value, with softer, less distinct edges and fewer details than objects in the foreground. Indicate these changes in your drawings to create a work of art with a sense of depth and realism. For this demonstration, I chose the view of Half Dome and the valley floor from Inspiration Point. This site is in my favorite place on earth —Yosemite National Park in California.

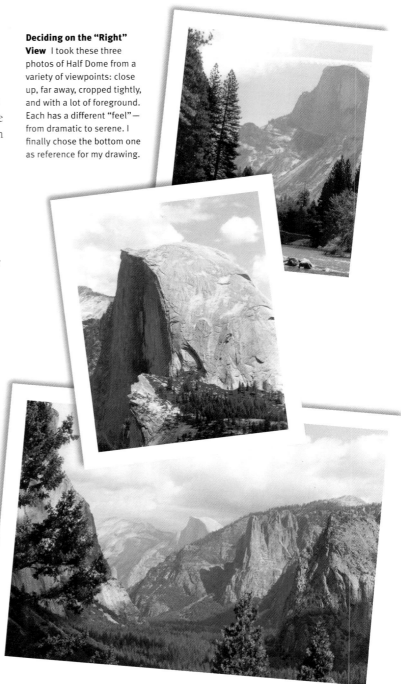

Deciding on the "Right" View I took these three photos of Half Dome from a variety of viewpoints: close up, far away, cropped tightly, and with a lot of foreground. Each has a different "feel"— from dramatic to serene. I finally chose the bottom one as reference for my drawing.

Step 1 First, I studied the scene to determine the significant shapes and masses. Then, using a sharp HB point, I lightly placed the most important lines of each major formation. At this stage, I completely ignored all detail. Instead, I concentrated on the edges and angles of each formation and its position in relation to the formations around it.

Step 2 Next, I sketched in more edges and planes within each major shape, adding only the most obvious ones. (I'll develop the smaller planes as I shade.) Notice that I darkened one small area in the center; this dark "eye anchor" made it easier to quickly find my place in the composition as I looked back and forth from my reference to my drawing.

Step 3 Here, I added foreground elements—the detailed trees and bushes. I began shading the more distant trees on the valley floor, using a rounded HB pencil and vertical strokes. I suggested the pointed treetops with a sharpened HB. Then I began lightly shading the mountains with wide strokes, following the direction of each surface and plane.

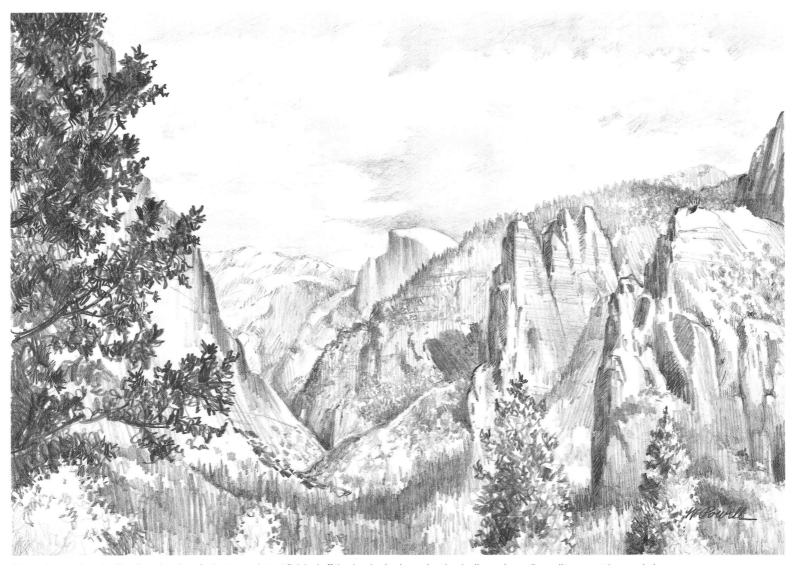

Step 4 Constantly rechecking the values by referring to my photo, I finished off the drawing by deepening the shading, using a 2B pencil to accent the very darkest areas.

Foreground Trees This foliage has the darkest values and the most distinct detail. To render it, I used the point of an HB pencil and drew bold, squiggled lines without lifting the pencil from the surface. I changed values and stroke direction for variety and used a softer 2B pencil to darken some areas for contrast and to add depth.

Distant Trees In contrast to the detailed trees in the foreground, I merely suggested the trees in the valley (which is the middle ground) with a series of vertical strokes. I varied the pressure on my pencil to make darker strokes for the shadows. Then I used the sharpened point of an HB to sketch a few treetops here and there.

Foreground Peaks To create the drama of the grand peaks near the foreground, I set very dark edges against the lighter rock faces. I made several slightly angled horizontal strokes to suggest the uneven surfaces, and I used vertical strokes in the shadows to accentuate the rock's immense strength and vertical shape.

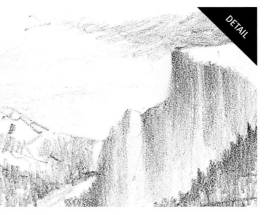

Distant Peaks Here, I used aerial perspective techniques, keeping the values subtle and light where I wanted to suggest distance. Notice that the sky value is darker than the top of Half Dome but lighter than the dome's face. On the more distant peaks, I used thin, faint lines that follow the direction of each surface, and I left plenty of clean paper for the lightest value: white.

DESERTS

Deserts make excellent landscape subjects because they provide a variety of challenging textures and shapes. In step 1, lay out the major elements with an HB pencil, and then refine the shapes. Then add a few light shadows in step 2. The finished drawing shows minimal shading, which creates the illusion of expansive light around the entire landscape.

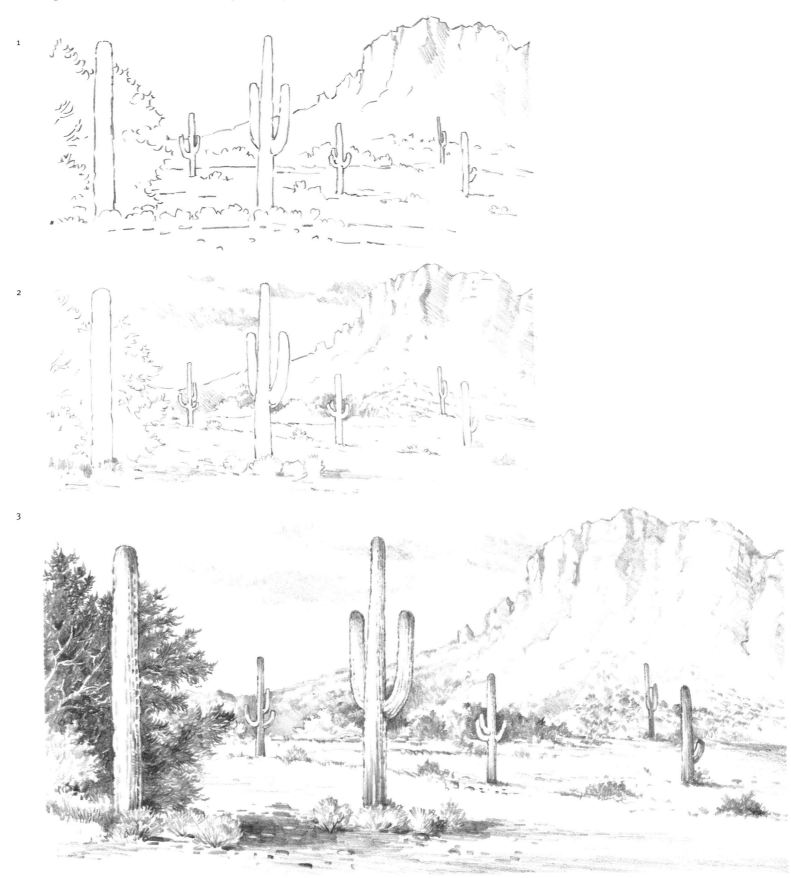

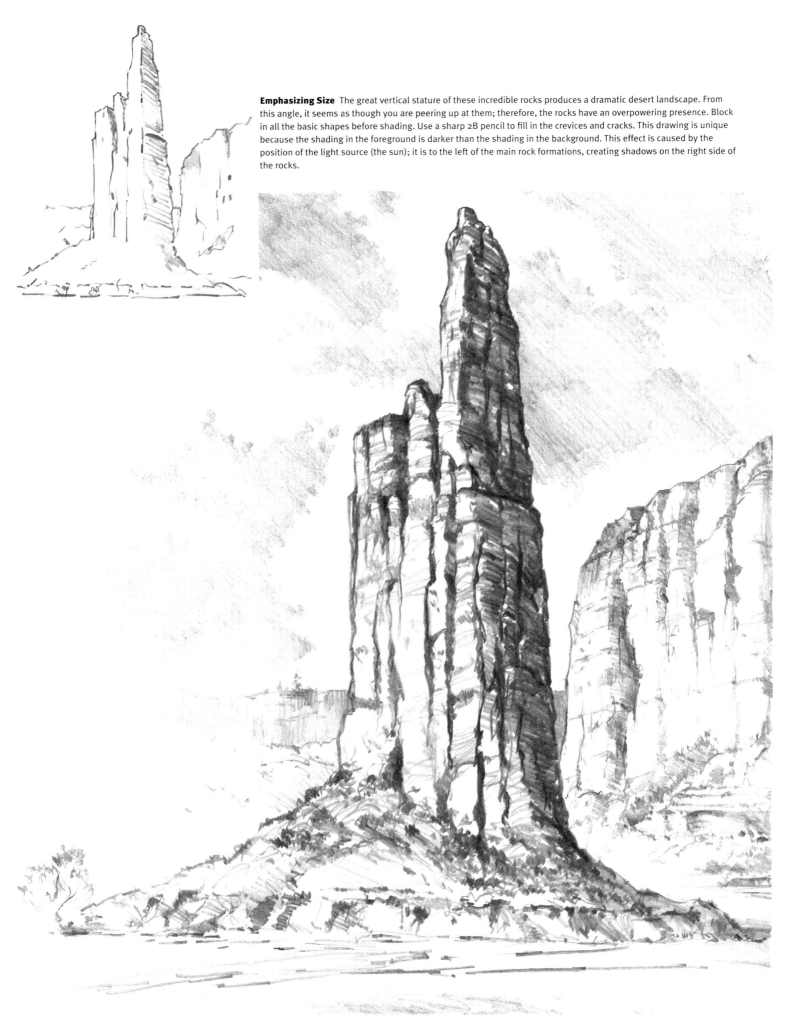

Emphasizing Size The great vertical stature of these incredible rocks produces a dramatic desert landscape. From this angle, it seems as though you are peering up at them; therefore, the rocks have an overpowering presence. Block in all the basic shapes before shading. Use a sharp 2B pencil to fill in the crevices and cracks. This drawing is unique because the shading in the foreground is darker than the shading in the background. This effect is caused by the position of the light source (the sun); it is to the left of the main rock formations, creating shadows on the right side of the rocks.

EXPLORING DISTANCE

O ne of the great joys of drawing is being able to depict nature's wide open spaces on my small sheet of paper. By sharpening or blurring details, overlapping objects, and emphasizing size differences, I can make mountains appear far away and flowers seem close enough to pick. Here are some simple tips for creating a sense of depth in your drawings.

PUTTING THINGS IN PERSPECTIVE

One of the neatest tricks for making objects appear to recede is by applying *atmospheric perspective*: showing that the atmosphere makes distant forms less detailed and lighter in color or, for pencil drawing, lighter in value. Another simple method is to overlap items: Whatever is in front automatically looks as if it is closer to the viewer. I also pay attention to the sizes of objects: Things that are near appear larger than those farther away, so elements in the foreground will be much larger in relation to elements in the background. Anything in the middle ground should be a size that's somewhere in between.

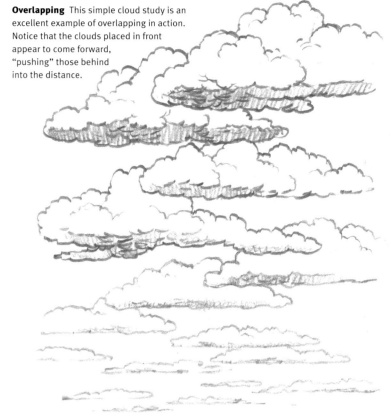

Overlapping This simple cloud study is an excellent example of overlapping in action. Notice that the clouds placed in front appear to come forward, "pushing" those behind into the distance.

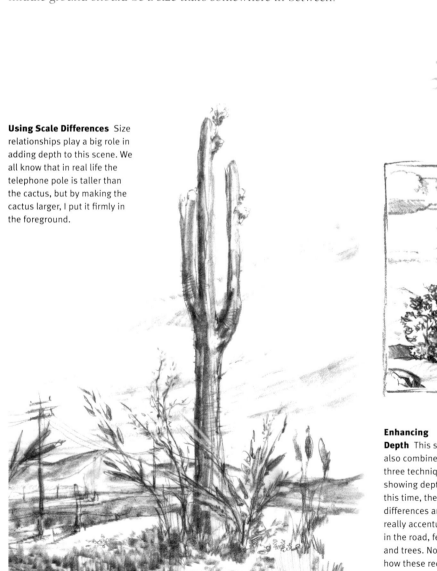

Using Scale Differences Size relationships play a big role in adding depth to this scene. We all know that in real life the telephone pole is taller than the cactus, but by making the cactus larger, I put it firmly in the foreground.

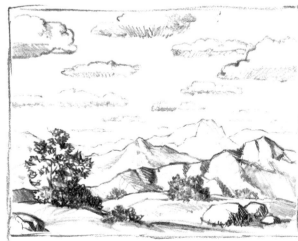

Combing Methods Combining overlapping techniques with texture variation is a great way to create depth. In this thumbnail, I overlapped the hills and reduced the size of the clouds as they move toward the horizon. I added more definition in the foreground elements, making them gradually lighter toward the hills.

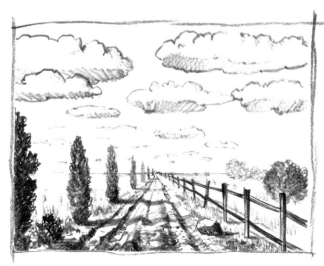

Enhancing Depth This sketch also combines all three techniques for showing depth, but this time, the size differences are really accentuated in the road, fence, and trees. Notice how these receding lines narrow to a point on the horizon. This is an example of *linear perspective* and adds depth in any scene.

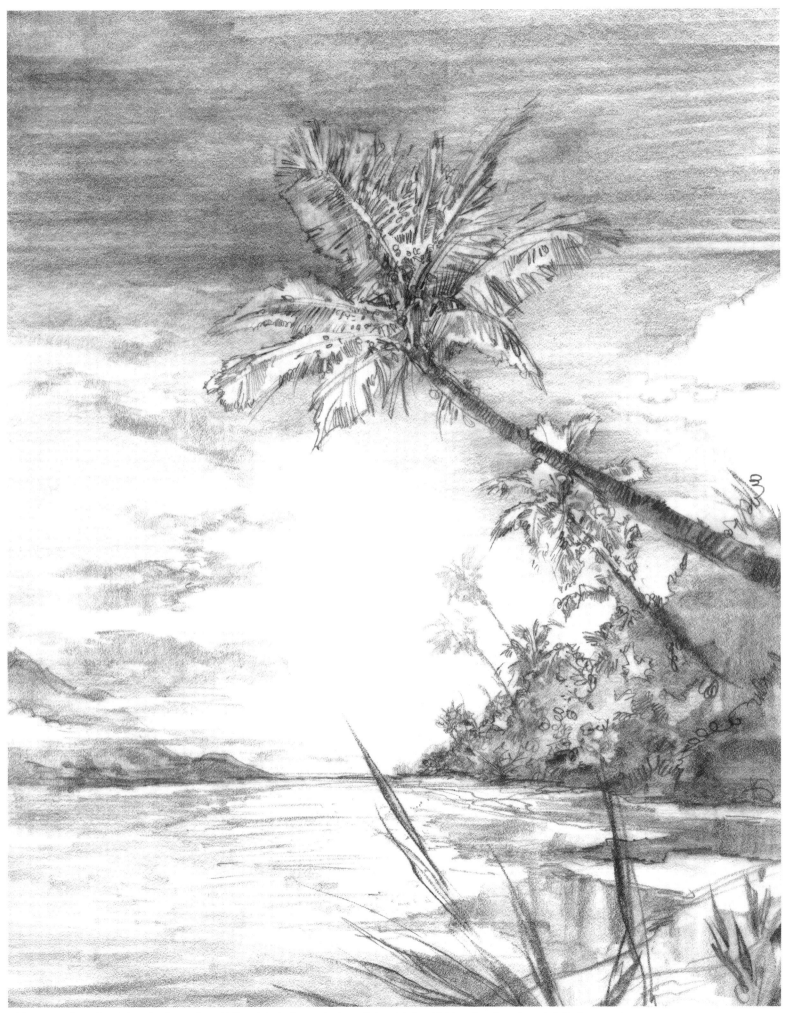

Adding Atmosphere Here, I drew the distant sky and hills and the background palms with less detail and lighter values than elements in the foreground.

ANIMALS

DRAWING FROM PHOTOGRAPHS

Photographs are wonderful references for drawing animals. When you take the photos yourself, try to catch a motion or pose that is characteristic of the animal, such as the position of a cheetah just before it pounces or the stretch of a spider monkey in mid-swing. Always be prepared to take a snapshot at any time, and take several different shots of the same subject. It is challenging to capture an animal's personality on disk or film, but it is well worth the wait!

When you are ready to begin drawing, look over all your photographs, and choose the one you like best. Don't feel restricted to using only one reference source. You may decide you like the facial expression in one photo but the body pose in another; you may even have other references for background elements that you'd like to include. Use them all! Combine your references any way you choose, altering the scene to suit yourself. That is referred to as "taking artistic license," and it's one of the most important "tools" artists have at their disposal.

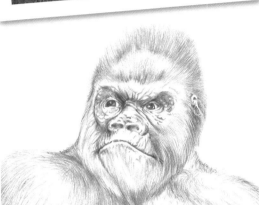

Copying a Portrait This drawing was based on the photo reference shown above. It captured the proud, strong expression and physical characteristics so typical of mature male gorillas. Because the photo was so clear, the drawing follows it faithfully.

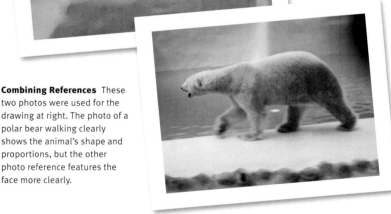

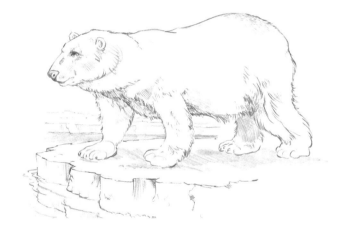

Combining References These two photos were used for the drawing at right. The photo of a polar bear walking clearly shows the animal's shape and proportions, but the other photo reference features the face more clearly.

CREATING AN ARTIST'S MORGUE

The more skilled you become at drawing and the more different animals appeal to you as subjects, the more references you'll want to have on hand. Many artists keep some type of file for storing images, also called an "artist's morgue." This system of collecting film prints, slides, and digital images can supplement the information you note in your sketchbook (see page 79), such as the color, texture, or proportions of a subject. You may also want to include magazine clippings, postcards, or other visual materials in your file, but be sure to use these items as loose references for general information only; replicating another's work without permission is a copyright infringement.

Artists today are fortunate to have many means of obtaining and cataloging pictures. You can store thousands of photos, and each picture can be pulled up on screen in a matter of seconds. If you choose to create physical folders, you might want to file your images alphabetically by subject so they are easily accessible when the need for a reference arises. Use all forms of storage for your artist's morgue—you can even print still-frame shots from your own scenic videos.

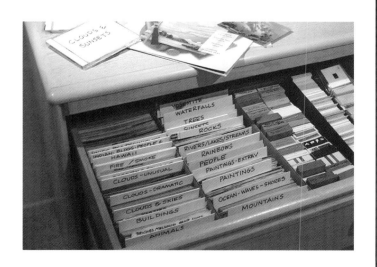

DRAWING FROM LIFE

Sketching animals from life gives you a fresh approach to drawing that is spontaneous and original—every pose and composition you discover is unique! Creating a finished drawing on site has its disadvantages, however. You may not be able to stay on location for the duration of the drawing, and the light shifts as time passes, changing the shadows and highlights. Of course, most animals are bound to change positions or even walk away as you work, making it difficult for you to capture a good likeness. Instead of trying to produce a final, detailed pencil drawing in the field, use a sketchbook to gather all the information you'll need for a completed piece later. Work quickly and loosely, concentrating on replicating the animal's general shapes, main features, gestures, and expressions. Practice using your whole arm to draw, not just your wrist and hand. Vary the position of your pencil as you stroke, and involve your shoulder in each movement you make. Then jot down notes to complete the information you'll want to retrieve later. When it comes time for the final drawings, you'll be surprised at how often you'll refer to the notes you've recorded in your sketchbook!

Drawing at the Zoo The zoo is an ideal place for sketching a wide range of interesting animals. Before you begin to draw, take some time to observe their general proportions as well as the way the animals move and how they interact with one another. The more you know about your subject, the more convincing your drawings will be.

Keeping a Sketchbook When you sketch from life to prepare for a drawing, be careful to take notes about the values, light, and the time of day as well as any other details you are likely to forget. Sometimes you may want to take the time to more fully render a facial feature, such as an eye, and try sketching each animal from several different angles. Remember that no matter how much time you spend observing a subject, the impression in your mind will surely fade with time, so be as thorough in your notes as you can.

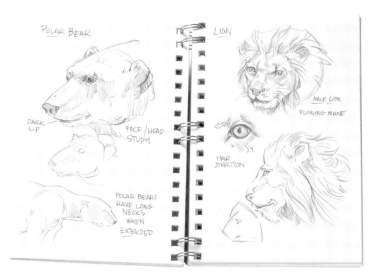

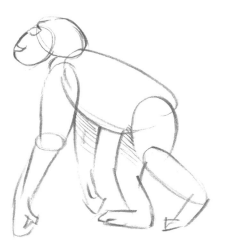

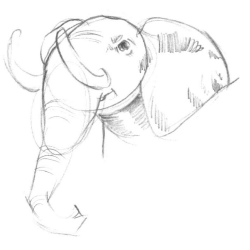

USING A VIEWFINDER

If you have a hard time deciding how to arrange the animal or animals on your paper, try looking through a viewfinder. You can form a double "L" with your fingers or use a cardboard frame, as shown below, and look through the opening. Bring the viewfinder closer and hold it out farther; move it around the scene; look at your subject from high and low viewpoints; and make the opening wider and narrower. Then choose the view that pleases you most.

Starting with Basic Shapes Your sketches don't need to be as fully developed as the drawings shown in the sketchbook (above). Concentrate on training your eye to see your subject in terms of basic shapes—circles, ovals, rectangles, and triangles—and put them together in a rough drawing. For example, the sketch of the chimpanzee on the left started with a series of ovals, which were then connected with a few simple lines; the hands, feet, and facial features were merely suggested. The elephant portrait began with a circle, an oval, and roughly triangular shapes; from that point, it was easy to sketch out the shape of the trunk and place a few strokes for shading to hint at the elephant's form.

DRAWING ANIMALS

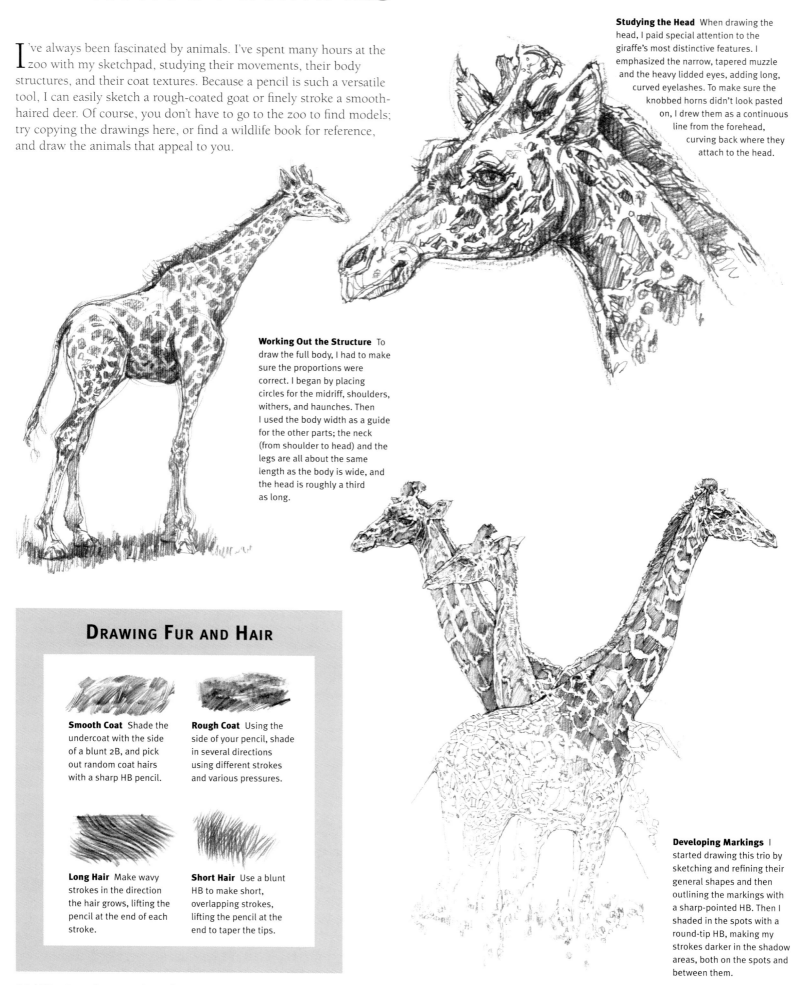

I've always been fascinated by animals. I've spent many hours at the zoo with my sketchpad, studying their movements, their body structures, and their coat textures. Because a pencil is such a versatile tool, I can easily sketch a rough-coated goat or finely stroke a smooth-haired deer. Of course, you don't have to go to the zoo to find models; try copying the drawings here, or find a wildlife book for reference, and draw the animals that appeal to you.

Studying the Head When drawing the head, I paid special attention to the giraffe's most distinctive features. I emphasized the narrow, tapered muzzle and the heavy lidded eyes, adding long, curved eyelashes. To make sure the knobbed horns didn't look pasted on, I drew them as a continuous line from the forehead, curving back where they attach to the head.

Working Out the Structure To draw the full body, I had to make sure the proportions were correct. I began by placing circles for the midriff, shoulders, withers, and haunches. Then I used the body width as a guide for the other parts; the neck (from shoulder to head) and the legs are all about the same length as the body is wide, and the head is roughly a third as long.

DRAWING FUR AND HAIR

Smooth Coat Shade the undercoat with the side of a blunt 2B, and pick out random coat hairs with a sharp HB pencil.

Rough Coat Using the side of your pencil, shade in several directions using different strokes and various pressures.

Long Hair Make wavy strokes in the direction the hair grows, lifting the pencil at the end of each stroke.

Short Hair Use a blunt HB to make short, overlapping strokes, lifting the pencil at the end to taper the tips.

Developing Markings I started drawing this trio by sketching and refining their general shapes and then outlining the markings with a sharp-pointed HB. Then I shaded in the spots with a round-tip HB, making my strokes darker in the shadow areas, both on the spots and between them.

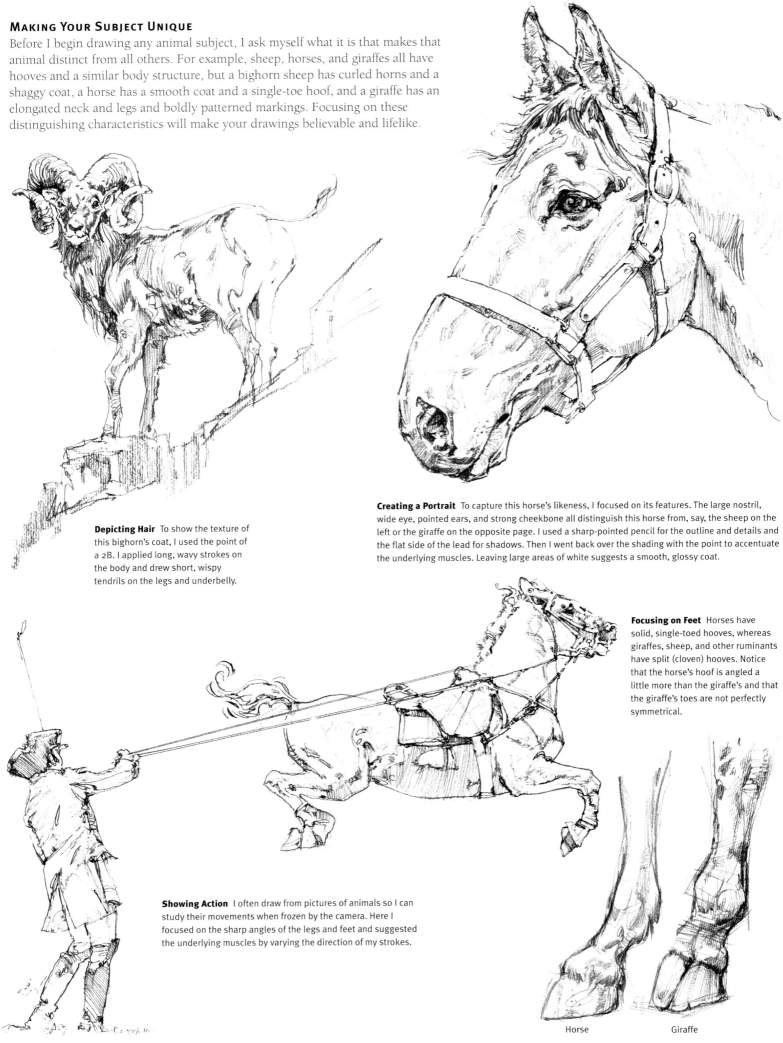

MAKING YOUR SUBJECT UNIQUE

Before I begin drawing any animal subject, I ask myself what it is that makes that animal distinct from all others. For example, sheep, horses, and giraffes all have hooves and a similar body structure, but a bighorn sheep has curled horns and a shaggy coat, a horse has a smooth coat and a single-toe hoof, and a giraffe has an elongated neck and legs and boldly patterned markings. Focusing on these distinguishing characteristics will make your drawings believable and lifelike.

Depicting Hair To show the texture of this bighorn's coat, I used the point of a 2B. I applied long, wavy strokes on the body and drew short, wispy tendrils on the legs and underbelly.

Creating a Portrait To capture this horse's likeness, I focused on its features. The large nostril, wide eye, pointed ears, and strong cheekbone all distinguish this horse from, say, the sheep on the left or the giraffe on the opposite page. I used a sharp-pointed pencil for the outline and details and the flat side of the lead for shadows. Then I went back over the shading with the point to accentuate the underlying muscles. Leaving large areas of white suggests a smooth, glossy coat.

Focusing on Feet Horses have solid, single-toed hooves, whereas giraffes, sheep, and other ruminants have split (cloven) hooves. Notice that the horse's hoof is angled a little more than the giraffe's and that the giraffe's toes are not perfectly symmetrical.

Showing Action I often draw from pictures of animals so I can study their movements when frozen by the camera. Here I focused on the sharp angles of the legs and feet and suggested the underlying muscles by varying the direction of my strokes.

Horse Giraffe

SHADING TECHNIQUES

Solid Fur

Step 1 Use the side of an HB lead to cover the surface with even, vertical strokes. Apply layer upon layer to build depth.

Step 2 Use the corner of a firm block eraser to pull out thick, light hairs in the direction of growth. Practice lifting the eraser at the end of the stroke to make a tapered point.

Striped Fur

Step 1 For striped fur, begin to suggest the dark areas with the side and point of an HB pencil.

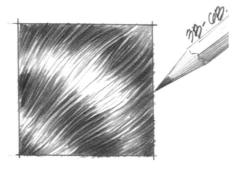

Step 2 Refine the texture, and add details and the darkest values with pencils ranging from 3B to 6B. Use a paper stump to soften the darkest areas.

Thick Fur

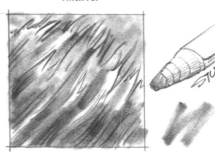

Step 1 Create thin, dark lines with an HB pencil; then rub a paper stump over some of the lines to soften and smudge them.

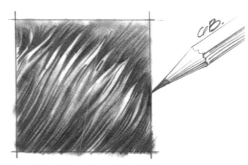

Step 2 Use a sharp 6B pencil to refine the texture, stroking in the direction of fur growth. Enhance the white areas with an eraser.

Whiskers

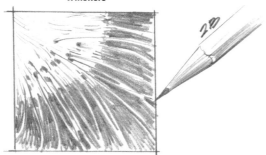

Step 1 With the side and point of a 2B pencil, indicate the fur and whiskers.

Step 2 Use a 6B pencil to refine the whiskers and shade the darkest areas.

USING BRUSH AND INK

You can create different effects with a round watercolor brush and india ink. Try diluting the ink for lighter values. Use a wet brush for smooth lines or a dry brush for more texture.

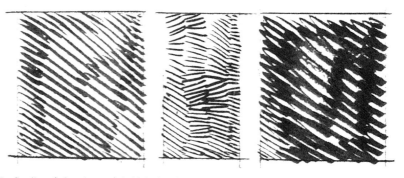

For fine lines (left and center), hold the brush vertically to the paper, and stroke lightly with just the tip of the brush. For broad lines (right), increase the pressure on the brush, and apply more ink.

CREATING ANIMAL TEXTURES

Smooth Scales To depict smooth scales, first draw ovals of various sizes; then shade between them. Because scales overlap, be sure to partially cover each scale with the next layer.

Rough Scales For rough scales, create irregular shapes that follow a slightly curved alignment. Shade darkly between the shapes, and then shade over them with light, parallel strokes.

Fine Feathers For light, downy feathers, apply thin, parallel lines along the feather stems to form a series of V shapes. Avoid crisp outlines, which can take away from the softness.

Heavy Feathers To create thicker, more defined feathers, use heavier parallel strokes, and blend with a tortillion. Apply the most graphite to the shadowed areas between the feathers.

Hide To create a shiny, short-haired hide, apply short, straight strokes with the broad side of the pencil. For subtle wrinkles, add a few horizontal strips that are lighter in value.

Wavy Hair For layers of soft curls, stroke in S-shaped lines that end in tighter curves. Leave the highlights free of graphite, and stroke with more pressure as you move to the shadows.

Rough Coat For a subtle striped pattern, apply short strokes in the direction of fur growth. Then apply darker strokes in irregular horizontal bands. Pull out highlights with an eraser.

Smooth Coat For a smooth, silky coat, use sweeping parallel pencil strokes, leaving the highlighted areas free of graphite. Alternate between the pencil tip and the broad side for variation.

Curly Hair Curly, woolly coats can be drawn with overlapping circular strokes of varying values. For realism, draw curls of differing shapes and sizes, and blend for softness.

Long Hair To render long hair—whether it's the whole coat or just a mane or tail—use longer, sweeping strokes that curve slightly, and taper the hairs to a point at the ends.

Whiskers To suggest whiskers, first apply rows of dots on the animal's cheek. Fill in the fur as you have elsewhere; then, with the tip of a kneaded eraser, lift out thin, curving lines.

Nose Most animal noses have a bumpy texture that can be achieved with a very light scale pattern. Add a shadow beneath the nose; then pull out highlights with a kneaded eraser.

RABBITS

Drawing rabbits requires you to observe them carefully. For example, ear length varies with different breeds. The ears on this guy may be a bit too small. If this happens to you, keep trying until you get it right.

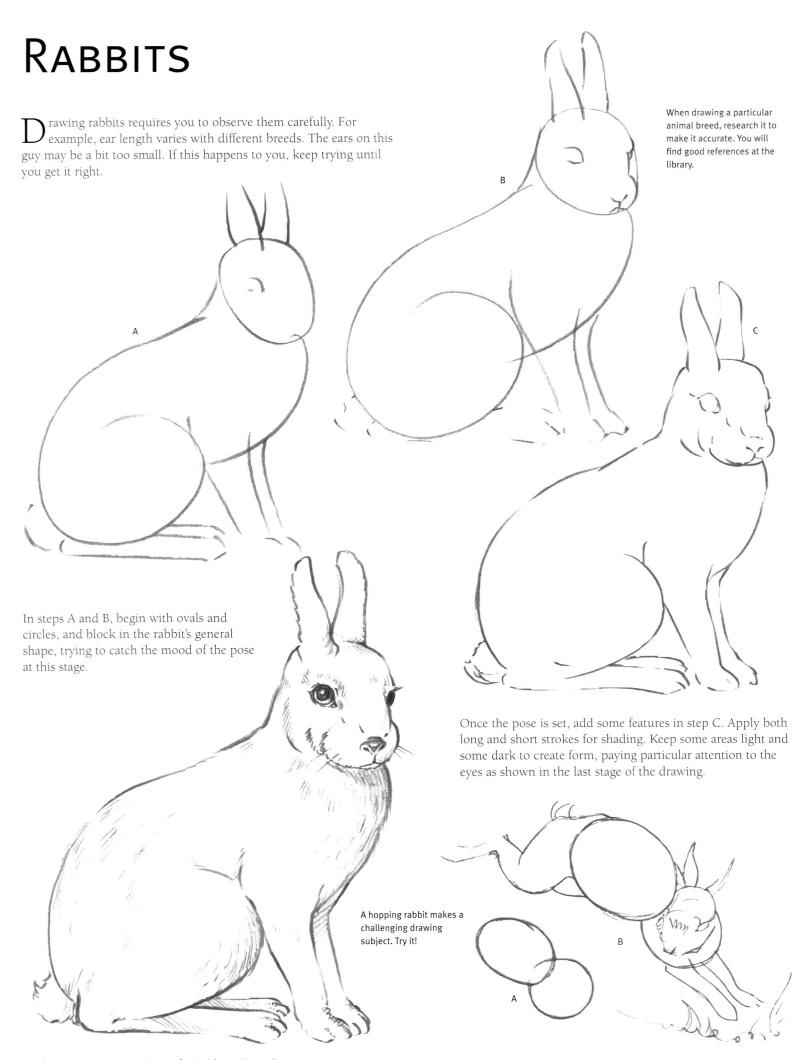

When drawing a particular animal breed, research it to make it accurate. You will find good references at the library.

In steps A and B, begin with ovals and circles, and block in the rabbit's general shape, trying to catch the mood of the pose at this stage.

Once the pose is set, add some features in step C. Apply both long and short strokes for shading. Keep some areas light and some dark to create form, paying particular attention to the eyes as shown in the last stage of the drawing.

A hopping rabbit makes a challenging drawing subject. Try it!

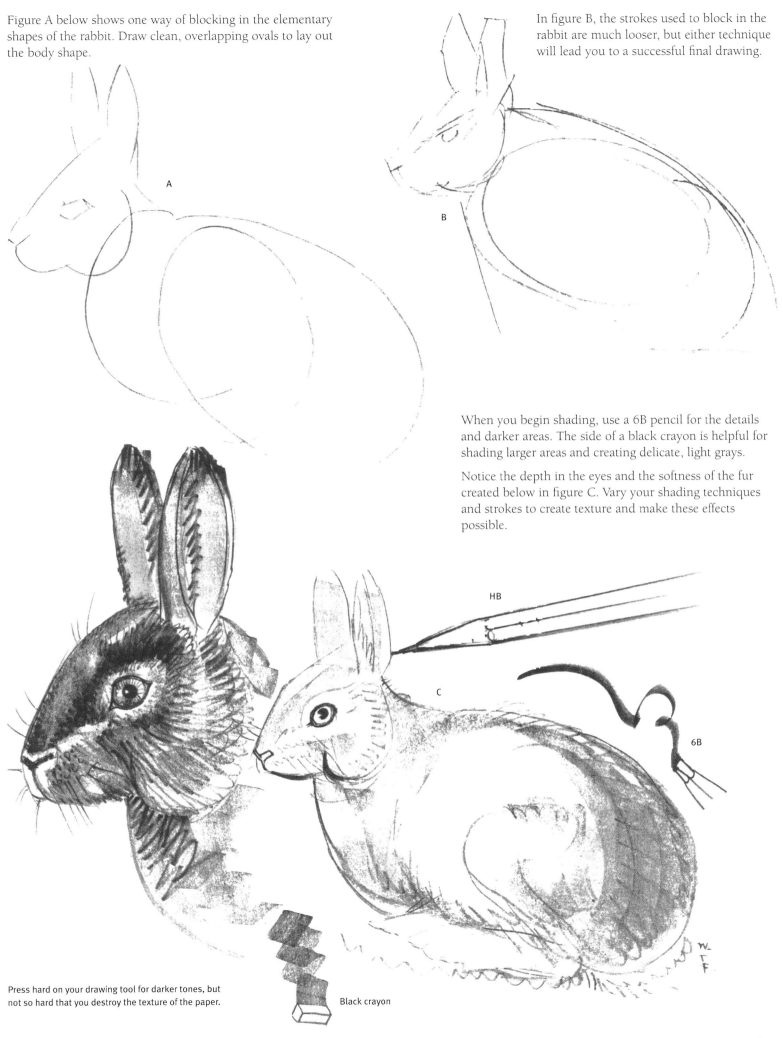

Figure A below shows one way of blocking in the elementary shapes of the rabbit. Draw clean, overlapping ovals to lay out the body shape.

A

In figure B, the strokes used to block in the rabbit are much looser, but either technique will lead you to a successful final drawing.

B

When you begin shading, use a 6B pencil for the details and darker areas. The side of a black crayon is helpful for shading larger areas and creating delicate, light grays.

Notice the depth in the eyes and the softness of the fur created below in figure C. Vary your shading techniques and strokes to create texture and make these effects possible.

HB

C

6B

Press hard on your drawing tool for darker tones, but not so hard that you destroy the texture of the paper.

Black crayon

GUINEA PIG

Step 1 I start by establishing the form of the head and body with two overlapping egg shapes. Then I draw a few guidelines for the features, dividing the face into quadrants and adding a V for the nose.

Step 2 Next, I establish the underlying structure, indicating the legs and paws with a series of ovals. I add the position of the ears and place the eyes just above the horizontal guideline.

Step 3 Now I begin to define the individual toes on the paws. I also suggest the shape of the nasal area with a U-shaped line, and I use small ovals to define the cheek pouches.

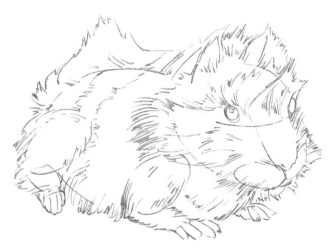

Step 4 I begin to render the thick, furry coat around the basic structure I've already established, applying short strokes of varying thicknesses. It's much easier to work out the direction of fur growth and the overall shape of the animal when you know what is underneath.

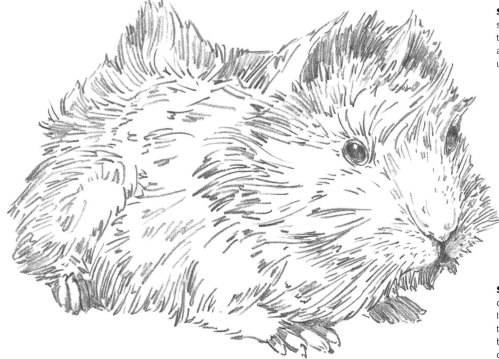

Step 5 Next, I erase any guidelines that I don't need and continue to develop the fur. With the broad side of a pencil, I stroke light shadows around the edges of the guinea pig to suggest its roundness. I keep the drawing simple because the guinea pig's shape is rather vague, concentrating instead on suggesting the tufts of fur.

Squirrel

All animals have beautiful lines—the squirrel is no exception. Here, the overall form of the squirrel is made up of gracefully curved lines flowing together in perfect harmony.

To draw this little fellow, first block in the basic pose in step A. Add the features and details in steps B and C. Shade with the side of a black crayon to bring out the squirrel's form, and use a pencil to create the fur. Try different types of strokes to produce a variety of textures.

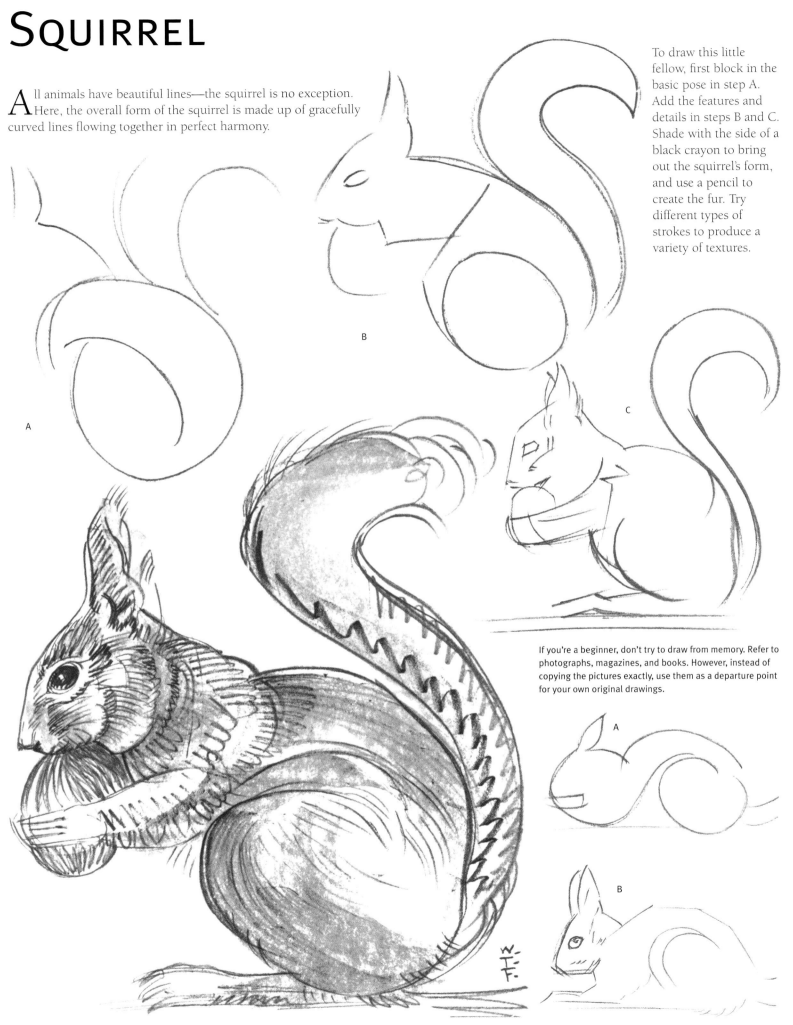

If you're a beginner, don't try to draw from memory. Refer to photographs, magazines, and books. However, instead of copying the pictures exactly, use them as a departure point for your own original drawings.

Kangaroo

With the kangaroo, it's especially important to draw what you see, not what you expect to see. Study the features of the animal to begin. For example, notice that the kangaroo's ears, tail, and feet are disproportionately large in comparison to its other features. Attention to detail will produce a more accurate final drawing.

Step 1 First draw a pear shape for the torso of the kangaroo. Then establish the lower body and hindquarters with two concentric circles. Add an oval to place the head, and then block in the rest of the kangaroo, adding the forelegs, back legs, and long, thick tail.

Step 2 Next, begin to refine and darken the outlines, creating smoother contours and adding a few details to the ears and back feet. Also, start to suggest the short hair with a few strokes along the rump.

Step 3 At this point, draw light outlines to place the eyes, muzzle, nose, and mouth, and start to refine the shapes of the toes on the forelegs. Then start to shade the coat by adding closely placed parallel strokes to the underside.

Step 4 Now erase any remaining guidelines that still show from the initial sketch, and continue to develop the coat texture. Add the suggestion of the muscles under the kangaroo's coat with short, curved strokes. Then complete the details on the claws and face, filling in the eyes and nose. Finally, add a cast shadow, stroking diagonally with the side of an HB pencil.

TOUCAN

Birds come in all shapes, sizes, and textures. This toucan's long, smooth feathers require long, soft strokes. Soft shading is also used to indicate the smooth texture of this bird's beak.

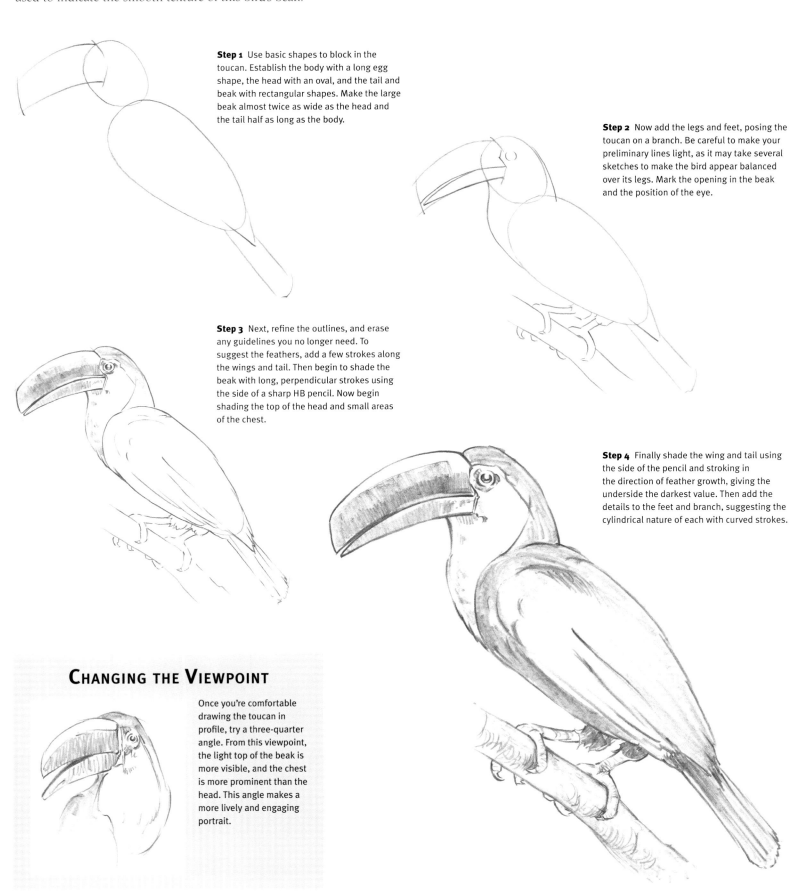

Step 1 Use basic shapes to block in the toucan. Establish the body with a long egg shape, the head with an oval, and the tail and beak with rectangular shapes. Make the large beak almost twice as wide as the head and the tail half as long as the body.

Step 2 Now add the legs and feet, posing the toucan on a branch. Be careful to make your preliminary lines light, as it may take several sketches to make the bird appear balanced over its legs. Mark the opening in the beak and the position of the eye.

Step 3 Next, refine the outlines, and erase any guidelines you no longer need. To suggest the feathers, add a few strokes along the wings and tail. Then begin to shade the beak with long, perpendicular strokes using the side of a sharp HB pencil. Now begin shading the top of the head and small areas of the chest.

Step 4 Finally shade the wing and tail using the side of the pencil and stroking in the direction of feather growth, giving the underside the darkest value. Then add the details to the feet and branch, suggesting the cylindrical nature of each with curved strokes.

CHANGING THE VIEWPOINT

Once you're comfortable drawing the toucan in profile, try a three-quarter angle. From this viewpoint, the light top of the beak is more visible, and the chest is more prominent than the head. This angle makes a more lively and engaging portrait.

BUDGERIGARS

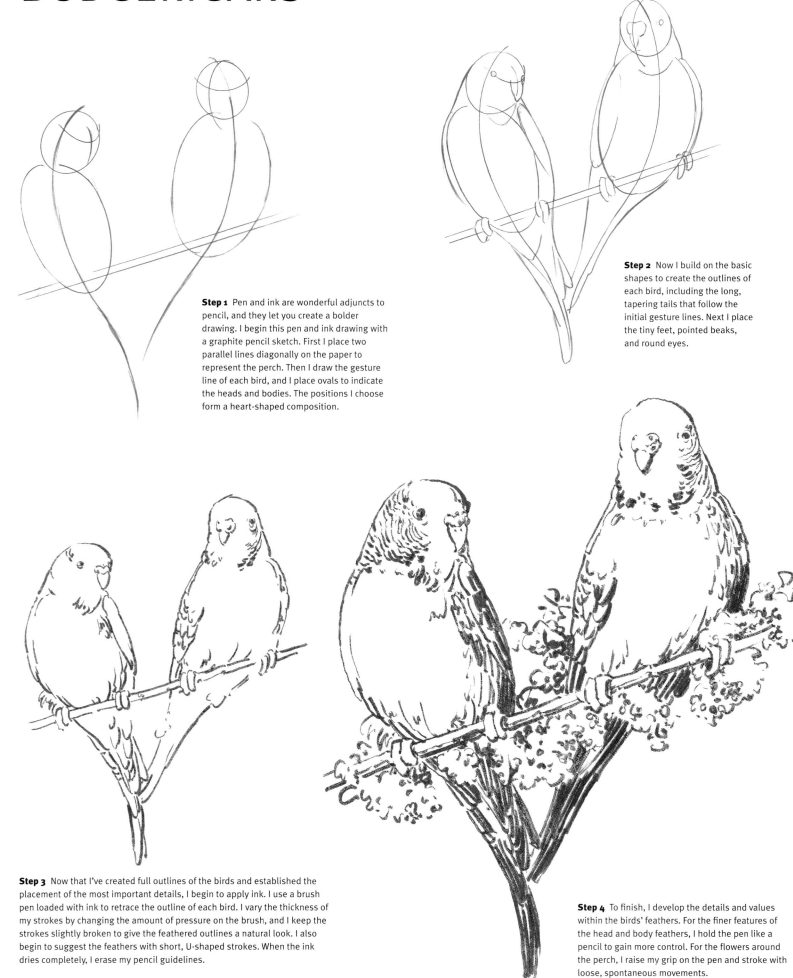

Step 1 Pen and ink are wonderful adjuncts to pencil, and they let you create a bolder drawing. I begin this pen and ink drawing with a graphite pencil sketch. First I place two parallel lines diagonally on the paper to represent the perch. Then I draw the gesture line of each bird, and I place ovals to indicate the heads and bodies. The positions I choose form a heart-shaped composition.

Step 2 Now I build on the basic shapes to create the outlines of each bird, including the long, tapering tails that follow the initial gesture lines. Next I place the tiny feet, pointed beaks, and round eyes.

Step 3 Now that I've created full outlines of the birds and established the placement of the most important details, I begin to apply ink. I use a brush pen loaded with ink to retrace the outline of each bird. I vary the thickness of my strokes by changing the amount of pressure on the brush, and I keep the strokes slightly broken to give the feathered outlines a natural look. I also begin to suggest the feathers with short, U-shaped strokes. When the ink dries completely, I erase my pencil guidelines.

Step 4 To finish, I develop the details and values within the birds' feathers. For the finer features of the head and body feathers, I hold the pen like a pencil to gain more control. For the flowers around the perch, I raise my grip on the pen and stroke with loose, spontaneous movements.

Iguana

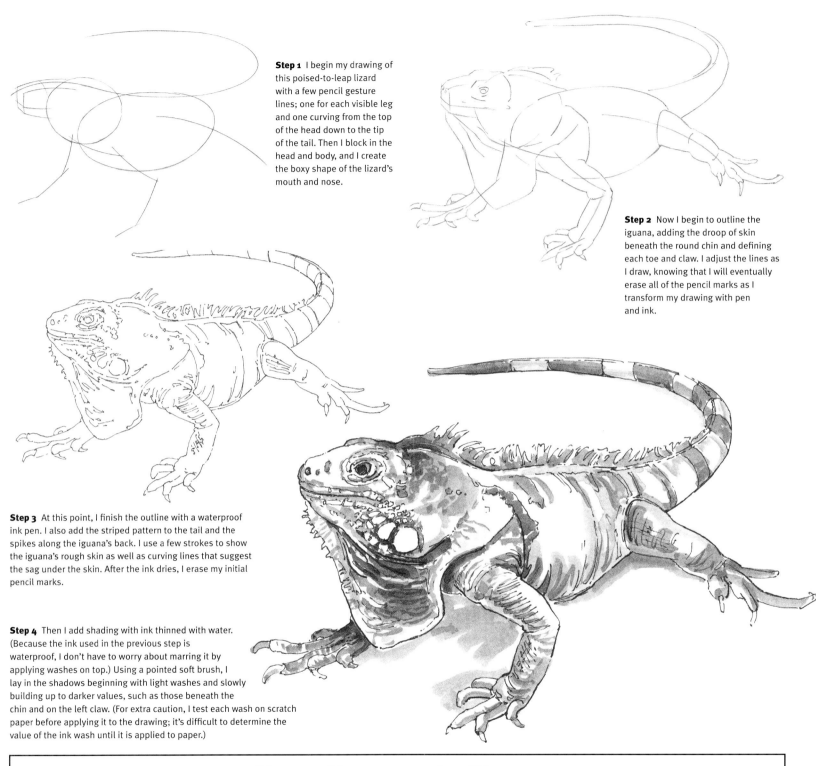

Step 1 I begin my drawing of this poised-to-leap lizard with a few pencil gesture lines; one for each visible leg and one curving from the top of the head down to the tip of the tail. Then I block in the head and body, and I create the boxy shape of the lizard's mouth and nose.

Step 2 Now I begin to outline the iguana, adding the droop of skin beneath the round chin and defining each toe and claw. I adjust the lines as I draw, knowing that I will eventually erase all of the pencil marks as I transform my drawing with pen and ink.

Step 3 At this point, I finish the outline with a waterproof ink pen. I also add the striped pattern to the tail and the spikes along the iguana's back. I use a few strokes to show the iguana's rough skin as well as curving lines that suggest the sag under the skin. After the ink dries, I erase my initial pencil marks.

Step 4 Then I add shading with ink thinned with water. (Because the ink used in the previous step is waterproof, I don't have to worry about marring it by applying washes on top.) Using a pointed soft brush, I lay in the shadows beginning with light washes and slowly building up to darker values, such as those beneath the chin and on the left claw. (For extra caution, I test each wash on scratch paper before applying it to the drawing; it's difficult to determine the value of the ink wash until it is applied to paper.)

VARYING VALUES WITH INK WASHES

Simply adjusting the amount of water you use in your ink washes can provide a variety of different values. When creating a wash, it is best to start with the lightest value and build up to a darker wash rather than adding water to a dark wash. To get acquainted with the process of mixing various values, create a value chart like the one above. Start with a very diluted wash at the left, and gradually add more pigment for successively darker values.

GIRAFFE

Accurate proportions are important when drawing the giraffe; when blocking in your drawing, consider how making the legs too short or the neck too thick could alter the animal's appearance. Use the head as a unit of measurement to draw the rest of the body in correct proportion; for example, pay attention to how many heads long the legs and neck are.

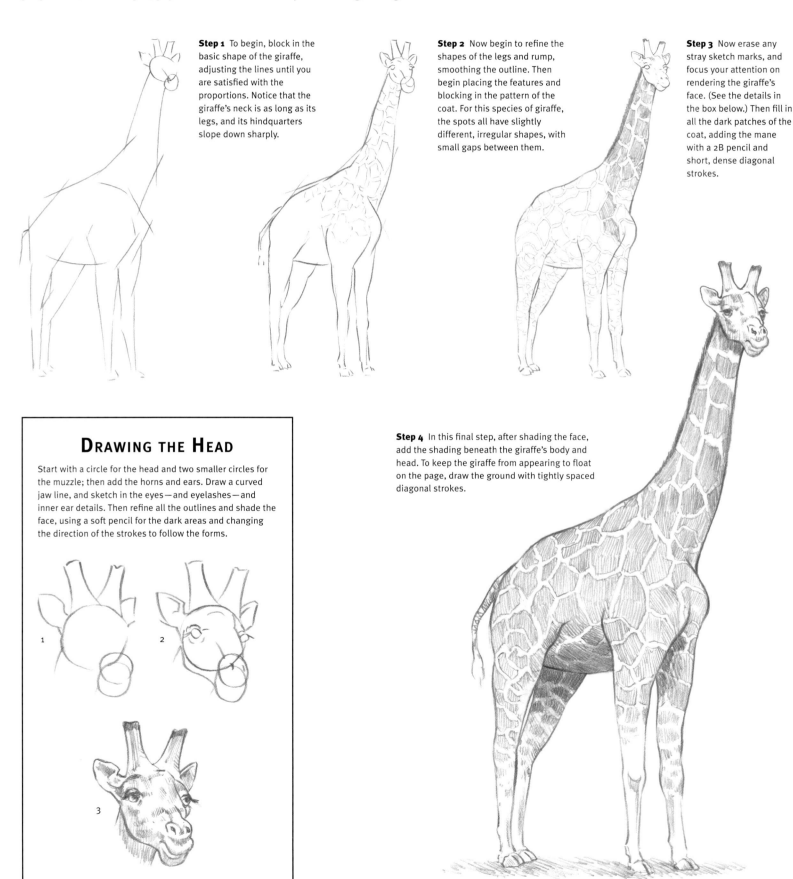

Step 1 To begin, block in the basic shape of the giraffe, adjusting the lines until you are satisfied with the proportions. Notice that the giraffe's neck is as long as its legs, and its hindquarters slope down sharply.

Step 2 Now begin to refine the shapes of the legs and rump, smoothing the outline. Then begin placing the features and blocking in the pattern of the coat. For this species of giraffe, the spots all have slightly different, irregular shapes, with small gaps between them.

Step 3 Now erase any stray sketch marks, and focus your attention on rendering the giraffe's face. (See the details in the box below.) Then fill in all the dark patches of the coat, adding the mane with a 2B pencil and short, dense diagonal strokes.

DRAWING THE HEAD

Start with a circle for the head and two smaller circles for the muzzle; then add the horns and ears. Draw a curved jaw line, and sketch in the eyes—and eyelashes—and inner ear details. Then refine all the outlines and shade the face, using a soft pencil for the dark areas and changing the direction of the strokes to follow the forms.

Step 4 In this final step, after shading the face, add the shading beneath the giraffe's body and head. To keep the giraffe from appearing to float on the page, draw the ground with tightly spaced diagonal strokes.

ELEPHANT

This elephant makes a simple subject because even its details are larger than average! Use simple shading to indicate its ridged tusk, wrinkled body, smooth tusks, and bent tail.

Step 1 Begin drawing the elephant with large, overlapping circles and ovals to place the elephant's head and establish the general bulk of the body.

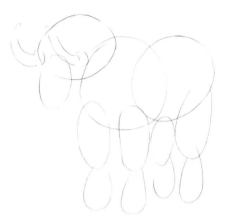

Step 2 Next draw thin, vertical ovals to indicate the legs and the widest part of the trunk. Then draw the curved shapes of the tusks on either side of the base of the trunk.

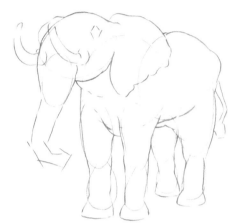

Step 3 Now, using the basic shapes as a guide, draw the outline of the elephant's body, ears, head, and legs as shown. Then sketch the shape of the trunk and the general outline of the tail.

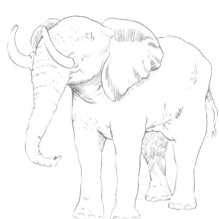

Step 4 Now refine the outlines, and erase any guidelines that remain. Then apply shading to the neck, ears, tail, and legs, reserving the darkest applications for the final step. Use short strokes to suggest the wrinkles on the trunk and some folds of skin on the body.

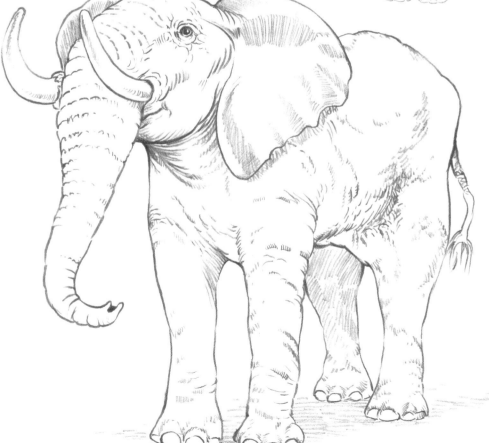

Step 5 Using a 2B pencil, reinforce the darkest shadows, such as on the tail and beneath the head. Then fill in the detail of the eye, leaving a small spot unshaded for the highlight. Finally, finish developing the shading and texture of the elephant, and then add a light cast shadow around the feet to anchor the elephant to the ground.

Baboon

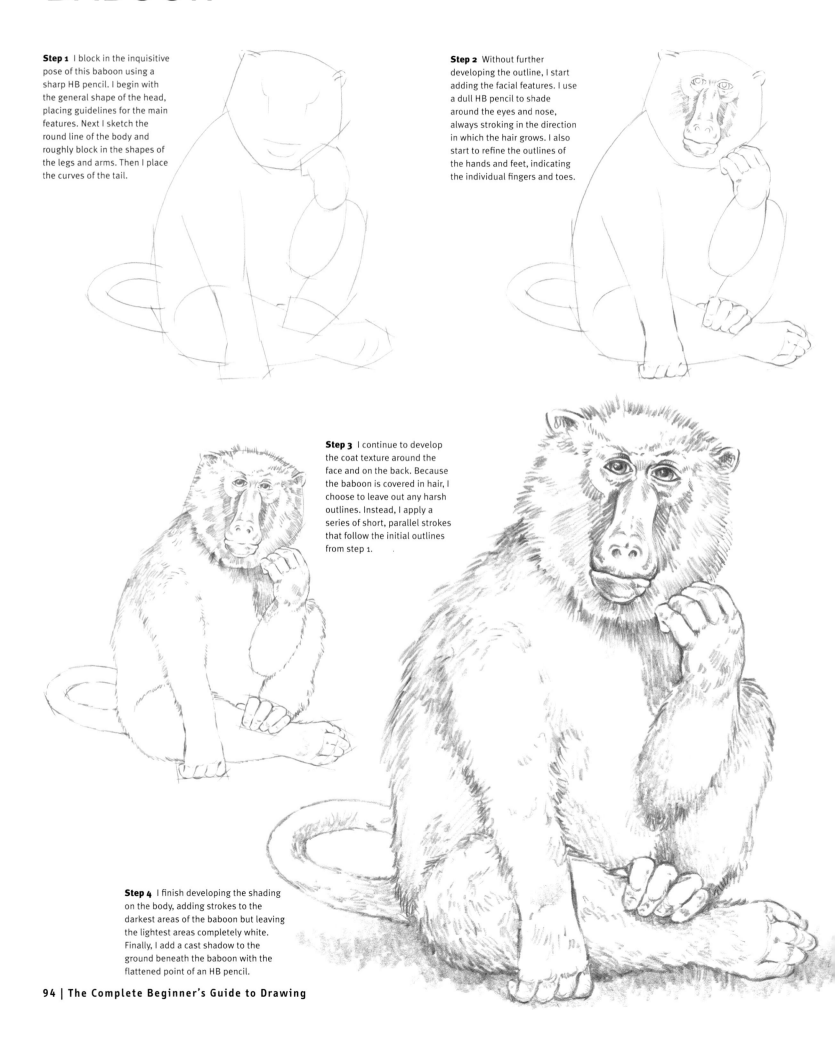

Step 1 I block in the inquisitive pose of this baboon using a sharp HB pencil. I begin with the general shape of the head, placing guidelines for the main features. Next I sketch the round line of the body and roughly block in the shapes of the legs and arms. Then I place the curves of the tail.

Step 2 Without further developing the outline, I start adding the facial features. I use a dull HB pencil to shade around the eyes and nose, always stroking in the direction in which the hair grows. I also start to refine the outlines of the hands and feet, indicating the individual fingers and toes.

Step 3 I continue to develop the coat texture around the face and on the back. Because the baboon is covered in hair, I choose to leave out any harsh outlines. Instead, I apply a series of short, parallel strokes that follow the initial outlines from step 1.

Step 4 I finish developing the shading on the body, adding strokes to the darkest areas of the baboon but leaving the lightest areas completely white. Finally, I add a cast shadow to the ground beneath the baboon with the flattened point of an HB pencil.

Giant Panda

Pandas are an easy subject to approach when you begin with simple shapes. Start with circles for the head and body; then add ovals for the arms, legs, and paws. Add the details, such as the eyes, nose, and bamboo leaves. Then use soft, short strokes to indicate the texture of the panda's thick black-and-white fur.

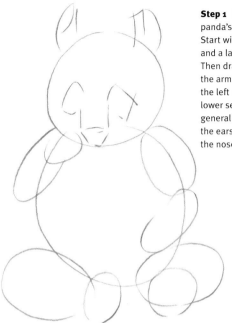

Step 1 First establish the panda's overall shape and pose. Start with a circle for the head and a larger oval for the body. Then draw a series of ovals for the arms, legs, and feet, dividing the left arm into upper and lower sections. Also mark the general shape and position of the ears, the eye mask, and the nose.

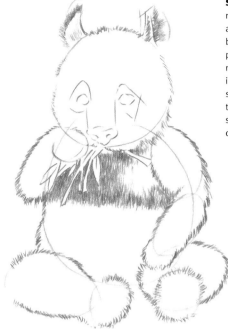

Step 2 Next place the eyes, refine the shape of the nose, and sketch in the branch of bamboo. Use the side of a soft pencil to make short, soft marks around the outlines to indicate fur. Then begin shading all the black areas on the coat with an HB pencil, stroking downward in the direction of the hair growth.

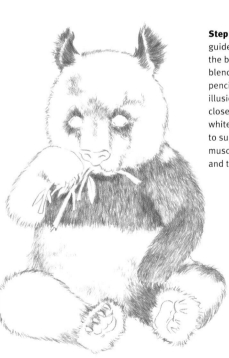

Step 3 Now erase any remaining guidelines, and continue shading the black areas of fur. Then use a blending stump to smooth the pencil strokes, creating the illusion of soft fur. Add a few closely spaced strokes in the white fur to give it dimension and to suggest the underlying muscles. Then draw the footpads and toenails.

Step 4 Continue to develop the shading with soft, short strokes to show the fur's texture. Also, keep building up the panda's form by varying the shading of the fur. For example, darken the areas between the arms and the body as well as the areas on the legs that are closest to the ground. Finally, add the details to finish the feet, claws, nose, and eyes.

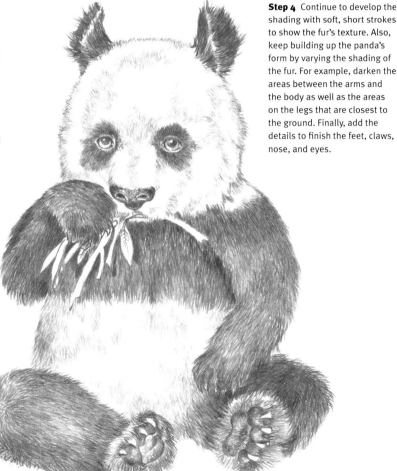

Chimpanzees

Step 1 With circular strokes and a sharp HB pencil, I build the basic form of each chimp's body. Note that, unlike humans, chimpanzees have longer arms than legs.

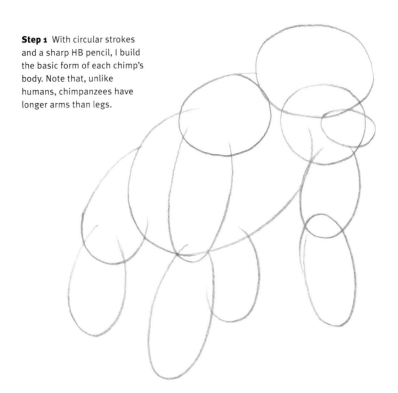

Step 2 Next, I block in the feet and hands with straight lines. I also mark the placement of the facial features, sketching in the outlines of the mouth, eyes, brow, and ears.

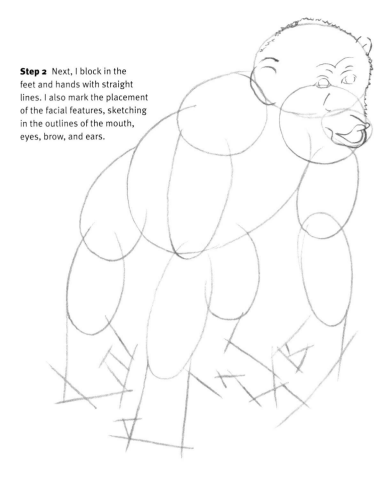

Step 3 At this point, I soften the outlines of the chimps with uneven, curved strokes and dashes. The outlines should not be solid and smooth; they should suggest the hairy texture of the chimp's coat. I also draw the hands and feet inside the guidelines from step two.

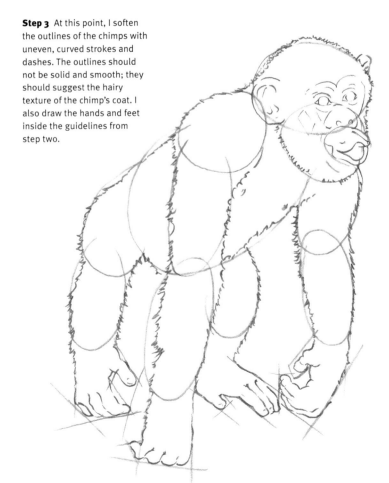

Step 4 Now I erase any initial guidelines that still show, and I begin shading in the chimps' dark coats with a soft pencil. I apply short strokes that follow the direction of the hair growth, adding fewer lines to the highlighted areas and more to the shadows and creases.

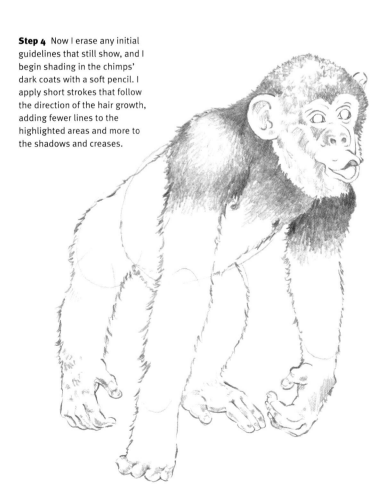

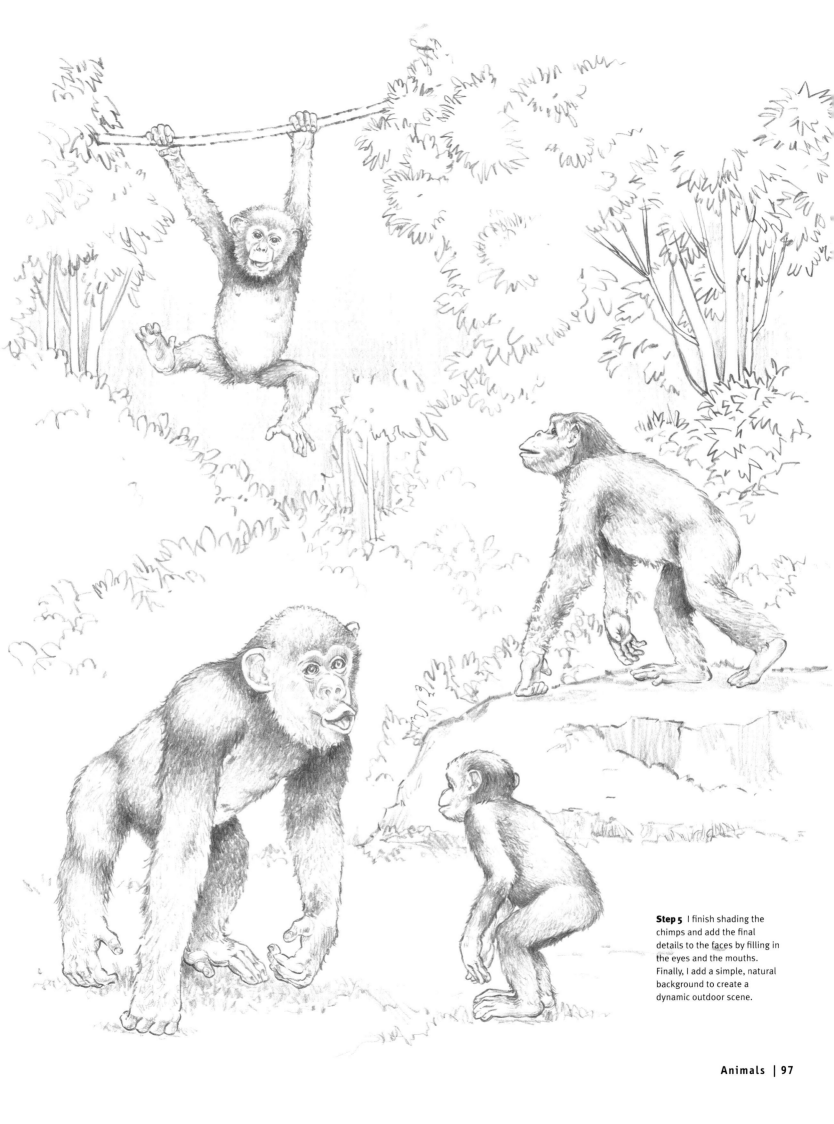

Step 5 I finish shading the chimps and add the final details to the faces by filling in the eyes and the mouths. Finally, I add a simple, natural background to create a dynamic outdoor scene.

Parrot

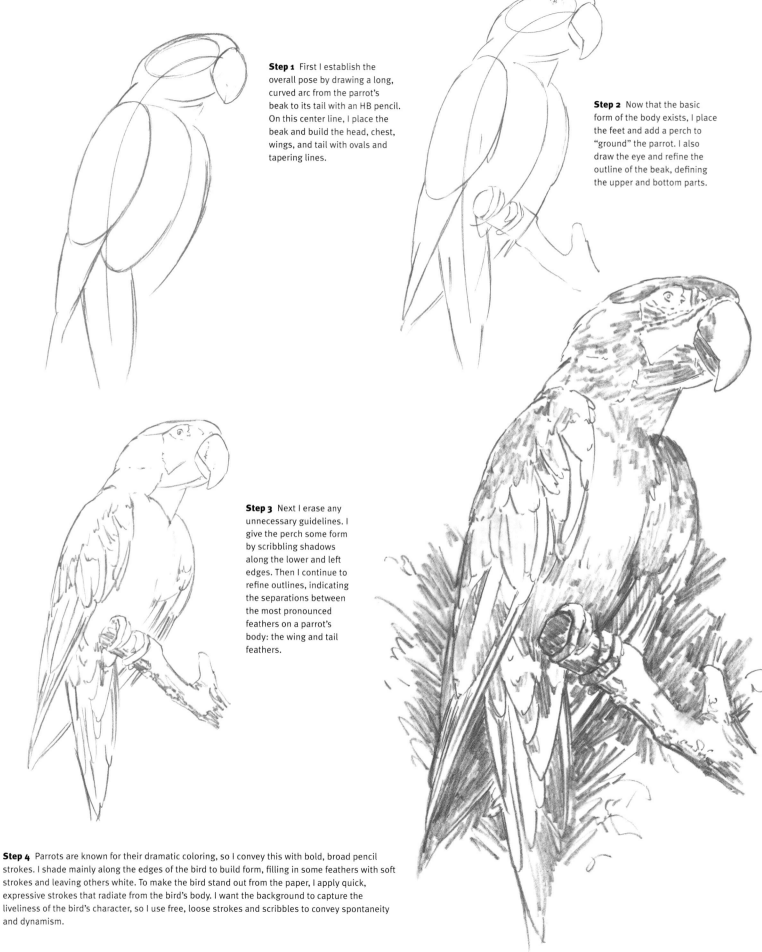

Step 1 First I establish the overall pose by drawing a long, curved arc from the parrot's beak to its tail with an HB pencil. On this center line, I place the beak and build the head, chest, wings, and tail with ovals and tapering lines.

Step 2 Now that the basic form of the body exists, I place the feet and add a perch to "ground" the parrot. I also draw the eye and refine the outline of the beak, defining the upper and bottom parts.

Step 3 Next I erase any unnecessary guidelines. I give the perch some form by scribbling shadows along the lower and left edges. Then I continue to refine outlines, indicating the separations between the most pronounced feathers on a parrot's body: the wing and tail feathers.

Step 4 Parrots are known for their dramatic coloring, so I convey this with bold, broad pencil strokes. I shade mainly along the edges of the bird to build form, filling in some feathers with soft strokes and leaving others white. To make the bird stand out from the paper, I apply quick, expressive strokes that radiate from the bird's body. I want the background to capture the liveliness of the bird's character, so I use free, loose strokes and scribbles to convey spontaneity and dynamism.

CATS

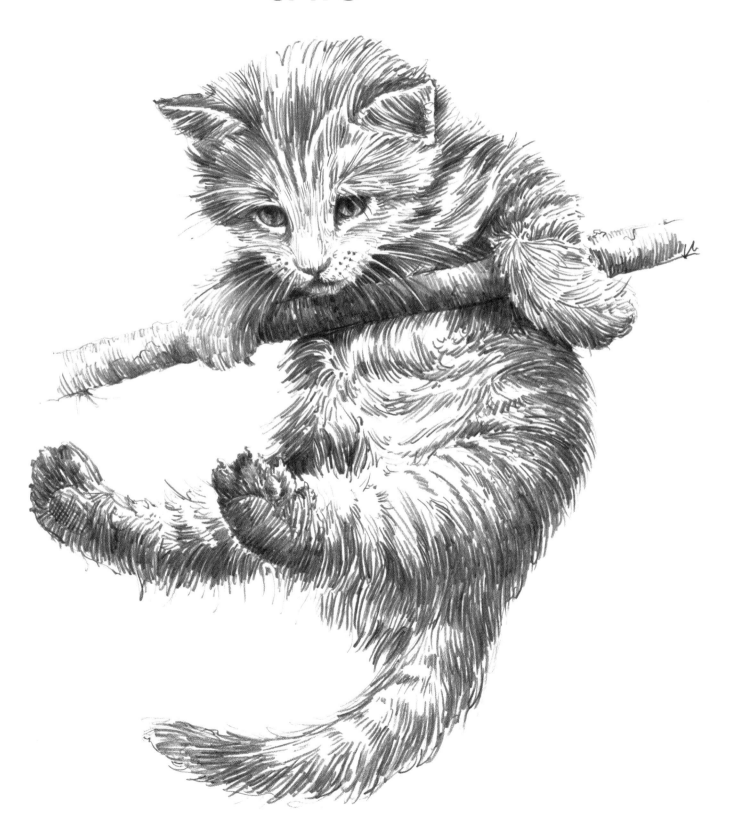

Rendering Cats

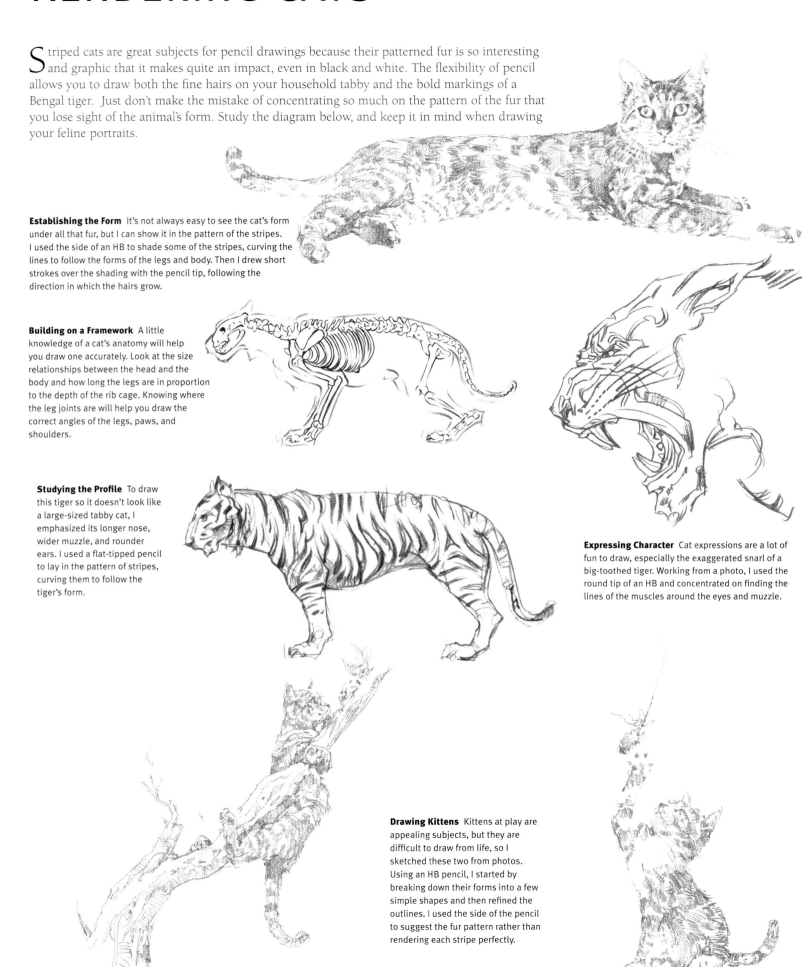

Striped cats are great subjects for pencil drawings because their patterned fur is so interesting and graphic that it makes quite an impact, even in black and white. The flexibility of pencil allows you to draw both the fine hairs on your household tabby and the bold markings of a Bengal tiger. Just don't make the mistake of concentrating so much on the pattern of the fur that you lose sight of the animal's form. Study the diagram below, and keep it in mind when drawing your feline portraits.

Establishing the Form It's not always easy to see the cat's form under all that fur, but I can show it in the pattern of the stripes. I used the side of an HB to shade some of the stripes, curving the lines to follow the forms of the legs and body. Then I drew short strokes over the shading with the pencil tip, following the direction in which the hairs grow.

Building on a Framework A little knowledge of a cat's anatomy will help you draw one accurately. Look at the size relationships between the head and the body and how long the legs are in proportion to the depth of the rib cage. Knowing where the leg joints are will help you draw the correct angles of the legs, paws, and shoulders.

Studying the Profile To draw this tiger so it doesn't look like a large-sized tabby cat, I emphasized its longer nose, wider muzzle, and rounder ears. I used a flat-tipped pencil to lay in the pattern of stripes, curving them to follow the tiger's form.

Expressing Character Cat expressions are a lot of fun to draw, especially the exaggerated snarl of a big-toothed tiger. Working from a photo, I used the round tip of an HB and concentrated on finding the lines of the muscles around the eyes and muzzle.

Drawing Kittens Kittens at play are appealing subjects, but they are difficult to draw from life, so I sketched these two from photos. Using an HB pencil, I started by breaking down their forms into a few simple shapes and then refined the outlines. I used the side of the pencil to suggest the fur pattern rather than rendering each stripe perfectly.

Foreshortening Unless you are viewing your subject in profile, one part will always be closer to you. The drawing technique called "foreshortening" allows you to create the illusion of depth by shortening the part of an object that is coming toward you. In this drawing of a tiger, notice how I foreshortened the cat's front legs and body. If he were standing, there would be much more distance between his paws and his chest, and his head certainly would not be sitting in the middle of his body! By distorting the proportions this way, I was able to convey a sense of depth and perspective.

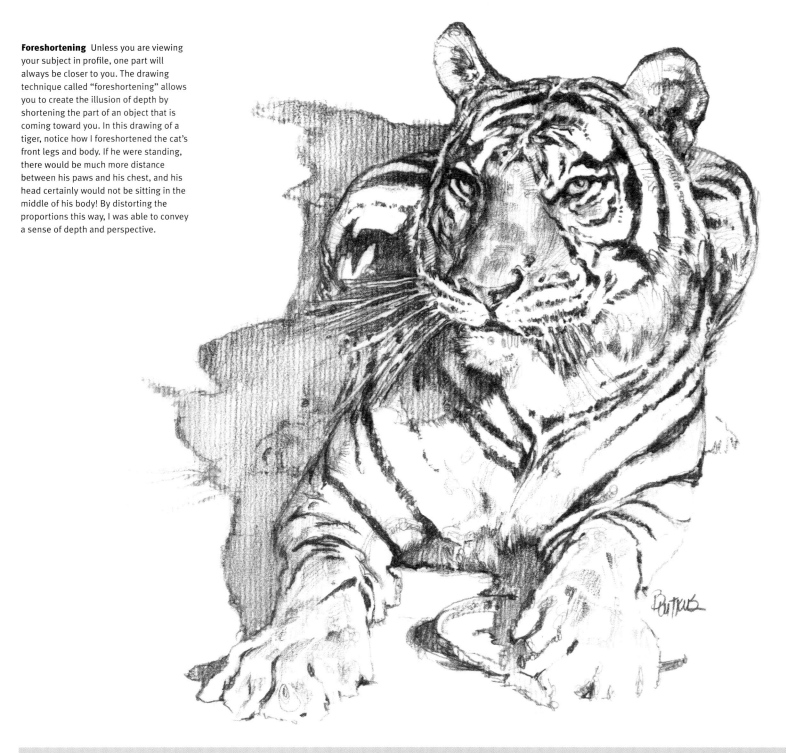

DEPICTING CAT FUR PATTERNS

Tabby Cat Tabbies have distinctive striped fur. Shade in the undercoat with the side of an HB. Draw the coat pattern using a 2B with a rounded point, and smudge to soften.

Ocelot Ocelots have variegated spots. Lightly place the overall pattern with the side of an HB. Use a sharp, pointed 2B to add the darker outlines. Vary the pressure for value changes.

Cheetah This cat's spots are smaller than an ocelot's and look more solidly black. Use a sharp, pointed HB, and vary the pressure as you stroke and then lift the pencil, creating soft edges.

Leopard Leopard spots have a definite rosette pattern. Apply short strokes using the sharpened point of an HB. Darken here and there with pressure variation and the point of a 2B.

FELINE FEATURES

Cats have very distinctive features, and the features vary between individuals and among breeds. Look carefully at your subject. Notice the general shape, proportion, and position of each feature and how each one relates to the others. These details make each cat unique. You may want to practice drawing the features separately before attempting a complete rendering.

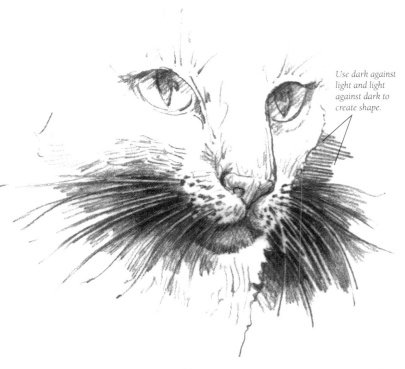

Use dark against light and light against dark to create shape.

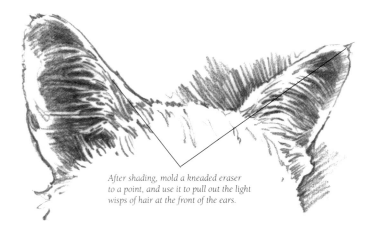

After shading, mold a kneaded eraser to a point, and use it to pull out the light wisps of hair at the front of the ears.

To draw the ear, first block in the general triangular shape with an HB pencil. Then observe your subject, and refine the shape. Compare the shape of the outer edge to that of the inner edge; note the angles and where each side meets the head. Once satisfied with the outline, use a soft lead pencil to create the three-dimensional form of the ear.

The cat's whiskers are long, stiff hairs that are very sensitive to touch. Draw the whiskers in the direction of growth with long, sweeping strokes. Use a sharp pencil to draw the whiskers on a light background, or try an eraser to pull them out of a dark background. Don't forget to add the dark hair follicles around the cat's muzzle.

Sketch the eye as a circle, tilted up at the outer corner. After roughing in the general shape, concentrate on rendering the eyeball and the hair surrounding the eye. Add layers of shading with a soft lead pencil to create depth. Remember always to leave a white highlight in or near the pupil to indicate the reflected light.

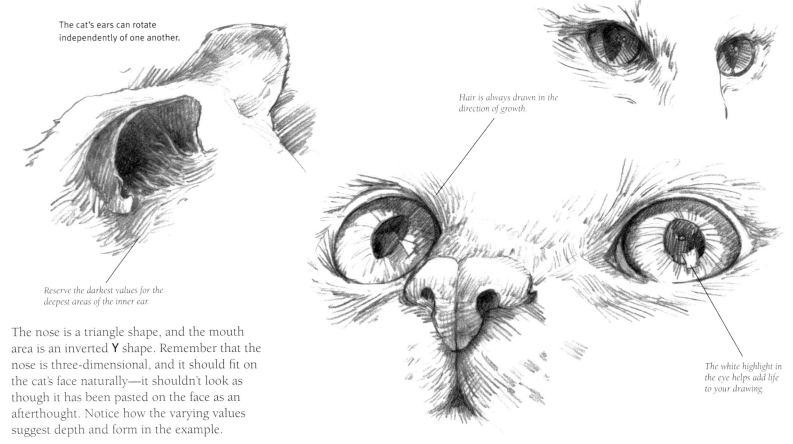

The cat's ears can rotate independently of one another.

Reserve the darkest values for the deepest areas of the inner ear.

Hair is always drawn in the direction of growth.

The white highlight in the eye helps add life to your drawing.

The nose is a triangle shape, and the mouth area is an inverted **Y** shape. Remember that the nose is three-dimensional, and it should fit on the cat's face naturally—it shouldn't look as though it has been pasted on the face as an afterthought. Notice how the varying values suggest depth and form in the example.

PAWS & TAILS

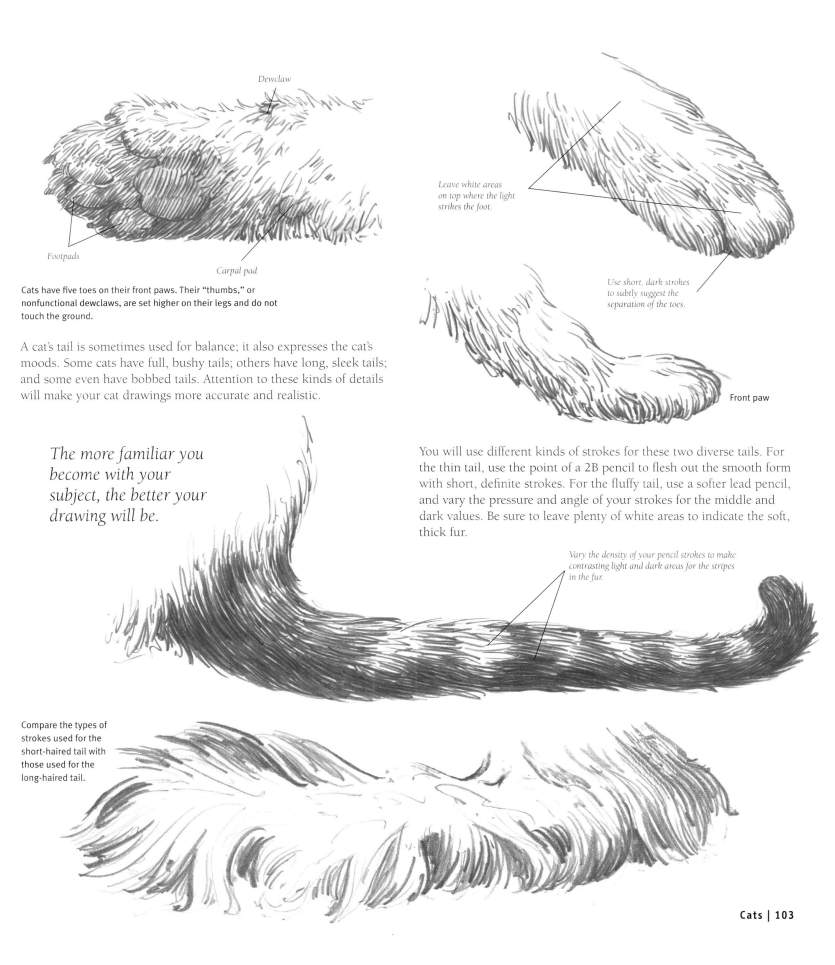

Dewclaw

Footpads

Carpal pad

Cats have five toes on their front paws. Their "thumbs," or nonfunctional dewclaws, are set higher on their legs and do not touch the ground.

A cat's tail is sometimes used for balance; it also expresses the cat's moods. Some cats have full, bushy tails; others have long, sleek tails; and some even have bobbed tails. Attention to these kinds of details will make your cat drawings more accurate and realistic.

Leave white areas on top where the light strikes the foot.

Use short, dark strokes to subtly suggest the separation of the toes.

Front paw

The more familiar you become with your subject, the better your drawing will be.

You will use different kinds of strokes for these two diverse tails. For the thin tail, use the point of a 2B pencil to flesh out the smooth form with short, definite strokes. For the fluffy tail, use a softer lead pencil, and vary the pressure and angle of your strokes for the middle and dark values. Be sure to leave plenty of white areas to indicate the soft, thick fur.

Vary the density of your pencil strokes to make contrasting light and dark areas for the stripes in the fur.

Compare the types of strokes used for the short-haired tail with those used for the long-haired tail.

TABBY CAT

Patterns and textures can add interest to an otherwise ordinary subject. For this sketch, the pairing of a ridged carpet and striped cat produces an eye-catching study in contrasts.

Step 1 Begin with a sideways S to establish the cat's gesture line, using a tighter curl for the tail. Then establish the basic shapes using a circle for the head and ovals for the chest, body, and haunches. To create guidelines for the cat's features, center a cross over the face, and add two dashes to indicate the positions of the mouth and nose.

Step 2 Now draw a smaller oval over the cat's stomach, blocking in the bulging fur of its underbelly. Then create the full outline of the cat's body, adding its four legs. Next draw the triangular ears and place the eyes, nose, and mouth.

Step 3 Next go over the outline with short, broken strokes that better depict the fur. In addition, define the toes and paw pads, and add a few lines to suggest the crease at the cat's shoulder. Also add more detail to the face, marking the stripes and filling in the crescent shapes of the pupils.

Step 4 Erase any guidelines you no longer need, and map out the basic tabby pattern of the cat's coat. Use curving lines to suggest the cat's rounded form. Then scribble in the contrasting parallel lines of the carpet, and place the first lines of the ottoman behind the cat.

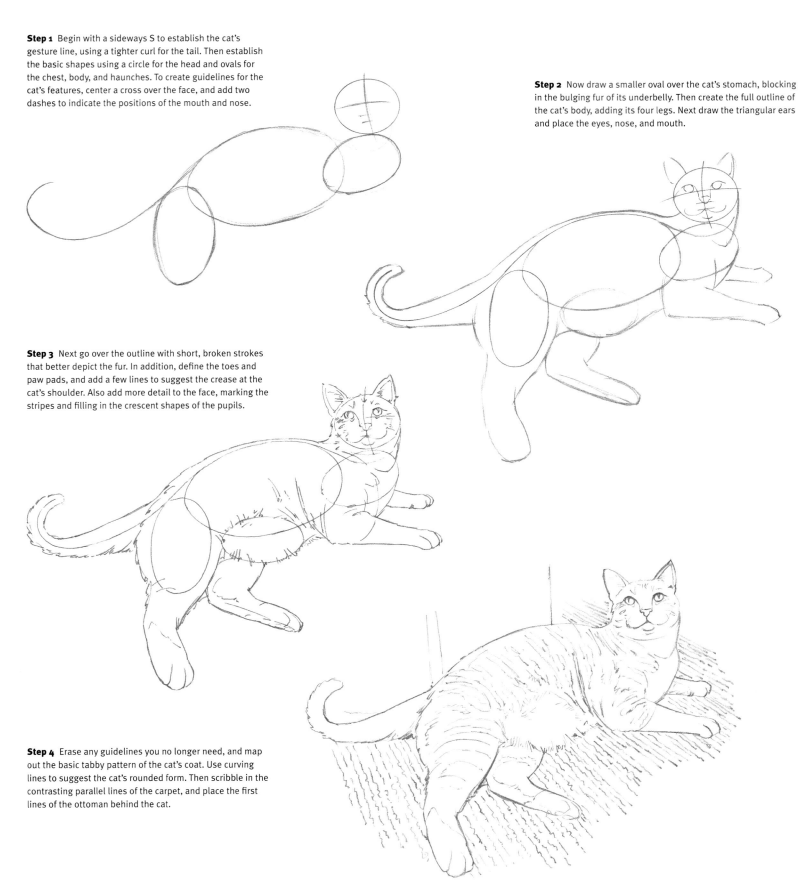

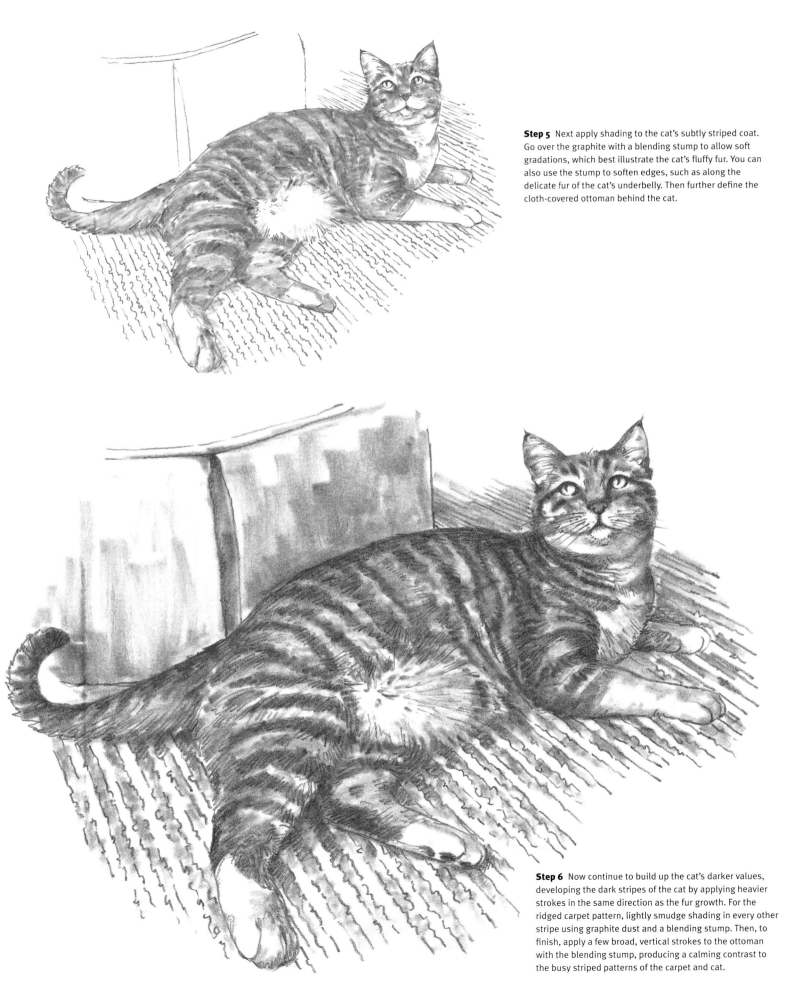

Step 5 Next apply shading to the cat's subtly striped coat. Go over the graphite with a blending stump to allow soft gradations, which best illustrate the cat's fluffy fur. You can also use the stump to soften edges, such as along the delicate fur of the cat's underbelly. Then further define the cloth-covered ottoman behind the cat.

Step 6 Now continue to build up the cat's darker values, developing the dark stripes of the cat by applying heavier strokes in the same direction as the fur growth. For the ridged carpet pattern, lightly smudge shading in every other stripe using graphite dust and a blending stump. Then, to finish, apply a few broad, vertical strokes to the ottoman with the blending stump, producing a calming contrast to the busy striped patterns of the carpet and cat.

PERSIAN CAT

The Persian is a stocky cat with long, silky hair. It has a large, round face with short, broad features and small ears. To depict the quality of this Persian's fur, keep your pencil strokes uniform and deliberate. Notice that this example has been developed much further than the previous examples were.

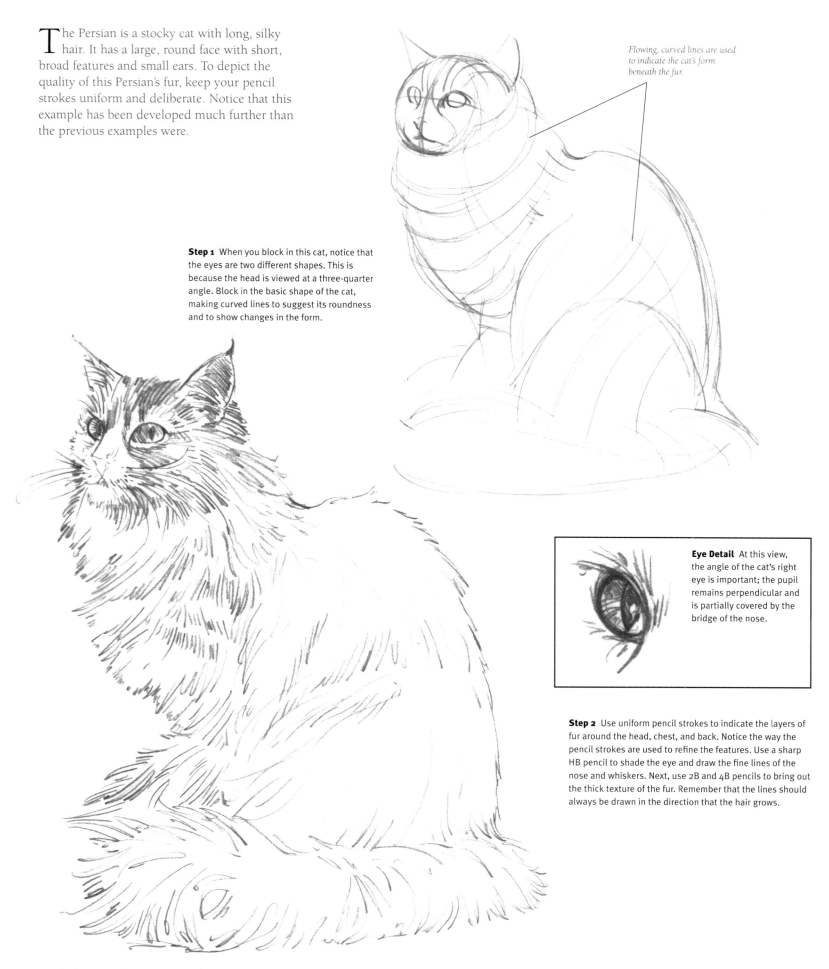

Flowing, curved lines are used to indicate the cat's form beneath the fur.

Step 1 When you block in this cat, notice that the eyes are two different shapes. This is because the head is viewed at a three-quarter angle. Block in the basic shape of the cat, making curved lines to suggest its roundness and to show changes in the form.

Eye Detail At this view, the angle of the cat's right eye is important; the pupil remains perpendicular and is partially covered by the bridge of the nose.

Step 2 Use uniform pencil strokes to indicate the layers of fur around the head, chest, and back. Notice the way the pencil strokes are used to refine the features. Use a sharp HB pencil to shade the eye and draw the fine lines of the nose and whiskers. Next, use 2B and 4B pencils to bring out the thick texture of the fur. Remember that the lines should always be drawn in the direction that the hair grows.

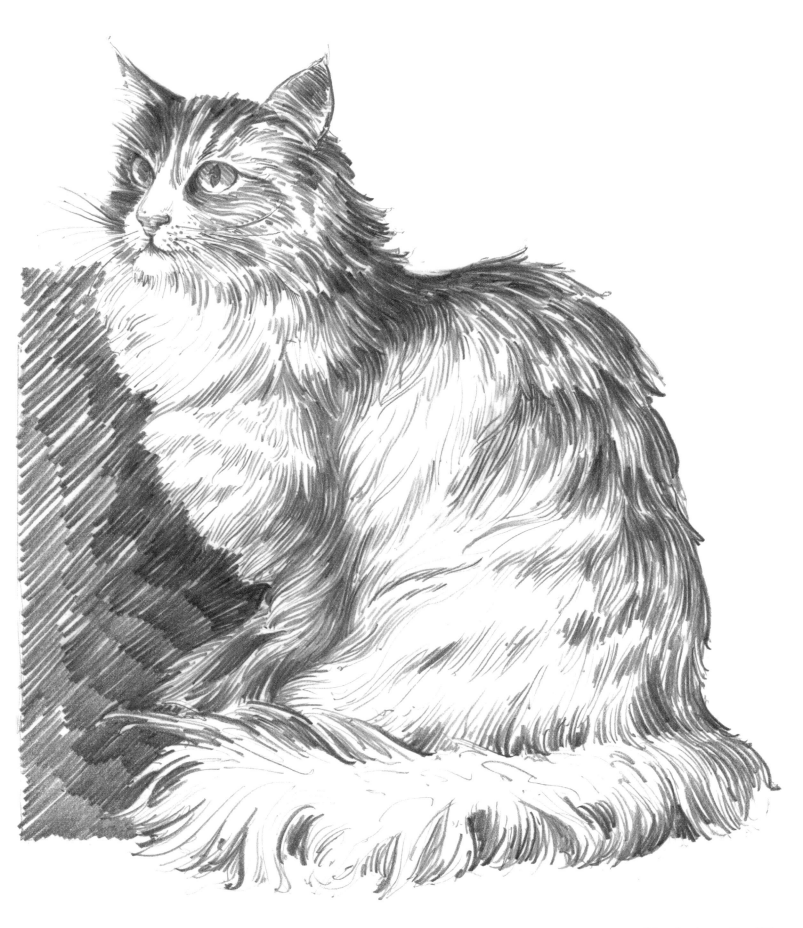

Step 3 The final rendering shows an effective use of contrasting values. The minimal shading in the white areas on the cat's chest and side reflect where the light strikes the coat. The middle values are shown in the fur along the left side of the cat's face and left ear. Use a 4B or 6B pencil for darker strokes along the backbone, neck, right side of the face, and parts of the tail. Notice how the dark background is used to create the shape of the light-colored fur on the cat's chest and tail.

COMPOSITION

This crouching pose is used as an example of how to create an interesting composition. *Composition* is the arrangement of elements of a drawing to form an overall design. An effective composition leads the viewer's eye through the entire rendering, directing attention to the focal point, or interest area. In contrast, a poor composition may direct the viewer's eye right out of the picture!

A

B

In this example, the kitten's face is the focal point of the rendering. When planning a drawing, keep in mind the following tips regarding composition. First, try not to place the focal point in the exact center; notice that the area of interest here is to the right of and below the center of the picture plane. Also, strong contrasts of value (or color) attract the viewer's eye; here, the bright white nose and milk stand out against the dark background. Finally, the lines of the composition should direct attention to the desired location; notice how the kitten's tail and paws lead the eye toward the right and how the milk spilling from the cup guides the eye to the left.

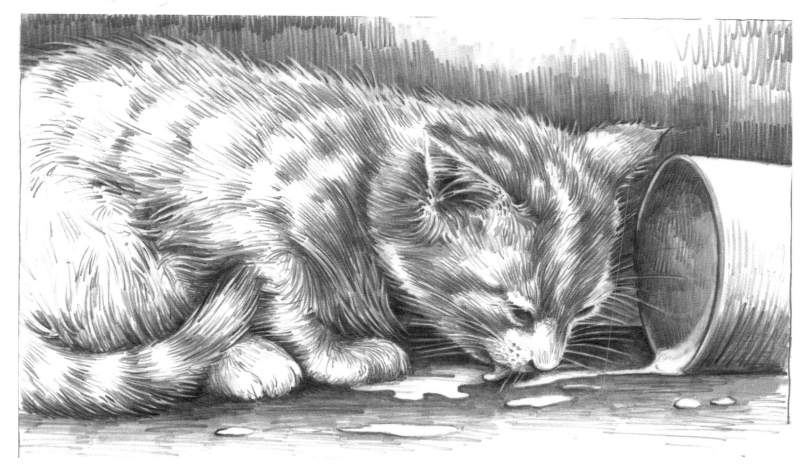

Cats can be amused for hours with toys or movable objects. They are also adept at manipulating inert objects to make them move, just so they can chase and catch them. Try to capture this sense of playfulness in your composition. In this drawing, the interest area is the mass of yarn entangling the kitten's paws. Notice how many different techniques are used to direct attention to this spot. Here, the yarn is created using negative shapes against a dark background. The use of negative space is an effective way not only to create interest but also to delineate form.

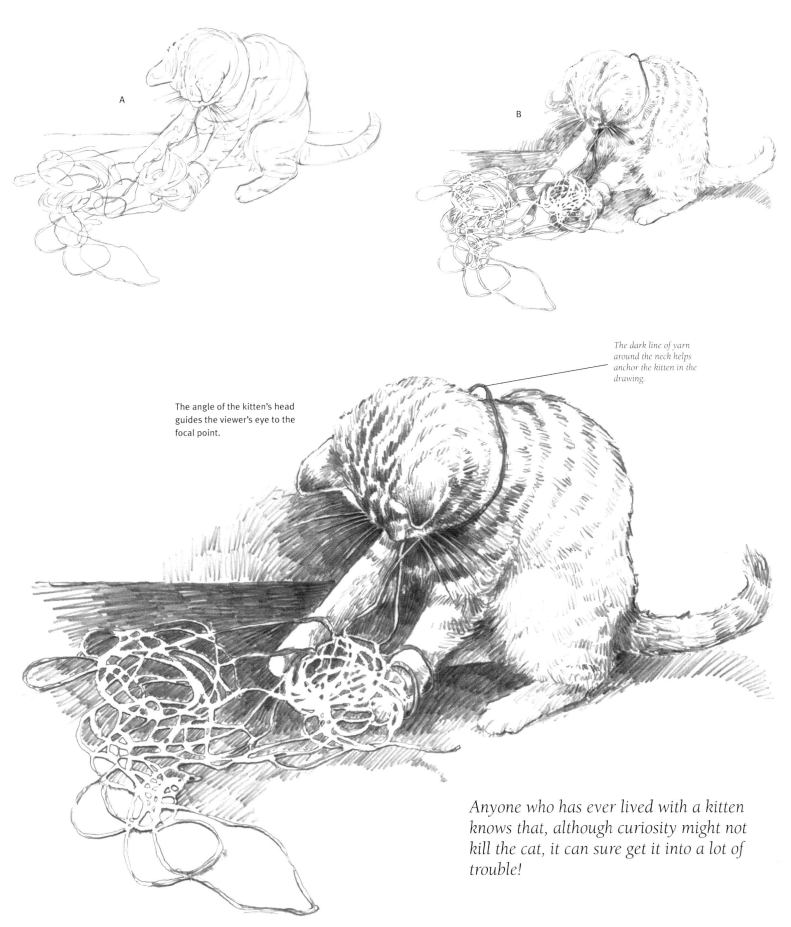

The angle of the kitten's head guides the viewer's eye to the focal point.

The dark line of yarn around the neck helps anchor the kitten in the drawing.

Anyone who has ever lived with a kitten knows that, although curiosity might not kill the cat, it can sure get it into a lot of trouble!

Common Cat Behaviors

Cats love to climb, although this kitten has found itself in a precarious situation. Note that kittens have round, barrel-shaped bodies, whereas adult cats have long, lanky bodies.

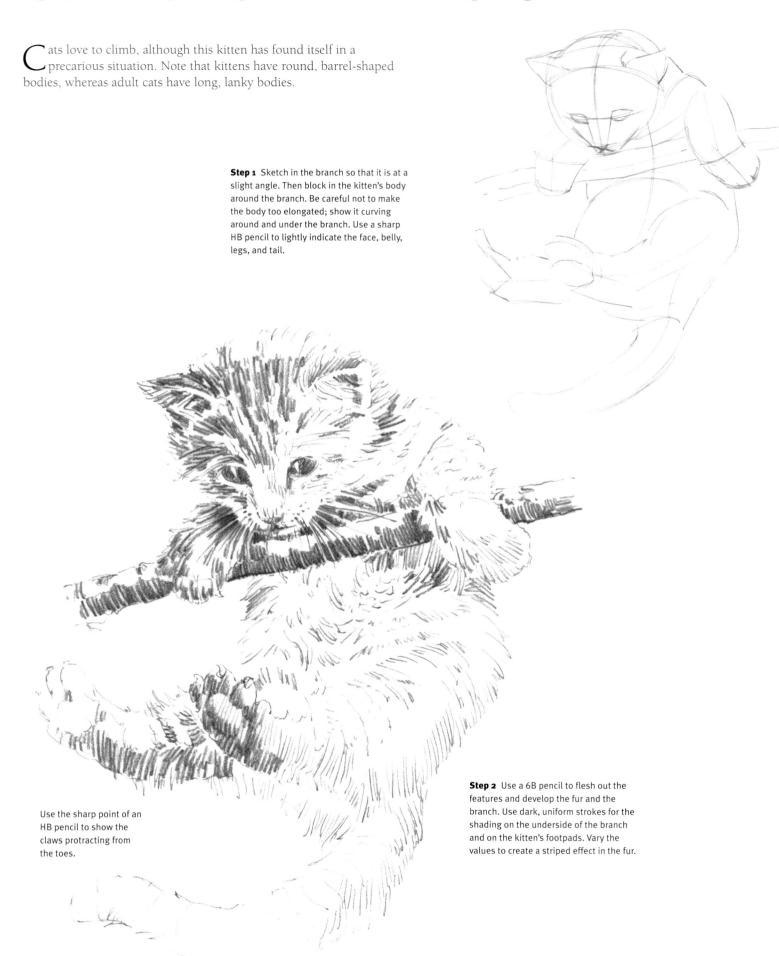

Step 1 Sketch in the branch so that it is at a slight angle. Then block in the kitten's body around the branch. Be careful not to make the body too elongated; show it curving around and under the branch. Use a sharp HB pencil to lightly indicate the face, belly, legs, and tail.

Use the sharp point of an HB pencil to show the claws protracting from the toes.

Step 2 Use a 6B pencil to flesh out the features and develop the fur and the branch. Use dark, uniform strokes for the shading on the underside of the branch and on the kitten's footpads. Vary the values to create a striped effect in the fur.

Step 3 Now develop the rendering to your satisfaction. Use an HB pencil for the whiskers over the eyes and the fine lines around the nose, eyes, and mouth. Continue creating the texture of the kitten's coat by making deliberate strokes of different lengths in the varying directions of fur growth. Remember to leave uniform areas of white to suggest this tabby's stripes.

Notice that the kitten has an expression of determination, not of fear.

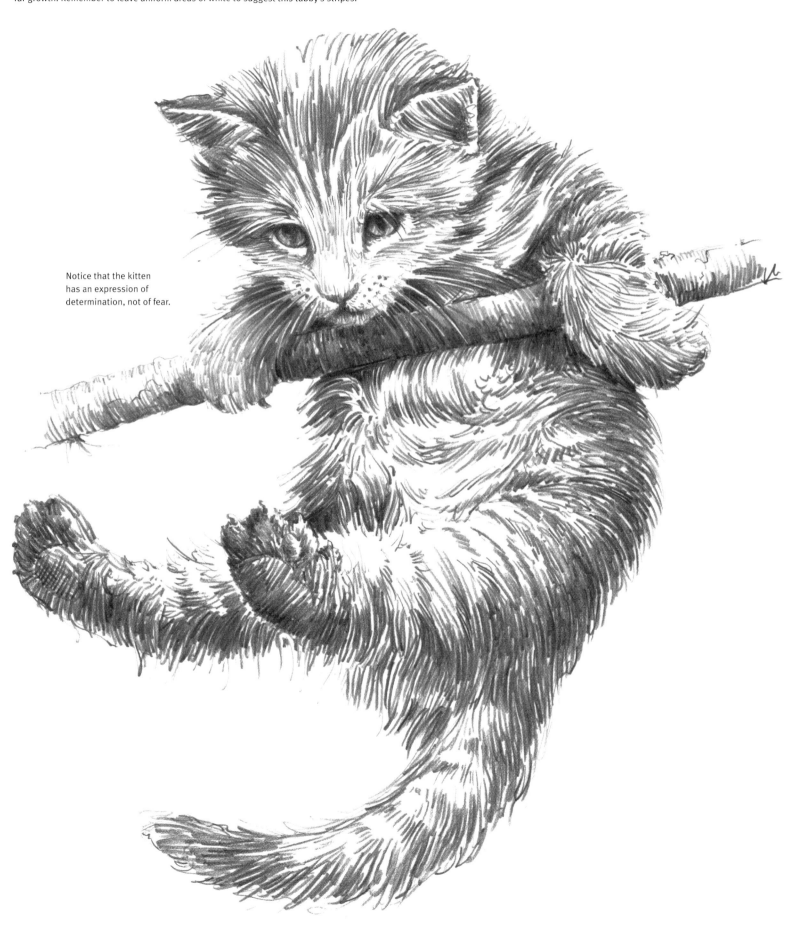

Adult Cats

It sometimes can be difficult to capture a cat's shape when it sits or sleeps. It may stand up and wander away right in the middle of your drawing! Don't worry about always completely finishing your renderings; instead, do quick, spontaneous sketches of the cat's different movements and poses. These quick studies are good practice.

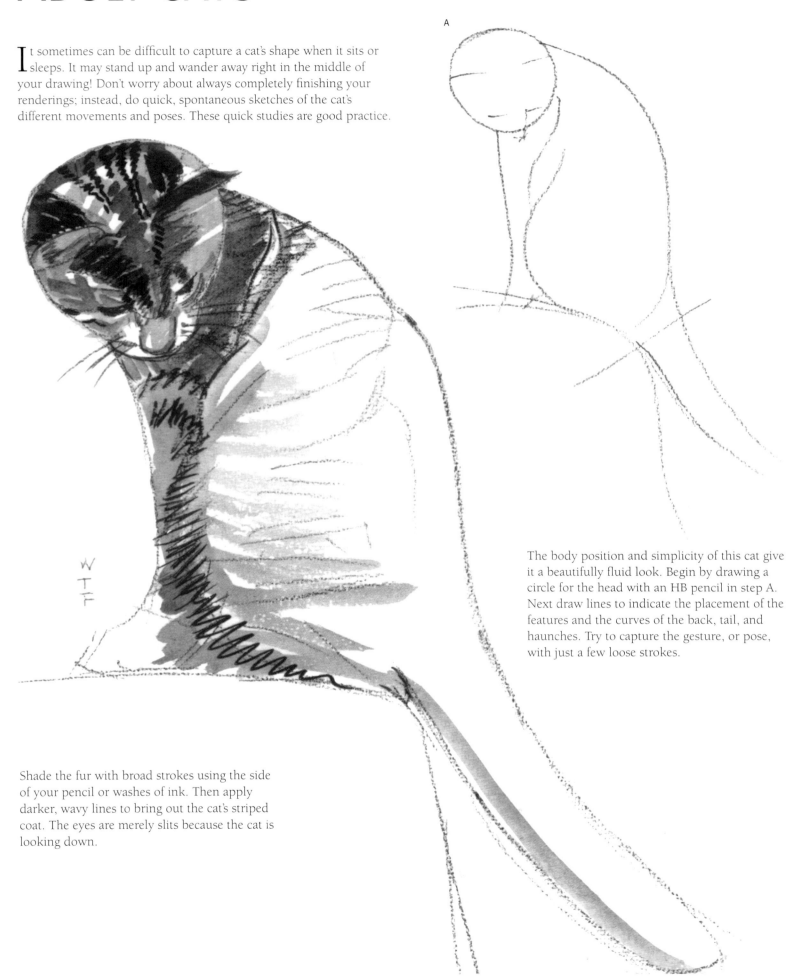

The body position and simplicity of this cat give it a beautifully fluid look. Begin by drawing a circle for the head with an HB pencil in step A. Next draw lines to indicate the placement of the features and the curves of the back, tail, and haunches. Try to capture the gesture, or pose, with just a few loose strokes.

Shade the fur with broad strokes using the side of your pencil or washes of ink. Then apply darker, wavy lines to bring out the cat's striped coat. The eyes are merely slits because the cat is looking down.

DOGS

Depicting Dogs

Dogs aren't only a human's best friend, they are also a favorite subject of artists. Even people who don't have dogs of their own find them appealing to draw because they are so accessible and expressive. They also come in many different shapes and sizes, so you can make hundreds of drawings without ever drawing the same dog twice!

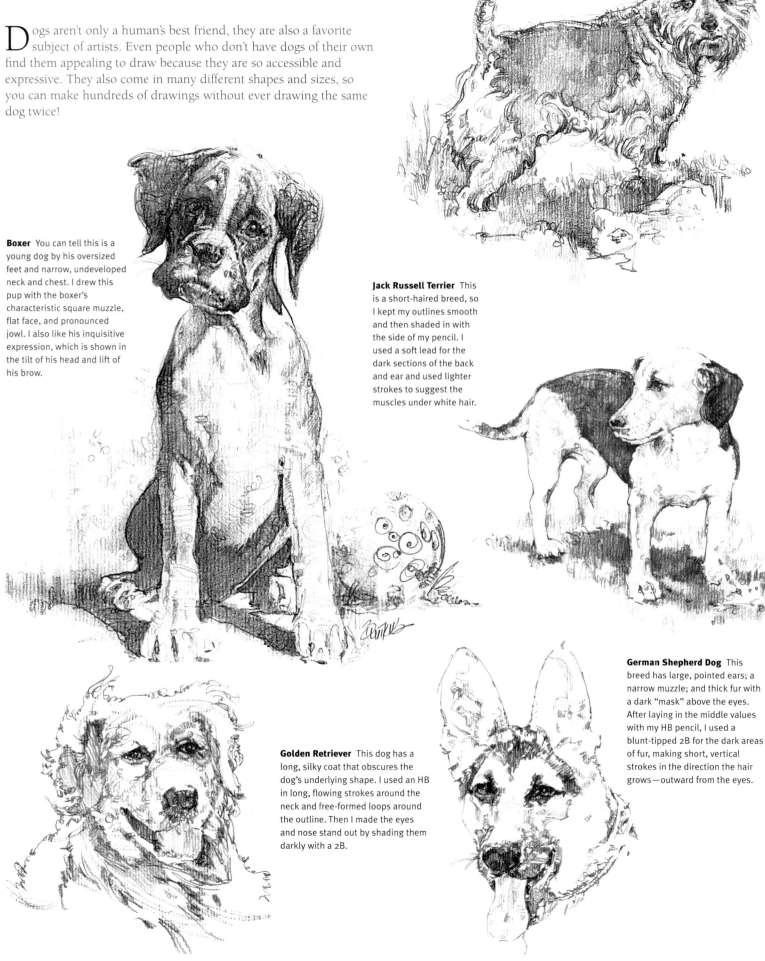

Boxer You can tell this is a young dog by his oversized feet and narrow, undeveloped neck and chest. I drew this pup with the boxer's characteristic square muzzle, flat face, and pronounced jowl. I also like his inquisitive expression, which is shown in the tilt of his head and lift of his brow.

Jack Russell Terrier This is a short-haired breed, so I kept my outlines smooth and then shaded in with the side of my pencil. I used a soft lead for the dark sections of the back and ear and used lighter strokes to suggest the muscles under white hair.

German Shepherd Dog This breed has large, pointed ears; a narrow muzzle; and thick fur with a dark "mask" above the eyes. After laying in the middle values with my HB pencil, I used a blunt-tipped 2B for the dark areas of fur, making short, vertical strokes in the direction the hair grows—outward from the eyes.

Golden Retriever This dog has a long, silky coat that obscures the dog's underlying shape. I used an HB in long, flowing strokes around the neck and free-formed loops around the outline. Then I made the eyes and nose stand out by shading them darkly with a 2B.

STUDYING YOUR SUBJECT

Although all dogs have a similar skeletal structure, there are many differences among the various breeds that you'll want to capture in your drawings. Look carefully at your subject—whether a live model or a photograph—and try to duplicate the unique characteristics you see. Is the muzzle pointed or square? Do the ears stick straight up or flop down? Are they sharply angled or round? Is the hair long and straight, short and curly, rough or smooth? When you're ready to start drawing, follow the steps in the chart below, and try some of the drawing techniques I've demonstrated on these pages.

A Girl and Her Pups Here I decided to do a fully developed drawing with a background and props—one that tells a story. I worked from a photo because neither the pups nor the young girl would hold still long enough for me to complete the rendering. Notice the foreshortening on the little girl's legs. (See page 222 for more on foreshortening.)

WORKING OUT THE PROPORTIONS

 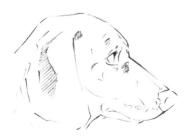 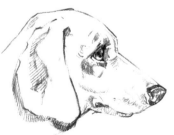

Blocking Begin by blocking in the most simple shapes that make up the overall shape of the head. Use the side of an HB, and make quick strokes to sketch the angles.

Refining Next, refine the basic shapes by placing a few strokes inside to indicate the planes of the face and the line of the nostril. Use the same loose pencil technique.

Shading Now refine the lines and develop the form a bit more by blocking in the basic shading. Use the side and point of a rounded HB for this step.

Adding Details Use both the side and tip of a sharp HB to define the hairs and develop shadows further. Use the point of a sharp 2B for deep shadows. Smudge softly.

PROPORTION & ANATOMY

To accurately render the various dog breeds, it's necessary to draw the body parts in proper proportion. Proportion is the correct relation between things or parts in regard to size, quantity, etc. An effective method for establishing proportion is to use one body part as a unit of measurement for determining the size of the other parts. For instance, you can use the dog's head to determine the length and height of the dog's body; the dog to the right is about 4 heads long and 3½ heads high. Make certain the proportions are accurate before working on any details.

Knowledge of basic anatomy will also help you accurately draw your subject. The diagram below illustrates the various parts of the dog. As you study the dogs in this book, notice how these parts differ according to breed. You will have better results if you do so.

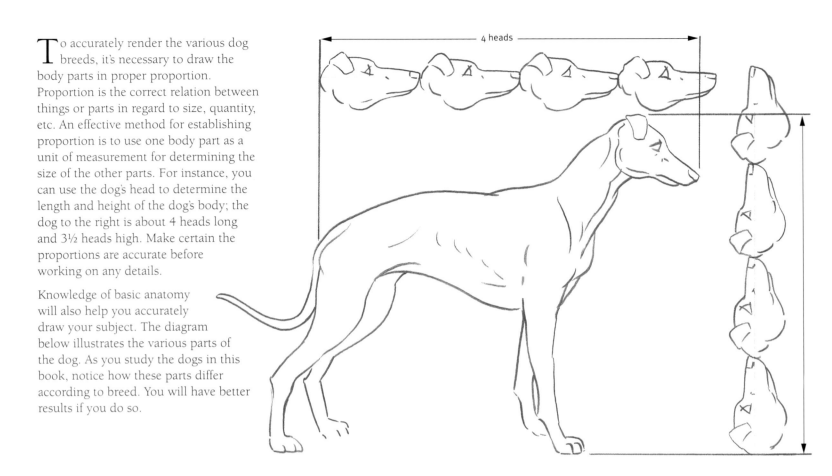

Study the various body parts labeled on this page to become more familiar with your subject.

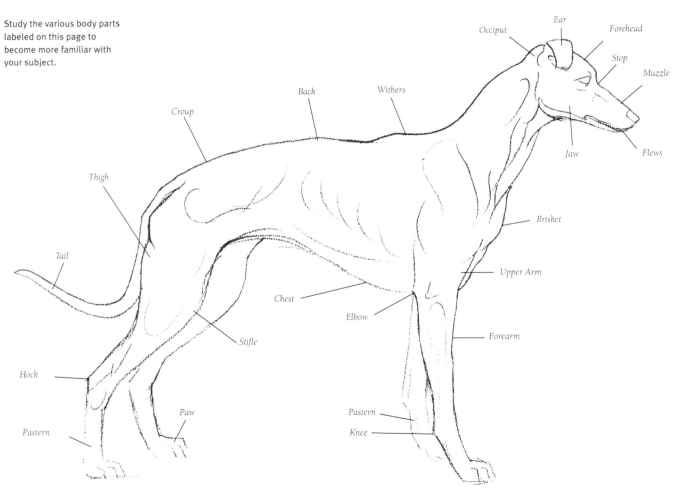

Muscular structure also affects an animal's form, determining where the contours of the body bulge and curve. Therefore, knowledge of muscle construction allows you to shade drawing subjects with better insight while creating more convincing work. The diagrams on the opposite page illustrate the dog's basic muscular structure. Study the muscles closely, and keep them in mind as you draw. As you observe your subject or model, consider how the location of the muscles might affect your shading. Once the basic drawing is correct, you can begin to develop the details. The illustrations below demonstrate in steps how to render a dog's eye and paw. Begin with very simple lines, and slowly refine the shapes. Use a sharp pencil for bringing out the fine details in the eye and for rendering the fur along the paw. Follow the steps closely to achieve a good likeness.

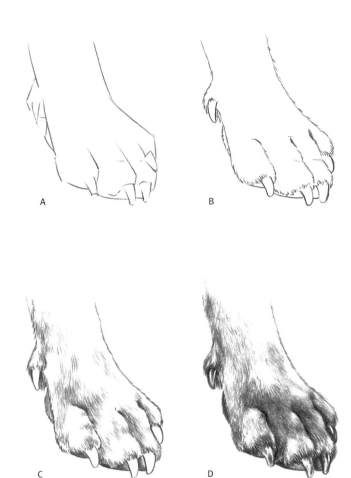

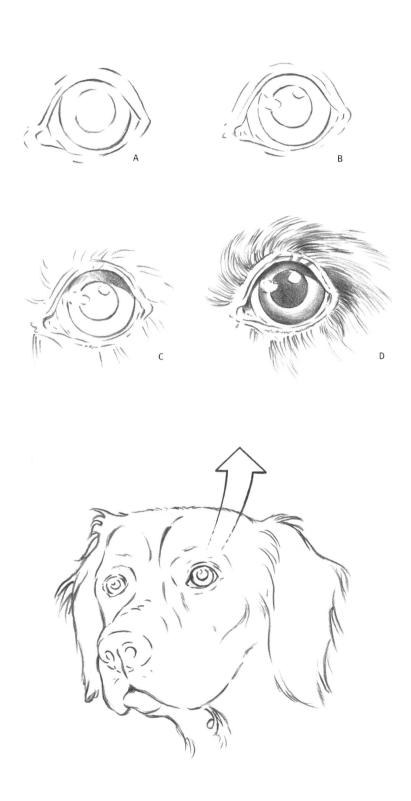

Muzzles

The shapes of dogs' muzzles vary depending on the breed. Study the muzzles of the dogs on this page. Some are long and narrow, while others are short and wide. These characteristics will affect your drawing, so observe your subjects well.

Once you establish the shape of the muzzle, you'll need to draw the nose. To draw the nose, lightly sketch the basic shapes in step A. Then refine the lines, and begin shading inside the nostrils with a sharp pencil in step B. The shading should be darkest near the inside curve of each nostril. In step C, continue shading the nose, taking note of how the value differences create form. As you draw the fur around the nose, make sure its texture contrasts with the smoothness of the nose. Also, keep in mind that the fur grows outward from the nose, as shown in the final step.

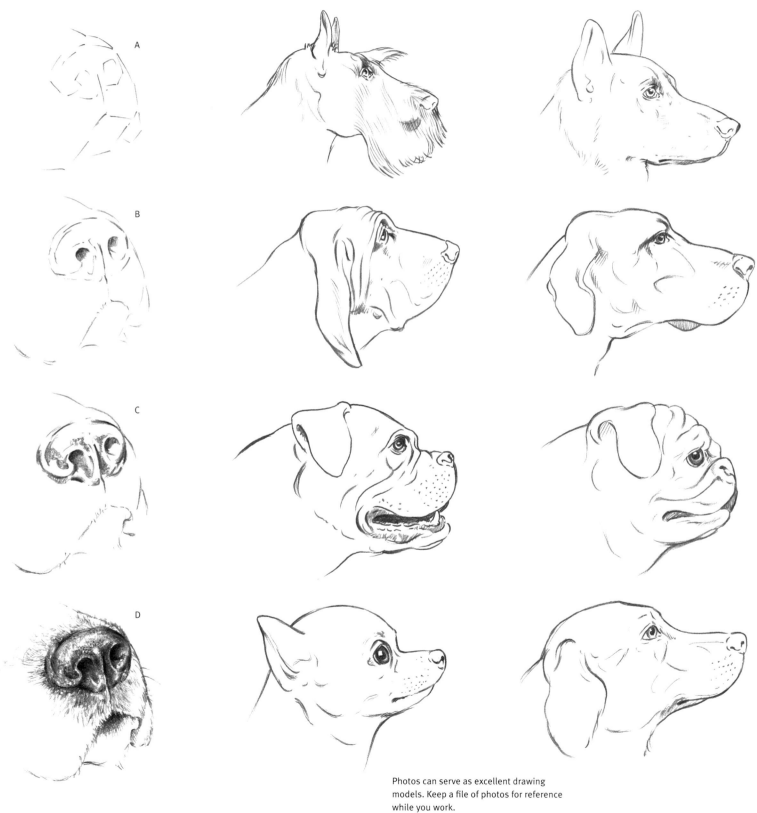

A

B

C

D

Photos can serve as excellent drawing models. Keep a file of photos for reference while you work.

DOBERMAN PINSCHER

Doberman Pinschers are known for their sleek, dark coats. When drawing the shiny coat, be sure always to sketch in the direction that the hair grows, as this will give your drawing a more realistic appearance.

Step 3 Next, erase any guidelines that are no longer needed. Then begin placing light, broken lines made up of short dashes to indicate where the value changes in the coat are. These initial lines will act as a map for later shading.

Step 2 Using the lines from the previous step as a guide, adjust the outline of the ears, head, and neck to give them a more contoured appearance. Then add the eyes and nose, following the facial guidelines. Finally, refine the outline of the muzzle.

Step 1 With a sharp HB pencil, block in the boxy shape of the Doberman's head and shoulders with quick, straight lines. Even at this early stage, you want to establish a sense of dimension and form, which you'll build upon as the drawing progresses.

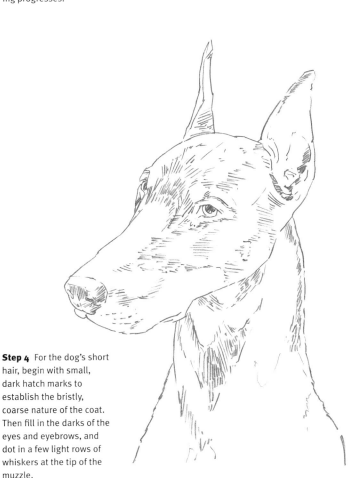

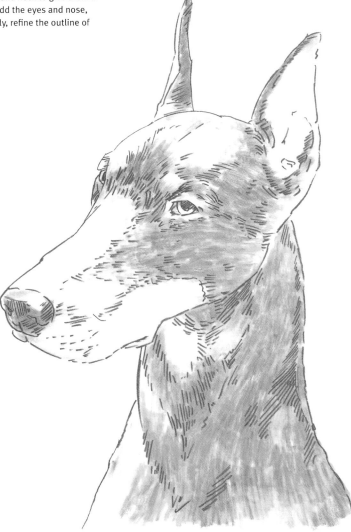

Step 4 For the dog's short hair, begin with small, dark hatch marks to establish the bristly, coarse nature of the coat. Then fill in the darks of the eyes and eyebrows, and dot in a few light rows of whiskers at the tip of the muzzle.

Step 5 Now fill in the remaining darks. First, create some graphite dust by rubbing a pencil over a sheet of fine sandpaper. Then pick up the graphite dust with a medium-sized blending stump, and shade in the dark areas of the dog's fur and nose. To avoid hard edges, blend to create soft gradations where the two values meet.

GREAT DANE

Great Danes have elegant statures and unique faces. While their enormous size (they can reach 30 inches tall at the shoulder) may be slightly intimidating, they are actually very gentle and affectionate, especially with children.

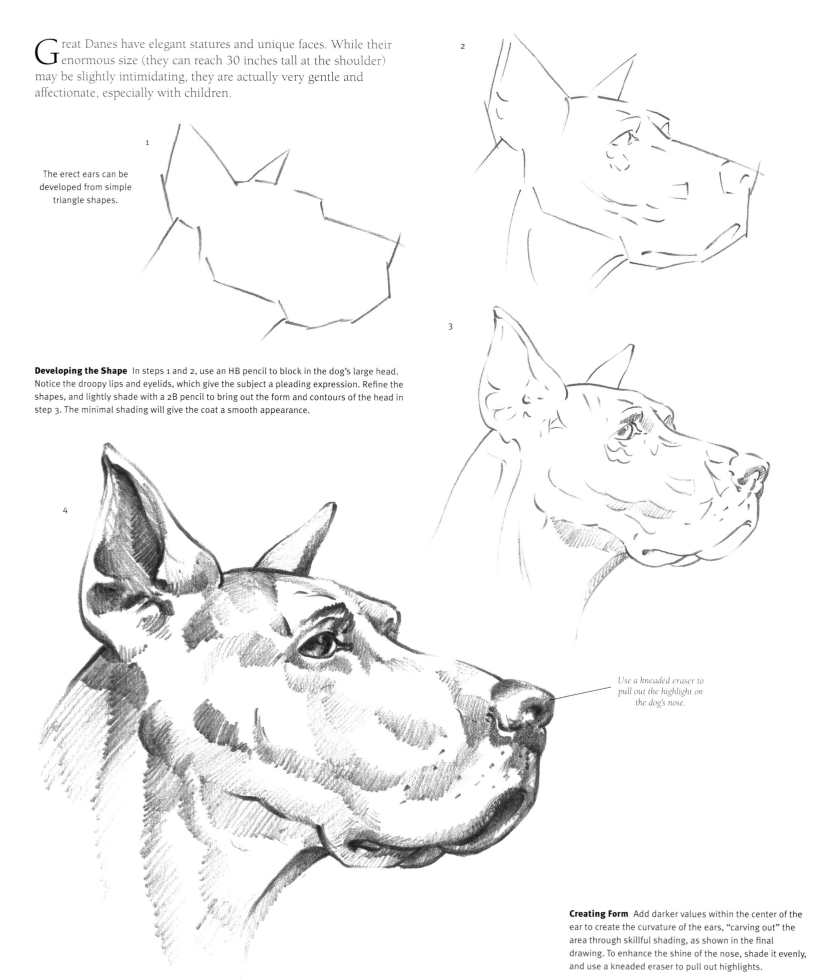

The erect ears can be developed from simple triangle shapes.

Developing the Shape In steps 1 and 2, use an HB pencil to block in the dog's large head. Notice the droopy lips and eyelids, which give the subject a pleading expression. Refine the shapes, and lightly shade with a 2B pencil to bring out the form and contours of the head in step 3. The minimal shading will give the coat a smooth appearance.

Use a kneaded eraser to pull out the highlight on the dog's nose.

Creating Form Add darker values within the center of the ear to create the curvature of the ears, "carving out" the area through skillful shading, as shown in the final drawing. To enhance the shine of the nose, shade it evenly, and use a kneaded eraser to pull out highlights.

Shar-Pei Puppy

The Shar-Pei is probably best known for its loose folds of skin. These wrinkles seem to give this breed a worried expression. The puppy shown here has looser skin than an adult; eventually, the body will fill out, and the folds will become less obvious.

As you block in the dog's shape in step A, use short strokes placed at wide angles to sketch the outline. To develop the folds in step B, start by lightly shading inside the creases. Give equal attention to each fold so the dog appears realistic. Continue to develop the shading with short slash-marks in step C, keeping the values darker between the folds. See page 10 for more detailed instructions on rendering this type of texture.

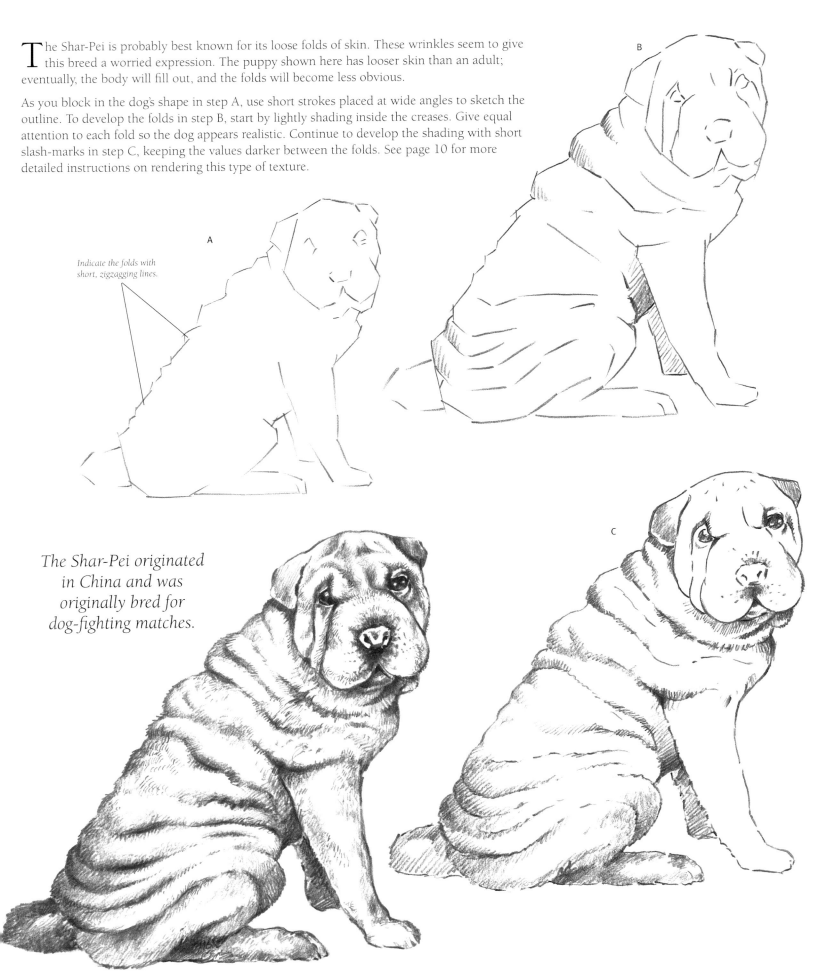

Indicate the folds with short, zigzagging lines.

The Shar-Pei originated in China and was originally bred for dog-fighting matches.

Golden Retriever

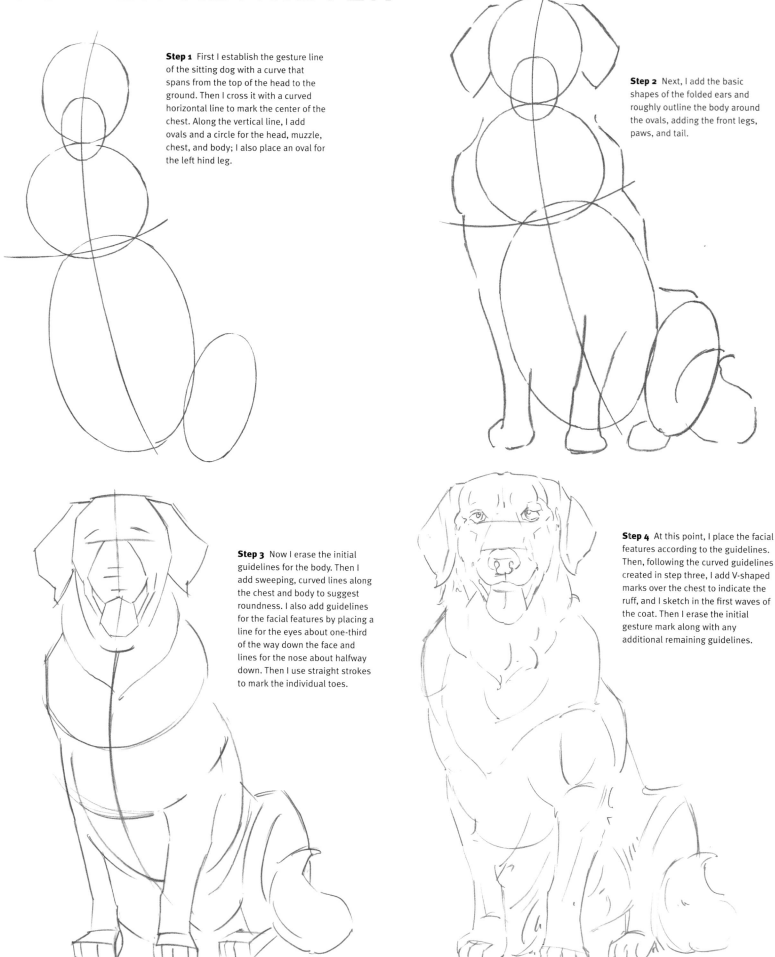

Step 1 First I establish the gesture line of the sitting dog with a curve that spans from the top of the head to the ground. Then I cross it with a curved horizontal line to mark the center of the chest. Along the vertical line, I add ovals and a circle for the head, muzzle, chest, and body; I also place an oval for the left hind leg.

Step 2 Next, I add the basic shapes of the folded ears and roughly outline the body around the ovals, adding the front legs, paws, and tail.

Step 3 Now I erase the initial guidelines for the body. Then I add sweeping, curved lines along the chest and body to suggest roundness. I also add guidelines for the facial features by placing a line for the eyes about one-third of the way down the face and lines for the nose about halfway down. Then I use straight strokes to mark the individual toes.

Step 4 At this point, I place the facial features according to the guidelines. Then, following the curved guidelines created in step three, I add V-shaped marks over the chest to indicate the ruff, and I sketch in the first waves of the coat. Then I erase the initial gesture mark along with any additional remaining guidelines.

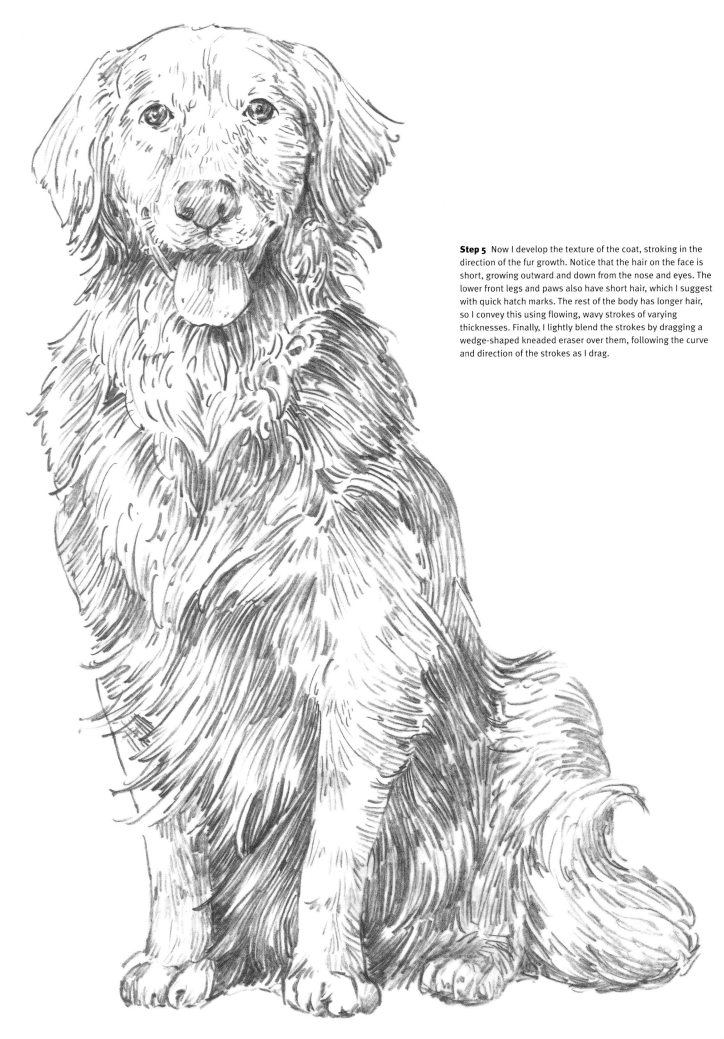

Step 5 Now I develop the texture of the coat, stroking in the direction of the fur growth. Notice that the hair on the face is short, growing outward and down from the nose and eyes. The lower front legs and paws also have short hair, which I suggest with quick hatch marks. The rest of the body has longer hair, so I convey this using flowing, wavy strokes of varying thicknesses. Finally, I lightly blend the strokes by dragging a wedge-shaped kneaded eraser over them, following the curve and direction of the strokes as I drag.

SIBERIAN HUSKY PUPPY

The husky is an athletic sled dog with a thick coat. It has a deep chest and a bushy tail that is evident even at the young age of this little pup.

Step 2 Now outline the entire torso using smooth, quick lines based on the initial shapes. Place the triangular ears, and suggest the upper portion of the four legs.

Step 1 First, suggest the position of the spine and tail with one gently curving gesture line. Then use this line to position the round shape of the head, body, and hindquarters. Next, draw guidelines for the pup's facial features while establishing the general shape of the muzzle.

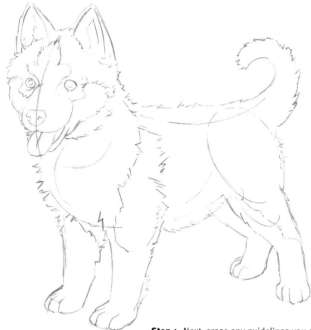

Step 4 Next, erase any guidelines you don't need and begin shading the dark areas of the fur with the broad side of the pencil. Use straight strokes that follow the direction of hair growth, radiating from the center of the face and chest. Next, shade in the nose and pupils. Then add a background to contrast with the white of the puppy's chest. Apply straight, broad strokes with the side of the pencil using horizontal hatching lines.

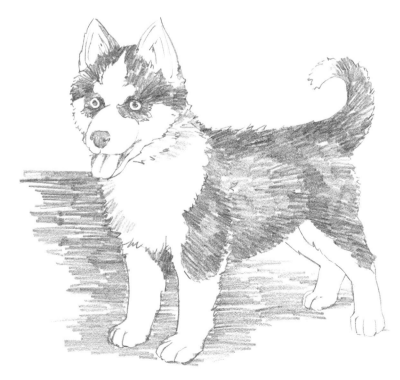

Step 3 Once you're satisfied with the pose and the way it has taken shape, begin to develop the puppy's coat. Apply a series of short, parallel strokes that follow the previous outline, producing the appearance of a thick coat. Using the same kind of strokes, outline the color pattern of the coat. Then place the eyes, nose, mouth, and tongue, and refine the paws.

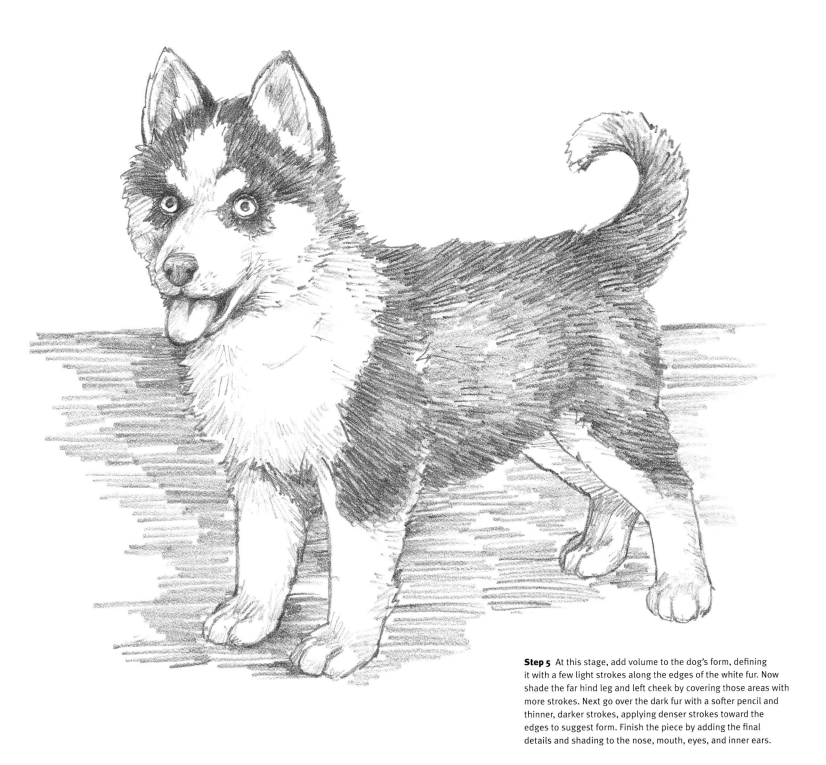

Step 5 At this stage, add volume to the dog's form, defining it with a few light strokes along the edges of the white fur. Now shade the far hind leg and left cheek by covering those areas with more strokes. Next go over the dark fur with a softer pencil and thinner, darker strokes, applying denser strokes toward the edges to suggest form. Finish the piece by adding the final details and shading to the nose, mouth, eyes, and inner ears.

COMPARING THE PUPPY AND THE DOG

Young puppies and full-sized dogs have the same features but in different proportions. *Proportion* refers to the proper relation of one part to another or to the whole—particularly in terms of size or shape—and it is a key factor in achieving a good likeness. A puppy isn't just a small dog. Although a puppy has all the same parts as its adult counterpart, the puppy's body appears more compact than the dog's—and its paws, ears, and eyes seem much larger in proportion to the rest of its body. In contrast, the adult dog seems longer, leaner, and taller. Its muzzle appears larger in proportion to the rest of its body, and its teeth are noticeably bigger. Keeping these proportional differences in mind and incorporating them in your drawings will help you make your artwork look convincingly realistic.

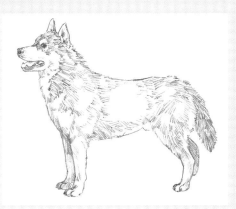

ROUGH COLLIES

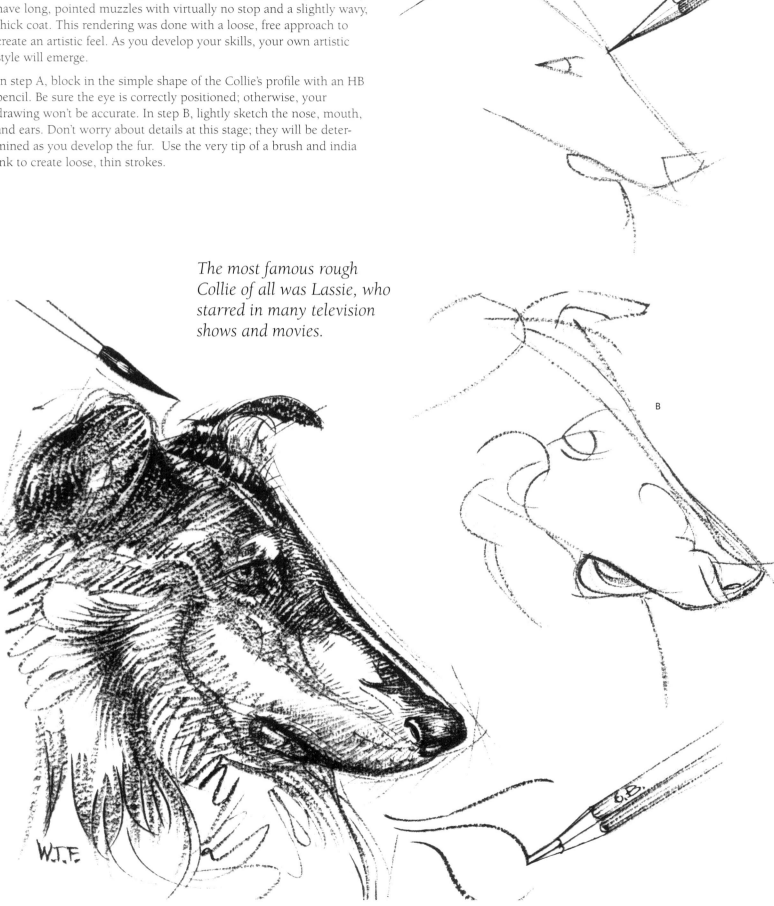

Although Collies can be found in many households, they are also known as herding dogs in Scotland, Ireland, and England. They have long, pointed muzzles with virtually no stop and a slightly wavy, thick coat. This rendering was done with a loose, free approach to create an artistic feel. As you develop your skills, your own artistic style will emerge.

In step A, block in the simple shape of the Collie's profile with an HB pencil. Be sure the eye is correctly positioned; otherwise, your drawing won't be accurate. In step B, lightly sketch the nose, mouth, and ears. Don't worry about details at this stage; they will be determined as you develop the fur. Use the very tip of a brush and india ink to create loose, thin strokes.

The most famous rough Collie of all was Lassie, who starred in many television shows and movies.

This drawing shows a different view of the Collie's head. The muzzle appears especially long and narrow from this angle. Follow steps A and B to block in the basic shape. Begin shading with charcoal and a chisel-pointed 4B pencil. Render the darker fur along the top of the head with short, firm strokes, and use longer, well-placed strokes for the mane. Keep in mind that the fur grows upward and outward, making it appear fluffy and full.

The origin of this breed dates back to the 1500s in Great Britain.

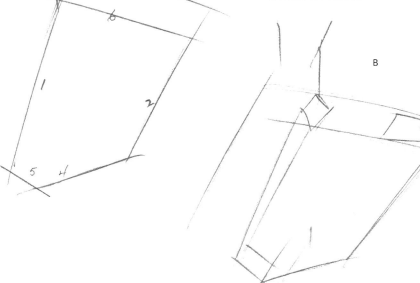

A chisel-pointed 6B pencil will make dark, broad lines. These lines should follow the direction of fur growth.

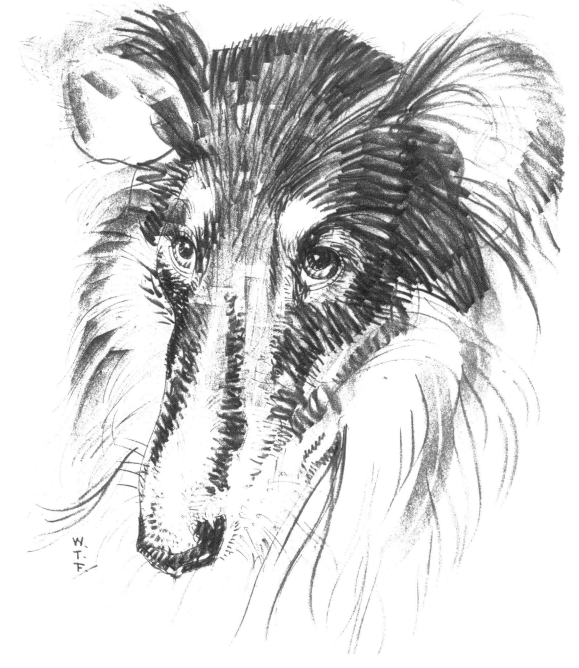

BLOODHOUND

The Bloodhound is distinguished by its long, floppy ears; sad eyes; and loose skin. This breed may have a melancholy expression, but it's known as a gentle companion.

In step A, use an HB pencil to sketch each line in the numbered order indicated. Continue to block in the basic shapes in step B, including the facial features. Keep in mind that the eyes angle slightly downward.

The Bloodhound, with its incredible tracking ability, has been known to follow a 14-day-old scent for more than 138 miles!

In step C, smooth out the block-in lines, and begin to sketch the folds and wrinkles along the face. Use the side of a black Conté crayon to add a sparse layer of shading over the face. In the final stage, refine the form by shading with a soft 2B or 4B pencil, especially within the wrinkles. Use heavy shading lines to develop the contours of the dog's face and create a sad expression.

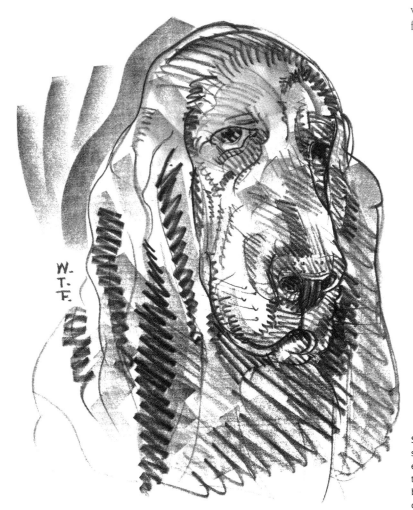

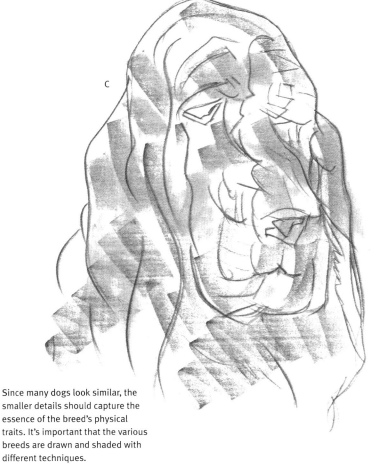

Since many dogs look similar, the smaller details should capture the essence of the breed's physical traits. It's important that the various breeds are drawn and shaded with different techniques.

DACHSHUND

The Dachshund is a hound with short legs and a long, sturdy body. It can be smooth-, wire-, or long-haired. This example is a profile of a smooth-haired Dachshund.

Use an HB pencil to block in the general shape in step A, smoothing out the lines in step B. Add the facial features in step C, using a blunt 2B pencil or round watercolor brush and india ink. These tools will produce heavy, solid lines, which are good for dark areas such as the eye and nose.

In step D, bring out the form of the head using a soft pencil sharpened to a chisel point, and add finer details with a brush and ink. You can also use the side of a black Conté crayon to create gray values over larger areas, as shown in the finished drawing.

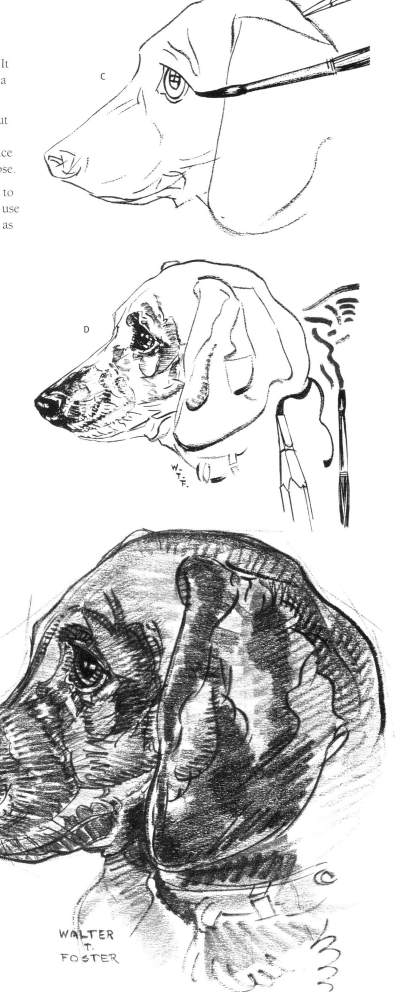

The Dachshund is also known as a "wiener dog" because of its elongated body.

Maltese

This toy breed has a long, white coat and round, black eyes. Like the Yorkshire Terrier, the Maltese is rendered mostly by developing its long coat.

Only a few simple strokes are needed to suggest the shape of the head. In step A, begin with a rectangle and guidelines drawn in the numbered order shown. Make certain the lines provide accurate placement for the features. In step B, lightly sketch the eyes and nose on the block-in guides.

In step C, begin adding fur using long, flowing strokes in the direction of the hair growth. Note how the minimal amount of strokes makes the dog appear white. Use a sharp pencil or a thin brush and ink to add fine details to the eyes and nose. Again, leave white areas for the highlights in the eyes.

C

A curtain of hair often covers the eyes of these dogs, which were prized by the ancient rulers of Malta.

A

B

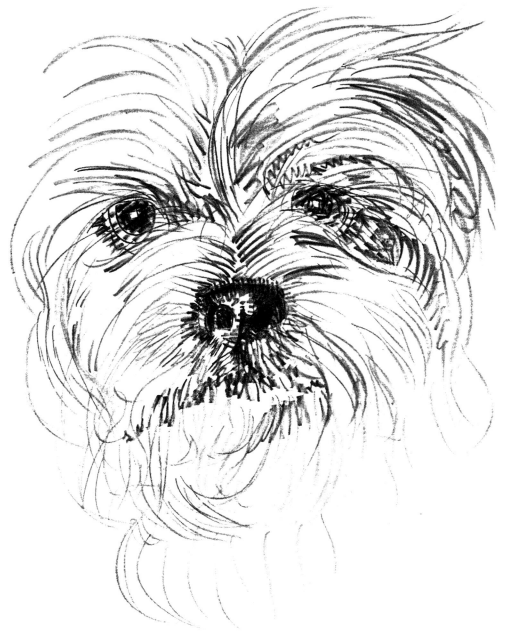

HORSES

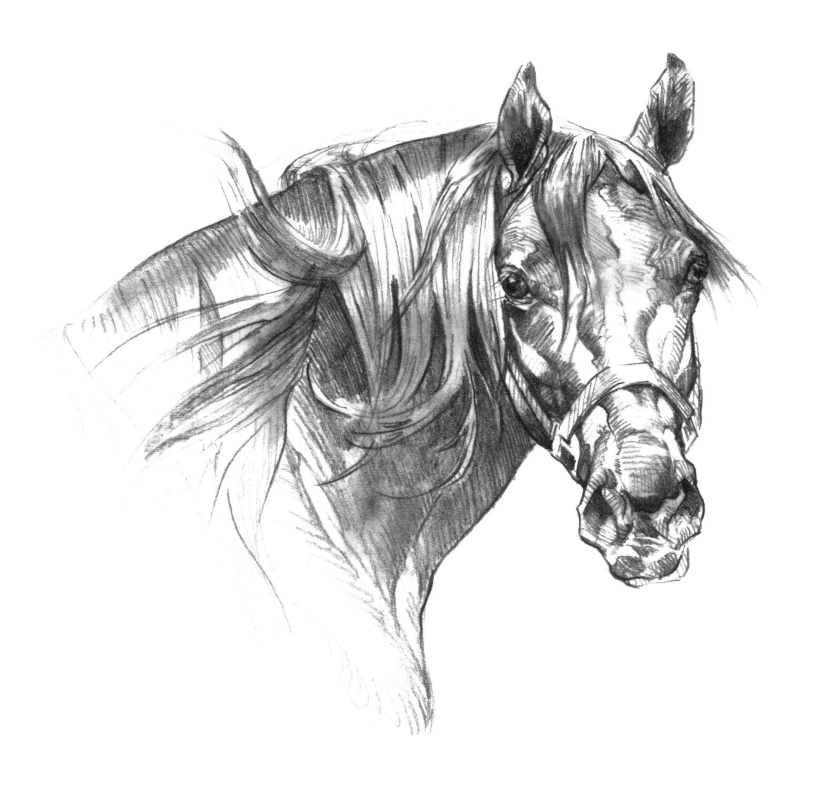

Basic Heads

The proportions of this young foal are slightly different from those of the adult horse on the opposite page. It is also shown at a slight three-quarter angle.

In steps A and B, start with three basic guideline strokes to establish the size and shape of the head. The strokes are numbered to enable you to see the first stroke while you make the second, ensuring that your proportions are accurate. Follow the right- or left-handed approach, as applicable.

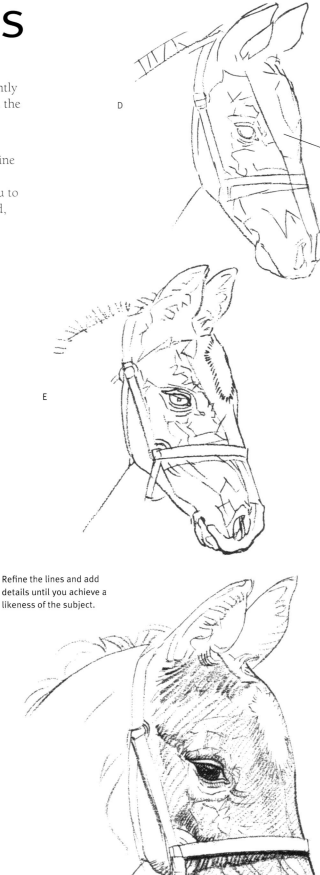

This line defines the planes of the head.

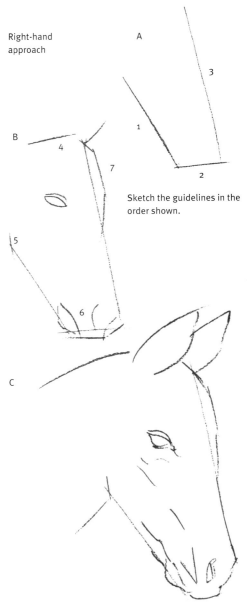

Right-hand approach

Sketch the guidelines in the order shown.

Refine the lines and add details until you achieve a likeness of the subject.

Once you've established the placement of the features, begin refining the lines as in steps C and D. Notice the line that extends along the face in step D; this line defines the top plane from the side plane, giving the head a three-dimensional appearance. Continue adding details until you are satisfied. If you wish, add some shading to enhance the form.

Lightly suggest the muscles lying just beneath the skin.

Although horses' heads all have a similar basic shape, there are variations among breeds and between individual horses. The drawing here is of a classic thoroughbred profile, with a straight nose and slightly tapered muzzle. Practice drawing many different profiles, and see if you can bring out the unique characteristics in each one.

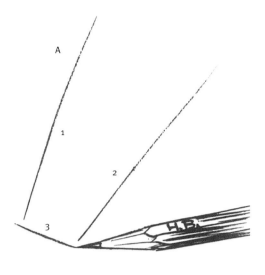

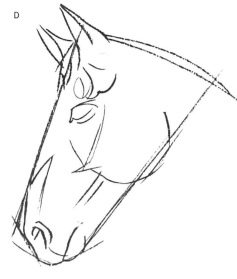

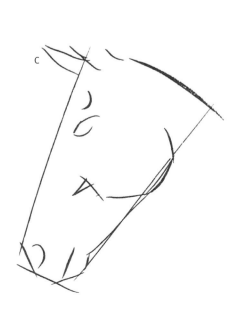

In steps A and B, use an HB pencil to block in a few basic guidelines to establish the placement and general proportion of the head. Then sketch in the outline of the ears and cheek, and block in the position of the eye, nostril, and mouth, as in step C. When you're comfortable with the outline, round out the muzzle, define the features, and suggest the underlying muscles as shown in steps D and E.

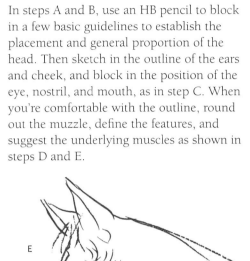

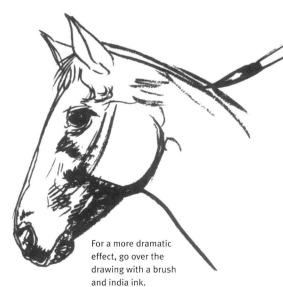

In the final steps, study your reference before further refining the shapes and adding the details. Make note of the length and position of the ears, the angle of the neck, and the curve of the nose and lower lip. Look for the point where the lines of the neck and lower jaw meet the cheek. As your observation skills improve, so will your drawings!

Don't worry about making a final rendering at this point. As you work out proportions and improve your observation skills, keep the drawings loose and sketchy. You can focus on shading techniques later.

For a more dramatic effect, go over the drawing with a brush and india ink.

Horse Portrait

Horses are fantastic drawing subjects, as their inherent beauty and grace can be quite captivating. Pay careful attention to the detail of the eye to express this gentle creature's warmth and intelligence.

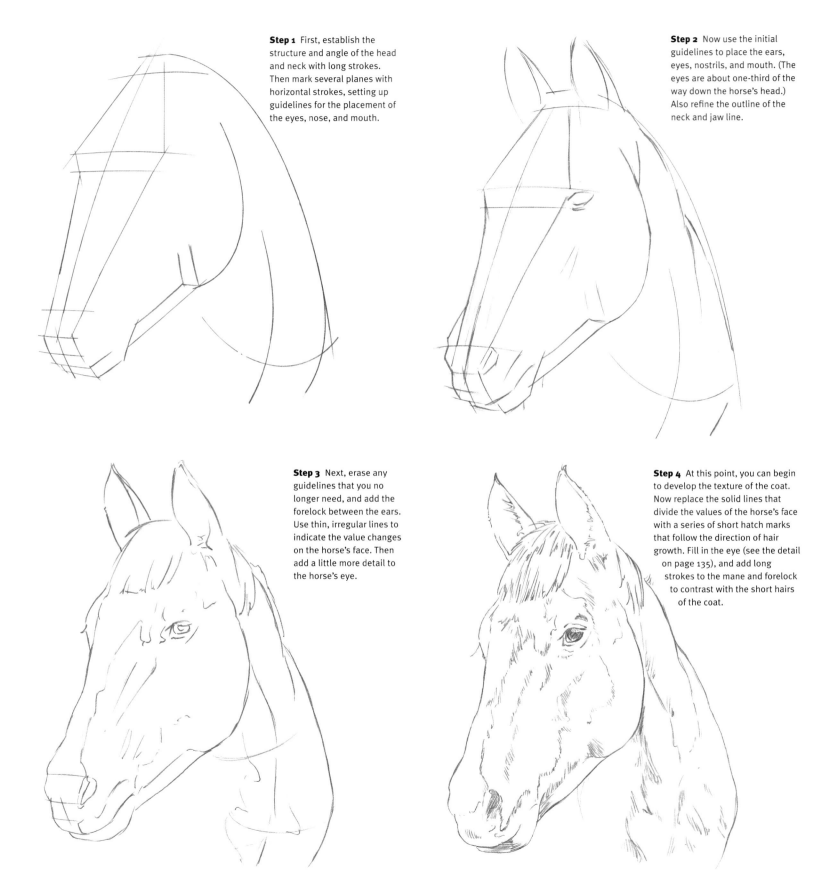

Step 1 First, establish the structure and angle of the head and neck with long strokes. Then mark several planes with horizontal strokes, setting up guidelines for the placement of the eyes, nose, and mouth.

Step 2 Now use the initial guidelines to place the ears, eyes, nostrils, and mouth. (The eyes are about one-third of the way down the horse's head.) Also refine the outline of the neck and jaw line.

Step 3 Next, erase any guidelines that you no longer need, and add the forelock between the ears. Use thin, irregular lines to indicate the value changes on the horse's face. Then add a little more detail to the horse's eye.

Step 4 At this point, you can begin to develop the texture of the coat. Now replace the solid lines that divide the values of the horse's face with a series of short hatch marks that follow the direction of hair growth. Fill in the eye (see the detail on page 135), and add long strokes to the mane and forelock to contrast with the short hairs of the coat.

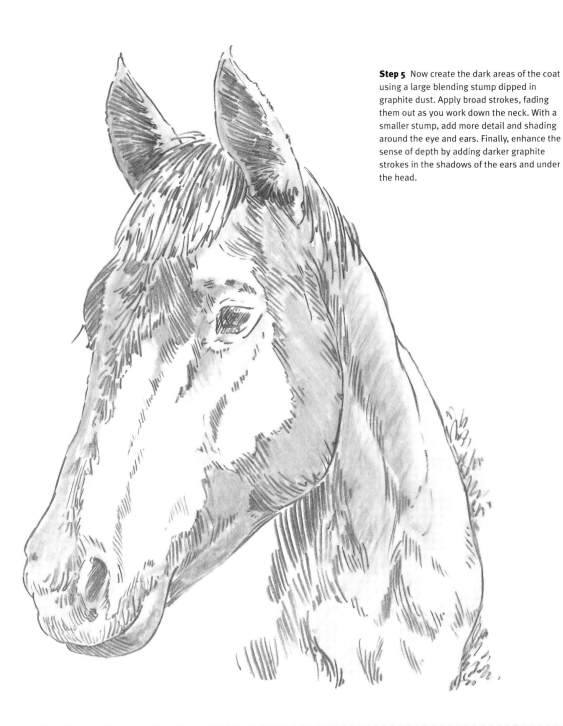

Step 5 Now create the dark areas of the coat using a large blending stump dipped in graphite dust. Apply broad strokes, fading them out as you work down the neck. With a smaller stump, add more detail and shading around the eye and ears. Finally, enhance the sense of depth by adding darker graphite strokes in the shadows of the ears and under the head.

HORSE DETAILS

Muzzle The muzzle has subtle, curved forms, which are defined with careful shading. The area around the nostril is raised, as is the area just above the mouth. Indicate this shape by pulling out highlights with a kneaded eraser.

Eye Horses' eyes have a lot of detail, from the creases around the eyes to the straight, thick eyelashes that protect them. To create a sense of life in the eye, leave a light crescent-shaped area to show reflected light, and leave a stark white highlight above it.

Ears Render the horse's forelock hair with long, slightly curving strokes. Then shade the interior of the ear with upward, parallel strokes, making them darkest at the bottom and gradually lighter as you move up the ear.

Horse Head in Profile

For this profile, start by blocking in the basic shape of the horse's head, and then gradually develop the form, being more careful and deliberate with your lines and shading strokes. Remember to observe your subject closely so you can render a good likeness.

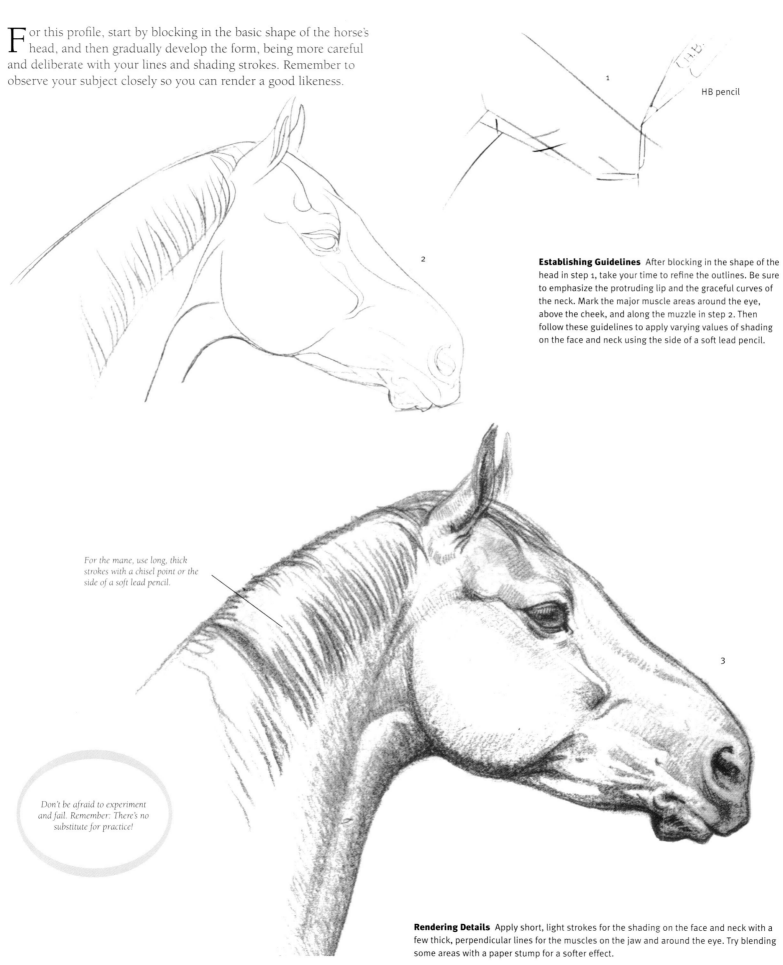

HB pencil

Establishing Guidelines After blocking in the shape of the head in step 1, take your time to refine the outlines. Be sure to emphasize the protruding lip and the graceful curves of the neck. Mark the major muscle areas around the eye, above the cheek, and along the muzzle in step 2. Then follow these guidelines to apply varying values of shading on the face and neck using the side of a soft lead pencil.

For the mane, use long, thick strokes with a chisel point or the side of a soft lead pencil.

Don't be afraid to experiment and fail. Remember: There's no substitute for practice!

Rendering Details Apply short, light strokes for the shading on the face and neck with a few thick, perpendicular lines for the muscles on the jaw and around the eye. Try blending some areas with a paper stump for a softer effect.

ADVANCED HORSE HEADS

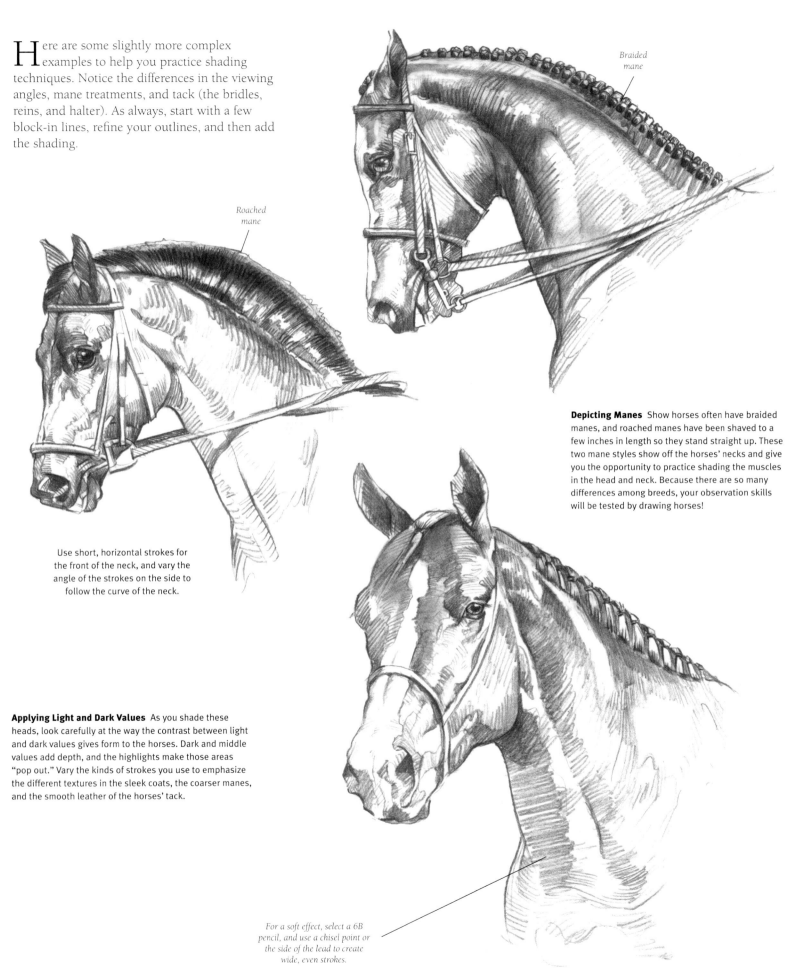

Here are some slightly more complex examples to help you practice shading techniques. Notice the differences in the viewing angles, mane treatments, and tack (the bridles, reins, and halter). As always, start with a few block-in lines, refine your outlines, and then add the shading.

Braided mane

Roached mane

Depicting Manes Show horses often have braided manes, and roached manes have been shaved to a few inches in length so they stand straight up. These two mane styles show off the horses' necks and give you the opportunity to practice shading the muscles in the head and neck. Because there are so many differences among breeds, your observation skills will be tested by drawing horses!

Use short, horizontal strokes for the front of the neck, and vary the angle of the strokes on the side to follow the curve of the neck.

Applying Light and Dark Values As you shade these heads, look carefully at the way the contrast between light and dark values gives form to the horses. Dark and middle values add depth, and the highlights make those areas "pop out." Vary the kinds of strokes you use to emphasize the different textures in the sleek coats, the coarser manes, and the smooth leather of the horses' tack.

For a soft effect, select a 6B pencil, and use a chisel point or the side of the lead to create wide, even strokes.

PONY

Ponies are not just small horses—they are a distinct species. Smaller in size than horses, ponies are also more sure-footed and have a stronger sense of self-preservation.

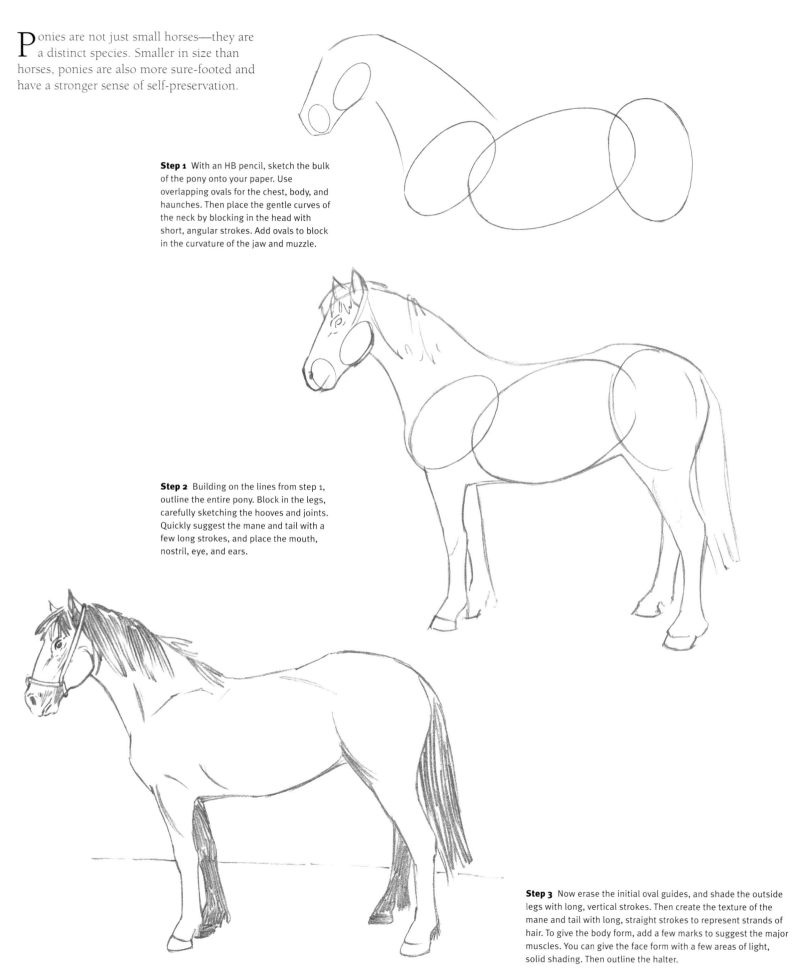

Step 1 With an HB pencil, sketch the bulk of the pony onto your paper. Use overlapping ovals for the chest, body, and haunches. Then place the gentle curves of the neck by blocking in the head with short, angular strokes. Add ovals to block in the curvature of the jaw and muzzle.

Step 2 Building on the lines from step 1, outline the entire pony. Block in the legs, carefully sketching the hooves and joints. Quickly suggest the mane and tail with a few long strokes, and place the mouth, nostril, eye, and ears.

Step 3 Now erase the initial oval guides, and shade the outside legs with long, vertical strokes. Then create the texture of the mane and tail with long, straight strokes to represent strands of hair. To give the body form, add a few marks to suggest the major muscles. You can give the face form with a few areas of light, solid shading. Then outline the halter.

PARTS OF HORSES AND PONIES

You certainly don't need to learn the names of every bone and muscle in order to draw an animal accurately, but it is helpful to have a little knowledge of the basic anatomy of your subject. For example, an understanding of the underlying shapes of the horse's skeletal and musculature structures will result in more realistic depictions of the horse's form. (Ponies have the same basic structure as horses, although sizes and proportions differ.) Knowing the shapes of the bones will help you draw lifelike legs, hooves, and faces. Familiarity with the major muscle groups will help you place your shadows and highlights accurately by bringing the horse or pony's form to life.

Drawing the horse's body is easy if you break down the animal into basic shapes. Start with circles, cylinders, and trapezoids—as shown on the horse at right—to help you get a good general sense of the size and proportion of the parts of the horse, such as the head, neck, belly, and legs. Then simply connect these shapes, refine the lines, and add a few details to produce a realistic outline of your equine subject.

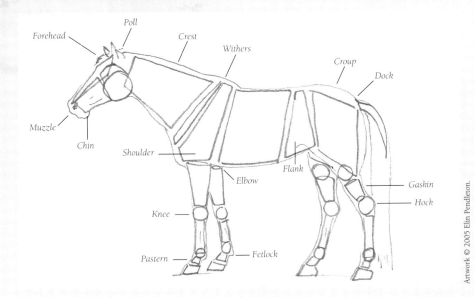

Artwork © 2005 Elin Pendleton.

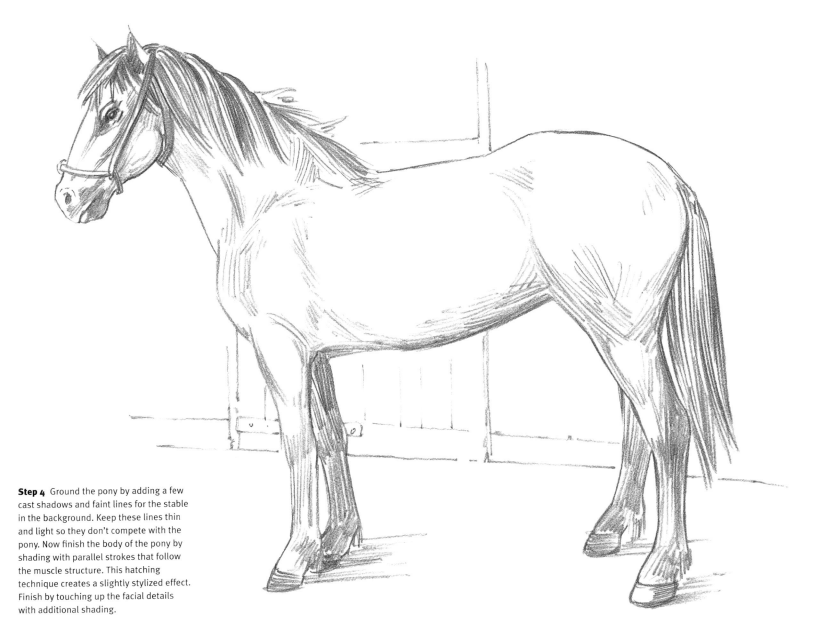

Step 4 Ground the pony by adding a few cast shadows and faint lines for the stable in the background. Keep these lines thin and light so they don't compete with the pony. Now finish the body of the pony by shading with parallel strokes that follow the muscle structure. This hatching technique creates a slightly stylized effect. Finish by touching up the facial details with additional shading.

Foal's Body

Foals have a great zest for living and a fine sense of fun. They love to run and kick, and they are as fond of showing off as children. Try to capture this playfulness in your drawings.

To sketch the foal above, start by drawing an oval with an HB pencil. Block in the body parts around this shape, making sure all the elements are drawn in correct proportion. Notice how long the foal's legs are in relation to its body. Then use a 6B pencil to shade the foal, blending out some areas with a paper stump for a soft, rounded effect.

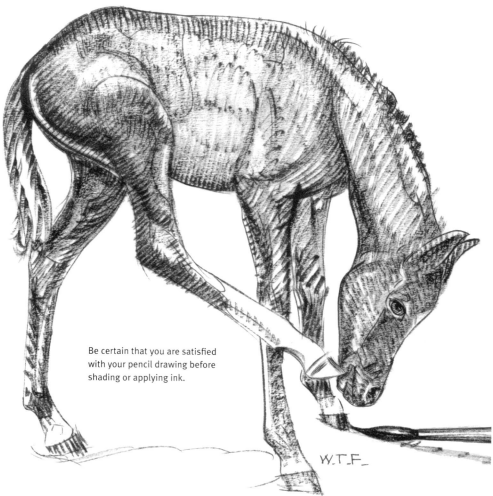

Be certain that you are satisfied with your pencil drawing before shading or applying ink.

This drawing was made on rough-textured paper and finished using a drybrush technique. After working out the outline of the foal in pencil, apply the light and middle values with washes of india ink or black watercolor paint. Then use a dry brush and undiluted ink to lay in the darkest shadows and details. The drybrush technique produces rough, broken lines with feathered edges and is an easy way to create texture.

Here again, layers of ink washes are used to achieve a more solid rendering. After blocking in the basic shape of the body with an HB pencil, refine the lines until you are satisfied with the proportions and outline. Then use a clean brush to apply plain water over the foal's body, being careful to stay within the outlines. Next load the brush with diluted ink, and wash it over the body in smooth, even layers. This technique is called wet-on-wet and produces soft, loose blends. Note, however, that the washes are more difficult to control with this method than when painting wet-on-dry or with the drybrush technique.

Experiment with either painting wet-on-wet or allowing the paper to dry between washes. As you apply your washes, leave some areas lighter for highlights, and brush on extra layers of ink for the dark areas on the neck and belly. Use the tip of a dry brush to draw the fine outlines and details.

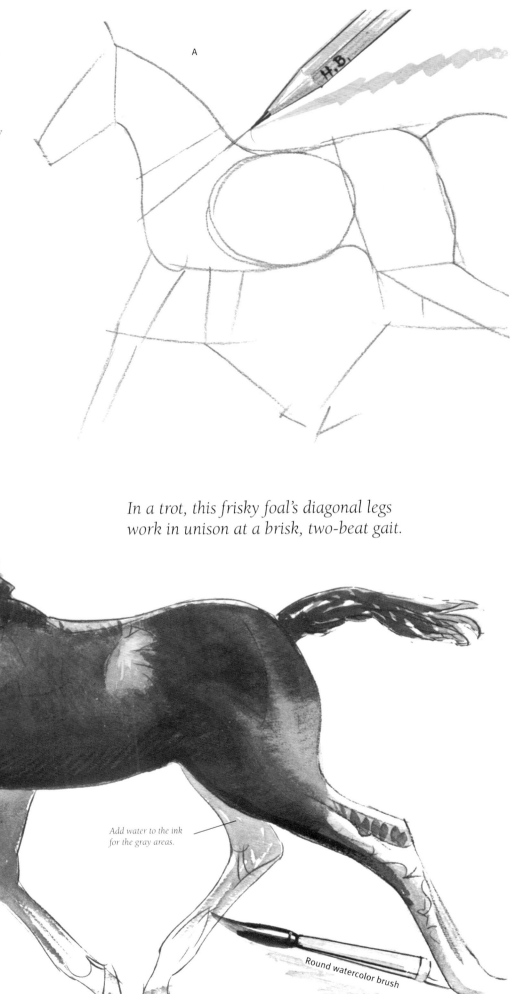

A

In a trot, this frisky foal's diagonal legs work in unison at a brisk, two-beat gait.

Apply multiple layers of diluted ink for the darkest areas.

Add water to the ink for the gray areas.

Leave some areas white for contrast.

Round watercolor brush

W.T.F.

ARABIAN

The Arabian is a high-spirited horse with a flamboyant tail carriage and distinctive dished profile. Though relatively small in stature, this breed is known for its stamina, graceful build, intelligence, and energy. Try to capture the Arabian's slender physique and high spirit in your drawing.

Block in the body with an HB pencil, placing the oval for the body at a slight angle to indicate that the body will be foreshortened. When blocking in the head, take care to stress the concave nose, large nostrils, and small muzzle. As you start shading in steps B and C, keep the lines for the tail and mane loose and free, and accent the graceful arch of the neck.

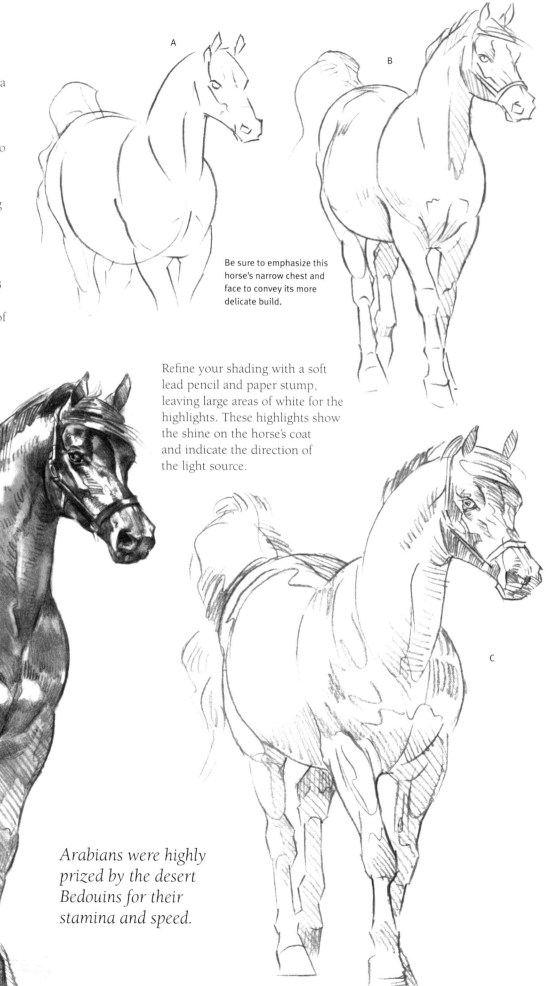

A

B

Be sure to emphasize this horse's narrow chest and face to convey its more delicate build.

Refine your shading with a soft lead pencil and paper stump, leaving large areas of white for the highlights. These highlights show the shine on the horse's coat and indicate the direction of the light source.

From this angle, the line of the spine is visible. Add subtle shading here and along the withers to give your drawing a three-dimensional quality.

C

Arabians were highly prized by the desert Bedouins for their stamina and speed.

SHETLAND PONY

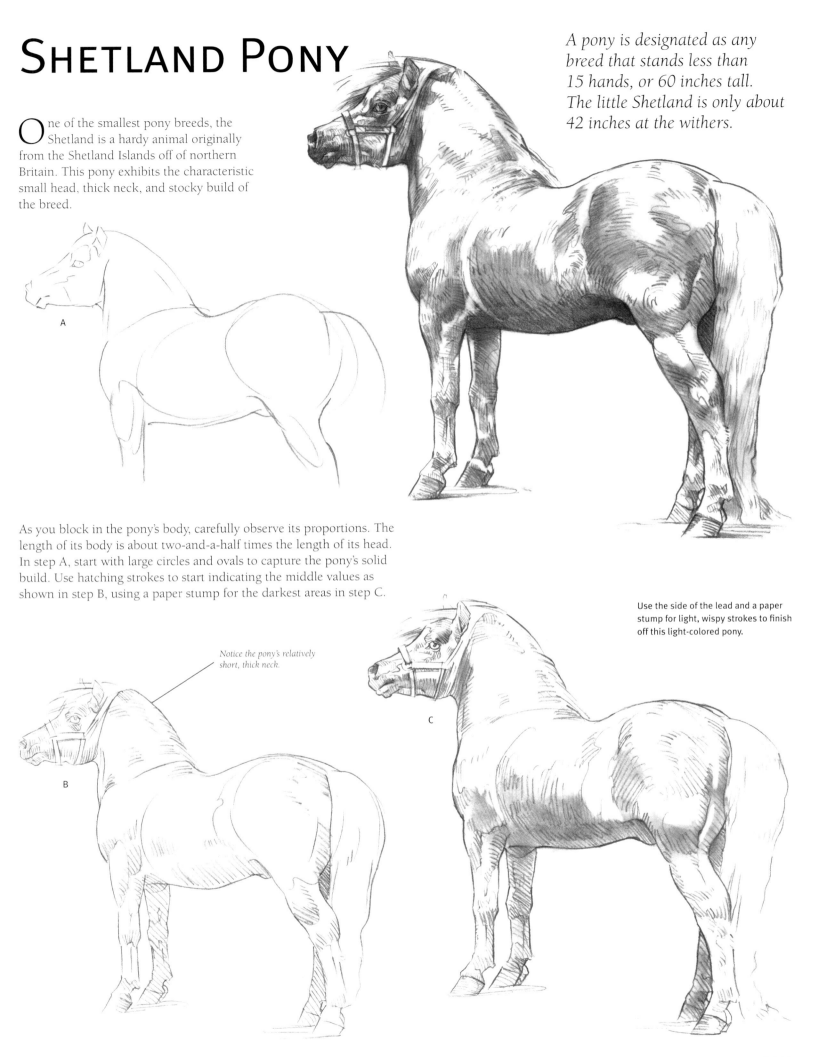

One of the smallest pony breeds, the Shetland is a hardy animal originally from the Shetland Islands off of northern Britain. This pony exhibits the characteristic small head, thick neck, and stocky build of the breed.

A pony is designated as any breed that stands less than 15 hands, or 60 inches tall. The little Shetland is only about 42 inches at the withers.

A

As you block in the pony's body, carefully observe its proportions. The length of its body is about two-and-a-half times the length of its head. In step A, start with large circles and ovals to capture the pony's solid build. Use hatching strokes to start indicating the middle values as shown in step B, using a paper stump for the darkest areas in step C.

Use the side of the lead and a paper stump for light, wispy strokes to finish off this light-colored pony.

Notice the pony's relatively short, thick neck.

B

C

ADULT HORSE'S BODY

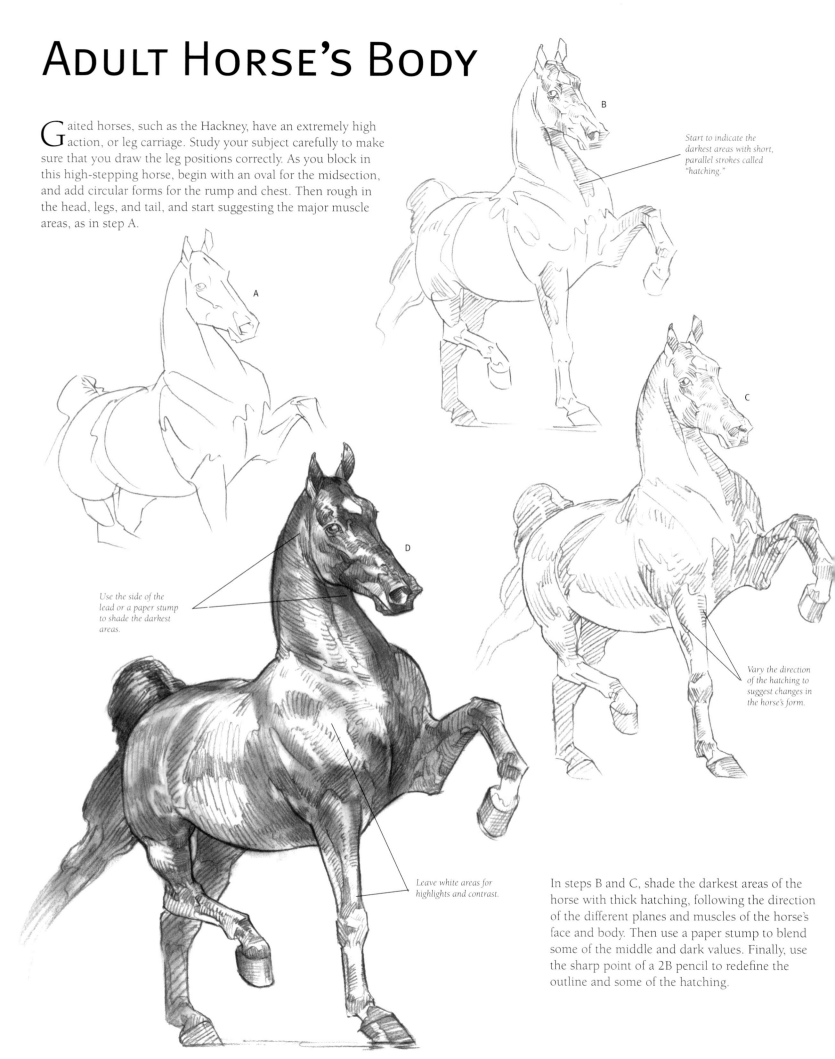

Gaited horses, such as the Hackney, have an extremely high action, or leg carriage. Study your subject carefully to make sure that you draw the leg positions correctly. As you block in this high-stepping horse, begin with an oval for the midsection, and add circular forms for the rump and chest. Then rough in the head, legs, and tail, and start suggesting the major muscle areas, as in step A.

Start to indicate the darkest areas with short, parallel strokes called "hatching."

Use the side of the lead or a paper stump to shade the darkest areas.

Vary the direction of the hatching to suggest changes in the horse's form.

Leave white areas for highlights and contrast.

In steps B and C, shade the darkest areas of the horse with thick hatching, following the direction of the different planes and muscles of the horse's face and body. Then use a paper stump to blend some of the middle and dark values. Finally, use the sharp point of a 2B pencil to redefine the outline and some of the hatching.

It's important to get the pose right when you draw a horse rearing up on its hind legs. Remember that the horse's center of gravity is over its shoulders. If you draw the horse leaning too far forward or too far back, the horse will look unsteady.

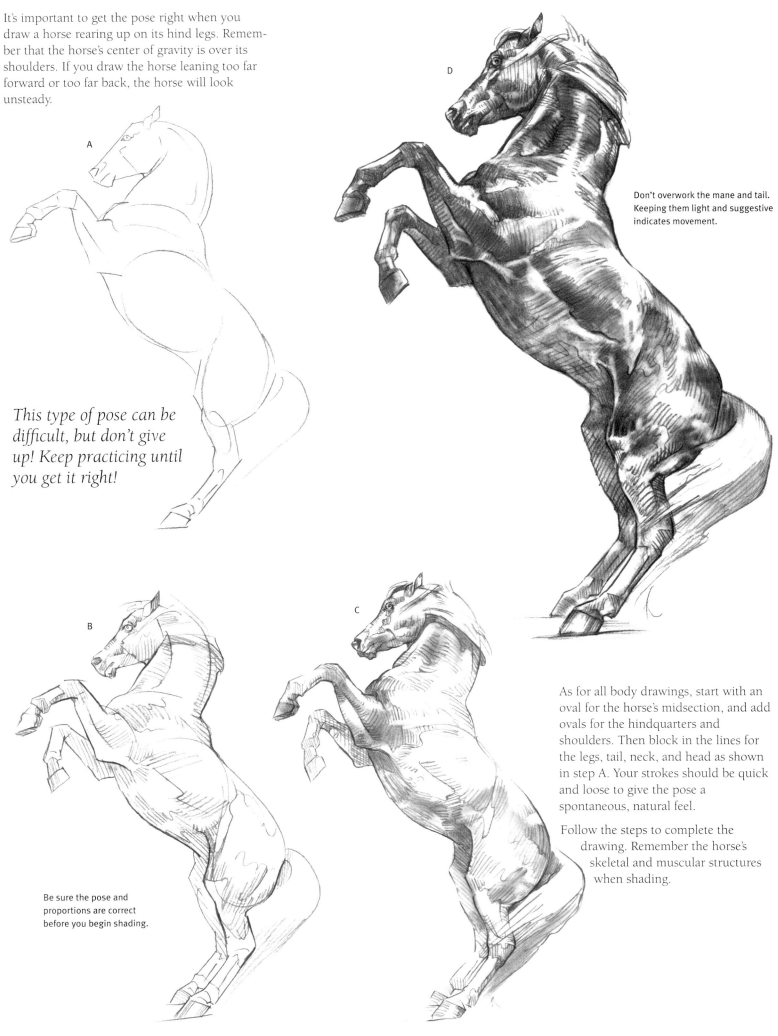

A

This type of pose can be difficult, but don't give up! Keep practicing until you get it right!

D

Don't overwork the mane and tail. Keeping them light and suggestive indicates movement.

B

Be sure the pose and proportions are correct before you begin shading.

C

As for all body drawings, start with an oval for the horse's midsection, and add ovals for the hindquarters and shoulders. Then block in the lines for the legs, tail, neck, and head as shown in step A. Your strokes should be quick and loose to give the pose a spontaneous, natural feel.

Follow the steps to complete the drawing. Remember the horse's skeletal and muscular structures when shading.

Horse & Rider in Action

When you depict a horse with a rider, the two should be drawn as if they are one entity. Develop them both at the same time as you draw. The rider's body, leg, and hand position are important elements that, when drawn correctly, will make your drawings realistic.

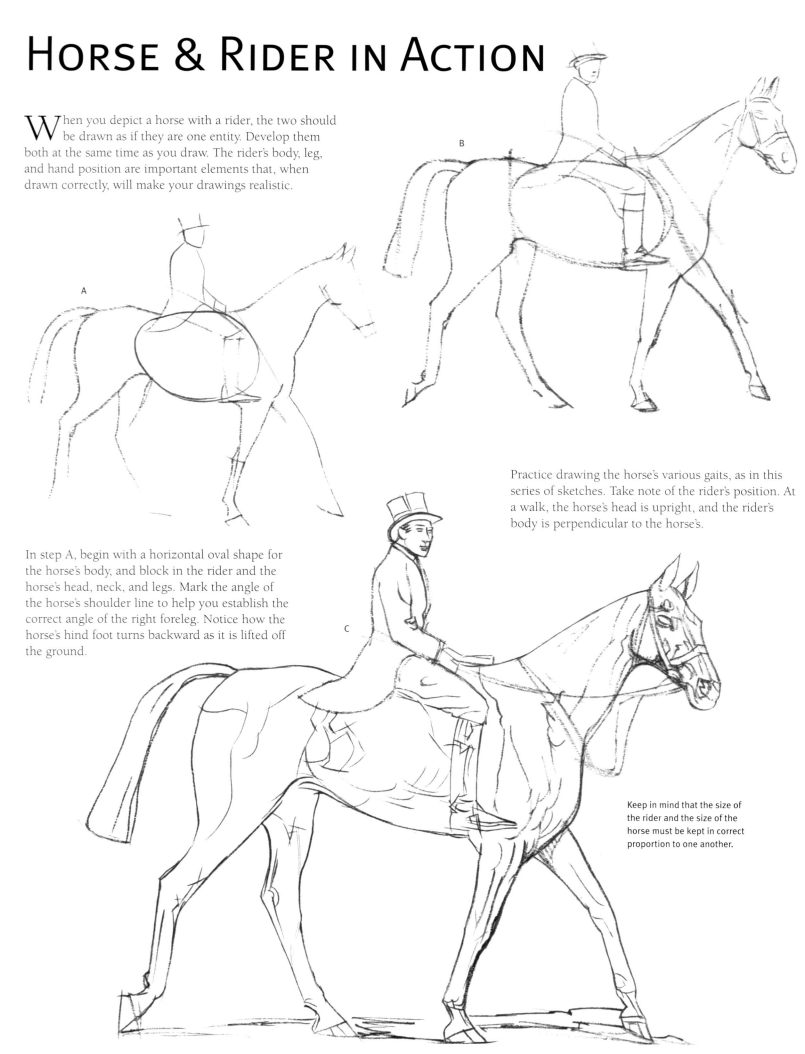

In step A, begin with a horizontal oval shape for the horse's body, and block in the rider and the horse's head, neck, and legs. Mark the angle of the horse's shoulder line to help you establish the correct angle of the right foreleg. Notice how the horse's hind foot turns backward as it is lifted off the ground.

Practice drawing the horse's various gaits, as in this series of sketches. Take note of the rider's position. At a walk, the horse's head is upright, and the rider's body is perpendicular to the horse's.

Keep in mind that the size of the rider and the size of the horse must be kept in correct proportion to one another.

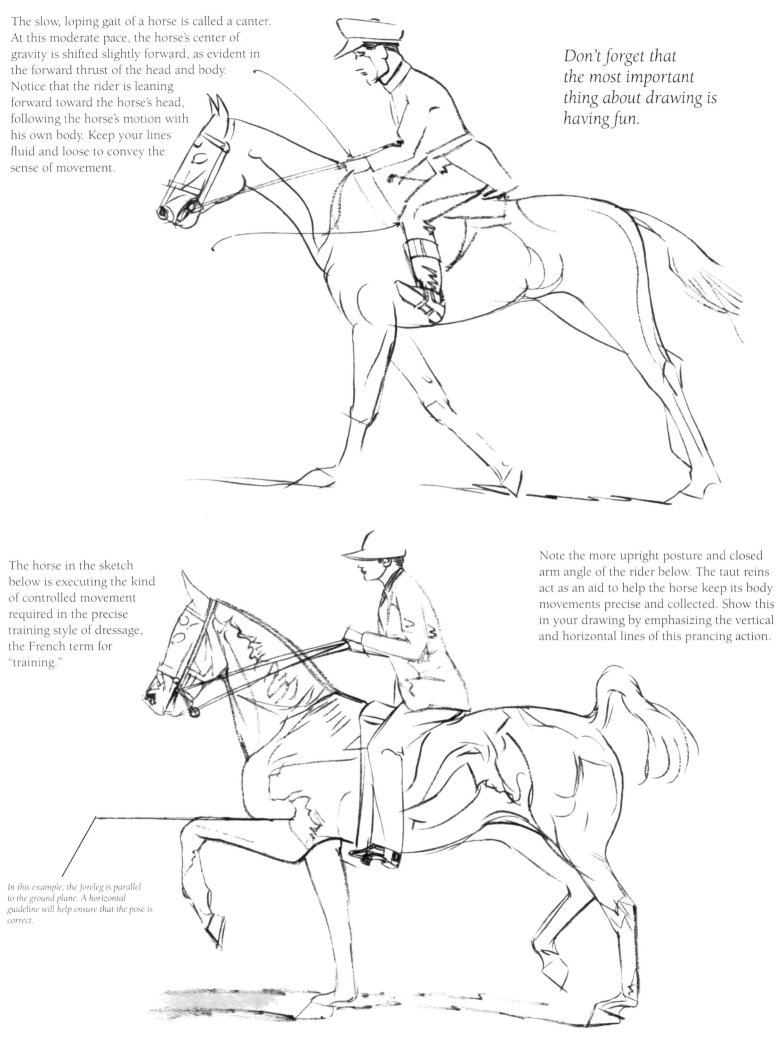

The slow, loping gait of a horse is called a canter. At this moderate pace, the horse's center of gravity is shifted slightly forward, as evident in the forward thrust of the head and body. Notice that the rider is leaning forward toward the horse's head, following the horse's motion with his own body. Keep your lines fluid and loose to convey the sense of movement.

Don't forget that the most important thing about drawing is having fun.

The horse in the sketch below is executing the kind of controlled movement required in the precise training style of dressage, the French term for "training."

Note the more upright posture and closed arm angle of the rider below. The taut reins act as an aid to help the horse keep its body movements precise and collected. Show this in your drawing by emphasizing the vertical and horizontal lines of this prancing action.

In this example, the foreleg is parallel to the ground plane. A horizontal guideline will help ensure that the pose is correct.

THE JUMP

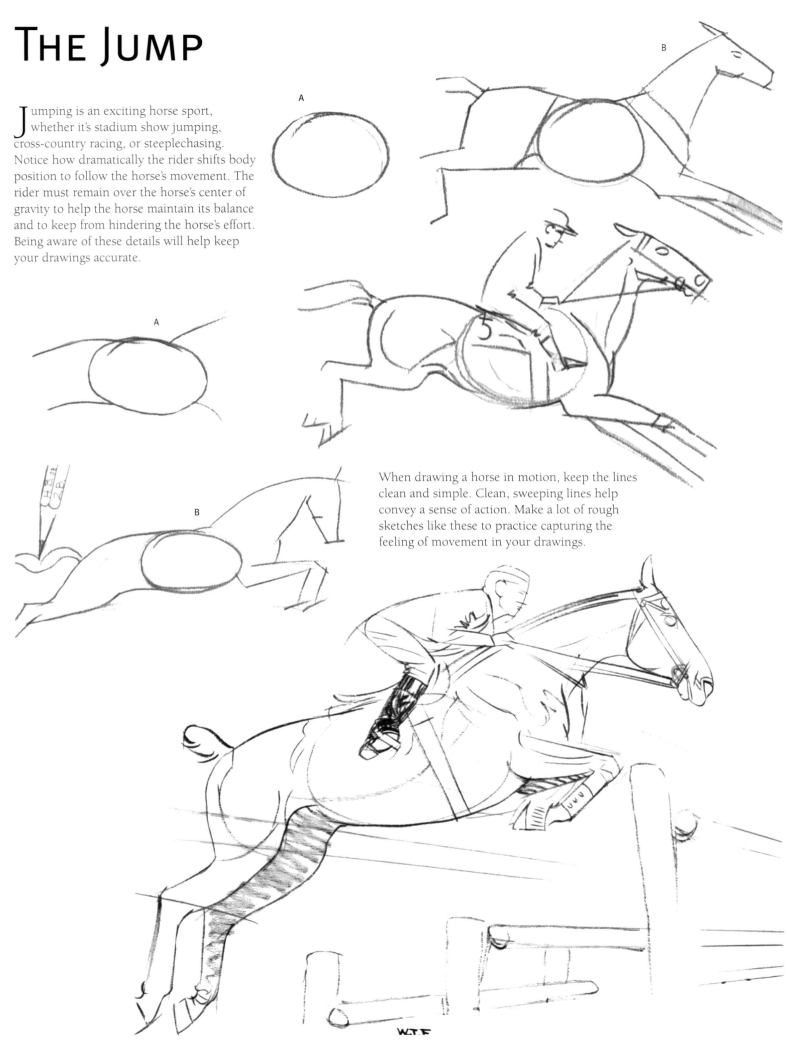

Jumping is an exciting horse sport, whether it's stadium show jumping, cross-country racing, or steeplechasing. Notice how dramatically the rider shifts body position to follow the horse's movement. The rider must remain over the horse's center of gravity to help the horse maintain its balance and to keep from hindering the horse's effort. Being aware of these details will help keep your drawings accurate.

A

B

A

B

When drawing a horse in motion, keep the lines clean and simple. Clean, sweeping lines help convey a sense of action. Make a lot of rough sketches like these to practice capturing the feeling of movement in your drawings.

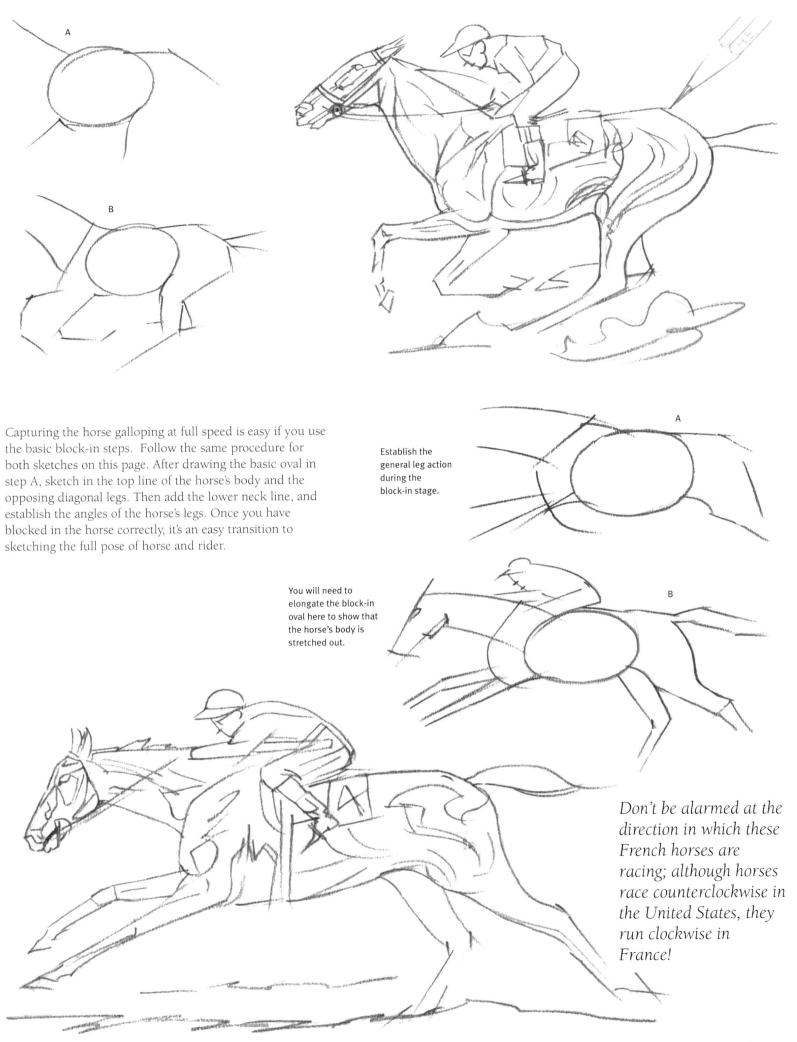

Capturing the horse galloping at full speed is easy if you use the basic block-in steps. Follow the same procedure for both sketches on this page. After drawing the basic oval in step A, sketch in the top line of the horse's body and the opposing diagonal legs. Then add the lower neck line, and establish the angles of the horse's legs. Once you have blocked in the horse correctly, it's an easy transition to sketching the full pose of horse and rider.

Establish the general leg action during the block-in stage.

You will need to elongate the block-in oval here to show that the horse's body is stretched out.

Don't be alarmed at the direction in which these French horses are racing; although horses race counterclockwise in the United States, they run clockwise in France!

William F. Powell

PEOPLE

BEGINNING PORTRAITURE

The head and face are a good starting point for drawing people. The shapes are fairly simple, and the proportions are easy to measure. Portraiture is also very rewarding. You can feel a great sense of satisfaction when you look at a portrait you've drawn and see a true likeness of your subject, especially when the model is someone near and dear to you. So why not start with children?

DRAWING A CHILD'S PORTRAIT

Once you've practiced drawing features, you're ready for a full portrait. You'll probably want to draw from a photo, though, since children rarely sit still for very long! Study the features carefully, and try to draw what you truly see, not what you think an eye or a nose should look like. But don't be discouraged if you don't get a perfect likeness right off the bat. Just keep practicing!

Understanding a Child's Proportions Draw guidelines to divide the head in half horizontally; then divide the lower half into fourths. Use the guidelines to place the eyes, nose, ears, and mouth, as shown.

Separating the Features Before you attempt a full portrait, try drawing the features separately to get a feel for the shapes and forms. Look at faces in books and magazines, and draw as many different features as you can.

Starting with a Good Photo When working from photographs, some artists prefer candid, relaxed poses over formal, "shoulders square" portraits. You can also try to get a closeup shot of the face so you can really study the features.

Sketching the Guidelines First, pencil an oval for the shape of the head, and lightly draw a vertical center line. Then add horizontal guidelines according to the chart at the top of the page, and sketch in the general outlines of the features. When you are happy with the overall sketch, carefully erase the guidelines.

Finishing the Portrait With the side of a pencil, start laying in the middle values of the shadow areas, increasing the pressure slightly around the eye, nose, and collar. For the darkest shadows and the straight, black hair, use the side of a 2B, and overlap your strokes, add a few fine hairs along the forehead with the sharp-pointed tip of your pencil.

COMMON PROPORTION FLAWS

Quite a few things are wrong with these drawings of this child's head. Compare them to the photo at left, and see if you can spot the errors before reading the captions.

Thin Neck
The child in the photo at left has a slender neck, but not this slender! Refer to the photo to see where his neck appears to touch his face and ear.

Not Enough Forehead
Children have proportionately larger foreheads than adults. By making the forehead too small in this example, I've added years to the child's age.

Cheeks Too Round
Children do have round faces, but don't make them look like chipmunks. Be sure to make the ears round, not pointed.

Sticks for Eyelashes
Eyelashes should not stick straight out like spokes on a wheel. Draw the teeth as one shape; don't try to draw each tooth separately.

DRAWING THE ADULT HEAD

An adult's head has slightly different proportions than a child's head (see page 154 for more precise adult proportions), but the drawing process is the same: Sketch in guidelines to place the features, and start with a sketch of basic shapes. Don't forget the profile view. Adults with interesting features are a lot of fun to draw from the side, because you can really see the shape of the brow, the outline of the nose, and the form of the lips.

Art by William F. Powell

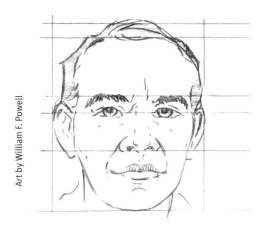

Focusing on Adult Proportions Look for the proportions that make your adult subject unique. Notice the distance from the top of the head to the eyes, from the eyes to the the nose, and from the nose to the chin. Look at where the mouth falls between the nose and the chin and where the ears align with the eyes and the nose.

Drawing the Profile Some people have very pronounced features, so it can be fun to draw them in profile. Use the point and the side of an HB for this pose.

Artist's Tip
If you can't find a photo of an expression you want to draw, try looking in a mirror and drawing your own expressions. That way you can "custom make" them!

EXPRESSING EMOTION

Drawing a wide range of different facial expressions and emotions, especially extreme ones, can be quite enjoyable. Because these are just studies and not formal portraits, draw loosely to add energy and a look of spontaneity—as if a camera had captured the face at just that moment. Some artists don't bother with a background because as they don't want anything to detract from the expression. But do draw the neck and shoulders so the head doesn't appear to be floating in space.

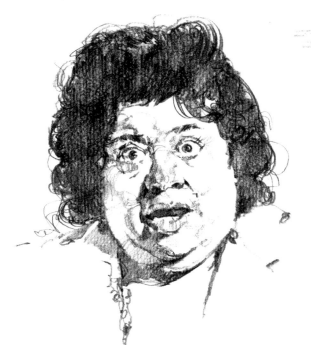

Depicting Shock When you want to show an extreme expression, focus on the lines around the eyes and mouth. Exposing the whole, round shape of the iris conveys a sense of shock, just as the exposed eyelid and open mouth do.

Portraying Happiness
Young children have smooth complexions, so make the smile lines fairly subtle. Use light shading with the side of your pencil to create creases around the mouth, and make the eyes slightly narrower to show how smiles pull the cheek muscles up.

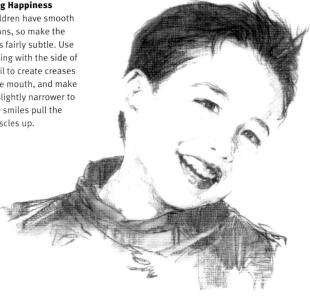

Showing Surprise Here, a lot of the face has been left white to keep most of the attention on the eyes and mouth. Use the tip of the pencil for the loose expression lines and the side for the mass of dark hair.

ADULT HEAD PROPORTIONS

Learning proper head proportions will enable you to accurately draw the head of a person. Study the measurements on the illustration at right, draw a basic oval head shape, and divide it in half with a light, horizontal line. On an adult, the eyes fall on this line, usually about one "eye-width" apart. Draw another line dividing the head in half vertically to locate the position of the nose.

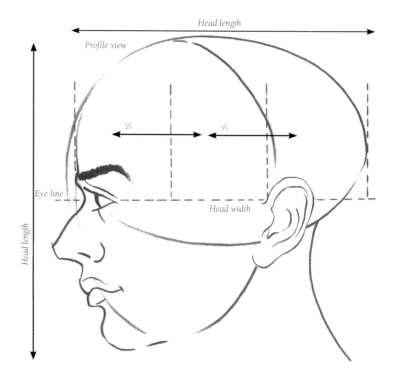

Profile view

Head length

Head length

Eye line

Head width

Looking at Profile Proportions The horizontal length of the head, including the nose, is usually equal to the vertical length. Divide the cranial mass into thirds to help place the ear.

Facial mass

Placing Facial Features The diagram below illustrates how to determine correct placement for the rest of the facial features. Study it closely before beginning to draw, and make some practice sketches. The bottom of the nose lies halfway between the brow line and the bottom of the chin. The bottom lip rests halfway between the nose and the chin. The length of the ears extends from brow line to the bottom of the nose.

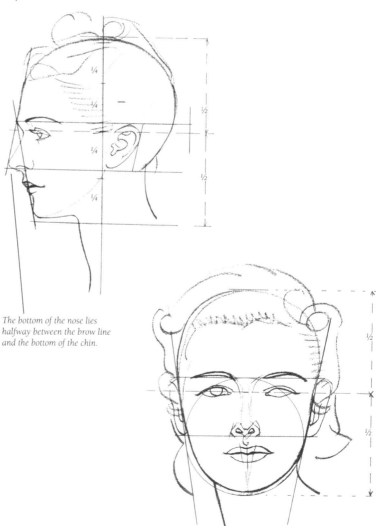

The bottom of the nose lies halfway between the brow line and the bottom of the chin.

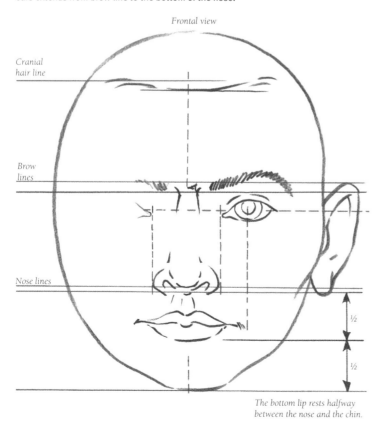

Frontal view

Cranial hair line

Brow lines

Nose lines

The bottom lip rests halfway between the nose and the chin.

WOMAN IN PROFILE

Once you have practiced drawing the facial features separately and have memorized the proportions, you can combine your skills to draw the entire head. Start with a simple rendering that has minimal shading, such as the profile shown here.

Establishing Proportions As shown in step 1, use an HB pencil to block in the proportion guidelines, and then carefully sketch the basic shapes of the features as shown in steps 2 and 3. To make your lines smooth and fresh, keep your hand loose, and try to draw with your whole arm rather than just your wrist. Check your proportions before continuing.

Finish the drawing by refining the shapes, suggesting the hair, and adding minimal shading to the lips and nose with a 2B or 4B pencil. A pencil sharpened to a chisel point is used to create the broad strokes for the hair.

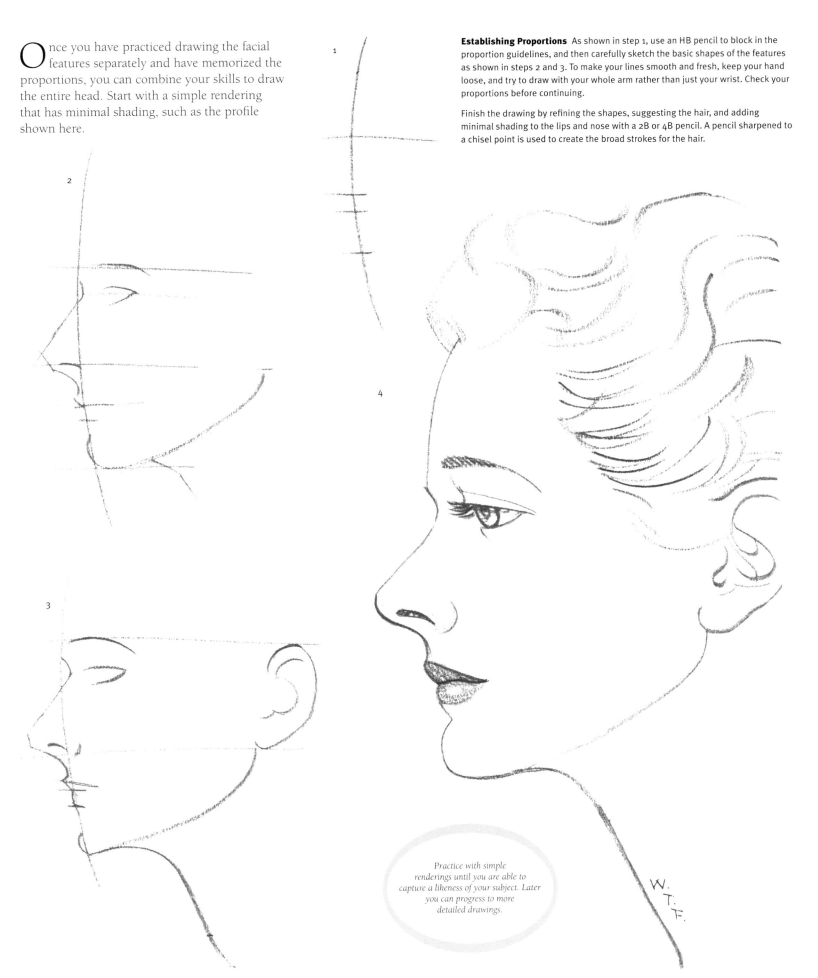

Practice with simple renderings until you are able to capture a likeness of your subject. Later you can progress to more detailed drawings.

W.
T.
F.

STUDYING ADULT PROPORTIONS

Understanding the basic rules of human proportions (meaning the comparative sizes and placement of parts to one another) is imperative for accurately drawing the human face. Understanding proper proportions will help you determine the correct size and placement of each facial feature as well as how to modify them to fit the unique, individual characteristics of your subject.

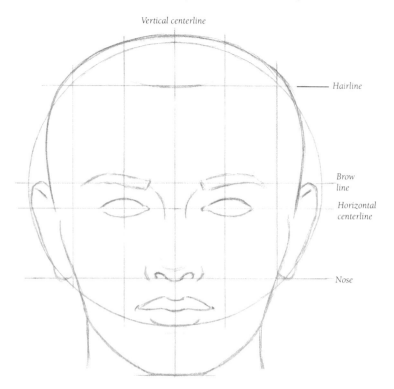

Vertical centerline

Hairline

Brow line

Horizontal centerline

Nose

Establishing Guidelines Visualize the head as a ball that has been flattened on the sides. The ball is divided in half horizontally and vertically, and the face is divided horizontally into three equal parts: the hairline, the brow line, and the line for the nose. Use these guidelines to determine the correct placement and spacing of adult facial features.

Placing the Features The eyes lie between the horizontal centerline and the brow line. The bottom of the nose is halfway between the brow line and the bottom of the chin. The bottom lip is halfway between the bottom of the nose and the chin, and the ears extend from the brow line to the bottom of the nose.

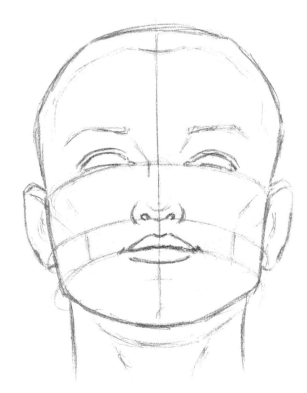

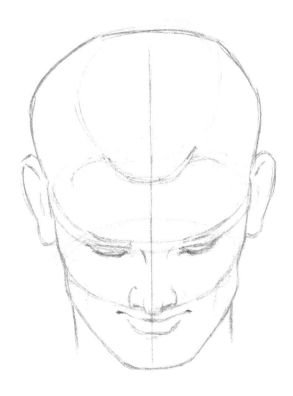

Looking Up When the head is tilted back, the horizontal guidelines curve with the shape of the face. Note the way the features change when the head tilts back: The ears appear a little lower on the head, and more of the whites of the eyes is visible.

Looking Down When the head is tilted forward, the eyes appear closed and much more of the top of the head is visible. The ears appear higher, almost lining up with the hairline and following the curve of the horizontal guideline.

EXPLORING OTHER VIEWS

Beginning artists often study profile views first, as this angle tends to simplify the drawing process. For example, in a profile view, you don't have to worry about aligning symmetrical features. But the rules of proportion still apply when drawing profile views and the more complex three-quarter views.

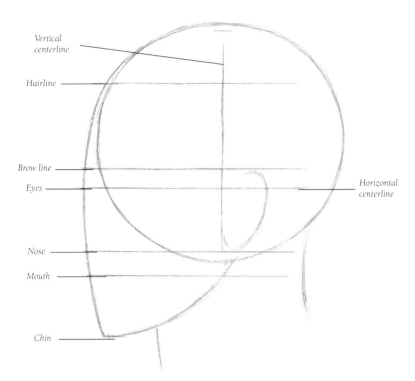

Simplifying the Profile To draw an adult head in profile, start by blocking in the cranial mass with a large circle. Add two curved lines that meet at a point to establish the face and chin. Place the ear just behind the vertical centerline.

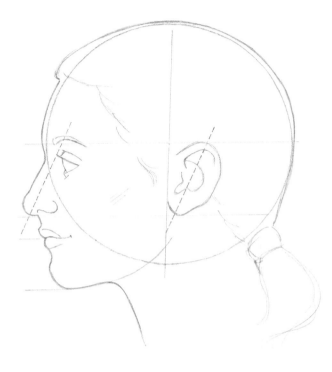

Placing the Features Use the large cranial circle as a guideline for placing the features. The nose, lips, and chin fall outside the circle, whereas the eyes and ear remain inside. The slanted, broken lines indicate the parallel slant of the nose and ear.

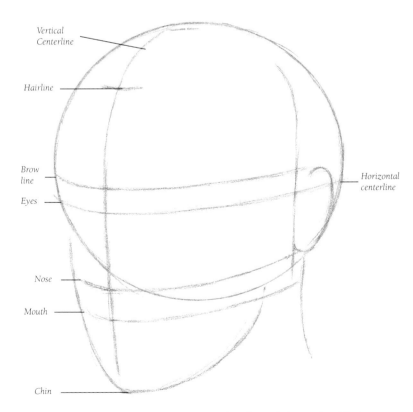

Drawing a Three-Quarter View In a three-quarter view, the vertical centerline shifts into view. More of the left side of the subject's head is visible, but you still see only the left ear. As the head turns, the guidelines also curve, following the shape of the head.

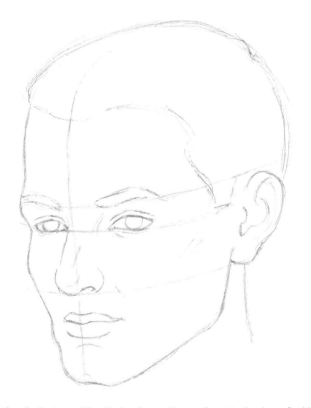

Distorting the Features When the head turns, the eye closest to the viewer (in this case, the left eye) appears larger than the other eye. This is a technique called "foreshortening" in which elements of a drawing are distorted to create the illusion of three-dimensional space; objects closer to the viewer appear larger than objects that are farther away.

DEPICTING ADULT FEATURES

I f you're a beginner, it's a good idea to practice drawing all of the facial features separately, working out any problems before attempting a complete portrait. Facial features work together to convey everything from mood and emotion to age. Pay attention to the areas around the features as well; wrinkles, moles, and other similar characteristics help make your subject distinct.

EYES

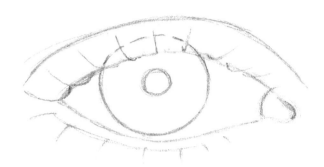

Step 1 Make a circle for the iris first; then draw the eyelid over it. (Drawing an entire object before adding any overlapping elements is called "drawing through.") Note that part of the iris is always covered by the eyelid.

Step 1 Draw through a circle for the eye first; then draw the eyelid around it as shown. In a profile view, the iris and pupil are ellipses; the top and bottom of the iris are covered by the upper and lower eyelids.

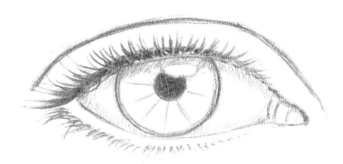

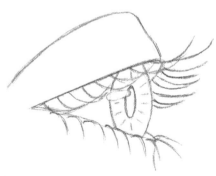

Step 2 Start shading the iris, drawing lines that radiate out from the pupil. Then add the eyelashes and the shadow being cast on the eyeball from the upper lid and eyelashes, working around the highlight on the iris.

Step 2 To draw eyelashes in profile, start at the outside corner of the eye and make quick, curved lines, always stroking in the direction of growth. The longest lashes are at the center of the eye.

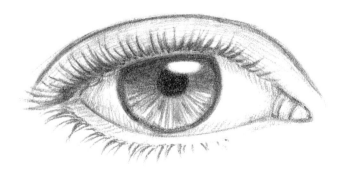

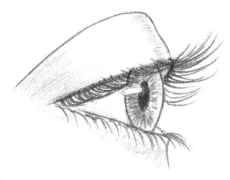

Step 3 Continue shading the iris, stroking outward from the pupil. Then shade the eyelid and the white of the eye to add three-dimensional form.

Step 3 When shading the eyelid, make light lines that follow the curve of the eyelid. As with the frontal view, the shading in the iris radiates out from the pupil.

<div align="center">Step 1</div>

<div align="center">Step 2</div>

<div align="center">Step 3</div>

<div align="center">Step 4</div>

Rendering a Pair of Eyes After becoming comfortable with drawing the eye itself, start developing the features around the eye, including the eyebrows and the nose. Be sure to space adult eyes about one eye-width apart from each other. Keep in mind that eyes are always glossy—the highlights help indicate this. It's best to shade around the highlights, but if you accidentally shade over the area, you can pull out the highlight with a kneaded eraser.

VARYING QUALITIES

Several characteristics influence the final impression that a pair of eyes gives: The shape of the eye, position of the eyebrows, length and thickness of the eyelashes, and number of creases and wrinkles can denote everything from age and gender to mood and ethnicity. Study the examples below to see how these different elements work together.

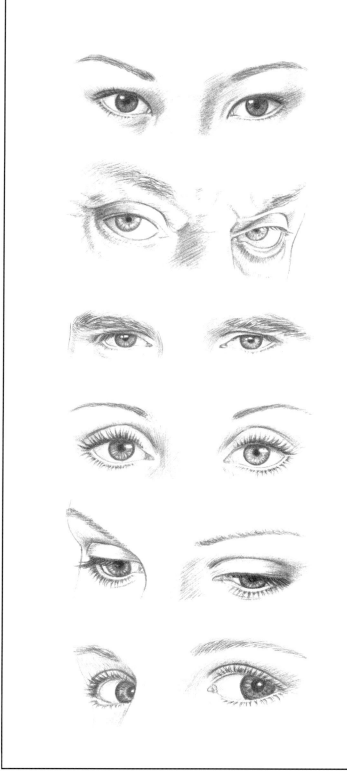

THE NOSE, EARS & MOUTH

NOSES

Rendering Noses To draw a nose, I first block in the four planes—two for the bridge and two for the sides (see "Combining Features" on the right). Then I study the way each plane is lit before adding the dark and light values. The nostrils should be shaded lightly; if they're too dark, they'll draw attention away from the rest of the face. Generally men's nostrils are more angular, whereas women's are more gently curved.

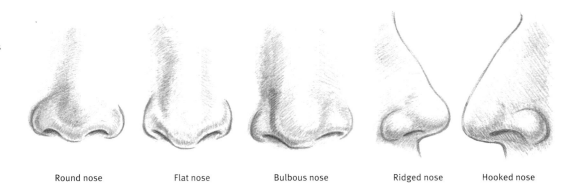

| Round nose | Flat nose | Bulbous nose | Ridged nose | Hooked nose |

EARS

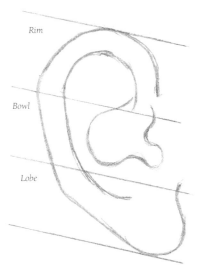

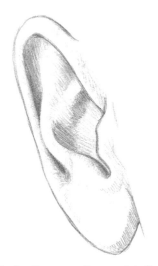

Artist Tip
Men have more rectangular shaped nostrils, while women have more round.

Dividing the Ear The ear is shaped like a disk divided into three parts: the rim, the bowl, and the lobe.

Sizing the Ear The ear usually connects to the head at a slight angle; the width is generally about one-half of the length.

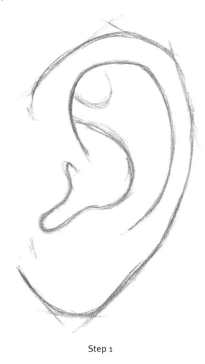

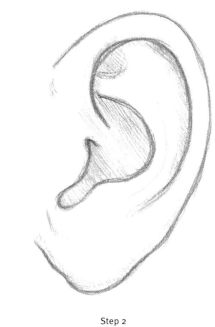

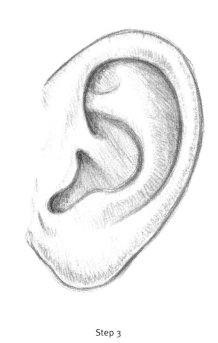

| Step 1 | Step 2 | Step 3 |

Developing the Ear in Profile I first block in the general shape, visually dividing it into its three parts. Next I start shading the darkest areas, defining the ridges and folds. Then I shade the entire ear, leaving highlights in key areas to create the illusion of form.

LIPS

Step 1 When drawing lips, I first sketch the basic outline. The top lip slightly protrudes over the bottom lip; the bottom lip is also usually fuller than the top lip.

Step 2 Next I begin shading in the direction of the planes of the lips. The shading on the top lip curves upward, and the shading on the bottom lip curves downward.

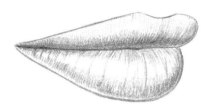

Step 3 I continue shading, making the darkest value at the line where the lips meet. Then I pull out some highlights to give the lips shine and form. Highlights also enhance the lips' fullness, so it's often best to include larger highlights on the fuller bottom lip.

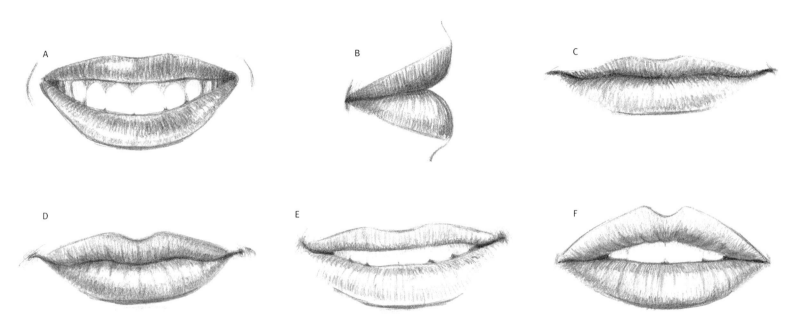

Detailing the lips Determine how much detail you'd like to add to your renderings of lips. You can add smile lines and dimples (A, B, and D), you can draw clearly defined teeth (A) or parts of the teeth (E and F), or you can draw closed lips (B, C, and D).

COMBINING FEATURES

Step 1 First I simplify the nose by dividing it into four planes—plus a circle on the tip to indicate its roundness. Then I draw the outline of the lips. I add a small circle to connect the base of the nose with the top of the lip. The arrows on the lips indicate the direction in which I will shade them.

Step 2 Now I lightly shade the sides of the nose as well as the nostrils and the area between the nose and lips. I begin shading the lips in the direction indicated by the arrows in step 1. Then I shade the dark area between the top and bottom lips. This helps separate the lips and gives them form.

Step 3 I continue shading to create the forms of the nose and mouth. Where appropriate, I retain lighter areas for highlights and to show reflected light. For example, I use a kneaded eraser to pull out highlights on the top lip, on the tip of the nose, and on the bridge of the nose.

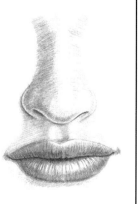

HEAD POSITIONS

The boxes shown here correlate with the head positions directly below them. First drawing boxes like these will help you correctly position the head. The boxes also allow the major frontal and profile planes, or level surfaces, of the face to be discernable. Once you become comfortable with this process, practice drawing the heads shown on this page.

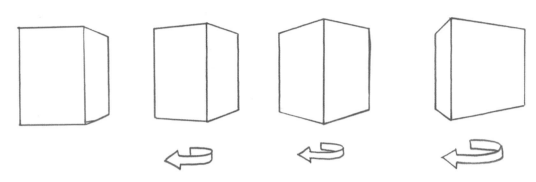

First observe the main principles of perspective by learning how to draw a three-dimensional cube from different angles. Once you have mastered drawing a simple shape in perspective, you can create a basic representation of the head (see below).

Use only a few strokes to sketch the basic head shape of this smiling man. Apply the same principles of perspective you used for the cubes above. For more on perspective, see page 214.

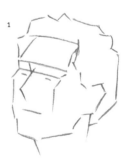

1

Keep all guidelines very light so they won't show in your actual drawing.

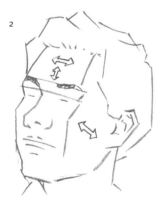

2

Your shading strokes should follow the arrow directions to bring out the contours of the face.

3

LEARNING THE PLANES OF THE FACE

Once you understand the basic structure of the head, you can simplify the complex shapes of the skull into geometric planes. These planes are the foundation for shading, as they act as a guide to help you properly place highlights and shadows.

THE EFFECTS OF LIGHT

Lighting the Planes from Above When light comes from above, the more prominent planes of the face—such as the bridge of the nose and the cheekbones—are highlighted. The eyes, which recede slightly, are shadowed by the brow; the sides of the nose, bottom of the chin, and underside of the neck are also in shadow.

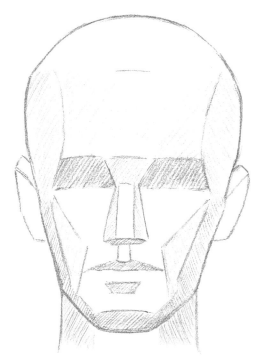

Lighting the Planes from the Side Features are shaded differently when light hits the side of the face: The eyes are still in shadow, but the side of the face and neck are now highlighted. The shading on the head becomes darker as it recedes toward the neck; the sides of the cheeks appear "sunken"; and the ear casts a shadow on the back of the head.

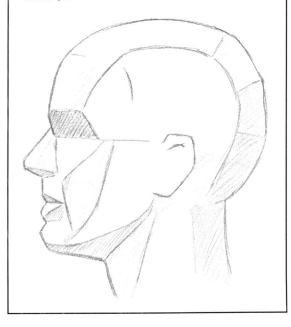

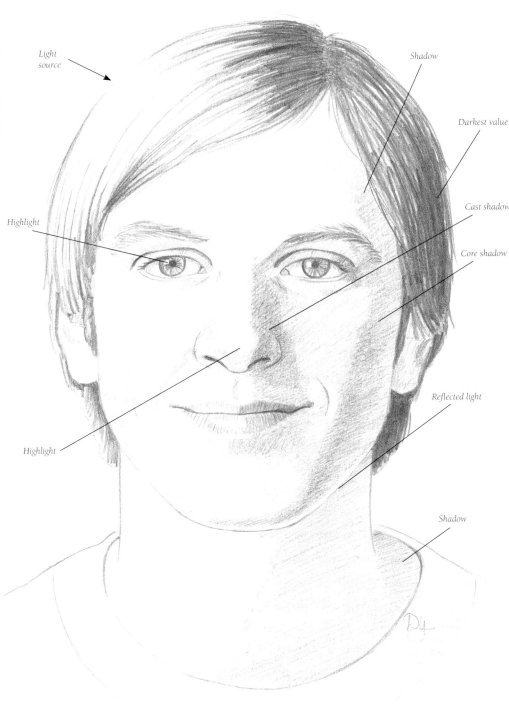

Light source

Shadow

Darkest value

Cast shadow

Core shadow

Highlight

Reflected light

Highlight

Shadow

Shading the Planes of the Face Many types and values of shadows contribute to the piecing together of all the planes of the face. Core shadows—or the main value of the shadows—are a result of both the underlying structure and the light source. Protruding objects, such as the nose, produce cast shadows, like the dark area on the left of this subject's nose. Highlights are most visible when directly in the light's path; here the light source is coming from above left, so the lightest planes of the face are the top of the head and the forehead. The darkest areas are directly opposite the light source, here the left side of the subject's face and neck. Even in shadow, however, there are areas of the planes that receive spots of reflected light, such as those shown here on the chin and under the eye.

APPROACHING A PROFILE VIEW

A profile view can be very dramatic. Seeing only one side of the face can bring out a subject's distinctive features, such as a protruding brow, an upturned nose, or a strong chin. Because parts of the face appear more prominent in profile, be careful not to allow any one feature to dominate the entire drawing. Take your time working out the proportions before drawing the complete portrait.

Drawing in Profile When drawing a subject in profile, be careful with proportions, as your facial guidelines will differ slightly. In a profile view, you see more of the back of the head than you do of the face, so be sure to draw the shape of the skull accordingly.

Step 1 After lightly drawing a circle for the cranial mass, I use an HB pencil to block in the general shapes of the face, chin, and jaw line. Then I add guidelines for the eyes, nose, mouth, and ear. (See page 157 for general rules regarding the placement of features in a profile view.) I closely observe my subject to see how the positions and angles of his features differ from the "average."

Step 2 Following the guidelines, I rough in the shapes of the features, including my subject's slightly protruding upper lip. I sketch a small part of the eye to indicate how little of the iris you actually see in a profile view. (See page 158 for more information on drawing eyes in profile.)

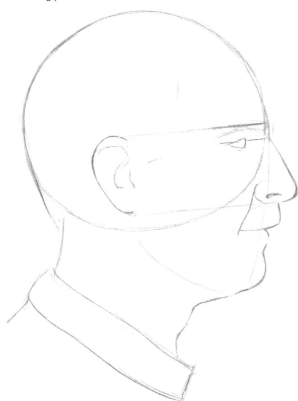

Step 3 When I sketch the eyebrow, I pay particular attention to the space between the eye and the eyebrow; in this case, the subject's eyebrow is fairly close to his eye. It also grows past the inside corner of his eye, very close to his nose, and tapers toward the outside corner of the eye. Next, I continue refining the profile by carefully defining the shapes of the chin and the neck (including the Adam's apple).

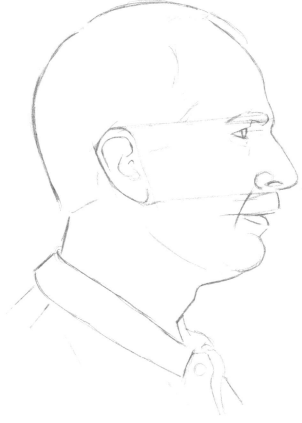

Step 4 In a profile view, the hairline is important to achieving a likeness, as it affects the size and shape of the forehead. This subject has a very high forehead, so the hairline starts near the vertical centerline of the cranial mass. Once I'm happy with the shapes of the face and hairline, I start refining the features, giving them form.

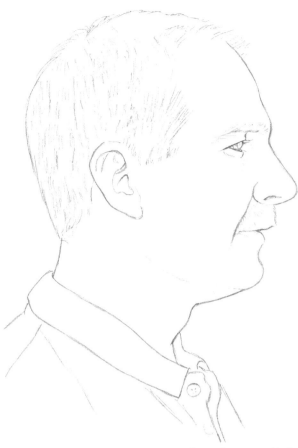

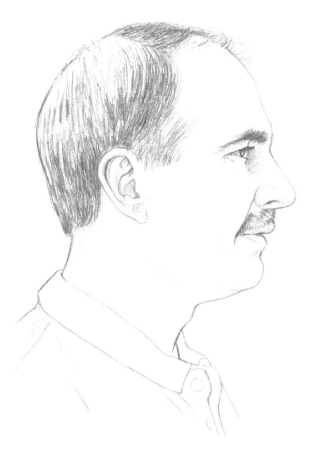

Step 5 Here you can see that the drawing is really starting to resemble the subject. Next I switch to a 2B pencil and continue building up the forms: I round out the nose and chin; add light, soft strokes to the area above the lip for the mustache; and suggest the hair using short, quick strokes. Then I add more detail to the eye and develop the ear and the eyebrow.

Step 6 Still using the 2B, I continue to develop the hair, eyebrows, and mustache, always stroking in the direction that the hair grows. I leave plenty of white areas in the hair to create the illusion of individual strands. Next, I begin to suggest the curves and shadows of the face by shading the eye, ear, and nose. (See "The Effects of Light" on page 163 for tips on shading a profile.)

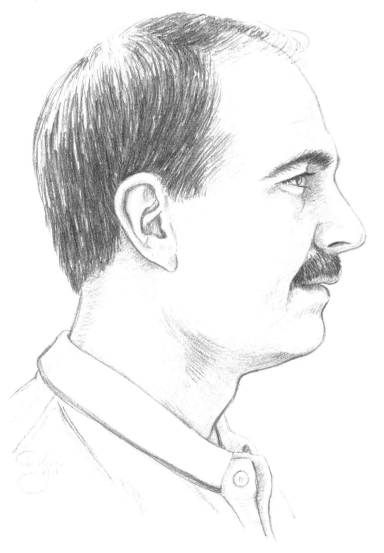

Step 7 I continue shading the lips, pulling out a white highlight on the bottom lip with a kneaded eraser. Then I shade more of the ear and add even darker values to the hair, leaving highlights on the crown of the head, as it is in the direct path of the light source. I also shade the forehead, the nose, and the chin. I leave the majority of the cheek and the middle part of the forehead white. This helps indicate that the light source is coming from above, angled toward the visible side of the face.

WOMAN FRONTAL VIEW

W hen you are ready to progress to more detailed drawings, try working from a photo. A black-and-white photo will allow you to see all the variations in value, which can be helpful when shading your subject.

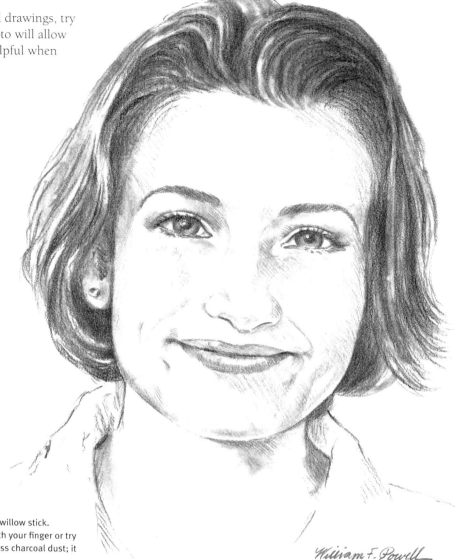

Drawing from a Snapshot In this photo, you can see the subject's delicate features, smooth skin, and sparkling eyes. You should to try to capture the features that are unique to her: the slightly crooked mouth, smile lines, and wide-set eyes. Note also that you can barely see her nostrils. It's details like these that will make the drawing look like the subject and no one else.

Step 4 Continue building up the shading with the charcoal pencil and willow stick. For gradual blends and soft gradations of value, rub the area gently with your finger or try using a blending stump. (Don't use a brush or cloth to remove the excess charcoal dust; it will smear the drawing.)

William F. Powell

Step 1 Start with a sharp HB charcoal pencil, and very lightly sketch the general shapes of the head, hair, and shirt collar. (Charcoal is used for this drawing because it allows for very subtle value changes.) Then lightly place the facial features.

Step 2 Begin refining the features, adding the pupil and iris in each eye, dimples, and smile lines. At this stage, study the photo carefully so you can duplicate the angles and lines that make the features unique to your subject. Then begin adding a few shadows.

Step 3 As you develop the forms with shading, use the side of an HB charcoal pencil, and follow the direction of the facial planes. Then shape a kneaded eraser to a point to lift out the eye highlights, and use a soft willow charcoal stick for the dark masses of hair.

DEVELOPING A PORTRAIT

Drawing a person is really no different than drawing anything else. A human face has contours just like a landscape, an apple, or any other subject—and these contours catch the light and create shadow patterns just as they do on any other object. The difference is that the contours of the face change slightly from individual to individual. The "trick" to portraiture is observing these differences and duplicating them in your drawings.

CAPTURING A LIKENESS

You don't need to memorize all the bones, muscles, and tendons in the human head to draw a portrait; just follow the general rules of proportions as shown in the chart at right. Simply divide the face into thirds, and note where the features fall in relation to the face and to one another. Then study your model to determine how his or her face differs from the chart (that is, how it is unique). Look for subtle changes, such as a wider nose, thinner lips, wide- or close-set eyes, or a higher or lower forehead. It is also important to practice drawing faces from different viewpoints—front, side, and three-quarter views—keeping the proportions the same but noting how the features change as the head turns. Remember: Draw what you really see, and your portrait will look like your model!

Lips In a frontal view, the upper lip has two "peaks" and a slight protrusion in the center. The lower lip is fleshier and has no sharp peaks. When shading, I define the bottom edge of the lower lip by shading the area directly below it.

Eyes In a side view, the eye has a triangular shape, the iris has an oval shape, and the eyelids slightly cover it at the top and bottom. When shading, I concentrate on developing the iris, lashes, and lids, leaving most of the brow white.

Nose In a three-quarter view, the far nostril is partially hidden from sight. The light strikes most strongly on the center ridge, so I create the form by shading the side of the nose, under its tip, and outside the nostril.

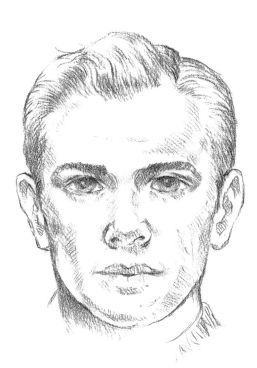

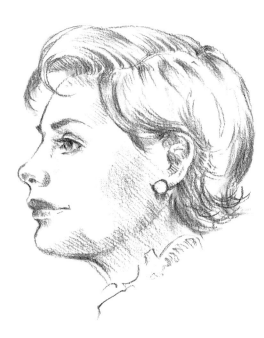

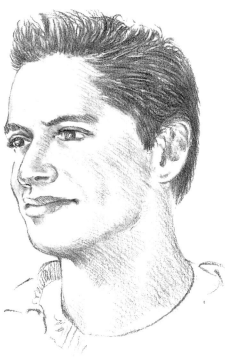

Frontal View In a frontal view, we can see that the face is not perfectly symmetrical. One eye is generally smaller than the other, or one might sit at a slightly different angle. The same is true of the ears, cheeks, and the sides of the nose and mouth.

Profile The head shape changes in a side view, but the features remain in the same relative positions. Although the nose is a prominent feature in a profile, take care not to let it dominate the face. Also, pay attention to where the eye sits and how the lower lip curves into the chin.

Three-Quarter View This view can be challenging because you have to distort the features to make them look realistic. Here I changed the eye and lip shapes to curve with the face. You might want to start with a contour drawing to work out how the features really look.

Capturing a Likeness

Once you've practiced drawing the individual features, you're ready to combine them in a full portrait. Use your understanding of the basics of proportion to block in the head and place the features. Study your subject carefully to see how his or her facial proportions differ from the "average" person. Capturing these subtle differences will help you achieve a better likeness to your subject.

Drawing What You See Working from a photo helps you draw what you really see—as opposed to what you expect to see, because you can change your viewpoint. Try turning both the photo and your drawing upside down as you work; you'll find that you can represent many shapes more accurately.

Step 1 Using an HB pencil, I sketch the general outline of the subject's face. Then I place the facial guidelines before blocking in the eyes, nose, and mouth. (Notice that the mouth takes up about one-fourth of the face.) I also block in the shape of her hair, including the bangs.

Step 2 Switching to a 2B pencil, I indicate the roundness of the facial features. I compare my sketch to the photograph, making sure that I've captured the things that make this individual unique, like the turned-up nose, slightly asymmetrical eyes, and wide smile.

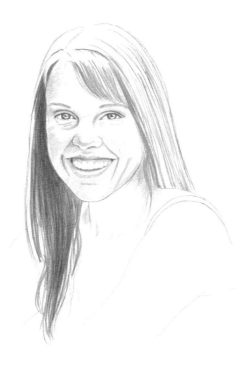

Step 3 I erase my guidelines and then begin shading, following the form of the face with the 2B pencil and softly blending to create the smoothness of the skin. Next I create the teeth, lightly indicating the separations with incomplete lines. Then I switch to a 3B pencil to lay in more dark streaks of hair.

Step 4 To render the smooth, shiny hair, I use a 4B pencil to lay in darker values. I vary the length of the strokes, pulling some strokes into the areas at the top of her head that have been left white for highlights to produce a gradual transition from light to dark. Then I refine the eyes and mouth by adding darker layers of shading.

Focusing on Features

This drawing shows the same young lady with a different hair style, expression, and pose. Although she's in costume, she is still recognizable as the same subject because I was faithful to the facial characteristics specific to this individual.

INCLUDING A BACKGROUND

An effective background will draw the viewer's eye to your subject and play a role in setting a mood. A background should always complement a drawing; it should never overwhelm the subject. Generally a light, neutral setting will enhance a subject with dark hair or skin, and a dark background will set off a subject with light hair or skin.

Simplifying a Background When working from a photo reference that features an unflattering background, you can easily change it. Simplify a background by removing any extraneous elements or altering the overall values.

Step 1 With an HB pencil, I sketch in the basic head shape and the guidelines, and then I block in the position of the eyes, brows, nose, and mouth. (Notice that the center guideline is to the far left of the face because of the way the head is turned.) Next I indicate the neck and the hair.

Step 2 Switching to a 2B pencil, I begin refining the shape of the eyes, brows, nose, and mouth. I block in the hair with long, sweeping strokes, curving around the face and drawing in the direction the hair grows. Then I add a neckline to her shirt.

Step 3 First I shade the irises with a 2B pencil. Then I begin shading the background using diagonal hatching strokes. Once the background is laid in, I use a 3B pencil to build up the dark values of the hair. (I create the background before developing the hair so my hand doesn't smear the delicate strands of hair.)

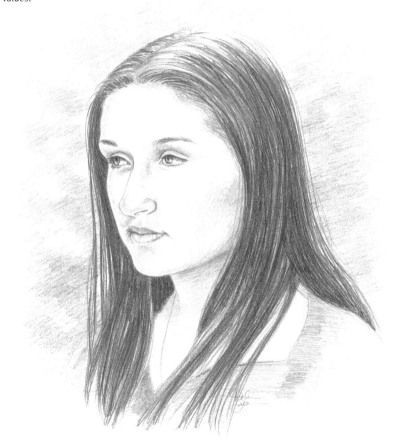

Step 4 I finish shading the face, neck, and shirt with a 2B pencil, and then I switch to a 3B to add more dark streaks to the hair. I apply another layer of strokes to the background, carefully working around the hair and leaving a few gaps between the strokes to create texture and interest. Next I use a kneaded eraser to smooth out the transitions.

CREATING DRAMA

A darker background can add intensity or drama to your portrait. Here the subject is in profile so the lightest values of her face stand out against the dark values of the background. To ensure that her dark hair does not become "lost," I create a gradation from dark to light, leaving the lightest areas of the background at the top and along the edge of the hair for separation.

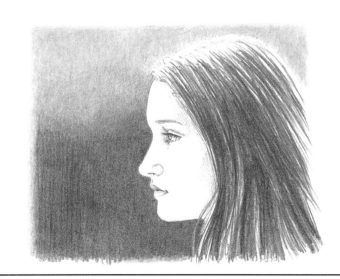

DEPICTING AGE

As people age, their skin loses its elasticity, which causes loose, wrinkled skin; drooping noses; and sagging ears. In addition, lips often become thinner, hair turns gray, and eyesight becomes poor (which is why many elderly subjects wear glasses). Accurately rendering these characteristics is essential to creating successful portraits of mature subjects.

Step 2 I draw the basic shape of the eyeglasses, and then I begin to suggest my subject's age by adding delicate lines around her eyes and across her forehead. I also round out the jaw and chin to show where the skin has begun to sag. I draw loose skin on the neck and deep lines on either side of the nose.

Step 1 I block in the face with an HB pencil. Then I add guidelines, which I use to place the eyes, nose, ears, eyebrows, and mouth. The lips thin out and move inward as a person ages, so I draw them accordingly. I also sketch the wavy outline of the hair.

Step 3 Switching to a 2B pencil, I begin shading the hair and developing the eyes, adding light, curved lines around and under the eyes to create "bags." I magnify the wrinkles slightly where they can be seen through the glasses. (See "Rendering Wrinkles" on the right.)

Step 4 Still using a 2B, I shade the face and neck, adding strokes to the side of the neck for wrinkles. I finish shading the irises and the eyelids. I shade the area between the right side of the cheek and the jawbone to show the prominent cheekbone, and I add shading around the nose and mouth to make the skin appear puffy. Then I add darker values to the hair and earrings.

Step 5 As I continue shading the face, I add more definition to the wrinkles around the eyes so they don't disappear into the shaded areas. I am careful to keep them subtle by smoothing out the transitions with a blending stump. (See "Rendering Wrinkles" below for more on blending.) Finally, I add a button to her collar and create the plaid pattern of her shirt. I stand back from the drawing, making sure I'm pleased with the effect the angular bones, loose skin, and wrinkles have on the subject's face and that they suggest her age.

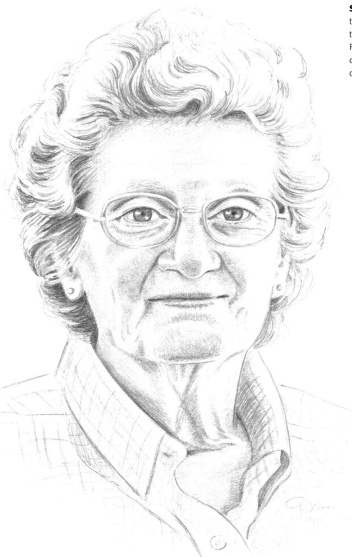

RENDERING WRINKLES

The key to drawing realistic-looking wrinkles is to keep them subtle. Indicate wrinkles with soft shading, not with hard or angular lines. You can best achieve this effect by using a dull pencil point. You can also use a cloth or a blending stump to softly blend the transitions between the light and dark values in the wrinkles, or use a kneaded eraser to soften wrinkles that appear too deep.

When drawing a subject with glasses, as in the example below, try to magnify the wrinkle lines that are seen through the lenses. You can do this by drawing the lines of shading a little larger and spacing them farther apart.

ELDERLY MEN

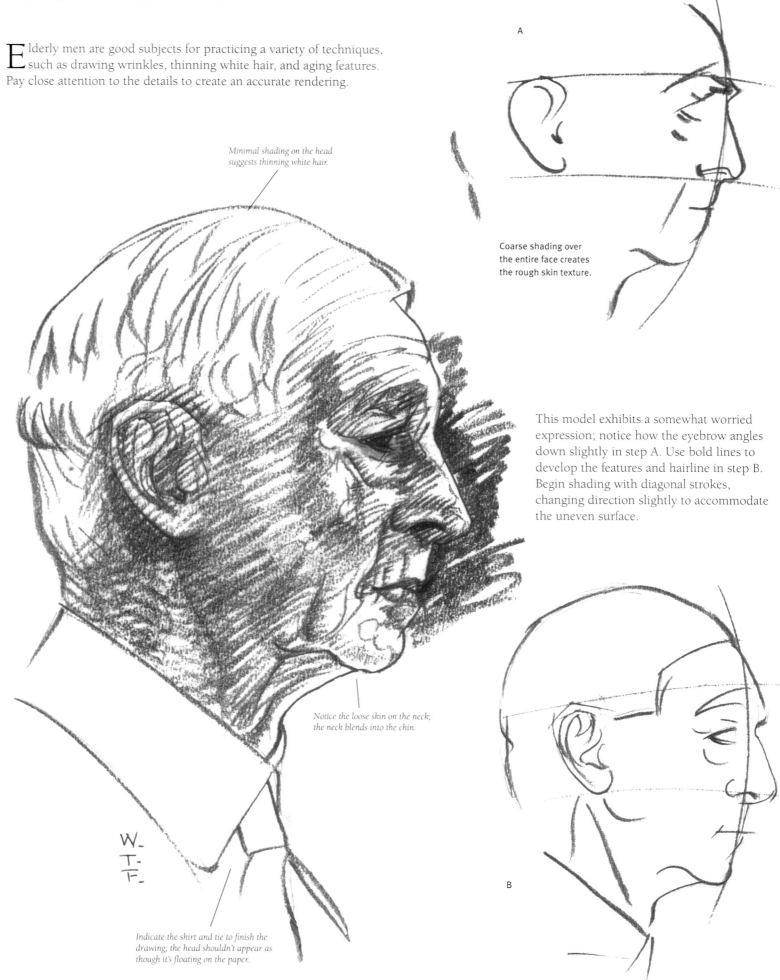

Elderly men are good subjects for practicing a variety of techniques, such as drawing wrinkles, thinning white hair, and aging features. Pay close attention to the details to create an accurate rendering.

A

Minimal shading on the head suggests thinning white hair.

Coarse shading over the entire face creates the rough skin texture.

This model exhibits a somewhat worried expression; notice how the eyebrow angles down slightly in step A. Use bold lines to develop the features and hairline in step B. Begin shading with diagonal strokes, changing direction slightly to accommodate the uneven surface.

Notice the loose skin on the neck; the neck blends into the chin.

W-
T-
F-

Indicate the shirt and tie to finish the drawing; the head shouldn't appear as though it's floating on the paper.

B

BODY

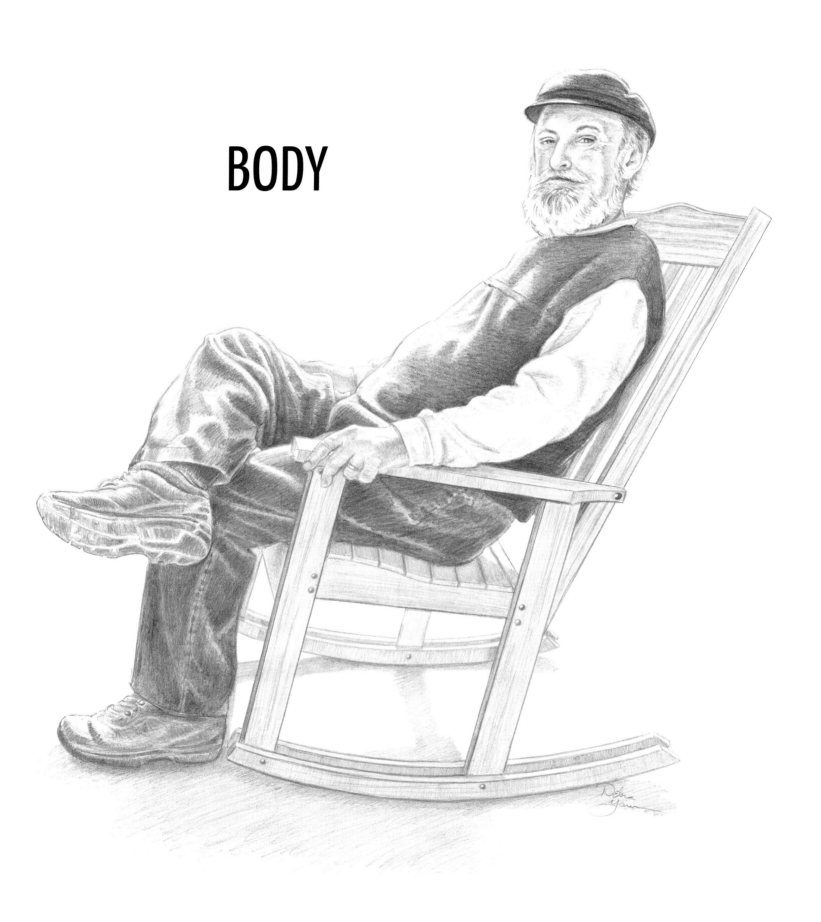

FIGURES IN ACTION

To draw the human figure from head to toe, it helps to know something about the framework on which it's built. Many art classes have students draw people as skeletons, which is good practice for visualizing how all of the parts fit together. You don't have to try that exercise; the simple drawings here will suffice. Start with simple stick figure sketches of the skull, shoulders, rib cage, and add the arms and legs. Then, once you have the proportions right, you can flesh out the forms.

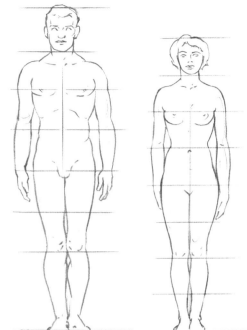

CAPTURING ACTION

Remember that a gesture drawing is a quick, rough sketch that illustrates a moment of an action (see below). The idea is simply to capture the gesture—it isn't about trying to get a likeness. Give yourself 10 minutes to draw the entire figure engaged in some sport or full-body activity, working either from life or from a photo. Set a timer, and stop when the alarm goes off. Working against the clock teaches you to focus on the essentials and get them down on paper quickly.

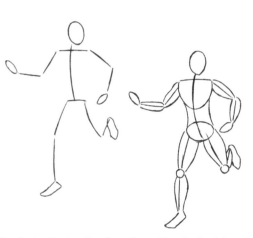

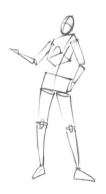

The human figure can be broken down into several basic shapes. To help you see the human body in three-dimensional form, practice building a figure with cylinders, boxes, and spheres.

Developing Gesture Drawings Start with a simple stick figure to catch the motion; then add circles and ovals to flesh out the forms.

Blocking in Shadows To keep the feeling of free movement, don't draw perfectly refined lines and shadows. Instead, focus on making delicate outlines for the dancers, and quickly lay in broad, dark strokes for their clothing.

Suggesting Movement First sketch in the diagonal center lines for the arms and legs, and add ovals and circles for the heads and joints. Then rough in the general outlines.

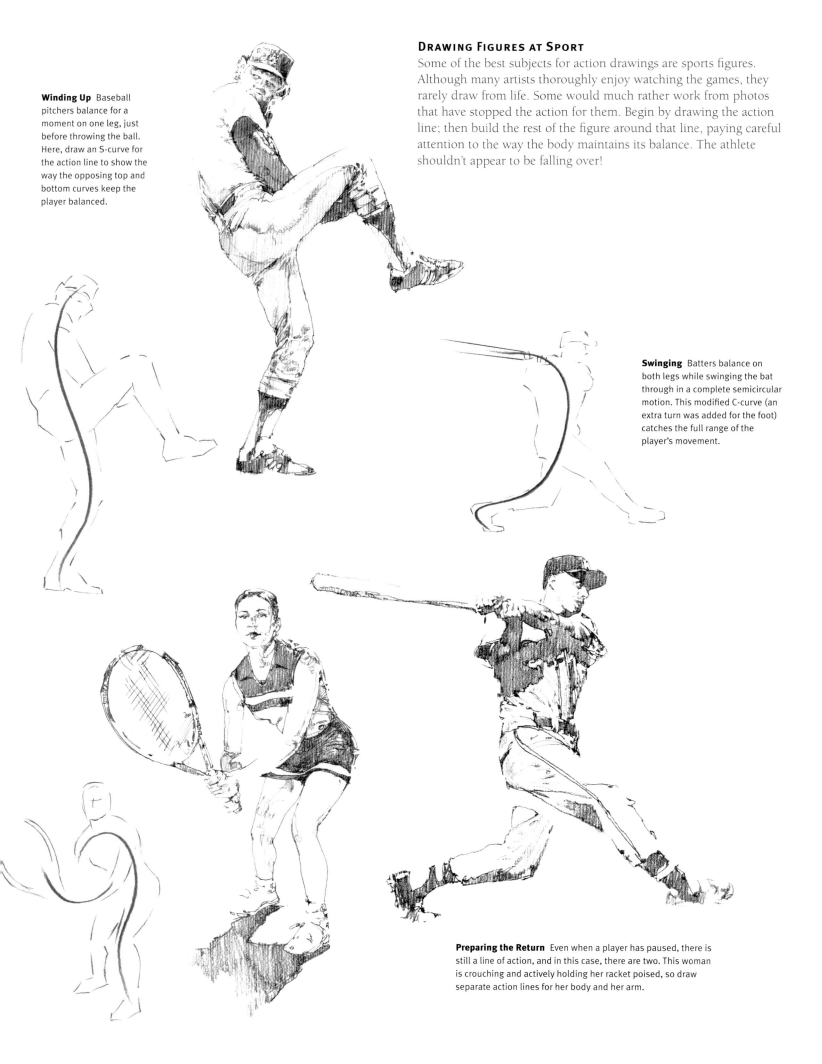

DRAWING FIGURES AT SPORT

Some of the best subjects for action drawings are sports figures. Although many artists thoroughly enjoy watching the games, they rarely draw from life. Some would much rather work from photos that have stopped the action for them. Begin by drawing the action line; then build the rest of the figure around that line, paying careful attention to the way the body maintains its balance. The athlete shouldn't appear to be falling over!

Winding Up Baseball pitchers balance for a moment on one leg, just before throwing the ball. Here, draw an S-curve for the action line to show the way the opposing top and bottom curves keep the player balanced.

Swinging Batters balance on both legs while swinging the bat through in a complete semicircular motion. This modified C-curve (an extra turn was added for the foot) catches the full range of the player's movement.

Preparing the Return Even when a player has paused, there is still a line of action, and in this case, there are two. This woman is crouching and actively holding her racket poised, so draw separate action lines for her body and her arm.

Body | 175

MOVEMENT & BALANCE

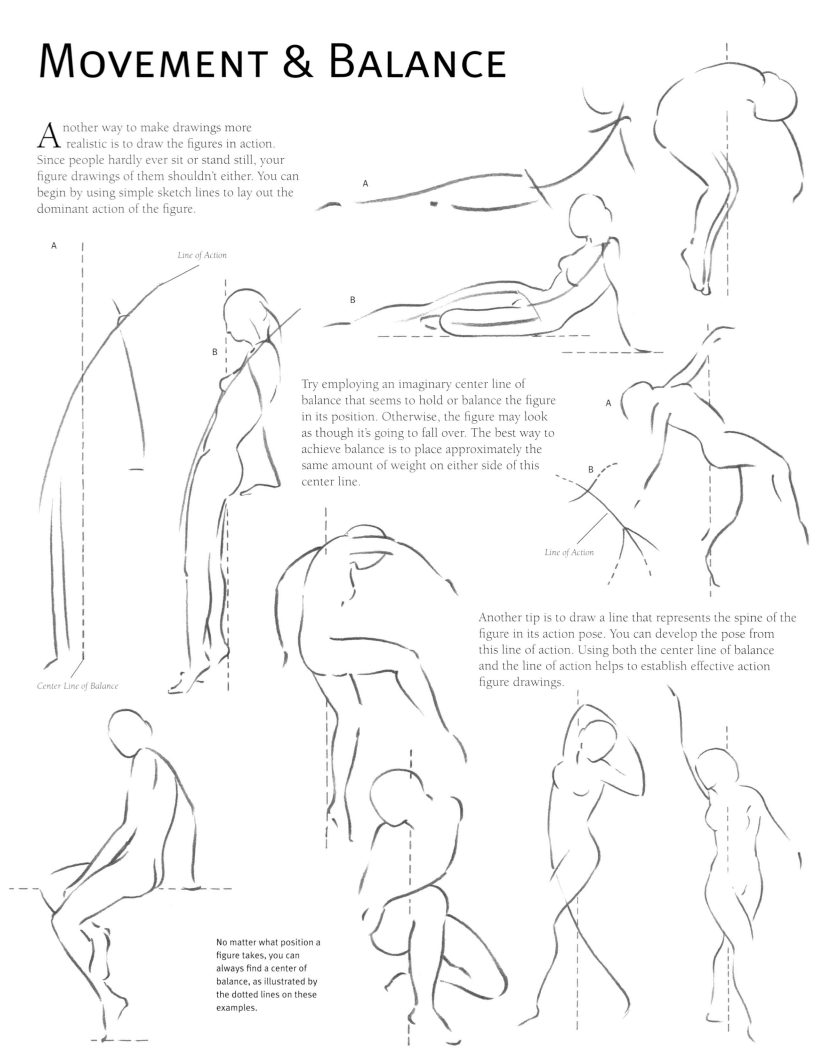

Another way to make drawings more realistic is to draw the figures in action. Since people hardly ever sit or stand still, your figure drawings of them shouldn't either. You can begin by using simple sketch lines to lay out the dominant action of the figure.

Line of Action

A

B

A

B

Center Line of Balance

Try employing an imaginary center line of balance that seems to hold or balance the figure in its position. Otherwise, the figure may look as though it's going to fall over. The best way to achieve balance is to place approximately the same amount of weight on either side of this center line.

A

B

Line of Action

Another tip is to draw a line that represents the spine of the figure in its action pose. You can develop the pose from this line of action. Using both the center line of balance and the line of action helps to establish effective action figure drawings.

No matter what position a figure takes, you can always find a center of balance, as illustrated by the dotted lines on these examples.

BENDING & TWISTING FIGURES

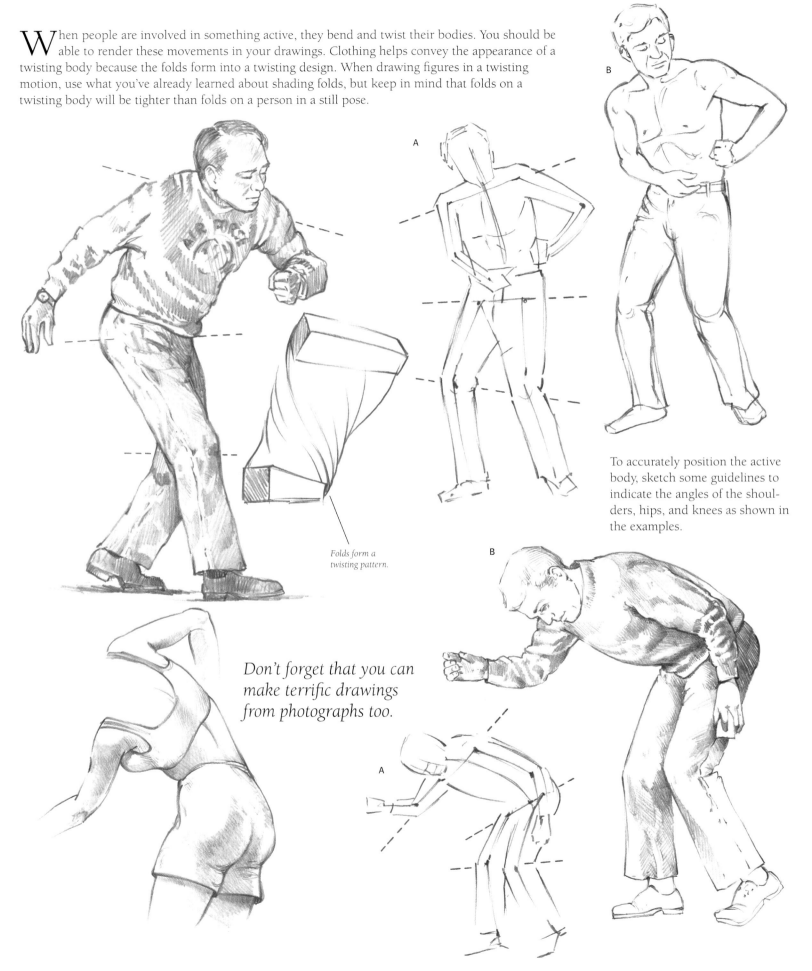

When people are involved in something active, they bend and twist their bodies. You should be able to render these movements in your drawings. Clothing helps convey the appearance of a twisting body because the folds form into a twisting design. When drawing figures in a twisting motion, use what you've already learned about shading folds, but keep in mind that folds on a twisting body will be tighter than folds on a person in a still pose.

Folds form a twisting pattern.

To accurately position the active body, sketch some guidelines to indicate the angles of the shoulders, hips, and knees as shown in the examples.

Don't forget that you can make terrific drawings from photographs too.

PROPORTION & DETAIL

Before drawing this ballerina, lightly sketch the center line of balance as well as the action line representing the shape of her spine. Start out with straight lines to lay out her body parts in correct proportion, eventually smoothing out the lines in accordance with her body contours.

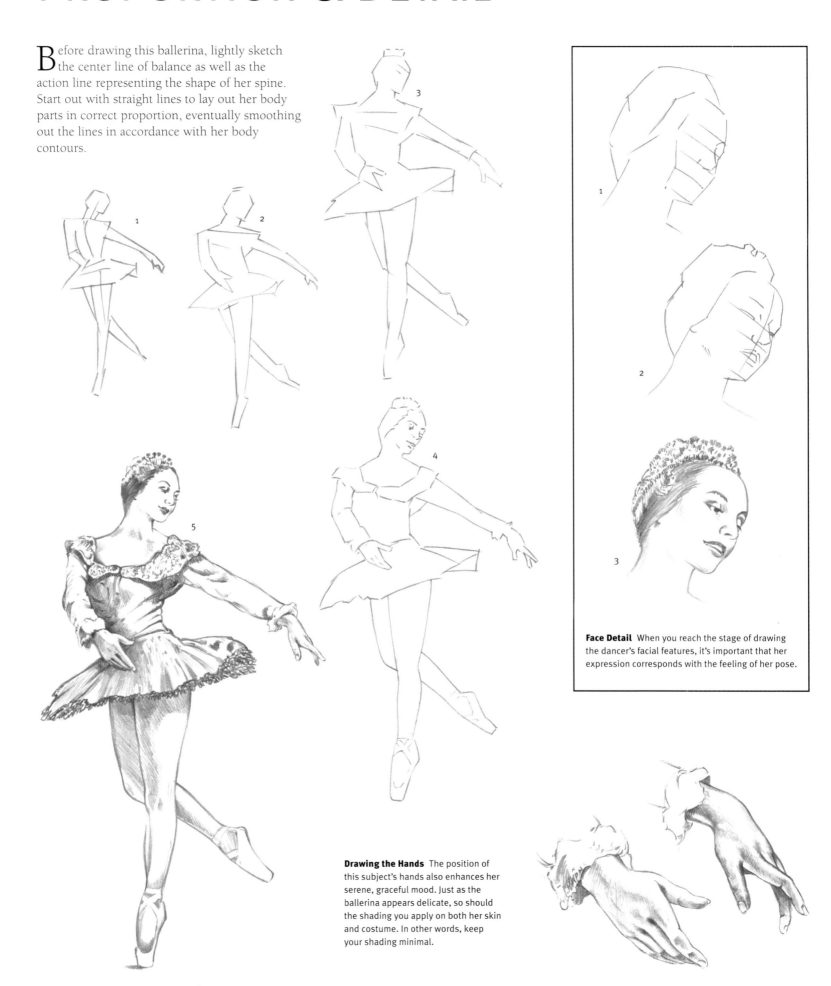

Face Detail When you reach the stage of drawing the dancer's facial features, it's important that her expression corresponds with the feeling of her pose.

Drawing the Hands The position of this subject's hands also enhances her serene, graceful mood. Just as the ballerina appears delicate, so should the shading you apply on both her skin and costume. In other words, keep your shading minimal.

HANDS & FEET

Hands and feet are very expressive parts of the body and are also an artistic challenge. To familiarize yourself with hand proportions, begin by drawing three curved lines equidistant from each other. The tips of the fingers fall at the first line, the second knuckle at the middle line, and the first knuckle at the last line. The third knuckle falls halfway between the finger tips and the second knuckle. Coincidentally, the palm is approximately the same length as the middle finger.

Third knuckle

Finger tips

Second knuckle

First knuckle

Your own hands and feet can make great drawing models.

½

½

½

Drawing Hands Every time a finger bends at the knuckle, a new plane is created. Picture the three-dimensional shape of the hand in various positions. This will help you correctly draw the hand.

Drawing Feet Follow the steps shown to draw the feet. Block in the shape in two parts: the main part of the foot and the toes. Once you've drawn a good outline, add minimal shading so you don't call too much attention to the feet.

1

2

1

2

1

2

3

4

DRAWING FROM LIFE

Drawing from a live model (also called "drawing from life" or "life drawing") is a wonderful exercise in drawing the human body in its various shapes and positions. Drawing from life helps you avoid overworking your drawing because you're focused on quickly recording the gesture and specific details of your model before he or she moves, resulting in a spontaneous, uncomplicated finished drawing. Take advantage of available models—your children, other family members, or friends—whenever possible. When drawing from life, be sure the pose is comfortable for the model. Allow short breaks for your models (also providing you with time to rest), and don't require them to smile, as this can tire out their facial muscles. Because you're working at a faster pace, drawing from life will help you learn freedom and flexibility—both of which will benefit your drawings regardless of the type of reference. It will also help you appreciate the subtleties the eye perceives that the camera can't, such as the twinkle in this man's eye!

Step 1 Using an HB pencil, lightly block in the basic shapes of the figure and the rocking chair, paying particular attention to the vertical lines and balance to make sure the figure doesn't look as if he's going to tip over in the chair. Notice that the model's back curves forward while the back of the chair angles backward, and his head aligns vertically with the back of the chair leg. Foreshorten the right leg and make the right foot larger than the left because the right leg is angled toward the viewer.

Step 2 Begin to refine the shapes, indicating the clothing and shoes. Then block in the mustache and beard, and place guidelines for the facial features. Study the model's face to see how the proportions and placement of the features differ from the "average" proportions explained on page 154.

Step 3 With a B pencil, draw in the facial features and refine the shapes of the head, including the ear, hair, and hat. Then hone the rest of the body, drawing the folds and details of the fabric and adding the fingers on the left hand. Next, further develop the chair, using a ruler to create straight lines. Continue by shading the hat, the sock, the far rocker, and the model's back.

Step 4 Using a 2B pencil, begin shading the hat, leaving the top edge and a line on the brim white. Add some detailing to the hair and beard with short strokes, following the direction of growth. Shade the clothing, leaving the areas white along the side where the light hits. Watch the shapes of the wrinkles and how they affect the lights and shadows. Also shade some of the rocker, and lightly sketch in the shapes of the cast shadows.

FACE DETAIL

To create the beard, apply very dark tones to areas of the beard, showing the gaps between groups of hair. Also, leave some areas of the paper completely white to reflect the areas of the beard that are in the direct path of sunlight. When detailing the face, shade very lightly to indicate wrinkles and creases. The wrinkles should appear soft, so avoid using hard lines. To create the twinkle in the eyes, pull out a highlight in each pupil with a kneaded eraser.

Step 5 Lightly shade the face, varying your strokes to follow the different planes. Add further details and shading to the eyes, nose, mouth, ear, hair, and facial hair. Study your model to see what details will help create a likeness. Then shade the clothing and chair, always keeping in mind where the light is coming from and adjusting the lights and shadows as needed to enhance the illusion of depth. Use a 4B pencil for the darkest areas, and leave the lightest areas pure white. Soften any hard edges with an eraser, a blending stump, or a tissue. Finally, step back from your drawing, squint your eyes, and see if there are any areas that need to be corrected. If any areas are too light or too dark, adjust them as necessary.

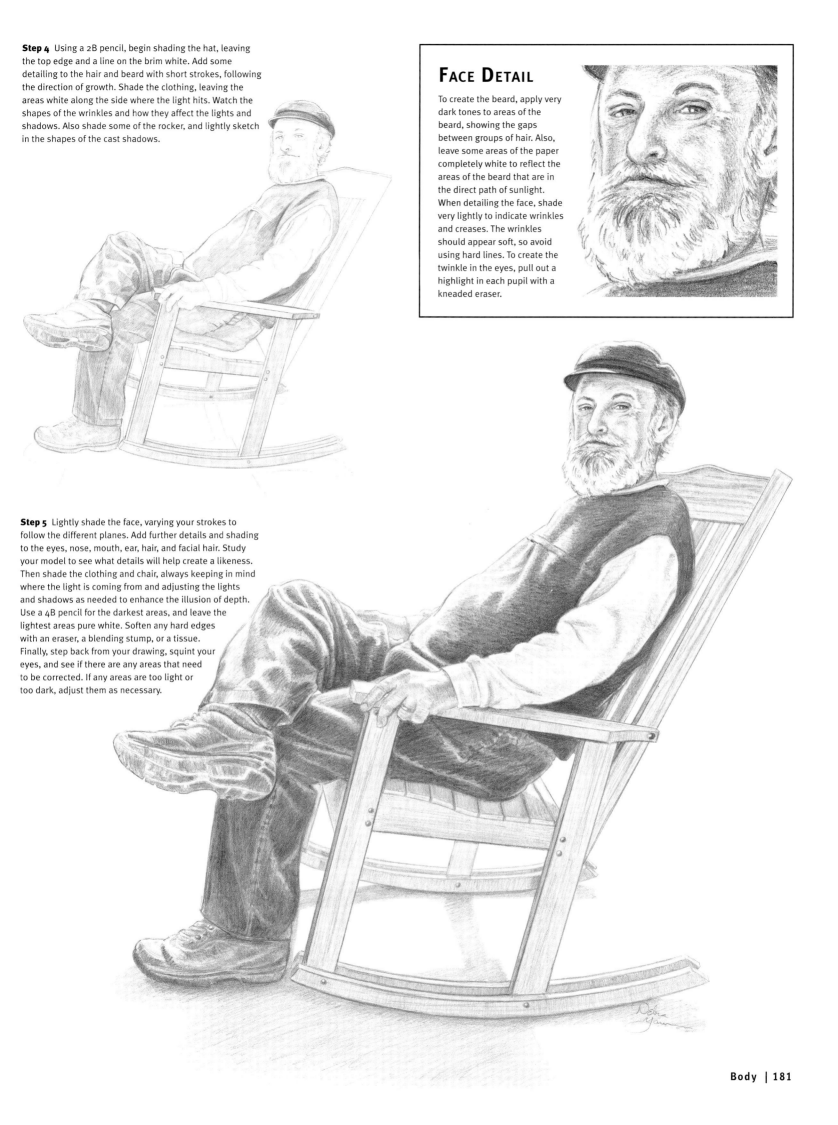

CLOTHING FOLDS

Now that you've mastered drawing the body, you need to know certain techniques that will improve the quality of your work. Drawing realistic clothing folds is one of those techniques.

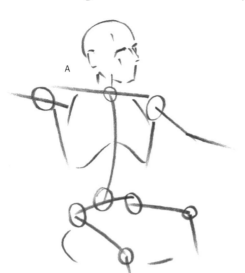

A

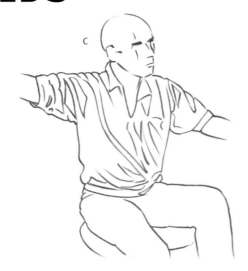

C

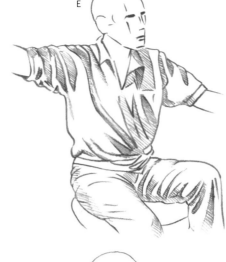

E

Begin by drawing a stick figure, indicating the location of each joint with some light circles. Then sketch the outline of the clothing along with preliminary guidelines for the folds; these guidelines will provide a map for your shading. Indicate only the major folds at this point while continuing to add light guidelines.

B

D

F

Darken the areas inside the folds with short, diagonal strokes using the point of a 2B pencil. Overlap your strokes at different angles, making them darker toward the center of the folds. Use a paper stump for the finishing touches, and blend the edges of the folded areas. You might want to leave some shading lines to give the drawing an artistic feel.

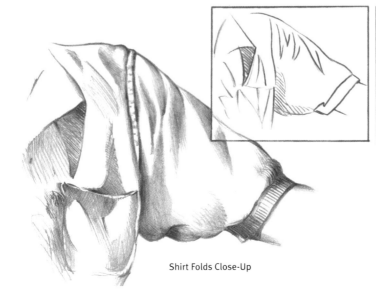

Shirt Folds Close-Up

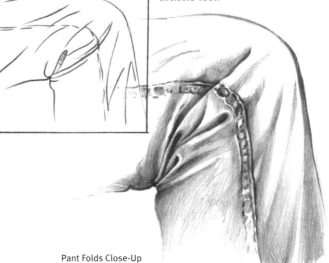

Pant Folds Close-Up

CHILDREN

PORTRAYING CHILDREN

Children are a joy to watch, and they make charming drawing subjects. If you don't have children of your own to observe, take a sketch pad to the beach or a neighborhood park, and make quick thumbnail sketches of kids at play. Sometimes it actually helps if you don't know your subject personally, because it helps you to see from a fresh and objective point of view.

MAKING QUICK SKETCHES

Children are more free and flexible in their expressions, gestures, poses, and movements than their inhibited elders are. To make sure you don't overwork your drawings of children, do speed sketches. Watch your subject closely for several minutes, and then close your eyes and form a picture of what you just saw. Next, open your eyes, and draw quickly from memory. This helps you keep your drawings uncomplicated—just as children are. Try it; it's a lot of fun!

Exploring a Toddler's Proportions Toddlers are approximately 4 heads tall, which makes their heads appear disproportionately large.

Establishing a Child's Proportions By about age 10, most children are closer to adult proportions and stand about 7 heads tall.

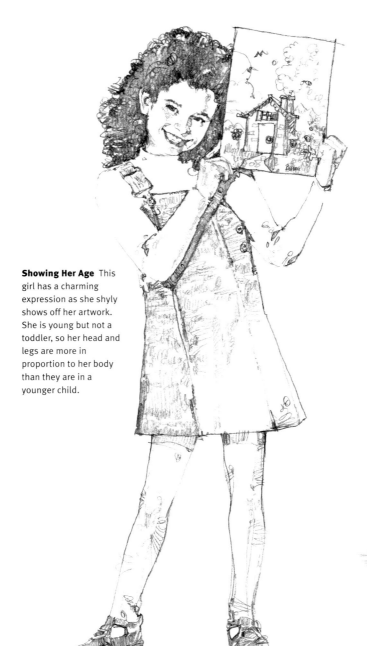

Showing Her Age This girl has a charming expression as she shyly shows off her artwork. She is young but not a toddler, so her head and legs are more in proportion to her body than they are in a younger child.

Practicing Proportions This little guy is a perfect example of a toddler: 4 heads tall, square body, and chubby legs and hands. His shoes are a little too big for his feet, which is exactly the way they are drawn. And to show that this was a bright summer day, he is shaded in only lightly, with pure white left for the areas in full sun.

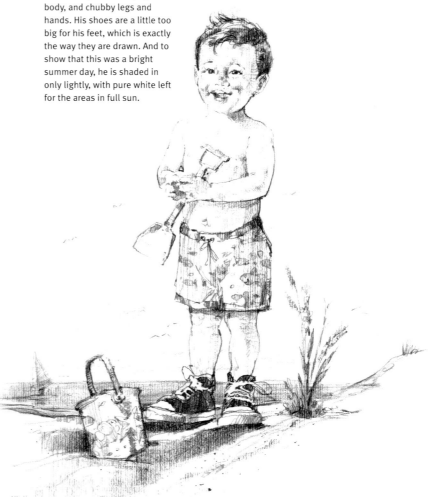

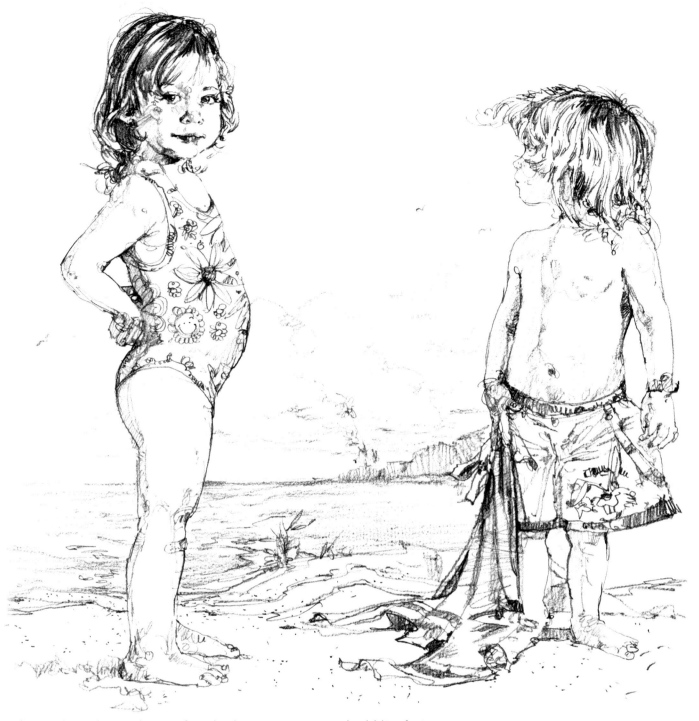

Staging To make sure they were the center of attention, these two youngsters were placed right up front and dwarf the background scenery.

DRAWING THE DIFFERENCES

Of course, there's more to drawing children than making sure they are the right number of heads tall. Their facial proportions are different from adults' (see pages 156 and 157), and they have pudgier hands and feet with relatively short fingers and toes. They often have slightly protruding stomachs and their forms are soft and round. Keep your pencil lines soft and light when drawing children and your strokes loose and fresh.

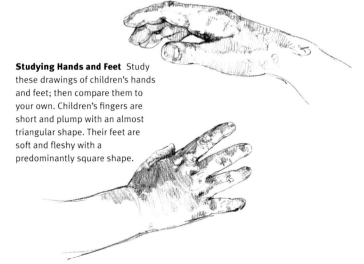

Studying Hands and Feet Study these drawings of children's hands and feet; then compare them to your own. Children's fingers are short and plump with an almost triangular shape. Their feet are soft and fleshy with a predominantly square shape.

Children's Proportions

The proportions of a child's head differ from those of an adult. For example, children generally have larger foreheads, so the eyebrows—not the eyes—fall on the horizontal center line. Also, a youngster's eyes are usually bigger, rounder, and spaced farther apart than an adult's.

As shown in the diagrams at right and lower left, use horizontal guidelines to divide the area from the brow line to the chin into four equal sections. Use these lines to determine the placement of the eyes, nose, and mouth.

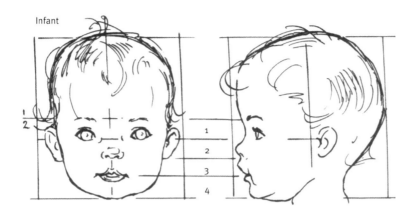

Infant

As children get older, their faces become longer, and the facial proportions change accordingly.

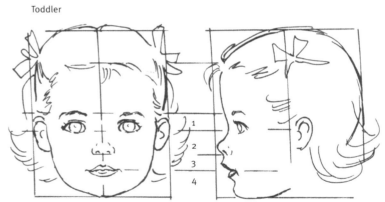

Toddler

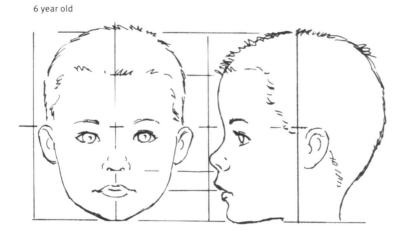

6 year old

Notice that, as the face becomes longer and narrower, the chin becomes more square, and the eyes appear smaller.

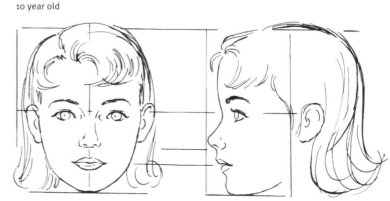

10 year old

GIRL IN PROFILE

The youthfulness of children is brought out with a delicate approach. Simple renderings like these require minimal shading to create the appearance of smooth skin.

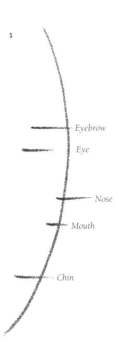

Placing the Features In step 1, begin with a very simple block-in method, using a curved line and horizontal strokes to determine the placement of the eyebrow, eye, nose, mouth, and chin. In step 2, sketch in the features along with the outline of the hair. Study your model to make sure that your proportions are correct.

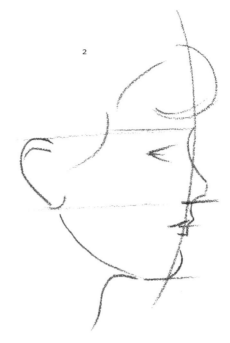

Remember that children generally have smooth, round features.

The hair ribbon should appear to wrap around the head; it shouldn't look as if it is sitting on top of it. Try to make it blend into the hair.

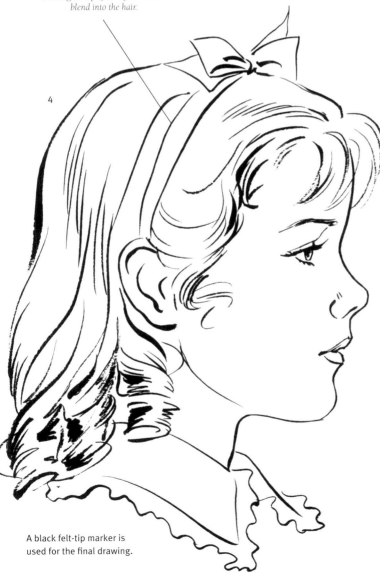

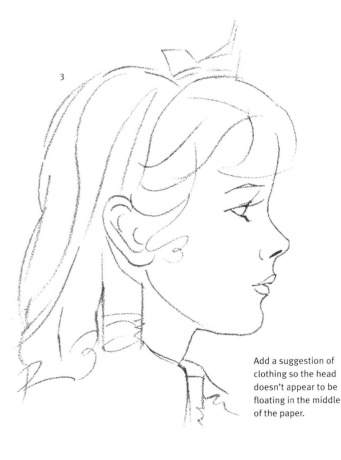

Add a suggestion of clothing so the head doesn't appear to be floating in the middle of the paper.

A black felt-tip marker is used for the final drawing.

Refining Details In step 3, refine the features and suggest the waves and curls with loose strokes. In the final rendering, develop the features, making your strokes bold and definite. Note that you don't have to draw every strand of hair; a few lines are enough to indicate the hair style.

INDICATING FAIR FEATURES

When drawing a subject with fair skin and hair, keep your shading to a minimum by applying just enough medium and dark values to create the illusion of form without creating the appearance of color. Draw blonde hair by outlining the general shape, and then add a few carefully placed strokes to suggest the hair style and create some dimension. Keep in mind that light, wispy eyebrows and freckles often accompany fair skin and hair.

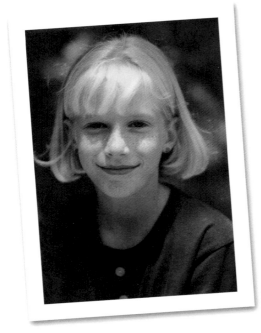

Shading Fair Skin and Hair In this photo, the overhead light makes the bangs, nose, and cheeks look nearly pure white, so I avoid these areas when shading my drawing, leaving much of the paper white.

Step 1 First, I lay out the face with an HB pencil. The face is slightly tilted to the subject's left, so I shift the vertical centerline to the left a bit as well. I lightly place the eyes, nose, mouth, and ears, and then I block in her long, slender neck.

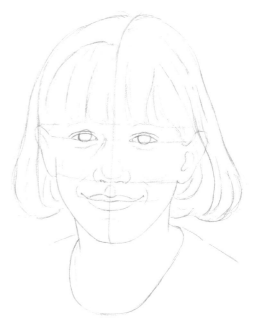

Step 2 Switching to a 2B pencil, I develop the features. Although I use the photo for a reference, I use artistic license to adjust my renderings as I see fit. For example, I sketch the bangs so they fall straight onto her forehead rather than being swept to the side as they are in the photo. I also omit the strand of hair that is blowing in the wind.

Step 3 Now I refine the features, erasing my guidelines as I draw. I continue building up the hair, leaving the top and sides mostly white, adding only a few dark strands here and there. The darkest values are around the ears where the hair is in shadow. Next I add small circles for the earrings and shade the insides of the ears. I develop the lips, and then I use horizontal strokes to shade the neck.

Step 4 I shade the face with light, soft strokes to depict the subject's fair skin. Then I make short, quick strokes for the eyebrows, keeping them light and soft to indicate blonde hair. Next I shade the irises using strokes that radiate out from the pupil. I also add some hatching strokes to the neckband of the shirt.

DEPICTING FINE HAIR

Blonde hair is often finer than darker hair, especially in children. Draw fine hair in narrow sections, leaving plenty of white areas showing through the dark values. Add some short, wispy strands of hair at the forehead to frame the face.

Step 5 Using a kneaded eraser, I pull out a highlight on the bottom lip. Then I create more dark strands of hair and further develop the eyes and eyebrows. I begin adding freckles, making sure that they vary in size and shape. (See "Creating Realistic Freckles" below.) Finally I shade the shirt, using relatively dark strokes. It's easy for a blonde subject to look washed out on white paper, so the dark values in the shirt help frame the subject and make her face stand out.

CREATING REALISTIC FRECKLES

To draw freckles, space them sporadically in varying sizes and distances from one other. You don't have to replicate every freckle on your subject's face—just draw the general shapes and let the viewer's eye fill in the rest.

What Not to Do When drawing freckles, do not space them too evenly or make them equal in size, as shown here. These freckles look more like polka dots!

CHILD BODY PROPORTIONS

Children of all ages are great drawing subjects. The illustrations at the bottom of the page explain how to use the size of the head as a measuring unit for drawing children of various ages. If you're observing your own model, measure exactly how many heads make up the height of the subject's actual body. Begin the drawing below by lightly sketching a stick figure in the general pose. Use simple shapes such as circles, ovals, and rectangles to block in the body. Smooth out the shapes into the actual body parts, and add the outline of the clothing.

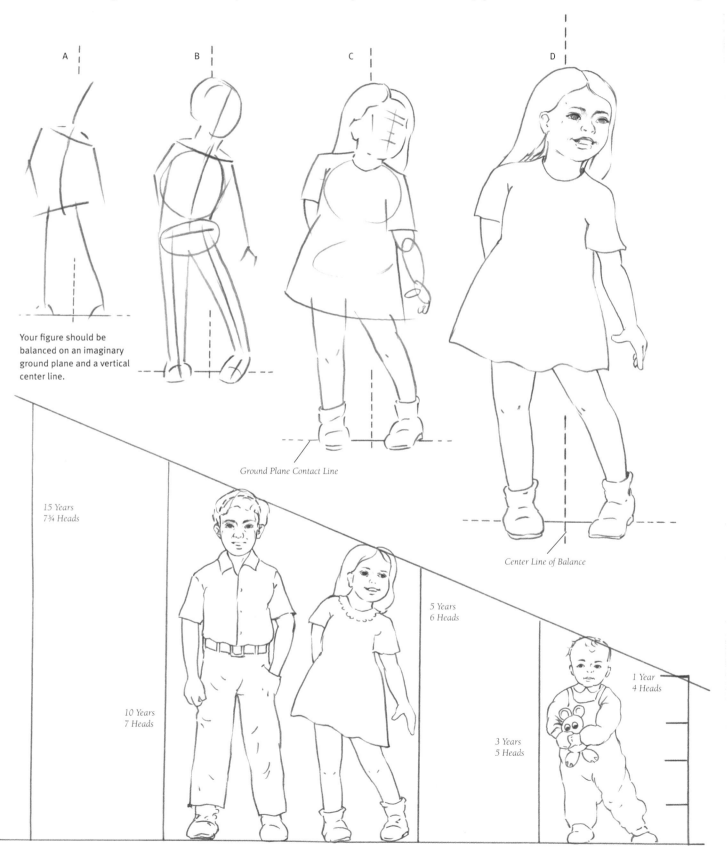

A

B

C

D

Your figure should be balanced on an imaginary ground plane and a vertical center line.

Ground Plane Contact Line

Center Line of Balance

15 Years
7¾ Heads

10 Years
7 Heads

5 Years
6 Heads

3 Years
5 Heads

1 Year
4 Heads

Toddlers are great fun to draw, but since children generally don't remain still for long periods, start by using photographs as models.

ANATOMY

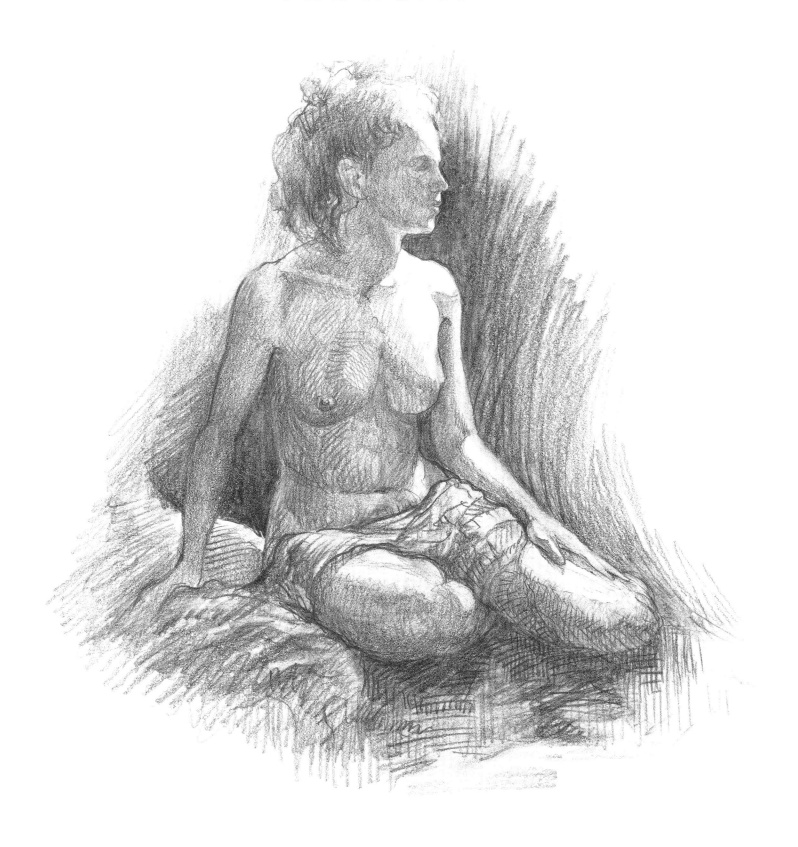

Getting to Know the Basics

N ow that you're familiar with the fundamental tools and materials needed to begin drawing in pencil, you're ready to move on to the next step. After becoming comfortable with your tools and practicing several different drawing and shading techniques, simply turn the page to get acquainted with the basics of the drawing subject: the human figure.

For many years, leaders in fields as diverse as medicine, science, sports, and art have marveled at the form and function of the human body. In truth, the information an artist needs to know about the body and its basic anatomy has barely changed since the time of Leonardo da Vinci. In fact, anatomical drawings made by artists of the 15th century are still used today! While medical professors and scientists are concerned with the body's function, artists are focused instead on the body's form. *Artistic anatomy*—the focus of this book—explores what creates and influences that form.

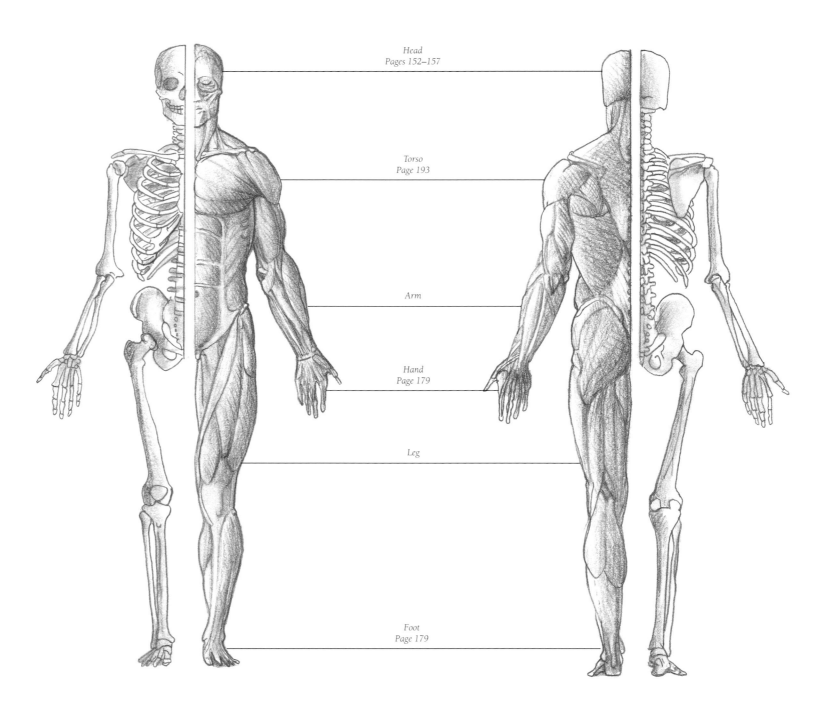

Head
Pages 152–157

Torso
Page 193

Arm

Hand
Page 179

Leg

Foot
Page 179

Visual Index This visual index includes many of the bones and muscles covered in this book. You can refer back to this page to test your newfound skills by identifying what you see here. If you need help, refer to the pages listed in the center of this chart.

EXPLORING THE TORSO

Front View

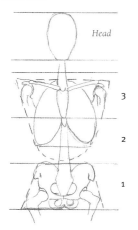

Proportion The *pelvic girdle* is about 1 head high, and the torso—from *trochanters* to *7th cervicle vertebrae*—is about 3 heads high.

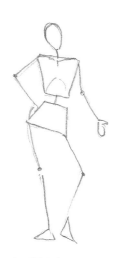

Simplified Figurette Sketching with simple lines and basic shapes is a good way to establish the base of a figure drawing.

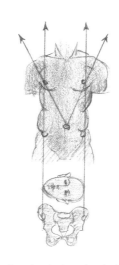

Tips The nipples, 1 head-width apart, are vertically aligned with pelvic landmarks and diagonally aligned with the *acromion processes*.

Detail Note the relationship between the skeletal and muscular structures (A). The *linea alba* (interrupting tendons) of the *rectus abdominis* create a "six pack" appearance as they arch progressively higher toward the *sternum* (B). Two of the interrupting tendons line up with the *10th rib* and the navel (C).

Back View

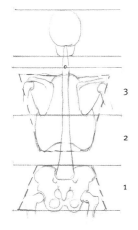

Trapezoids represent the overall bone structure of the torso from both front and rear views. Here you can see the same three-part division.

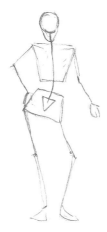

This simplified sketch from the back view includes an important feature: a line from the *7th cervicle vertebrae* to the sacral triangle.

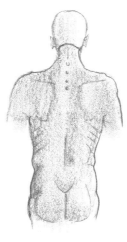

On an erect figure, the bones of both the lower ribs and the upper spine are apparent, while the *lumbar* region looks like a furrow.

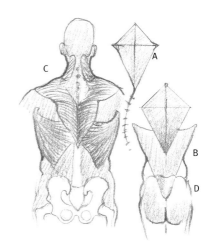

The shape of the *trapezius* is similar to that of a kite (A) or a four-pointed star (C). The simplified shape of the *latissimus dorsi* suggests the appearance of an upside-down triangle (B), with a diamond-shaped sheath removed from its upside-down apex (D).

Side View

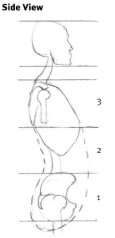

The simplified torso from the side view has a bean-shaped appearance, but the same proportional divisions of the torso apply.

The simplified figurette in profile makes use of the bean and oval shapes that appear in the proportional drawing at left.

cervical curve

thoracic curve

lumbar curve

sacral curve

Each spinal segment curves more as the column descends toward the sacrum. The thoracic region has the longest curve.

The serratus anterior muscle starts alongside the first eight ribs, then ends at the inner margin of the *scapula* (A). Its main mass appears as a bulge underneath the *latissimus dorsi* (B). At the muscle's origin (on the ribs), it looks a little like the fingers of a hand (C).

PORTRAYING A SEATED FIGURE IN PENCIL

Although understanding anatomical theory is an important step for beginning artists, it's equally important to be able to apply that knowledge to your artistic renderings. The figure drawing lessons on pages 192–193 demonstrate applied anatomical theory. Start with a simple pose like this one, which doesn't include the whole body (it excludes the lower legs and feet), and think about the anatomy of the figure while you draw.

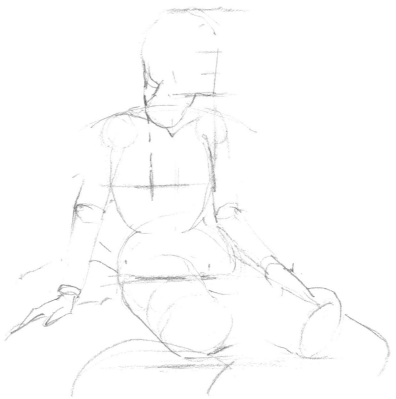

Step 1 I use the mid-hand position to begin lightly sketching the basic shapes of the subject. First, to establish correct proportions, I divide the figure horizontally into four head lengths. Then I sketch the rib cage, shoulders, and pelvis as circular forms and establish the arms and legs using cylindrical shapes with straight edges. I also add a plumb line—a guideline used to establish vertical alignment—from the back of the head to the right nipple to make sure I don't place the head too far forward or too far back.

Step 2 With the framework established, I switch my pencil to a handwriting position to define the anatomical contours. I keep in mind the skeletal and muscular landmarks as I draw, and I vary the strength of my lines to produce both light and dark values, giving the figure a fluid, natural appearance. I pay careful attention to proportions, adding a line from the pit of the neck down to the sternum—following the linea alba through the navel—to establish the vertical center of the torso. Notice that the upper left arm is parallel to this line, and the right arm is at an angle, countering the curve of the body to balance the pose.

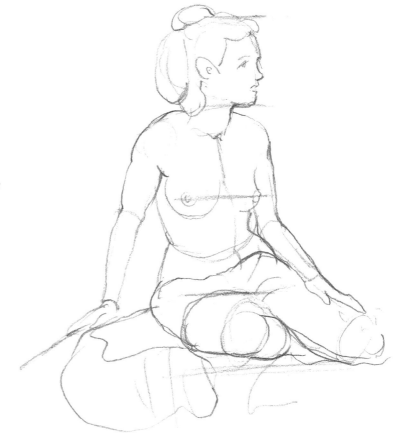

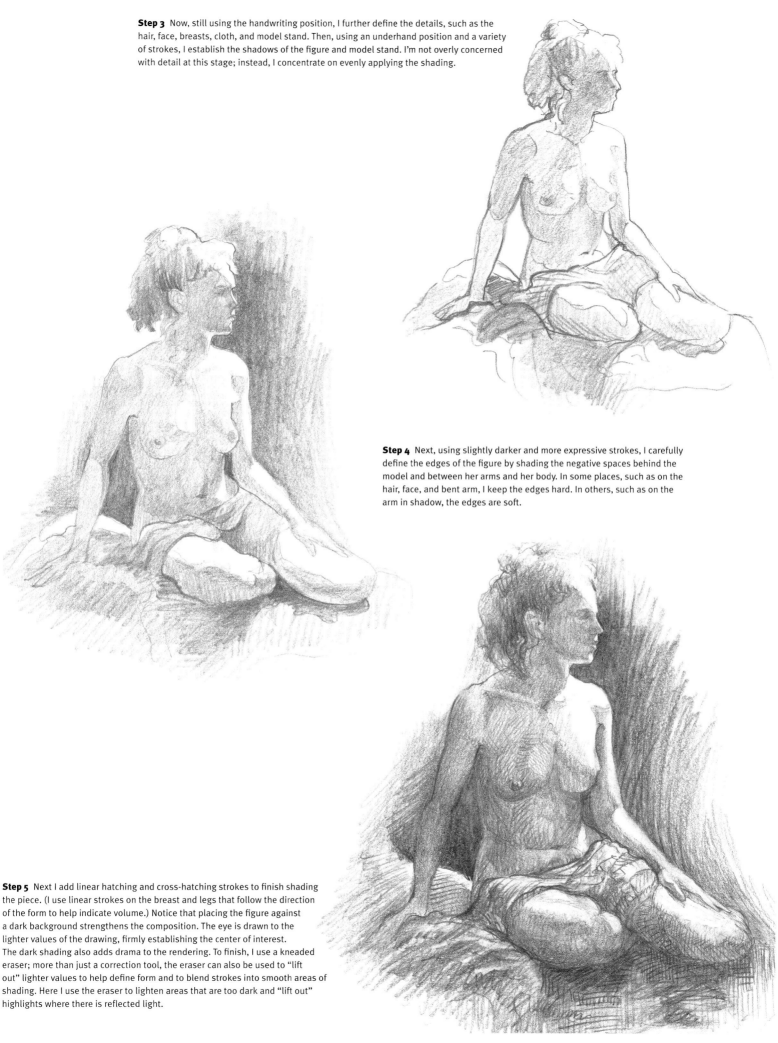

Step 3 Now, still using the handwriting position, I further define the details, such as the hair, face, breasts, cloth, and model stand. Then, using an underhand position and a variety of strokes, I establish the shadows of the figure and model stand. I'm not overly concerned with detail at this stage; instead, I concentrate on evenly applying the shading.

Step 4 Next, using slightly darker and more expressive strokes, I carefully define the edges of the figure by shading the negative spaces behind the model and between her arms and her body. In some places, such as on the hair, face, and bent arm, I keep the edges hard. In others, such as on the arm in shadow, the edges are soft.

Step 5 Next I add linear hatching and cross-hatching strokes to finish shading the piece. (I use linear strokes on the breast and legs that follow the direction of the form to help indicate volume.) Notice that placing the figure against a dark background strengthens the composition. The eye is drawn to the lighter values of the drawing, firmly establishing the center of interest. The dark shading also adds drama to the rendering. To finish, I use a kneaded eraser; more than just a correction tool, the eraser can also be used to "lift out" lighter values to help define form and to blend strokes into smooth areas of shading. Here I use the eraser to lighten areas that are too dark and "lift out" highlights where there is reflected light.

SKETCHING A STANDING FIGURE IN PENCIL

Many beginning artists prefer to draw figures from a straightforward viewpoint—a good position for practicing anatomical placement and proportion. But what is best for practice is not necessarily best for viewing; the straight-on view is typically too symmetrical to be very compelling. In this composition, the figure is posed rear-forward, providing a fresh and unique perspective. The figure's pose does not follow a straight line; instead it is curvilinear, with twists and turns that create interest and a turned head that lends drama to the composition. When you develop your own compositions, experiment with different viewpoints until you find the ones that create the most interest.

Step 1 The easiest way to begin drawing a standing figure is to sketch a simplified figurette. This sketch is really no more than a glorified stick figure with a head, rib cage, pelvis, and limbs represented by simple shapes. The figurette establishes the subject's proportions and alignments.

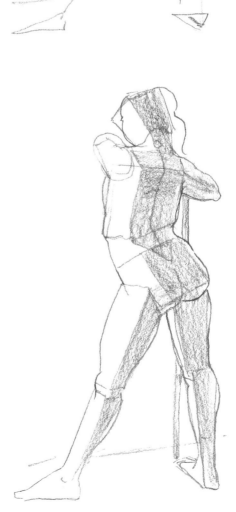

Step 2 Now I convert the flat shapes of the stick figure into geometric ones. (Pick the geometric shape—sphere, cube, cylinder, or pyramid—that most closely resembles each form you are trying to draw.) I also establish several important landmarks, including a line that unites the neck, thorax, and pelvis, running from the seventh cervical vertebrae down the spinal column and ending at the caudal triangle.

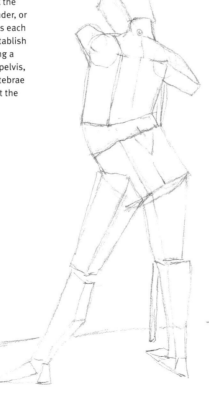

Step 3 Just as it is easier to begin a drawing with a long block that resembles a leg than it is to draw an anatomically correct leg, it is easier to simplify shading into light and dark blocks than it is to immediately establish all the nuances of value. This step demonstrates the shading concept, but rather than shading my actual drawing at this stage, I merely block in the placement of the shadows or create a separate study for this purpose. I then use this as a guide for my shading in step four.

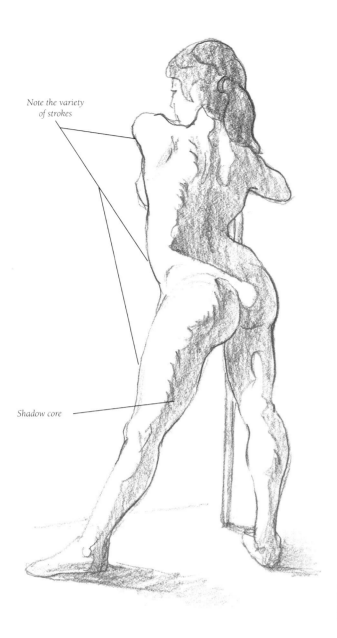

Note the variety of strokes

Shadow core

Step 4 Holding my pencil in a mid-hand position, I carefully draw the contours of the skeletal landmarks and muscle shapes. I vary the weight of my lines for greater realism and drama, using darker values both to indicate shadows and to emphasize interesting curves. Next, keeping in mind the simplified shading exercise in step three, I draw the shapes of the shadows, filling them with a flat shading stroke. Then I accent the shadow edges (or shadow cores) with darker hatched strokes.

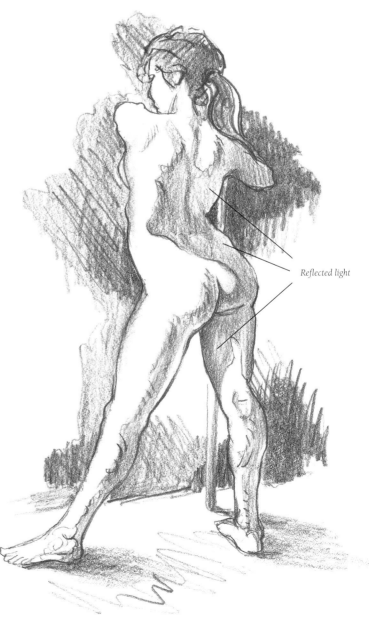

Reflected light

Step 5 Now I establish the dark tones of the background with varied strokes, butting them up against the figure. This dark shading serves two purposes: It brings forward the illuminated, advancing side of the figure and pushes back the shadowed, receding side. Next I add definition to the drawing. I refine the facial features, add gestural lines to the hair, darken the base of the staff, and accent the shadow cores. To finish, I use a kneaded eraser to pull out very subtle highlights where there is reflected light on the latissimus dorsi, gluteus medius, and adductor group.

RENDERING A RECLINING FIGURE IN CHARCOAL

Once you've mastered drawing the figure from a simple perspective, try a more complicated pose, such as this reclining figure. Here the body is positioned so that some of its parts of the body are closer to the viewer than others are, demonstrating foreshortening. Foreshortening causes objects to appear larger as they come toward you. When foreshortened, all the same anatomical landmarks are still evident, but their proportions are altered. For example, the length of the calf appears to be shorter than the length of the foot. When you draw figures in foreshortened poses such as this one, disregard the "rules" of proportion, and draw the figure as you really see it. Just as the calf appears much shorter than expected, advancing objects also may sometimes appear larger in proportion than you might first anticipate.

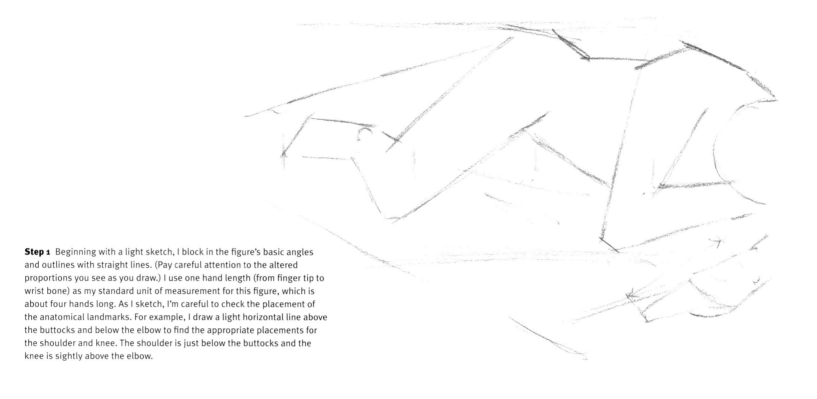

Step 1 Beginning with a light sketch, I block in the figure's basic angles and outlines with straight lines. (Pay careful attention to the altered proportions you see as you draw.) I use one hand length (from finger tip to wrist bone) as my standard unit of measurement for this figure, which is about four hands long. As I sketch, I'm careful to check the placement of the anatomical landmarks. For example, I draw a light horizontal line above the buttocks and below the elbow to find the appropriate placements for the shoulder and knee. The shoulder is just below the buttocks and the knee is sightly above the elbow.

Step 2 When I'm pleased with the overall blocking, I begin refining the drawing by giving it dimension. First, I create a sphere for the head, and then I convert the limbs and torso into very light cylinders. Because of the foreshortened perspective, the cylinders will appear to either come forward or retreat into the picture's space.

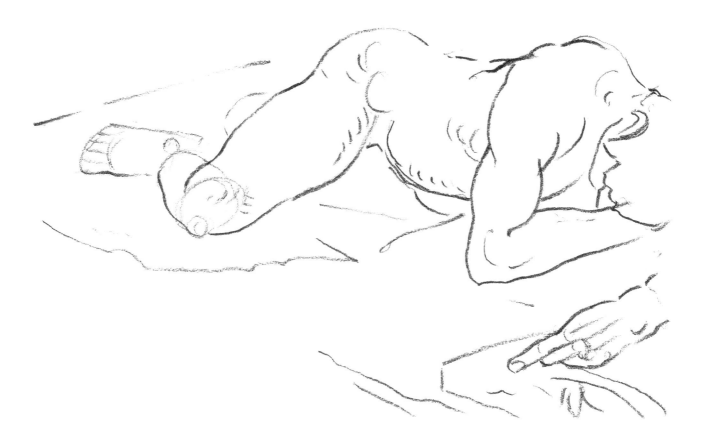

Step 3 I check the proportions again before I continue developing my drawing; it is much easier to make any corrections or adjustments at this early stage. Then, using the mid-hand position, I begin defining the actual anatomical contours. This particular pose features many prominent bones and muscles, such as the serratus anterior, evident near the ribs; the deltoid, giving shape to the upper arm; and the outer malleolus, protruding at the ankle. Despite the foreshortening, there are still a good number of readily identifiable landmarks.

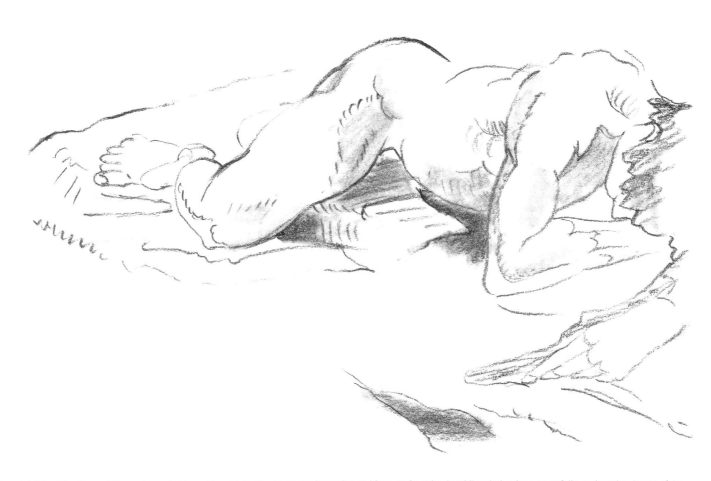

Step 4 Now I've established the shape of the contours, but I need to add shading to create dimension and form. Before I begin adding dark values, I carefully analyze the shapes of the shadows and very lightly map out their placement, delineating only the edges of all areas to be shaded. Next I shade inside the areas I've mapped, lightly blocking in a range of values that will serve as a guideline for more detailed shading later.

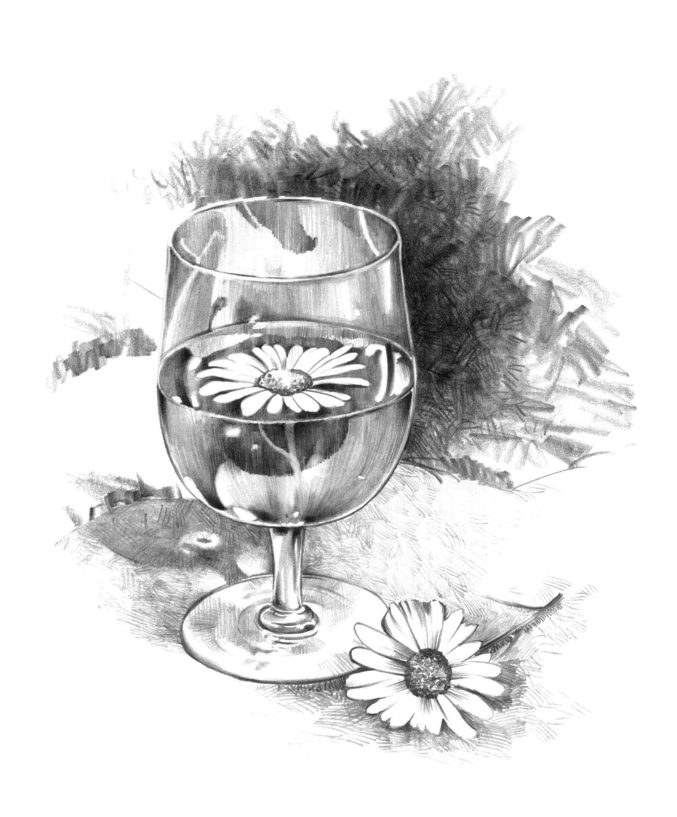

STILL LIFE

STILL LIFE COMPOSITION

Creating a good still life composition is simply arranging the elements of a drawing in such a way that they make an eye-pleasing, harmonious scene. It's easy to do once you have a few guidelines to follow. The most important things to keep in mind are: (1) choosing a format that fits the subject, (2) establishing a center of interest and a line of direction that carries the viewer's eye into and around the picture, and (3) creating a sense of depth by overlapping objects, varying the values, and placing elements on different planes. Like everything else, the more you study and practice forming pleasing compositions, the better you'll become.

ARRANGING A STILL LIFE

Composing still lifes is a great experience because you select the lighting, you place the elements where you like, and the objects don't move! Begin by choosing the items to include, and then try different groupings, lighting, and backgrounds. Test out the arrangements in small, quick thumbnails like the ones shown here. These studies are invaluable for working out the best possible composition.

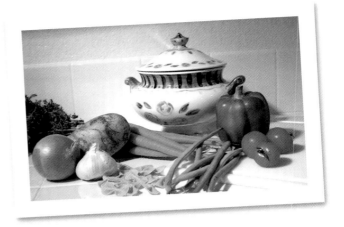

Composing with Photos Dynamic compositions rarely "just happen"—most are well planned, with objects specifically selected and arranged in an appealing manner to create good flow and depth. Taking snapshots of your arrangements will help you see how your setups will look when they're drawn on a flat surface.

SELECTING A FORMAT

Horizontal Format The "landscape" format is a traditional one and is perfect for drawing indoor or outdoor scenes. Here, as in any good composition, the overlapping vegetables lead the viewer's eye around the picture and toward the focal point—the tureen. Even the tile pattern points the way into the picture and toward the focal point.

Vertical Format In this "portrait" format, the carrot tops add height to the composition and counterbalance the arc of vegetables in the foreground. The tip of the head of garlic and the angle of the beans lead the viewer into the composition and toward the focal point. In the background, only a suggestion of shadows are drawn, and the vertical tiles are not clearly defined. This adds to the upward flow of the entire composition and keeps the viewer's attention focused on the tureen.

Step 1 From your thumbnail sketches, choose a horizontal format. Notice that the tureen is set off-center. If the focal point were dead center, your eye wouldn't be led around the whole drawing, which would make a boring composition. Then lightly block in the basic shapes with mostly loose, circular strokes, using your whole arm to keep the lines free.

Step 2 Next refine the shapes of the various elements, still keeping your lines fairly light to avoid creating harsh edges. Then, using the side of an HB pencil, begin indicating the cast shadows as well as some of the details on the tureen.

Step 3 Continue adding details on the tureen and darkening the cast shadows. Then start shading some of the objects to develop their forms. You might want to begin with the bell pepper and the potato using the point and side of an HB pencil.

Step 4 Next, build the forms of the other vegetables, using a range of values and shading techniques. To indicate the paper skins of the onion and the garlic, make strokes that curve with their shapes. For the rough texture of the potato, use more random strokes.

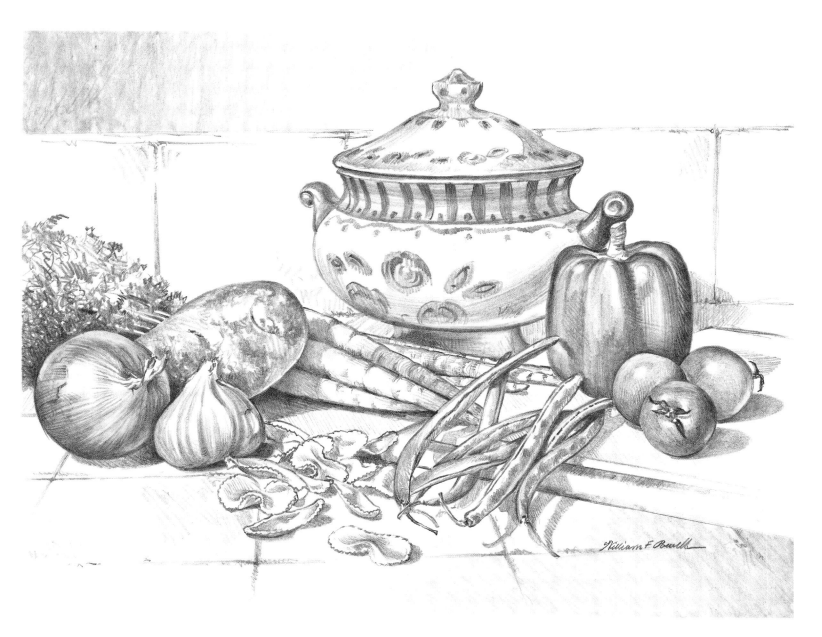

Step 5 When you are finished developing the light, middle, and dark values, use a 2B pencil for the darkest areas in the cast shadows (the areas closest to the objects casting the shadows).

Pinecone

Using an HB pencil, position the pinecone with light guidelines in step 1. Then indicate the tree trunk and pine needles in step 2, and add a grid for the pattern on the pinecone.

Sketch a grid for the surface pattern.

Establishing Detail Draw the shapes of the spiked scales, which change in size from one end of the cone to the other. In step 4, begin shading the cone and surrounding objects. Make the cast shadow appear to follow the curve of the tree root.

Working with Negative Space
Develop the grass in step 5 by drawing the negative spaces. Instead of drawing individual pine needles and blades of grass, fill in the shadows between them. By shading around the negative spaces, the grass shapes will automatically emerge from the white of the paper.

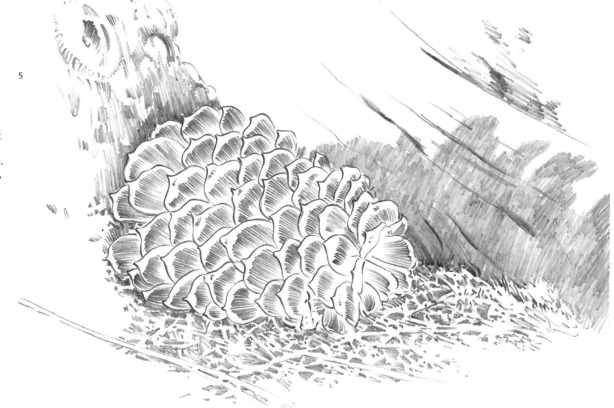

DEVELOPING DETAILS

Tree Texture Guidelines To render the bark and knothole of the gnarled tree trunk, first lightly draw in the texture design. Then, when you're happy with the general appearance, proceed with the shading.

Tree Texture Shading Short, rough strokes give the impression of texture, whereas long, smooth strokes provide interest and contrast. Use a combination of the two strokes to provide the bark's shading and details.

Pinecone Scale Shading Develop each pinecone scale separately, following the arrows on the diagram above for the direction of your strokes. Keep the hatched strokes smooth and close together.

6

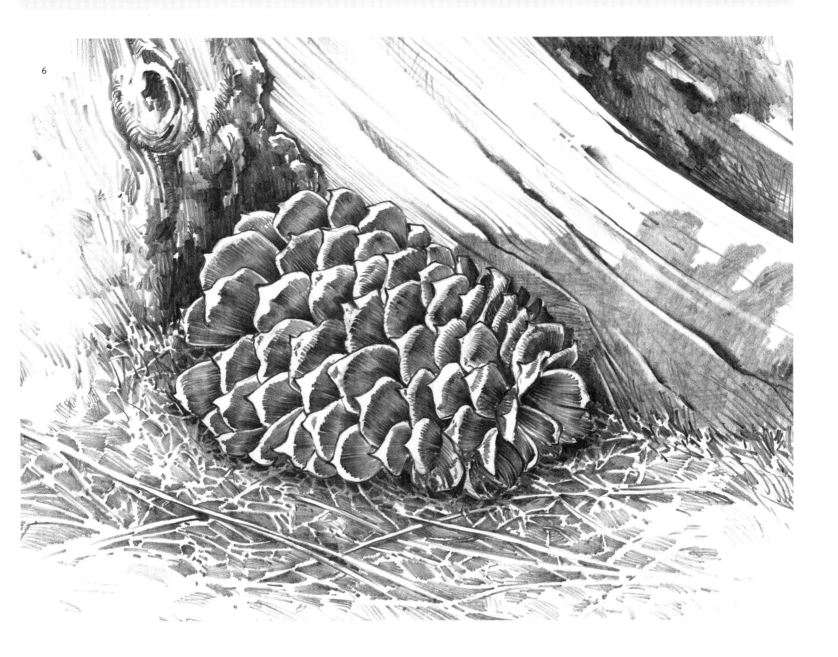

FLORAL ARRANGEMENT

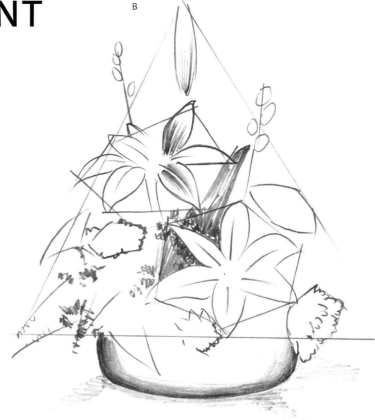

By varying your techniques, you become a more versatile artist. Therefore, this drawing was drawn more loosely than the previous one. Begin with an HB pencil, lightly drawing in the basic shapes within the floral arrangement.

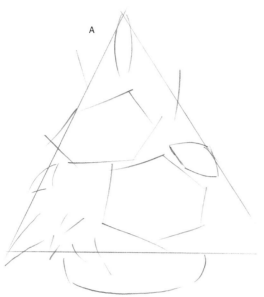

This rendering was finished using a loose, sketchy technique. Sometimes this type of final can be more pleasing than a highly detailed one.

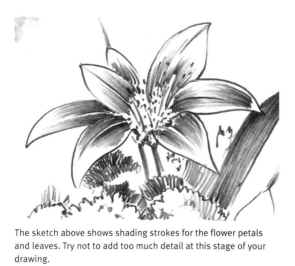

The sketch above shows shading strokes for the flower petals and leaves. Try not to add too much detail at this stage of your drawing.

As shown in the close-up above, the cast shadow needs the smoothest blending. Position the shadows using the side of an HB pencil; then blend softly with a paper stump.

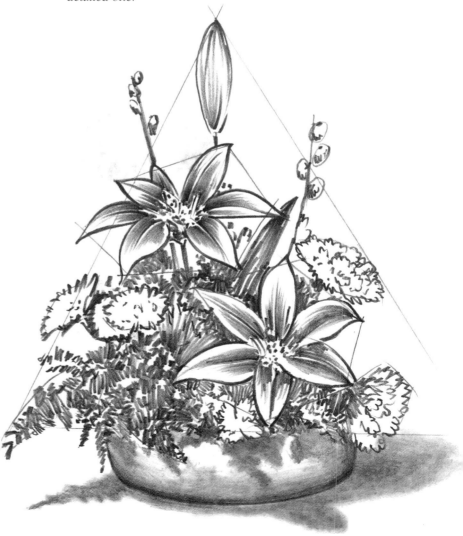

LIQUID & GLASS

This drawing involves more planning than the previous ones. It was done on Bristol board with a plate (smooth) finish. Use an HB pencil for most of the work and a 2B pencil for the dark shadows. A flat sketch pencil is good for creating the background texture.

In step C, use the flat lead of a sketching pencil for the background, making the background darker than the cast shadows. Note the pattern of lights and darks that can be found in the cast shadow.

B

A

In step A, sketch the basic shapes of the glass, liquid, and flowers. In step B, add more details, and begin shading the glass and liquid areas. Take your time, and try to make the edges clean.

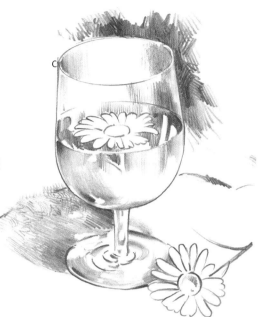

C

Use the arrows below as a guide for shading. Remember to keep the paper clean where you want highlights. Highlights help suggest light coming through the glass stem, creating a transparent look.

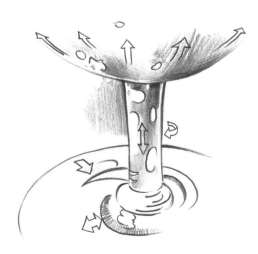

Once you've completed the steps, use the finished drawing as your guide for finalizing lights and shadows. If pencil smudges accidentally get in the highlights, clean them out with a kneaded eraser. Lastly, use sharp-pointed HB and 2B pencils to add final details.

BOTTLE & BREAD

This exercise was drawn on vellum-finish Bristol board with an HB pencil. Vellum finish has a bit more "tooth" than the smoother plate finish does, resulting in darker pencil marks.

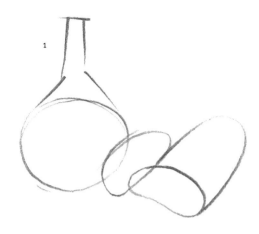

Paying Attention to Detail In the close-up examples below, the guidelines show the distorted wine level, which is caused by the bottle's uneven curves. An artist must make important observations like this in order to create natural, true-to-life drawings.

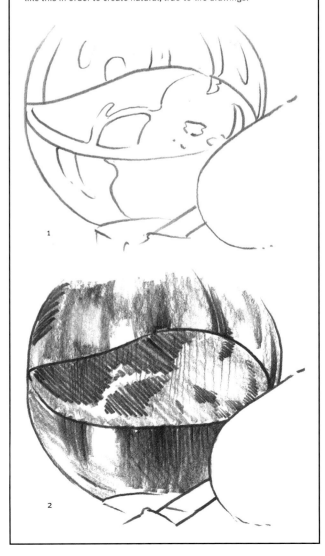

Blocking In the Composition Begin lightly sketching the wine bottle, bread loaf, knife, and cutting board, roughing in the prominent items first, and then adding the remaining elements in step 2. Continue refining the shapes in step 3, and then indicate the placement for the backdrop.

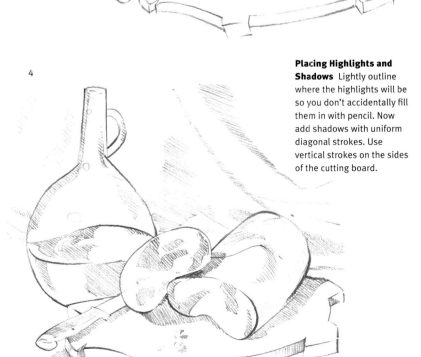

Placing Highlights and Shadows Lightly outline where the highlights will be so you don't accidentally fill them in with pencil. Now add shadows with uniform diagonal strokes. Use vertical strokes on the sides of the cutting board.

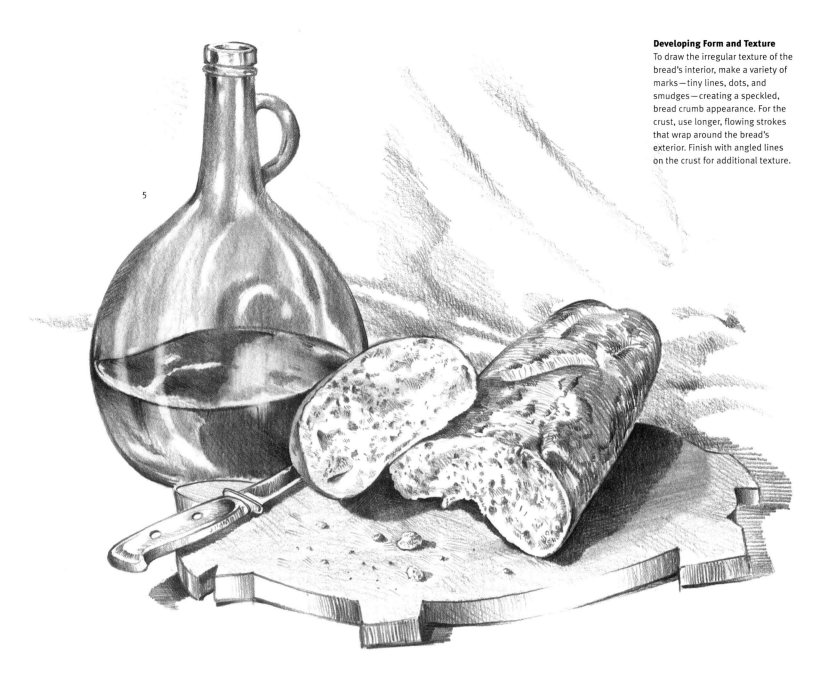

Developing Form and Texture
To draw the irregular texture of the bread's interior, make a variety of marks—tiny lines, dots, and smudges—creating a speckled, bread crumb appearance. For the crust, use longer, flowing strokes that wrap around the bread's exterior. Finish with angled lines on the crust for additional texture.

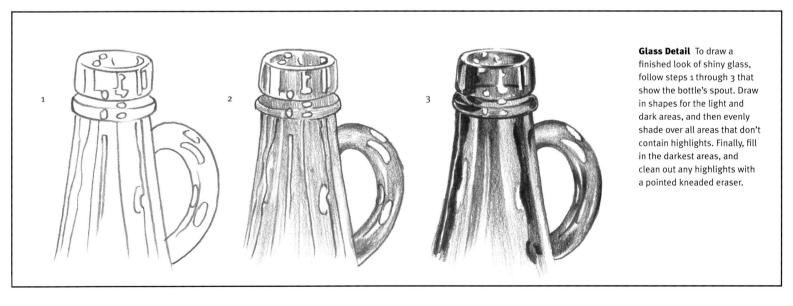

Glass Detail To draw a finished look of shiny glass, follow steps 1 through 3 that show the bottle's spout. Draw in shapes for the light and dark areas, and then evenly shade over all areas that don't contain highlights. Finally, fill in the darkest areas, and clean out any highlights with a pointed kneaded eraser.

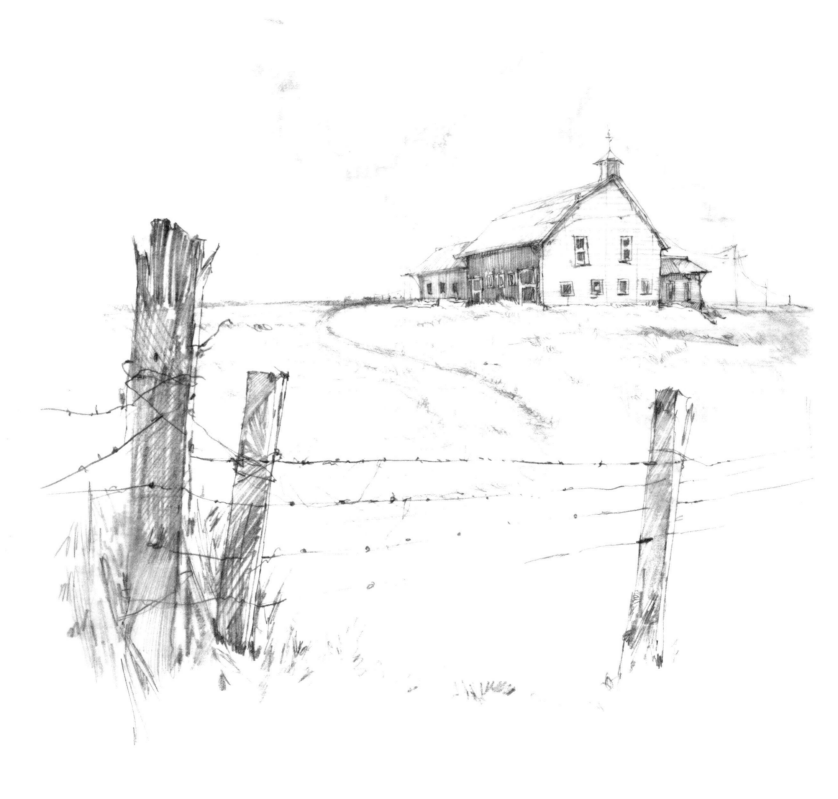

MORE TIPS

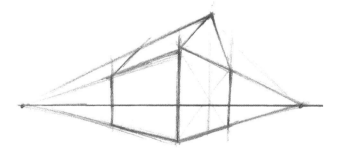

PICTORIAL COMPOSITION

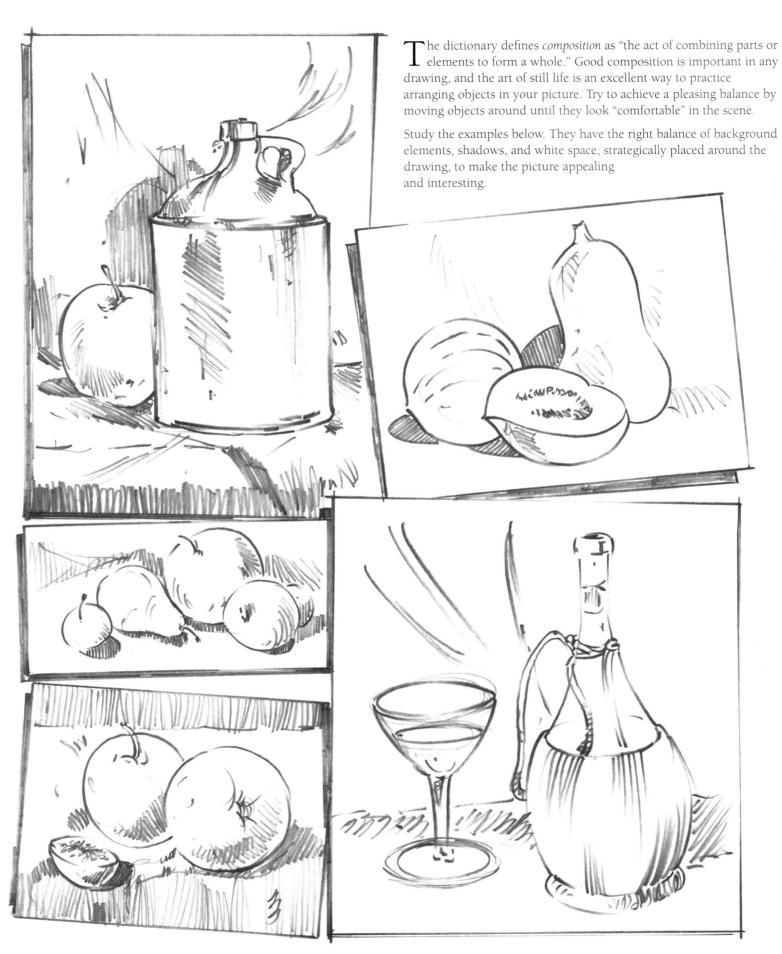

The dictionary defines *composition* as "the act of combining parts or elements to form a whole." Good composition is important in any drawing, and the art of still life is an excellent way to practice arranging objects in your picture. Try to achieve a pleasing balance by moving objects around until they look "comfortable" in the scene.

Study the examples below. They have the right balance of background elements, shadows, and white space, strategically placed around the drawing, to make the picture appealing and interesting.

When drawing, be sure to arrange the elements in a way that creates a pleasing design or composition. The overall design is determined by the placement of different shapes and lines. The composition should direct the viewer's attention to the most important area of the drawing.

In the example below, the fanlike shape of the treetop draws the eye to the trunk area.

Below, the tree to the left is in the *foreground*, the area that appears closest in distance. The vertical direction of the trunk is subdued by the rounded foliage mass in the upper left corner. Balance is achieved by placing the shrub in the background and to the right. The *background* is the area of the scene that is farthest away.

As shown below, a close-up of a tree can look very dramatic. Balance is achieved with opposing lines, which also lead the eye through the picture.

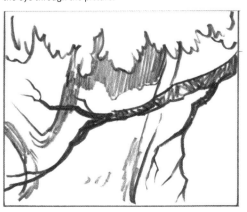

In the square composition below, the opposing lines of the branches create a focal point for the tree. (Try not to place the point of interest in the direct center.) The portrait (vertical) example to the right shows flowing lines, producing rhythm and balance.

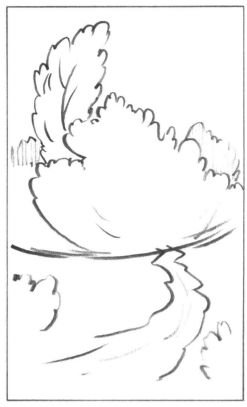

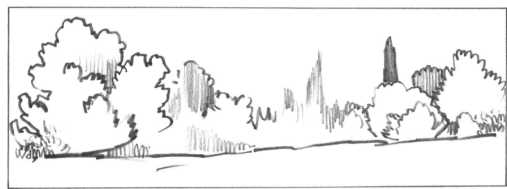

The landscape (horizontal) composition above represents a panoramic view. The large trees on the left are balanced by a group of smaller trees on the right. By placing the major elements on the right and left sides of the drawing, the center appears serene.

The tall tree in the foreground is complemented by the clouds, mountains, and smaller trees in the distance.

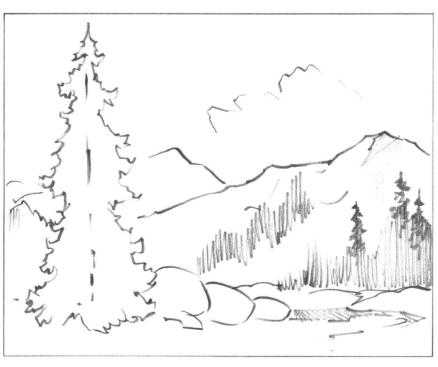

PERSPECTIVE

Drawing is actually quite simple. Just sketch the shapes and masses you see. Sketch loosely and freely—if you discover something wrong with the shapes, you can refer to the rules of perspective below to make corrections. Your drawings don't need to be tight and precise as far as geometric perspective goes, but they should be within the boundaries of these rules for a realistic portrayal of the subject.

Practice is the only way to improve your drawing skills and to polish your hand-eye relationships. It's a good idea to sketch everything you see and keep all your drawings in a sketchbook so you can track the improvement. The following are a few exercises to introduce the basic elements of drawing in perspective. Begin with the one-point exercise.

ONE-POINT PERSPECTIVE

In *one-point perspective,* the face of a box is the closest part to the viewer, and it is parallel to the horizon line (eye level). The bottom, top, and sides of the face are parallel to the picture plane.

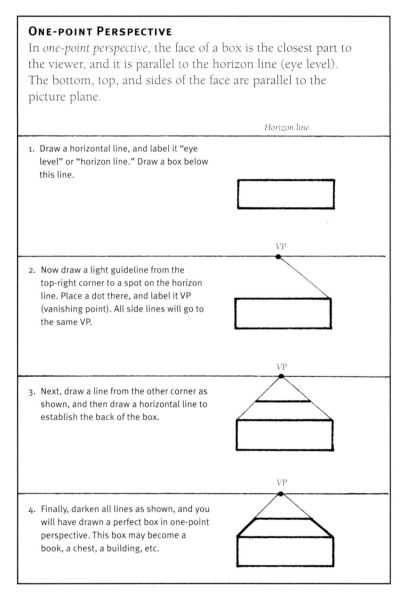

1. Draw a horizontal line, and label it "eye level" or "horizon line." Draw a box below this line.

2. Now draw a light guideline from the top-right corner to a spot on the horizon line. Place a dot there, and label it VP (vanishing point). All side lines will go to the same VP.

3. Next, draw a line from the other corner as shown, and then draw a horizontal line to establish the back of the box.

4. Finally, darken all lines as shown, and you will have drawn a perfect box in one-point perspective. This box may become a book, a chest, a building, etc.

TWO-POINT PERSPECTIVE

In *two-point perspective,* the corner of the box is closest to the viewer, and two VPs are needed. Nothing is parallel to the horizon line in this view. The vertical lines are parallel to the sides of the picture plane.

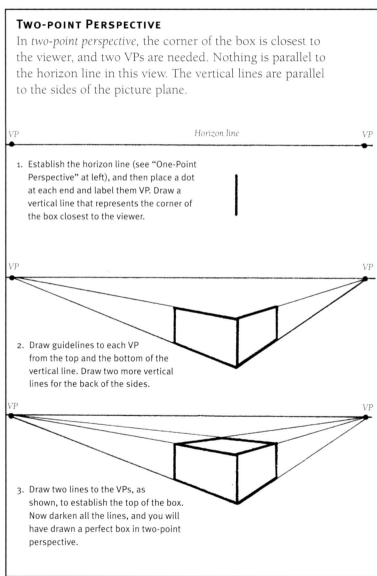

1. Establish the horizon line (see "One-Point Perspective" at left), and then place a dot at each end and label them VP. Draw a vertical line that represents the corner of the box closest to the viewer.

2. Draw guidelines to each VP from the top and the bottom of the vertical line. Draw two more vertical lines for the back of the sides.

3. Draw two lines to the VPs, as shown, to establish the top of the box. Now darken all the lines, and you will have drawn a perfect box in two-point perspective.

FINDING THE PROPER PEAK AND ANGLE OF A ROOF

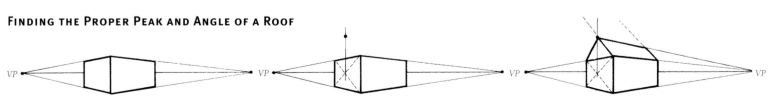

1. Draw a box in two-point perspective.

2. Find the center of the face by drawing diagonal lines from corner to corner; then draw a vertical line upward through the center. Make a dot for the roof height.

3. Using the vanishing point, draw a line for the angle of the roof ridge; then draw the back of the roof. The angled roof lines will meet at a third VP somewhere in the sky.

BASIC FORMS

There are four basic forms you should know: the cube, the cone, the cylinder, and the sphere. Each of these forms can be an excellent guide for beginning a complex drawing or painting. Below are some examples of these forms in simple use.

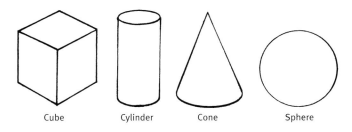

Cube Cylinder Cone Sphere

CREATING DEPTH WITH SHADING

To create the illusion of depth when the shapes are viewed straight on, shading must be added. Shading creates different values and gives the illusion of depth and form. The examples below show a cone, a cylinder, and a sphere in both the line stage and with shading for depth.

Line

Shaded

FORESHORTENING

As defined in Merriam-Webster's dictionary, to *foreshorten* is "to represent the lines (of an object) as shorter than they actually are in order to give the illusion of proper relative size, in accordance with the principles of perspective." (For more on foreshortening, see page 222.) Here are a few examples of foreshortening to practice.

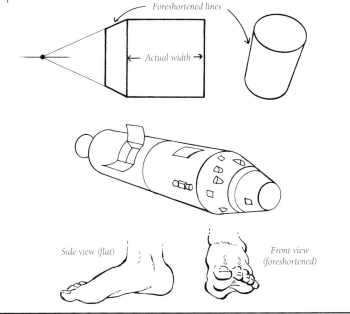

Foreshortened lines

← Actual width →

Side view (flat) *Front view (foreshortened)*

ELLIPSES

An *ellipse* is a circle viewed at an angle. Looking across the face of a circle, it is foreshortened and we see an ellipse. The axis of the ellipse is constant and represented as a straight centerline through the longest part of the ellipse. The height is constant to the height of the circle. Here is the sequence we might see in a spinning coin.

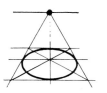

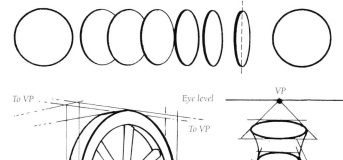

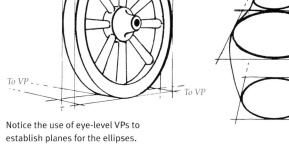

To VP *Eye level* *VP*

To VP

To VP *To VP*

Notice the use of eye-level VPs to establish planes for the ellipses.

CAST SHADOWS

When there is only one light source (such as the sun), all shadows in the picture are cast by that single source. All shadows read from the same vanishing point. Whether on the horizon line or more forward in the picture, this point is placed directly under the light source. The shadows follow the plane on which the object is sitting. Shadows also follow the contour of the plane on which they are cast.

Light rays travel in straight lines. When they strike an object, the object blocks the rays from continuing and creates a shadow relating to the shape of the blocking object. Here is a simple example of the way to plot the correct shape and length of a shadow for the shape and the height of the light.

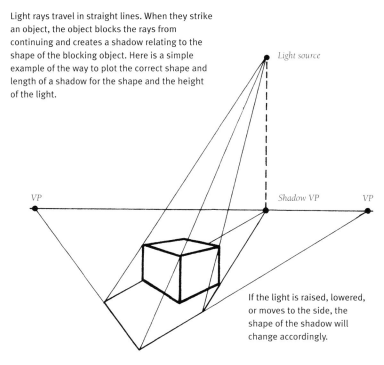

Light source

VP *Shadow VP* *VP*

If the light is raised, lowered, or moves to the side, the shape of the shadow will change accordingly.

PRACTICING PERSPECTIVE

A little bit of knowledge will go a long way, especially when it comes to perspective. Nothing will make your drawings of landscapes and buildings more realistic than applying a rule or two of perspective. In fact, you may already know more than you think. Have you ever noticed the way railroad tracks seem to narrow to one spot in the distance? That's *linear perspective* at work.

DEFINING THE TERMS

Linear perspective is a complex subject, but not one to fear once you are acquainted with a few basics. The horizon line is a horizontal line that's level with the viewer's eyes. In a landscape, it is usually the actual horizon. When two parallel lines recede, the point on the horizon line where they appear to converge is known as the *vanishing point* (VP). For example, picture a row of railroad tracks. This is called *one-point perspective,* because the lines meet at one point. When you draw a building at anything but a full frontal view, you will see two sides, or planes. Each plane will have its own vanishing point on the horizon, one to the left and one to the right of the building. This is an example of *two-point perspective* (see sketch at right). But enough of counting planes and points—let's draw some structures with linear perspective.

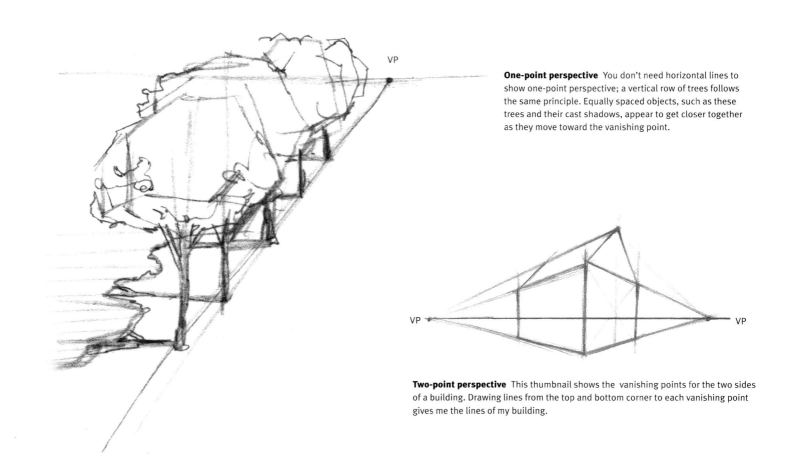

One-point perspective You don't need horizontal lines to show one-point perspective; a vertical row of trees follows the same principle. Equally spaced objects, such as these trees and their cast shadows, appear to get closer together as they move toward the vanishing point.

Two-point perspective This thumbnail shows the vanishing points for the two sides of a building. Drawing lines from the top and bottom corner to each vanishing point gives me the lines of my building.

Applying Perspective This simple-looking drawing is a wonderful example of how perspective can add interest and depth. The fence in the foreground and the telephone lines in the background were drawn with one-point perspective, and the building itself is drawn in two-point. Notice that the vanishing point for the fence isn't on my paper; it's farther off to the right, but it's there!

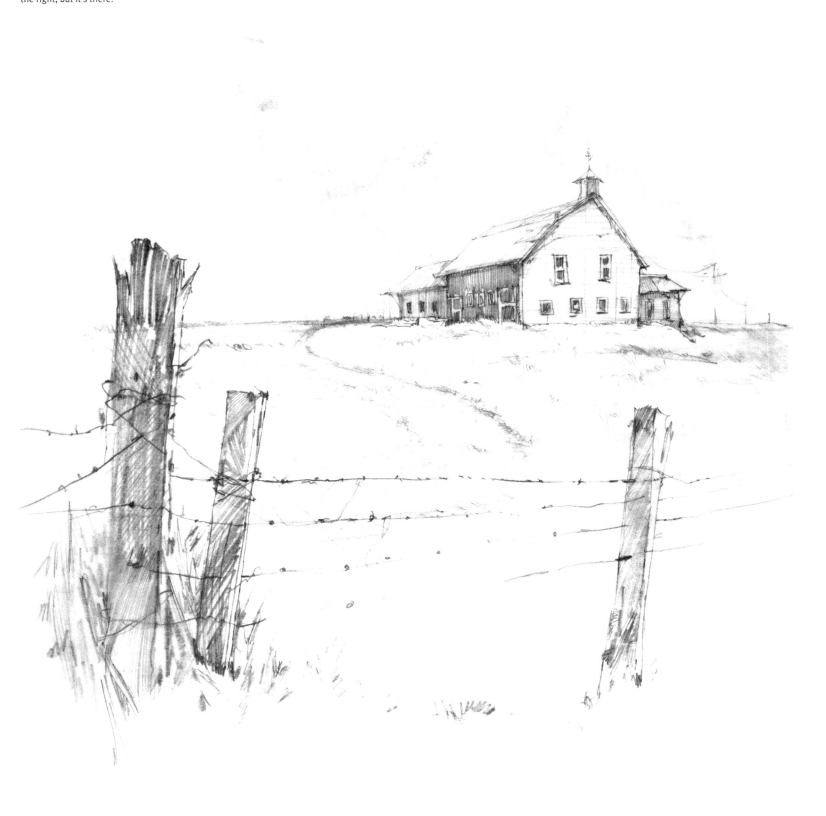

Conveying Distance This busy, big-city street scene is a classic example of one-point perspective, although that's not the only technique at play. I also overlapped objects, made scale changes, and lightened the distant values to let you know this traffic jam goes back a long, long way.

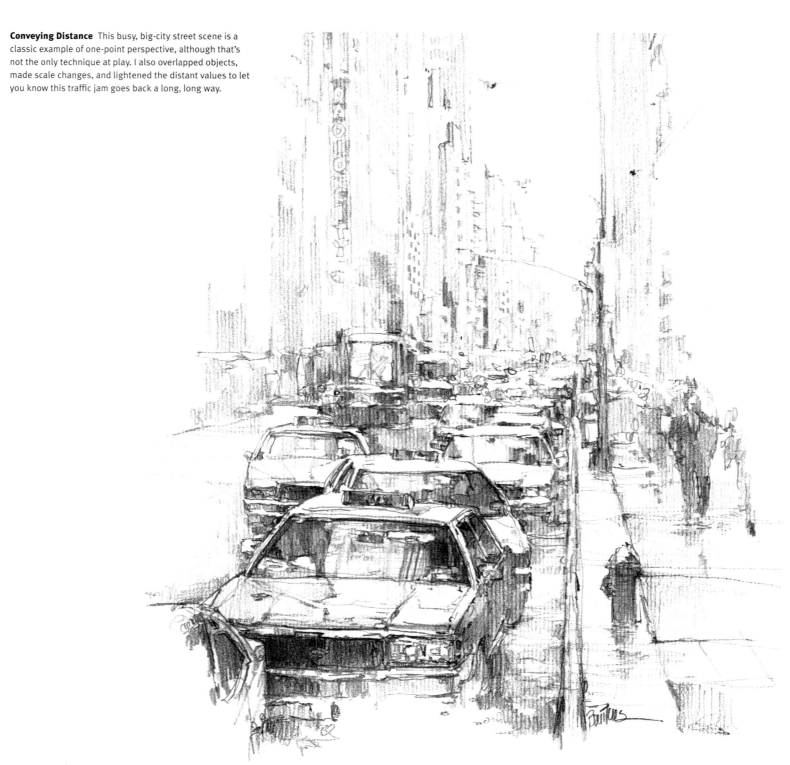

Taking Advantage of Thumbnails Small sketches are great for working out the correct perspective in a scene. This view is high, as if looking down from an upper window.

INDOOR PERSPECTIVE

With indoor compositions, you can't really see the horizon line, but it is at your eye level. Pick a point at your center of vision to be the vanishing point, and draw all lines of the room and the lines of the objects in it so they recede to that vanishing point. Then apply the same techniques you use in landscapes to create depth: Use lighter values in the background and more detail in the foreground. Just make the differences more subtle because the distance isn't great.

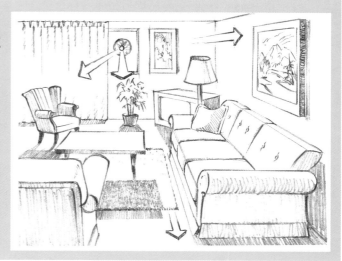

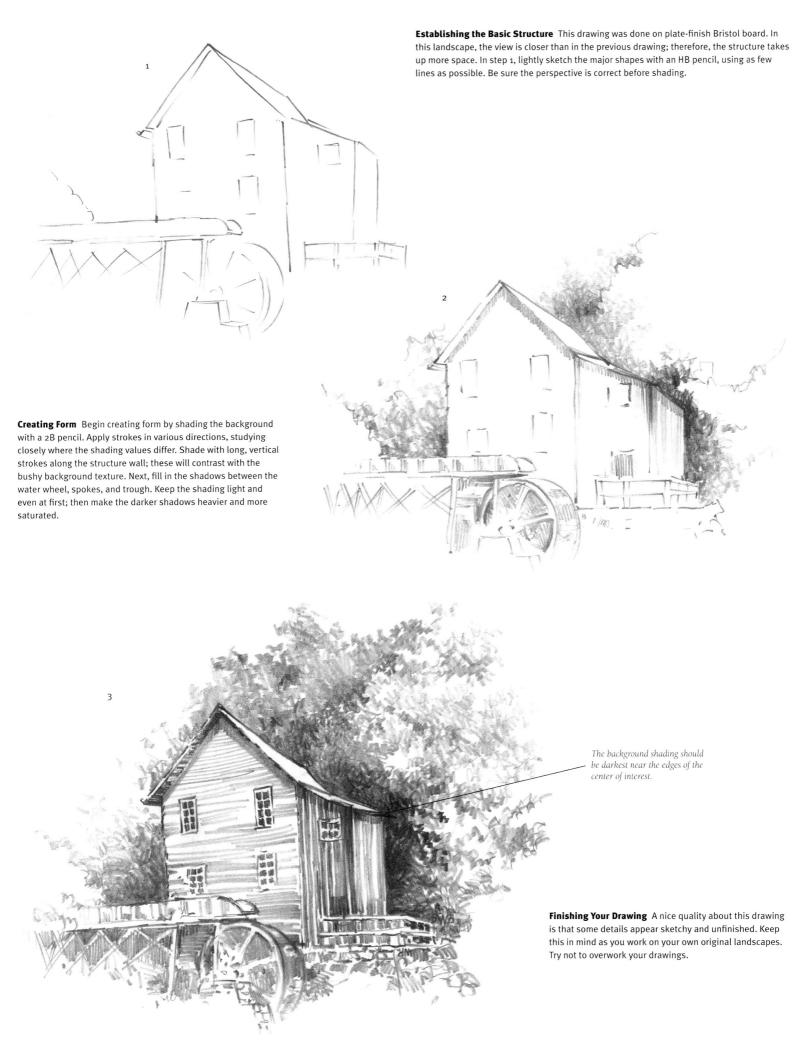

Establishing the Basic Structure This drawing was done on plate-finish Bristol board. In this landscape, the view is closer than in the previous drawing; therefore, the structure takes up more space. In step 1, lightly sketch the major shapes with an HB pencil, using as few lines as possible. Be sure the perspective is correct before shading.

Creating Form Begin creating form by shading the background with a 2B pencil. Apply strokes in various directions, studying closely where the shading values differ. Shade with long, vertical strokes along the structure wall; these will contrast with the bushy background texture. Next, fill in the shadows between the water wheel, spokes, and trough. Keep the shading light and even at first; then make the darker shadows heavier and more saturated.

The background shading should be darkest near the edges of the center of interest.

Finishing Your Drawing A nice quality about this drawing is that some details appear sketchy and unfinished. Keep this in mind as you work on your own original landscapes. Try not to overwork your drawings.

PEOPLE IN PERSPECTIVE

Knowing the principles of perspective allows you to draw more than one person in a scene realistically. As when you're drawing a building (see page 216), first establish the horizon line and the vanishing points. Any figures drawn along these lines will be in proper perspective. Study the diagrams at right and below to help you.

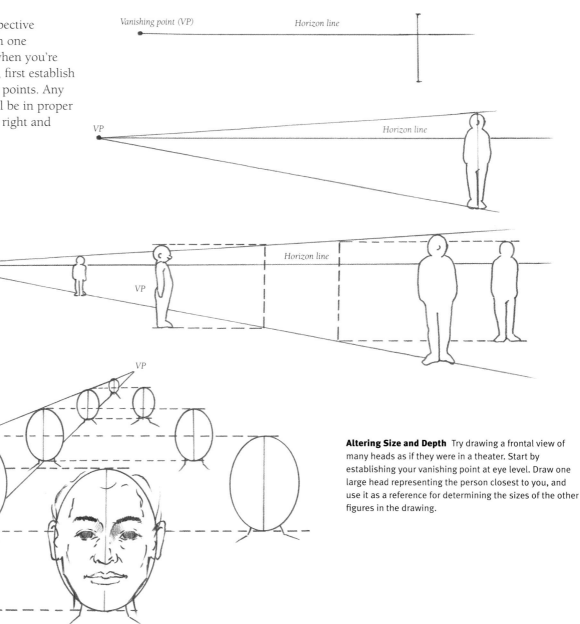

Altering Size and Depth Try drawing a frontal view of many heads as if they were in a theater. Start by establishing your vanishing point at eye level. Draw one large head representing the person closest to you, and use it as a reference for determining the sizes of the other figures in the drawing.

Drawing Full Figures The technique illustrated above can be applied when drawing entire figures, as shown in the diagram at right. Although all of these examples include just one vanishing point, a composition can even have two or three vanishing points. (See page 216.)

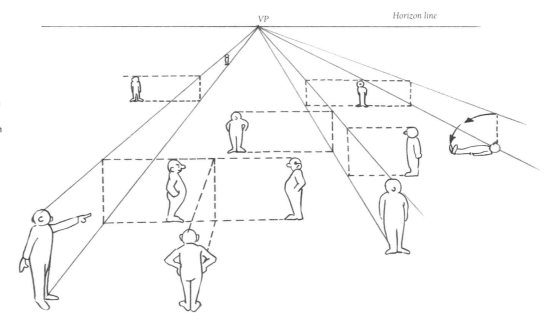

COMPOSING FIGURES

Creating a good composition is important in any drawing; therefore, let your subject(s) guide you. It's not necessary to place the main subject directly in the center of your composition. For example, the eyes of the girls below are looking in different directions, which determines where the girls are positioned.

Zooming In Intentionally drawing your subject larger than the image area, as shown in the example below, is also a unique composition. While part of the image may be cut off, this kind of close-up creates a dramatic mood.

Combining Multiple Subjects You can create a flow or connection between multiple subjects in a composition by creatively using circles and ellipses, as shown to the right.

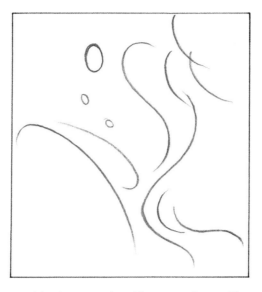

Practicing Curvatures Curved lines are good composition elements—they can evoke harmony and balance in your work. Try drawing some curved lines around the paper. The empty areas guide you in placing figures around your drawing.

Producing Sharp Angles Sharp angles can produce dramatic compositions. Draw a few straight lines in various angles, and make them intersect at certain points. Zigzagging lines also form sharp corners that give the composition an energetic feeling.

The compositions above and below illustrate how arm position, eyesight direction, and line intersection can guide the eye to a particular point of interest. Using these examples, try to design some of your own original compositions.

FORESHORTENING

To achieve realistic depth in your drawings, it's important to understand foreshortening. Foreshortening refers to the visual effect (or optical illusion) that an object is shorter than it actually is because it is angled toward the viewer. Objects closer to the viewer appear proportionately larger than objects farther away. For example, an arm held out toward the viewer will look shorter (and the hand will look larger) than an arm held straight down by the subject's side. When foreshortening something in a drawing, be sure to draw the object the way you really see it, not the way you think it should look. Foreshortening helps create a three-dimensional effect and often provides dramatic emphasis. Study the examples here to see how foreshortening influences their sense of depth.

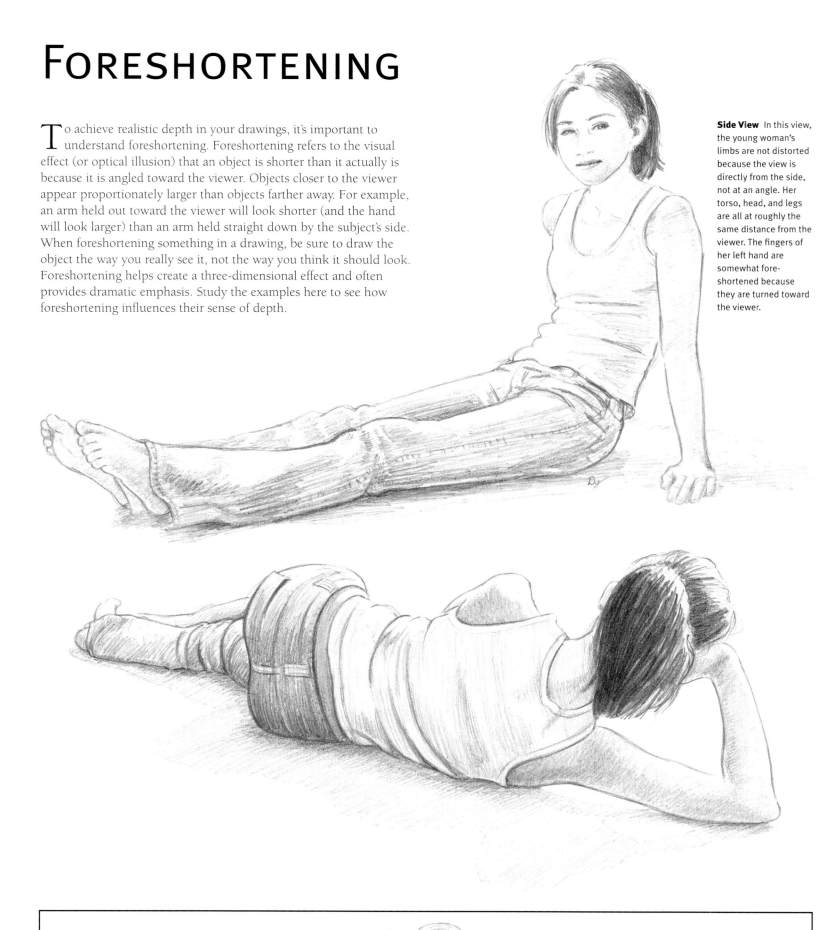

Side View In this view, the young woman's limbs are not distorted because the view is directly from the side, not at an angle. Her torso, head, and legs are all at roughly the same distance from the viewer. The fingers of her left hand are somewhat fore-shortened because they are turned toward the viewer.

FOCUS ON FINGERS

When foreshortening occurs, you must forget everything you know about proportion and draw what you see instead of what you expect to see. Even something as simple as a fingertip can take on a drastically different appearance.

Fingers When viewing a finger from the side (A), the tip of the finger is much smaller than the knuckle. When viewed straight on (B), the tip and the knuckle appear equal in size. When the lines of the rounded fingertip and nail are shortened, both appear quite square (C). Foreshortening from this angle causes the length of the fingernail to appear quite short as well.

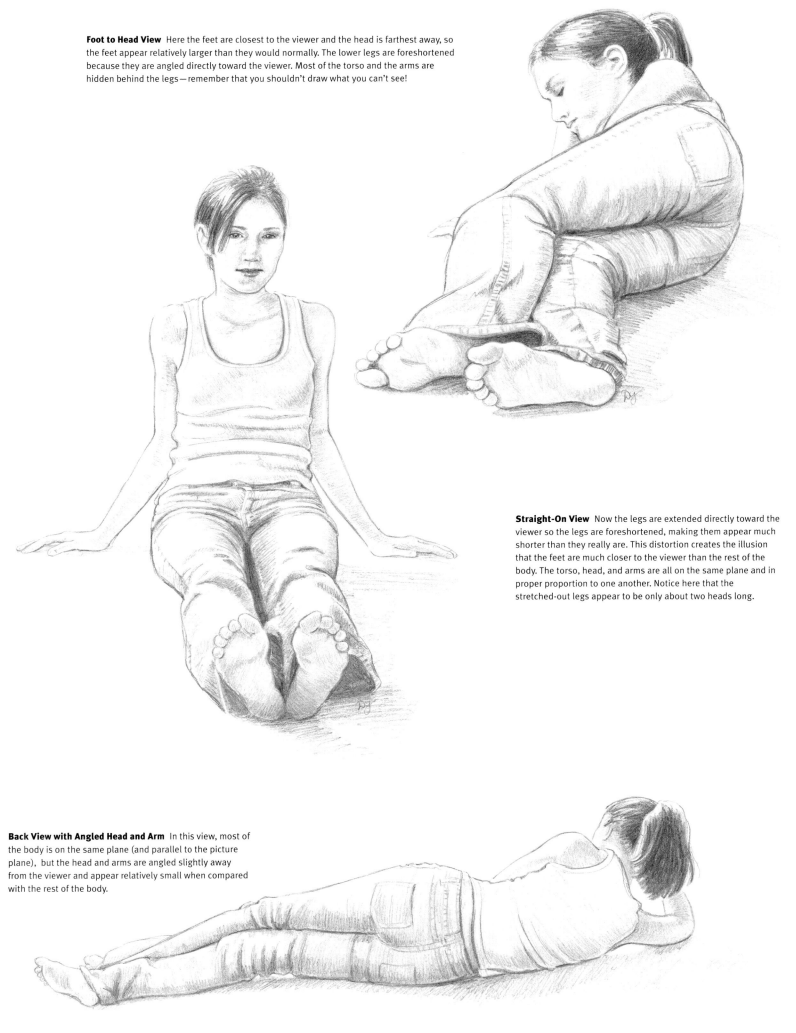

Foot to Head View Here the feet are closest to the viewer and the head is farthest away, so the feet appear relatively larger than they would normally. The lower legs are foreshortened because they are angled directly toward the viewer. Most of the torso and the arms are hidden behind the legs—remember that you shouldn't draw what you can't see!

Straight-On View Now the legs are extended directly toward the viewer so the legs are foreshortened, making them appear much shorter than they really are. This distortion creates the illusion that the feet are much closer to the viewer than the rest of the body. The torso, head, and arms are all on the same plane and in proper proportion to one another. Notice here that the stretched-out legs appear to be only about two heads long.

Back View with Angled Head and Arm In this view, most of the body is on the same plane (and parallel to the picture plane), but the head and arms are angled slightly away from the viewer and appear relatively small when compared with the rest of the body.

MORE FORESHORTENING

Foreshortening allows you to create the illusion of an object coming toward you in space. While the principles of perspective still exist, body parts are more difficult to draw in this manner because they don't have straight edges. In addition, the body proportions are somewhat skewed, or shortened, in a drawing that includes foreshortened subjects.

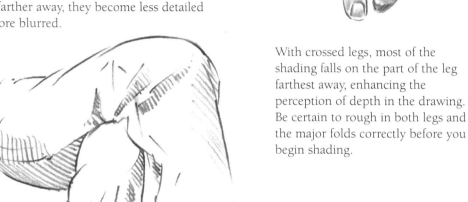

The arm resting on the keyboard appears to be receding back into space. The parts of the body closest to you should be shaded the least because they have the most light on them. Also, keep in mind that as objects move farther away, they become less detailed and more blurred.

With crossed legs, most of the shading falls on the part of the leg farthest away, enhancing the perception of depth in the drawing. Be certain to rough in both legs and the major folds correctly before you begin shading.

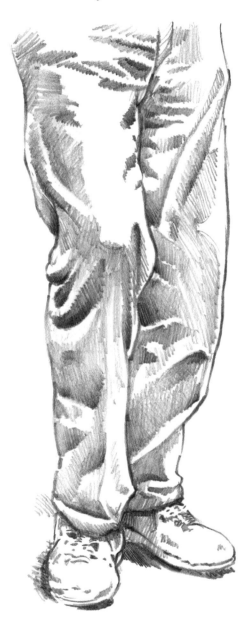

Foreshortening means you are shortening what is coming forward. Notice at the dinner table when someone passes you something how his or her arm is foreshortened.

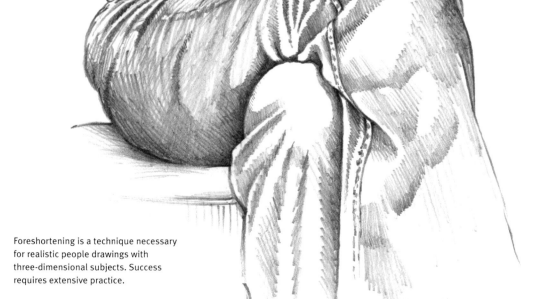

Foreshortening is a technique necessary for realistic people drawings with three-dimensional subjects. Success requires extensive practice.

CHOOSING A POSE

Not every photo you take is going to be good, and not every pose your model strikes is going to be perfect. Look for poses that are natural and balanced, not stiff or boring. Some movement or tension can make the pose more interesting, but your subject should look stable and comfortable in the position. Unless in motion, the model should not have his or her arms and legs stretched out in all directions. Instead, he or she should be more compact and relaxed. The pose should reflect the personality or interests of the subject. Take many photos to use as references, and evaluate them for suitability.

EVALUATING PHOTOS

A

B

C

Selecting a Photo Reference In photo A, the subject has a stable, compact pose, but he looks a bit stiff and bored, and his personality doesn't show through. The pose in photo B is more relaxed, but the boy looks a little out of balance, and his arms and legs are in awkward positions; in addition, the light behind him is a bit harsh. Photo C is a great pose to represent this young man. He looks comfortable and his hands and feet are in good, natural positions. His head is turned at a 90-degree angle to his body, which helps give some movement and interest to the pose. The lighting is more even as well. This is the best pose to use for a drawing.

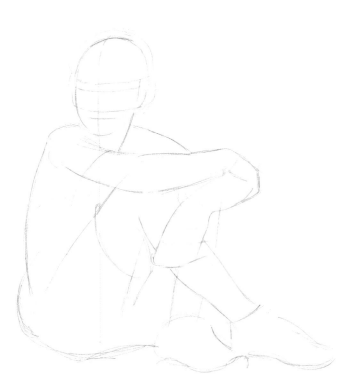

Step 1 Using an HB pencil, block in the figure. Place the head above the center of the main body mass, as indicated by the vertical line. Sketch the shapes of the arms and legs, drawing through the overlapping body parts for correct placement. The vertical centerline on the head shows the three-quarter view. Add the horizontal guidelines for the facial features. Sketch the general shapes of the shoes and the lines for the ends of the shorts and the shirt sleeve. Be sure the pose and proportions are accurate before adding any details.

Step 3 Erase the guidelines. Then use a B pencil to refine the facial features and the hair. Give the fingers a more precise shape, and add the fingernails. Refine the shapes of the arms, legs, and clothing, removing unneeded lines with a kneaded eraser. Using *artistic license* (the artist's prerogative to ignore what actually exists and to make changes, deletions, or additions), the author decides to change the shoelace so it is not awkwardly sticking up at an odd angle.

Step 2 Now it's time for some definition. Place the facial features on the guidelines. Remember: The guides you learned about earlier are based on averages. To achieve a good likeness, be sure to follow your photo reference and adjust accordingly—for example, accounting for this boy's high forehead and wide-set eyes. Indicate the hair, and sketch in the clothing, showing some of the folds and wrinkles. Sketch in the shapes of the fingers of his left hand and the elbow of his right arm. Refine the shapes of the shoes, and indicate laces.

Step 4 Using a 2B pencil, begin shading the hair with strokes that follow the direction of growth. Leave areas of white paper where the light hits the hair. Shade some darker areas around the eyes, cheekbones, and under the lips as well as on the neck. Use a very sharp pencil and small strokes for the eyebrows and lashes. Darken the legs where they are in shadow; these strokes follow the curve of the leg and help show its form. (See "Shading the Forms" to the right.) Begin to shade the arms and other areas in shadow, such as the ends of the fingers. Add more shading to the clothing and shoes, rendering additional details as you go.

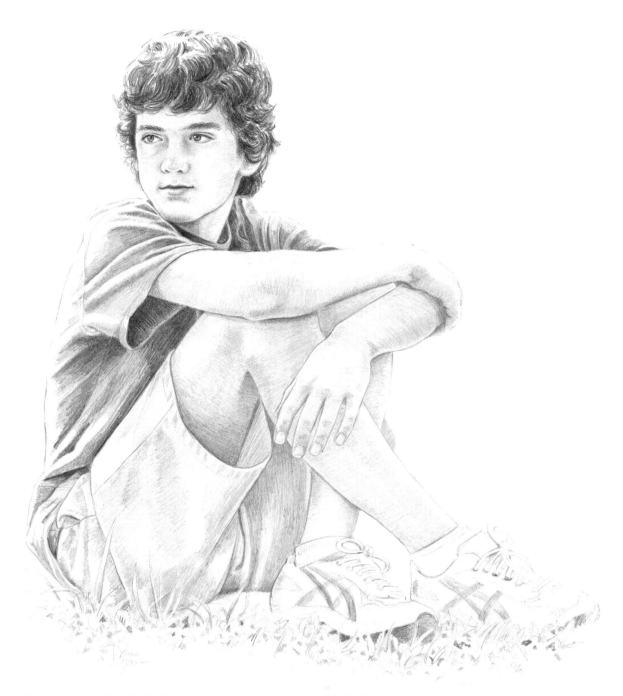

Step 5 Using a very sharp 2B pencil with light pressure, shade the face, leaving a white highlight on the nose and chin and on the side of the right cheek that is in more direct sunlight. To show the delicate form of the face, place your shading strokes very close together and follow the contours of the face, often changing direction. Shade the arms and legs using a little pressure for the lighter areas; press harder for darker areas. Leave a white highlight on the top of the right arm to show where the sunlight is reflected. Along the back, leave a vertical area of white paper to represent the bright sunlight on the shirt; other folds of the shirt and pants also have highlights. Use a 3B pencil to add some dark areas in the hair and in the darkest areas of the clothing before switching back to the 2B pencil. The shoes receive a little more refining and shading; don't draw all the details, as they are not needed. Add some grass, leaves, and a little shading to show that the boy is sitting outside. Leave a lot of white paper around him, providing very little detail to the grassy area to keep the focus on the boy.

SHADING THE FORMS

Shading with varying values—from black through all shades of gray to white—enhances the illusion of depth in a drawing. Effective shading also adds life and realism to a drawing. When shading cylindrical elements, such as the arms and legs, make sure your pencil strokes follow the curved forms, as shown in the diagram at the right. This illustration has been exaggerated to demonstrate the different directions the shading lines should follow. Your strokes, of course, will be smoother with subtle gradations and highlighting.

UNDERSTANDING LIGHTING

An important aspect of drawing—especially when drawing people—is lighting the subject. Lighting can have a dramatic effect on the figure's appearance, eliciting an emotional response from the viewer and setting the mood of the drawing. Subtle lighting often is associated with tranquility and can make a subject appear soft and smooth. This type of lighting tends to lighten the mood, generally lending a more cheerful feel to the composition. On the other hand, strong lighting makes it easier to see the contrasts between light and dark, which can add drama and make the subject appear more precisely formed. Longer shadows can mute the mood of a portrait, producing an air of pensiveness. Here strong shadows on the subject's face make her subtle smile seem reflective rather than content.

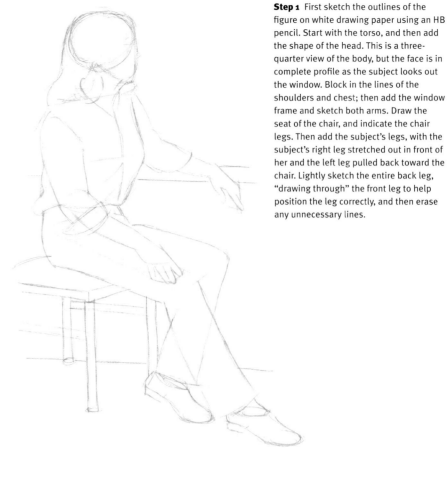

Step 1 First sketch the outlines of the figure on white drawing paper using an HB pencil. Start with the torso, and then add the shape of the head. This is a three-quarter view of the body, but the face is in complete profile as the subject looks out the window. Block in the lines of the shoulders and chest; then add the window frame and sketch both arms. Draw the seat of the chair, and indicate the chair legs. Then add the subject's legs, with the subject's right leg stretched out in front of her and the left leg pulled back toward the chair. Lightly sketch the entire back leg, "drawing through" the front leg to help position the leg correctly, and then erase any unnecessary lines.

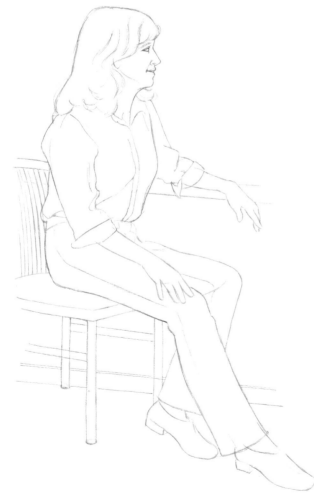

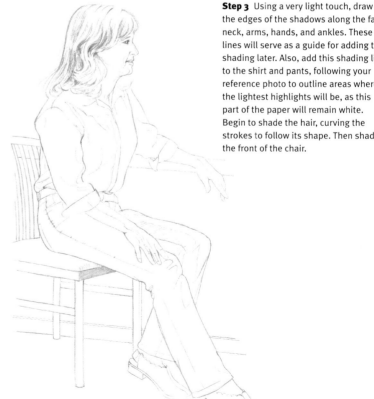

Step 3 Using a very light touch, draw the edges of the shadows along the face, neck, arms, hands, and ankles. These lines will serve as a guide for adding the shading later. Also, add this shading line to the shirt and pants, following your reference photo to outline areas where the lightest highlights will be, as this part of the paper will remain white. Begin to shade the hair, curving the strokes to follow its shape. Then shade the front of the chair.

Step 2 Switching to a B pencil, begin refining the head by adding the features and the hair, erasing unneeded lines as the drawing progresses. Refine the shirt and jeans, adding details like the seam along the leg. Add the back of the chair, and refine the shape of the rest of the chair. Draw the lower window frame, and refine her fingers and the shapes of the shoes. The main concern at this stage is establishing the overall shape of the figure—shading to indicate lighting and mood will come next.

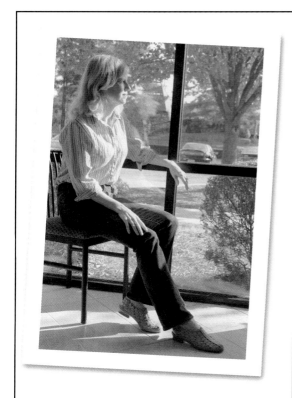

Using Strong Natural Light The model for this drawing is sitting beside a floor-to-ceiling window. The sun is streaming through the glass from above and in front of her. The strong light creates visual interest by casting deep shadows and creating bright highlights.

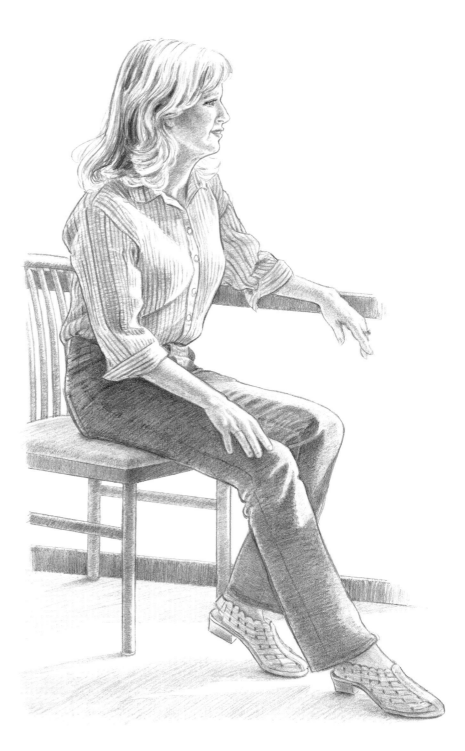

Step 4 Shade the skin using light, diagonal strokes, except where the highlight is strongest. Erase any remaining shading guidelines. Then draw the stripes of the subject's shirt, following the folds and curves of the fabric over her form and leaving the lightest areas white. After adding details to the shoes, use a 2B pencil to create dramatic contrasts in value —shading the inside of the left leg, adding a few more dark values to the hair, and drawing the outlines of the shadows on the floor. Look at your reference photo frequently to check the placement and strength of your highlights and dark values. Then apply additional shading to the back and legs of the chair, and shade the window frame.

Step 5 Switch back to a very sharp B pencil to add some details to the face. Using a 2B pencil, create more dark values in the hair, and shade the stripes on the shirt. Darken the rest of the jeans using strokes that follow the form of her legs. With a sharp pencil point, carefully add a layer of shading to the darker areas of the skin. Reflected light from the shirt lightens her jaw line. Reflected light also appears on her arms and fingers; stroke across the arms to give them form. Shade the rest of the chair, leaving white on the chair legs where the light hits them. Because this portrait utilizes strong contrasts in light, larger portions of the drawing will remain nearly white—including the highlights on her legs, her throat, and her chest. A portrait that comprises varying degrees of shadows without these large areas of highlight would lose drama and intensity. Next, shade the shoes, making them darker where the woven pattern is more detailed. On the floor, use diagonal hatching strokes, angling away from the light to create the shadows cast by the legs of both the subject and the chair.

DEPICTING TEXTURES

Textures are great fun to draw, and because each type of texture requires a different pencil technique, they add a tremendous amount of interest to a drawing. Test your observation skills by studying the textures of different subjects: Are they rough or smooth? Hard or soft? Dark or light? Then try to determine how to convey these qualities in your drawings. For instance, I would draw the texture of a plastered wall differently than I would that of a brick wall, a wooden wall, or one with peeling paint. And a piece of torn or broken bread has a different texture than a piece that's been neatly sliced. Some surfaces, such as rocks or tree trunks, require a combination of techniques—smooth, blended shading plus a variety of pencil strokes.

One of the best ways to learn how to create different textures is to draw a still life of objects you have at home. Gather items with a variety of different textures, and arrange them in a dynamic composition. For this project, I've chosen subjects of wood, glass, silver, fabric, liquid, and china. As you follow the steps on page 231, refer to the detailed enlargements below to better see the highlights and individual pencil strokes.

Thumbnail I worked out the composition in this thumbnail sketch to check that it "reads" well in two dimensions.

Crumbly Scone I made long, straight strokes with an HB pencil for the smooth portion of the scone and drew short, hatched strokes of different values and in different directions for the rough edge and broken portion. For the darker, more solid masses of currants within the scone, I used a 2B pencil.

Glass The best way to indicate the texture or surface of clear glass is not to draw it all—only suggest selected light and dark portions. I used the point and side of an HB pencil for this smooth surface and varied the values slightly. Notice that the glass also distorts the elliptical surface of the liquid at the left edge of the glass.

Silver The carefully placed highlights are the most important part of creating the illusion of metal. Notice that the shiny spoon absorbs dark areas and reflects light onto the side of the coffee cup. I used an HB pencil for the mid-tone areas and smoothed them with a blending stump. Next, I used a 2B pencil to build up the darks.

Basket To mimic the texture of the basket, I used a sharp HB pencil and made vertical strokes for the vertical weave and horizontal strokes for the horizontal weave. I started the strokes at the end of a segment and worked toward the middle, pressing firmly at the beginning of each stroke and lifting the pencil at the end.

Fabric I used a series of short, directional strokes with the blunt point of an HB pencil to make the small, dense weave of the cloth. I used the same strokes in the cast shadow but made them darker and placed them closer together. For the flower pattern, I varied the pressure on my pencil and the density of my strokes to duplicate the design.

Liquid The coffee is dark, but its surface reflects the light from the side of the cup. Notice that there are several areas of value changes within the dark coffee as well. After establishing the darks in the coffee and the middle and light values in the cup, I used a kneaded eraser to pull out highlights on the coffee surface.

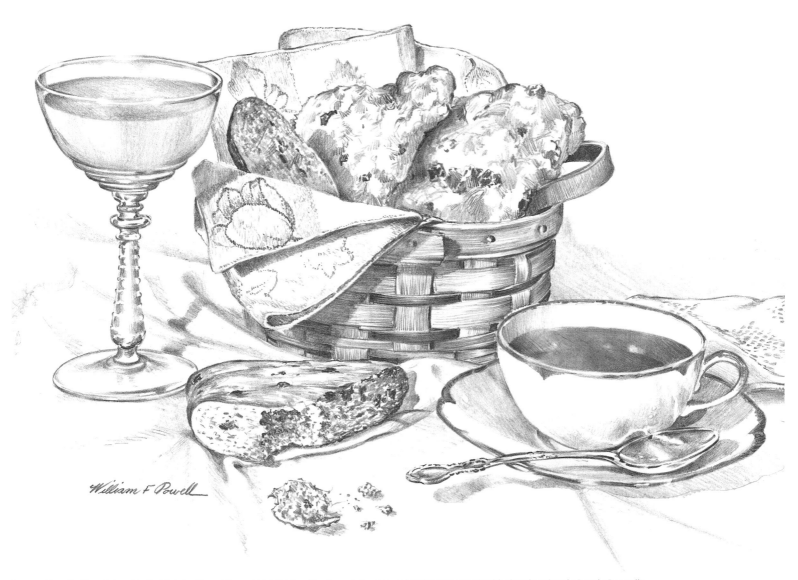

Step 3 After shading all the objects, I finished by pulling out highlights with a kneaded eraser and darkening accents with sharply pointed 2B and 4B pencils.

Step 1 With the point of an HB pencil, I blocked in the general shapes. Then I drew the outlines of each element in the composition with very light lines. I took my time on this step, frequently checking my drawing against the arrangement to make sure I got all the proportions right. I drew only a few lines for the folds in the cloth just for placement, because I will develop those forms with shading.

Step 2 When I was satisfied with the basic outlined shapes, I began building up their forms with various techniques (see details on page 230). I started with an HB pencil for the light values and then switched to a 2B pencil and a 4B pencil for the darkest accents. Rather than lay in and build up the values for the whole composition at once, I worked on one area at a time. That kept me from being confused by all the details of the entire scene.

DESCRIBING SURFACE TEXTURES

Being able to render textures will help you add realism and interest to your drawings. It's fun to explore a variety of surface textures, such as shiny metal or rough bark, and try to recreate them with paper and pencil. Even the most complex textures can be rendered with just a few pencil techniques—and a lot of practice!

MATCHING THE PENCIL TECHNIQUE TO THE TEXTURE

The first step in depicting texture is to find the technique that suits it best. The smooth, shiny surfaces of metal and glass reflect a lot of light. The highlights on these surfaces will be well-defined, and a tight, controlled pencil stroke is called for. For these subjects, use smooth paper and your harder pencil leads. To draw the irregular, rough texture of weathered wood, use both hard and soft pencils and a variety of strokes to suggest knots, gnarls, lumps, and bumps. The more loosely rendered, the better. Choose a paper with some texture, and let the tooth of the paper add its own texture to your drawing.

Rendering Bark I drew the rough texture of this gnarled tree trunk with a variety of pencil lines— doodles, scallops, and smudges —along with vertical strokes that followed the form of the trunk. You can see some of these different types of strokes in the detail below.

Detail

Drawing Shiny Surfaces The smooth, shiny surface of a spoon mirrors lights and darks and casts an interesting shadow. I used an HB to shade smooth layers of dark values, carefully duplicating the shapes I saw in the reflections. I left the paper white for the radiating highlights, as shown in the detail below right.

Detail

Combining Textures This still life of various surface sheens and texture patterns was challenging yet great fun. I simply looked for patterns and shapes and then drew exactly what I saw. For instance, I made the lace by drawing the shape of the holes and leaving the threads clean (drawing negative shapes), as shown below.

Detail

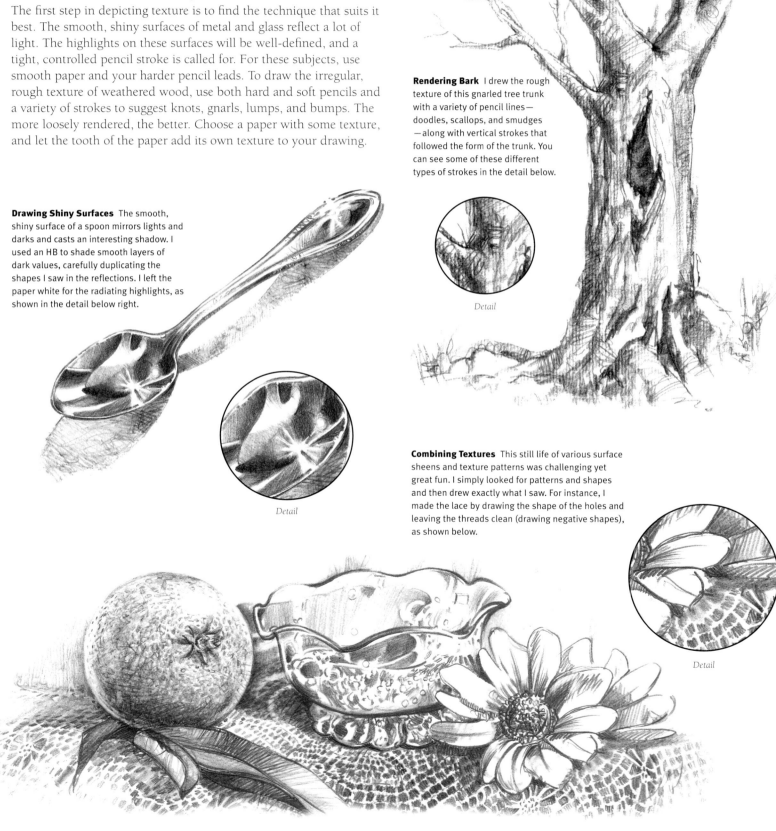

Rendering Reflections This vintage car made a great study in drawing reflective surfaces. To see the reflections as simple shapes, I squinted my eyes to blur the details, and then I sketched the outlines of the shapes I saw. Next I blocked in the medium and dark values with short strokes and hatches. Then I darkened the deepest shadows and added details with a sharp-pointed HB pencil.

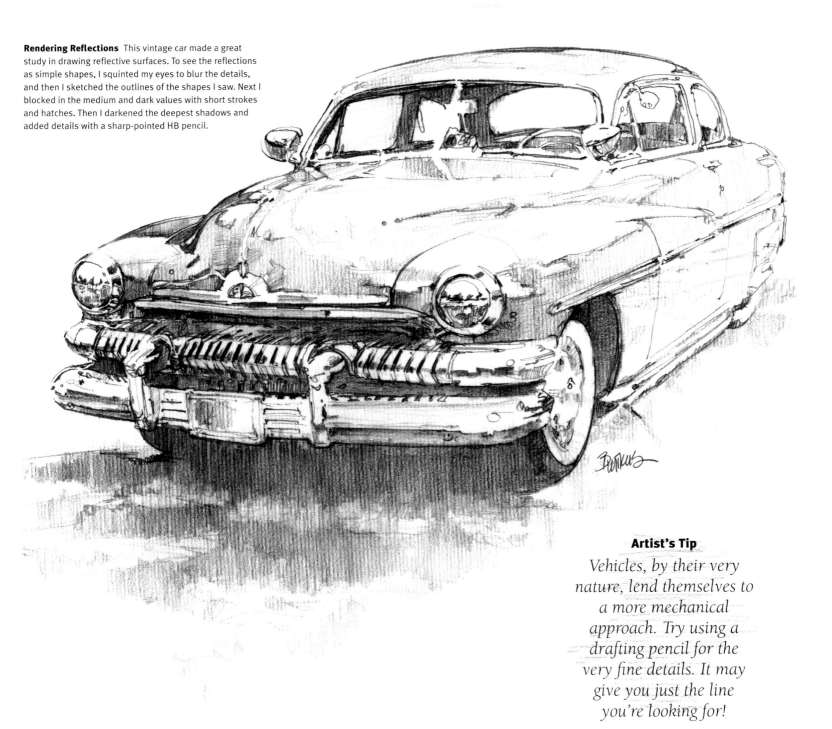

PICKING UP PATTERNS

Make rubbings from household surfaces or objects from nature for a quick, easy application of texture. Take rubbings from a leaf, crumpled aluminum foil, rice, basket, window screen, paper clips, or stucco wall—anything with an imprint. These make fantastic backgrounds.

Once you've recorded the impression, use your drawing tools—pencils, erasers, stumps, fingers—to enhance selected areas by darkening, lightening, or even accenting texture. Always use a thin paper in order to record the most texture possible. Also, make variations of a texture by using papers with different surface textures. The combination of paper and subject texture can create some very interesting designs.

Detailing Here, I paid special attention to the curvature of the highlighted areas and the distortion of reflected forms in this shiny, chrome bumper. This was a study in precise detail.

CAPTURING VACATION SCENES

I always keep my camera close by when I travel, because I may see an intriguing scene or subject and not have enough time to sketch it. I photograph everything that catches my eye (asking permission when necessary), always trying to create interesting compositions with my camera. I also photograph subjects from unusual points of view and from different angles. Then when I get home, I file them away for future drawing and painting reference.

RESEARCHING YOUR SUBJECT

In addition to taking your own photos, I recommend collecting pictures of places you visit from catalogs, magazines, books, and postcards. (A collection of such references is commonly called an "artist's morgue.") Take care when using these references. Copying photos you have taken yourself is fine, but be sure to use others' pictures for ideas and general references only. Never copy them exactly (or even closely), because you may infringe on someone else's copyright. Creating original compositions should be your goal!

Using Photos for Reference Photos don't have to be perfect to be helpful. From this photo of Waikiki Beach taken from a hotel terrace, I gleaned information about palm trees and cloud formations and used them in my drawing below.

CREATING A COMPOSITION WITH THE VIEWFINDER OF YOUR CAMERA

Use your camera's viewfinder to frame the scene, moving it around and zooming in or out to find the angle that best presents your subject. For taller objects, turn your camera sideways and shoot vertically. The photo above of the Jefferson Memorial in Washington, DC, is nice enough since it shows the structure and grace of the columns, but compare it with the view below.

I walked around the building until I came upon a more unusual view. This composition with the statue of Jefferson silhouetted between columns is far more striking and rich with feeling and meaning than the one above. Now I have two photos to use for reference. The first can be mined for its architectural information, and I can use this one for the final dramatic presentation of the scene.

Step 1 For this sunset scene, I lightly blocked in the outlines of all of the elements with the sharp point of an HB pencil. Notice that I placed the horizon line slightly below center.

Step 2 As I developed the contours of each object, I kept all guidelines light, especially in the sky. Just as I do with a still life, I checked that all elements are in correct proportion.

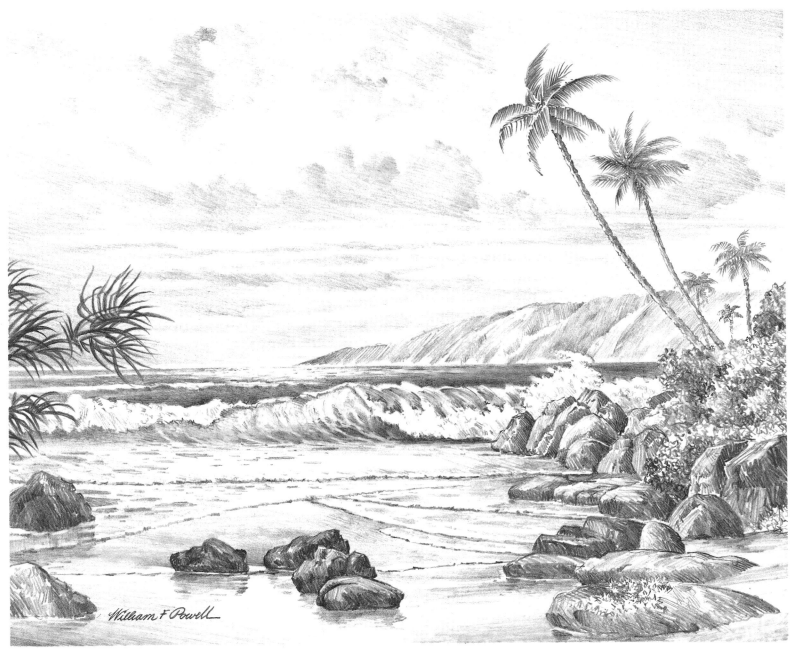

Step 5 I developed the shading values and textures using the point and sides of an HB pencil and the point of a 2B. I didn't overwork the background; I wanted it light to suggest distance.

Step 3 Using the side of an HB pencil, I built up the values and shapes of clouds in the sky, making most of my strokes follow the same angle. Then I began shading the water.

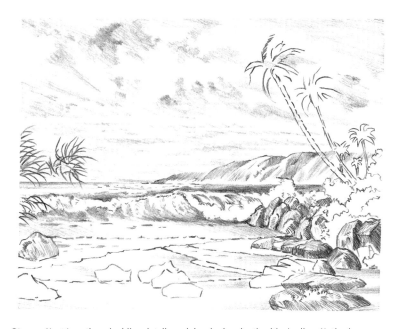

Step 4 Next I continued adding details and developing depth with shading. Notice how my pencil strokes follow the surface of the water and the shapes of the rocks.

EXPERIMENTING WITH DIFFERENT MEDIA

Drawing is a creative process. As an artist, I am constantly looking for new ways to stimulate my imagination, and I'm always interested in exploring different methods of working. One of the best ways to do this is to experiment with different media. Here I've branched out and drawn with pen and ink, charcoal sticks and pencils, and Conté crayons to show just a glimpse of the possibilities. Be adventurous, and try some new materials on your own.

EXPLORING ANIMAL TEXTURES

I love drawing animals, partly because I'm so fond of them and partly because they're such beautiful creatures. They range from small and delicate to large and powerful, with an array of different colors, textures, and patterns. It's great fun to try to show the differences between the shaggy coat of the coyote pup and the long mane of the lion, or the thick, black-and-white fur of the panda and the patterned stripes of the tiger or zebra. Try it yourself!

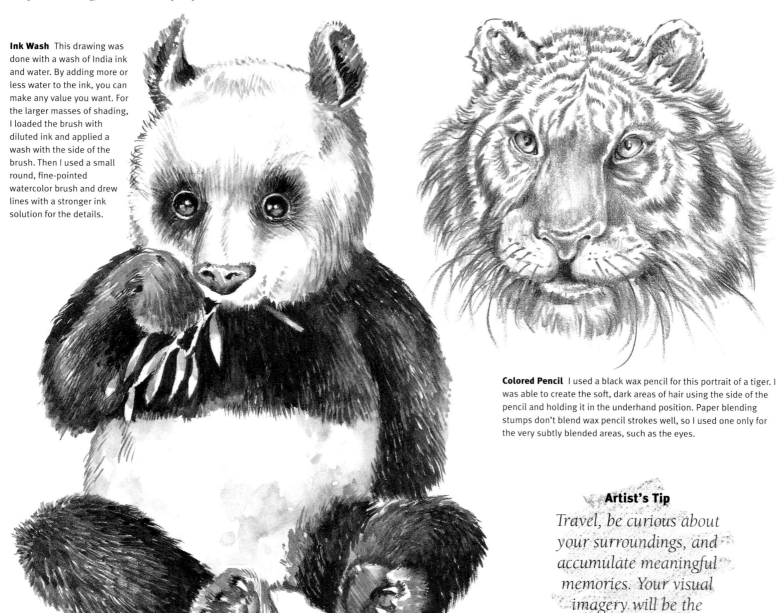

Conté Crayon To show the rough fur of this coyote pup, I decided to use Conté crayon. I used loose, sketchy strokes for the longer hair and blended my strokes around the eyes and face. To blend, you can smudge with your fingers or with a soft brush and water. Here I blended by layering a white Conté over the black.

Ink Wash This drawing was done with a wash of India ink and water. By adding more or less water to the ink, you can make any value you want. For the larger masses of shading, I loaded the brush with diluted ink and applied a wash with the side of the brush. Then I used a small round, fine-pointed watercolor brush and drew lines with a stronger ink solution for the details.

Colored Pencil I used a black wax pencil for this portrait of a tiger. I was able to create the soft, dark areas of hair using the side of the pencil and holding it in the underhand position. Paper blending stumps don't blend wax pencil strokes well, so I used one only for the very subtly blended areas, such as the eyes.

Artist's Tip

Travel, be curious about your surroundings, and accumulate meaningful memories. Your visual imagery will be the richer for it.

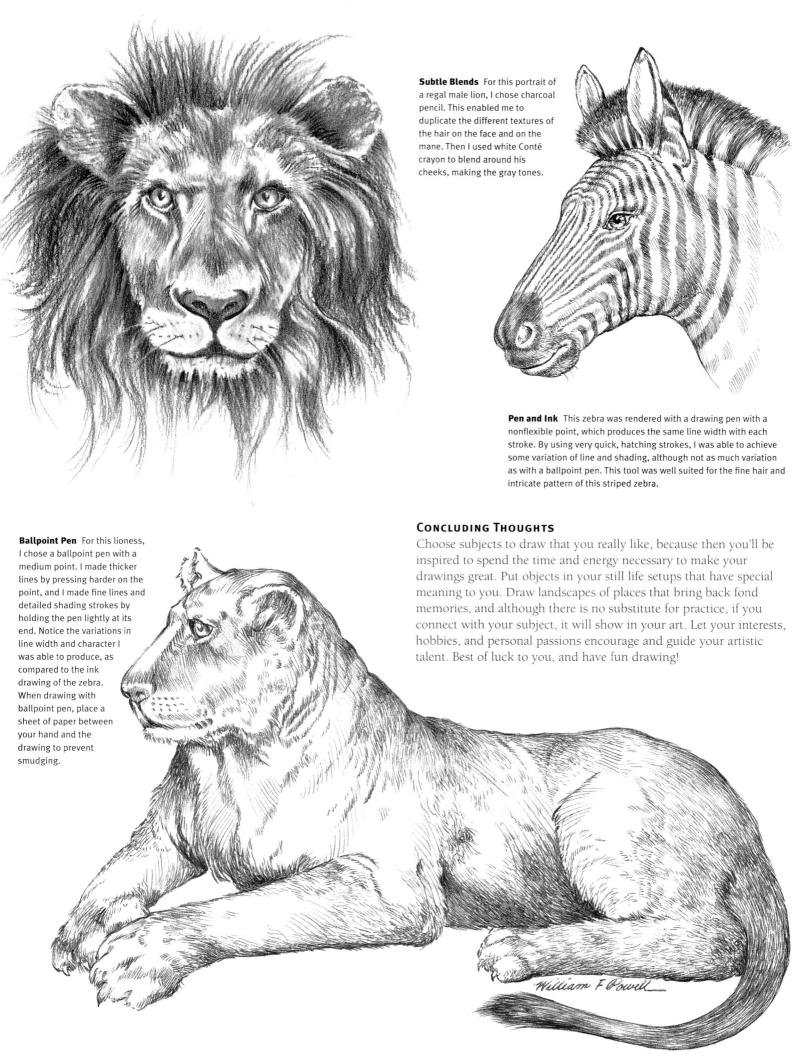

Subtle Blends For this portrait of a regal male lion, I chose charcoal pencil. This enabled me to duplicate the different textures of the hair on the face and on the mane. Then I used white Conté crayon to blend around his cheeks, making the gray tones.

Pen and Ink This zebra was rendered with a drawing pen with a nonflexible point, which produces the same line width with each stroke. By using very quick, hatching strokes, I was able to achieve some variation of line and shading, although not as much variation as with a ballpoint pen. This tool was well suited for the fine hair and intricate pattern of this striped zebra.

Ballpoint Pen For this lioness, I chose a ballpoint pen with a medium point. I made thicker lines by pressing harder on the point, and I made fine lines and detailed shading strokes by holding the pen lightly at its end. Notice the variations in line width and character I was able to produce, as compared to the ink drawing of the zebra. When drawing with ballpoint pen, place a sheet of paper between your hand and the drawing to prevent smudging.

Concluding Thoughts

Choose subjects to draw that you really like, because then you'll be inspired to spend the time and energy necessary to make your drawings great. Put objects in your still life setups that have special meaning to you. Draw landscapes of places that bring back fond memories, and although there is no substitute for practice, if you connect with your subject, it will show in your art. Let your interests, hobbies, and personal passions encourage and guide your artistic talent. Best of luck to you, and have fun drawing!

WALTER FOSTER PUBLISHING

Celebrating 90 years of art-instruction excellence

How to Draw & Paint

The titles in this classic series contain progressive visual demonstrations, expert advice, and simple written explanations that assist novice artists through the next stages of learning. In this series, professional artists walk the reader through the artistic process step by step, from preparation and preliminary sketches to special techniques and final details. Organized into six categories of instruction, these books provide an introduction to an array of media and subjects.

Artist's Library

These titles offer both beginning and advanced artists the opportunity to expand their creativity, conquer technical obstacles, and explore new media. Written and illustrated by professional artists, the books in this series are ideal for anyone aspiring to reach a new level of expertise. They serve as useful tools that artists of all skill levels can refer to again and again.

Drawing Made Easy, Acrylic Made Easy & Watercolor Made Easy

Every artist should have the opportunity to experience the joy of learning without having to deal with intimidating, complicated lessons. The books in these series simplify even the most complex concepts, making it easy for the beginner to gain an in-depth understanding of pencil, acrylic, or watercolor. These enjoyable, informative guides will teach you all you need to know about the tools and materials and basic strokes and techniques necessary for each medium. Then you'll discover a wealth of step-by-step projects, allowing you to put your newfound skills to work.

More than 90 years ago, Walter Foster—a well-known artist, instructor, and collector—began producing self-help art instruction books from his home in Laguna Beach, California. He originally wrote, illustrated, printed, bound, packaged, shipped, and distributed them himself. Although Walter passed away in 1981 at the age of 90, his legacy continues in a growing product line. Walter Foster Publishing now provides how-to books and kits to millions of enthusiastic artists worldwide who enjoy the rewards of learning to draw and paint. People who have never before picked up a paintbrush or drawing pencil have discovered their artistic talents through his easy-to-follow instruction books.

We are dedicated to preserving the high standards and superb quality you expect from our products. We believe artists are eager to learn, sharpen their skills, and experience new artistic horizons. Our mission is to provide the tools to accomplish those goals—we offer step-by-step books and kits that are accessible, entertaining, affordable, and informative. Whether this book is your first experience with us or the continuation of a long-term relationship with our products, we are sure that this title in our How to Draw & Paint series will delight you. Whatever your artistic ambitions may be, we wish you good luck and success and we hope that you always have fun in the process.

© 2016 Quarto Publishing Group USA Inc.

Pages 1, 2 (dog), 3 (child), 4, 18, 24-25, 28-29, 46-47, 74-75, 77, 80-81, 100-101, 114-115, 151-153, 174-175, 184-185, 210-211, 216-218, 232-233 © 1999, 2003, 2005, 2009 Michael Butkus. Pages 84-85, 87, 112, 116, 118, 126-130, 132-133, 136, 140-141, 146-149, 155, 172, 187 © 1989, 1997, 1998, 2003, 2009 Walter T. Foster. Pages 19, 191-199 © 2004, 2005, 2009 Ken Goldman. Pages 156-161, 163-165, 168-171, 173, 180-181, 183, 188-189, 222-223, 225-229 © 2006, 2007, 2009 Debra Kauffman Yaun. Pages 131, 137, 142-145 © 1989, 1998, 2003, 2009 Michele Maltseff. Pages 2 (rose, tree), 3 (glass), 5, 11 (leaf), 12-17, 20-23, 26, 30-44, 48-73, 76, 78-79, 88-89, 92-97, 117, 120-121, 150, 154, 162, 166-167, 176-179, 182-186, 190, 200-209, 212-213, 219-221, 224, 230-231, 234-237, 240 © 1989, 1997, 2001, 2003, 2005, 2009 William F. Powell. Pages 82-83, 86, 90-91, 98-99, 102-111, 113, 119, 122-125, 134-135, 138-139 © 1989, 1998, 2003, 2005, 2009 Mia Tavonatti. Pages 6-11, 214-215 © 2005 Walter Foster Publishing.

First published in 2016 by Walter Foster Publishing, an imprint of The Quarto Group.
26391 Crown Valley Parkway, Suite 220, Mission Viejo, CA 92691, USA.
T (949) 380-7510 F (949) 380-7575 www.QuartoKnows.com

Walter Foster Publishing titles are also available at discount for retail, wholesale, promotional, and bulk purchase. For details, contact the Special Sales Manager by email at specialsales@quarto.com or by mail at The Quarto Group, Attn: Special Sales Manager, 100 Cummings Center, Suite 265D, Beverly, MA 01915, USA.

ISBN: 978-1-63322-104-8

Printed in China
20 19 18 17 16

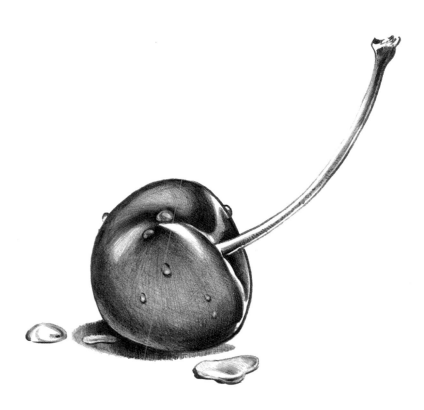